WILD PAGES 3
THE WILDLIFE FILM-MAKERS'
RESOURCE GUIDE

EDITED BY JASON PETERS
AND PIERS WARREN

Published by:

Wildeye
United Kingdom

Email: books@wildeye.co.uk
Websites: www.wildeye.co.uk/wild-pages
www.wildeye.co.uk/publishing

Copyright © Wildeye 2018
First published 2018

ISBN 978-1-905843-11-4

Cover photography by Jason Peters
www.jasonpeters.co.uk

This edition is dedicated to Jean Hartley 1947–2017

CONTENTS

INTRODUCTION

Welcome to the third edition of *Wild Pages: The Wildlife Film-makers' Resource Guide*.

The wildlife film-making industry is unique in many ways. The passion of the individuals involved, from camera operators to producers to distributors, is legendary. In many cases this leads practitioners to remain within the wildlife genre for all of their careers. Partly due to this, the industry has developed a community all of its own, with film festivals, production companies, and organisations devoted solely to wildlife imagery – whether it be productions for cinema, television, the internet, DVD/BD, phone applications and so on.

To find out who is in this community – whether you are looking for jobs, co-producers, footage, staff, work experience, film competitions or other opportunities – is not always easy. Trawling through the web and sending speculative emails can be very time-consuming and a hit-and-miss exercise. Festival directories may be invaluable, but few can afford to attend such events and the directories are usually only available to delegates.

Enter *Wild Pages*: a complete tool-kit of information for all wildlife film-makers – established and newcomers alike. Listings have been distributed into appropriate categories and many contain a description of the company/freelancer with full contact details, web-links etc. Where relevant, the companies have also been urged to give answers to those all-important questions such as whether they take people on work experience or consider co-productions, how to submit proposals and so on.

Keep *Wild Pages* on your desk, in your kit-bag or on your laptop or phone (there are eBook and Kindle editions available with active email/web-links) and access to the community will be constantly at your fingertips.

The first two editions of *Wild Pages* indeed proved to be 'essential pieces of kit' and this new edition is fully updated and with many new entries. We hope you will find it invaluable and good luck with your careers and productions.

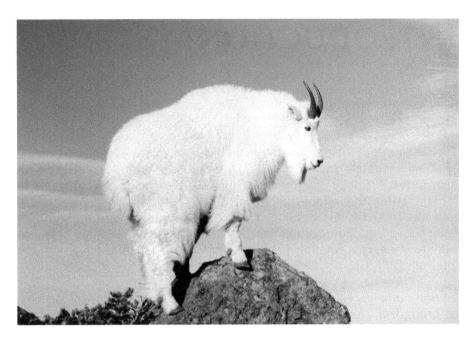

Note that this is an international guide, with listings from all over the world: you may notice that different countries spell some words in different ways – organize/organise, program/programme, for example. We have left the spellings true to the contributors' origins.

Also note that the '+' on the telephone numbers requires the international access code which is usually 00, and numbers in brackets e.g. (0) would be omitted if dialling from abroad.

PRODUCTION COMPANIES

1080 Film and Television
Address: 26 Blackthorn Way, Poringland, Norfolk NR14 7WD, UK
Phone: +44 (0)1603 327 333
Email: info@1080films.co.uk
Website: www.1080films.co.uk
Facebook.com/1080FilmsUK
Twitter.com/1080films
Director of Photography: Mark Dodd – markdodd@1080films.co.uk

1080 Films was set up in 2008 by Mark Dodd, an award winning photographer-filmmaker who has worked world-wide for 20 years with the BBC. We produce films for broadcast and commercial markets. Give us a call to chat about your requirements; we are a small but friendly team with access to some of the best talent in the broadcast market: presenters, producers, location crew, editors, web designers. These skills are selected to provide a tailor-made package, specific to the requirements of your project.

360 Degree Films
Address: GPO Box 2009, Darwin, NT 0800, AUSTRALIA
Phone: +61 41 853 0550
Email: info@360degreefilms.com.au
Website: www.360degreefilms.com.au
Facebook.com/pages/360-Degree-Films/108835979154278
Twitter.com/360degreefilms
Producer · Sally Ingleton

360 Degree Films is a film and television production company with offices in Darwin and Melbourne. Our motto is to make documentaries that matter. At the heart of our philosophy is the belief that it is possible to make insightful, entertaining films that inform, empower and inspire people to see the world differently. Principal Sally Ingleton has been a major player in the Australian industry for the past 30 years. Her award winning documentaries cover many genres including nature, science, environment, social issues and the arts. In the past 10 years Sally has been commissioned by the following broadcasters: ABC, BBC, National Geographic, Arte France, France TV, ITV, SBS, RTBF, RTE, SVT, YLE, TSR, DR and AVRO. Apart from producing and directing Sally has contributed and supported the Australian industry through mentoring young filmmakers, teaching and working at an executive level in screen agencies.

422 South
Address: Bristol, UK
Website: www.422south.com

We're an award-winning UK-based visual effects, animation and commercials company working for TV producers and advertising agencies around the world.
We have designers, directors, visual effects specialists, animators, compositors and technicians in our core team, with an extended family of trusted, specialist freelancers close to hand. We're always on the look out for talented individuals so please feel free to email talent@422south.com with any demo material, showreels, websites etc.

42°N Films
Address: Boston, USA
Website: www.42degreesnorth.com
Producer/Director/Writer: Kate Raisz

42 Degrees North specializes in translating complex ideas from science and natural history into compelling and dramatic media pieces for museums, television, and the web. Clients include Smithsonian National Museum of Natural History, NOAA, Discovery Channel, National Geographic, New England Aquarium and the Aquarium of the Pacific.

Abbey Gateway Productions
Address: Bristol, UK
Website: www.abbeygateway.co.uk

We are a fully inclusive production team specialising in HD and digital cinema delivery. We cover all aspects of production from research and development through to production and post-production. We strive to provide the best possible production values on every project we undertake. Some of the companies we have done work for include NASA, NatGeo Wild, The National Park Service, PBS, Oxford University, and The US Army. We are looking for collaborators, sponsors and actively seek co-productions.

ABC4EXPLORE
Address: 2264 Carter Street, Naples, Florida 34112, USA
Phone: +1 20 2415 4472
Email: abc4explore@yahoo.com
Website: www.abc4explore.com
Facebook.com/abc4explore
Instagram.com/abc4explore
Twitter.com/abc4explore
Cinematographer/Producer/Presenter: Andy Brandy Casagrande IV

Andy Brandy Casagrande IV (ABC4) is a two-time Emmy Award winning cinematographer, producer & television presenter specializing in wildlife & adventure films.

Achtel Pty Limited
Address: PO BOX 557, Rockdale, NSW 2216, AUSTRALIA
Wildlife-film.com/-/PawelAchtel.htm
Director: Pawel Achtel, ACS
Main listing in 'Equipment Hire/Sales' on Page 122

We specialise in underwater and wildlife cinematography, particularly for IMAX and Giant Screen. Not offering work experience.

AfriScreen Films
Address: P.O Box HA 40 HAK, Maun 267, BOTSWANA
Phone: +267 6862570 & +267 6801123
Mobile: +267 75253769
Fax to email: +27 86 6200739
Email: production@afriscreen.com
Website: www.afriscreen.com
Facebook.com/AfriScreenFilms
Wildlife-film.com/-/AfriScreen-Films.htm
Contacts:
Producer · Tania "TJ" Jenkins
Director/Cinematographer · Mike Holding

AfriScreen Films is a Botswana-based natural history production company. Our core team have worked in natural history, feature film, TV drama series and corporate film. All the experience, diverse disciplines and skills learnt are now melded into AfriScreen Films, where we have accumulated: 25+ years African wildlife filming expertise, 20+ years feature film and TV drama experience, 20+ years editing and post production skills and a lifetime of African bush skills and field operations. We produce our own films, film sequences for international productions and provide comprehensive fixing and facilitation services throughout Southern Africa. CV's welcome by email. Work experience offered for those with at least 3 years in the industry.

AGB Films
Address: Bristol, UK
Phone: +44(0) 1934 710283
Email: info@agbfilms.co.uk
Website: www.agbfilms.co.uk
Company Director: Andrew Graham-Brown

AGB Films is distinguished for being a dynamic, **multi award winning** independent production company with a sharp focus on producing high quality documentaries for British and International markets.

Altayfilm GmbH
Address: Erknerstraße 46, Gruenheide 15537, GERMANY
Email: mail@altayfilm.com
Website: www.altayfilm.com
Facebook.com/altayfilm
Camera/Producer: Yann Sochaczewski

Altayfilm is a natural-history film production company based in Berlin (Germany) specialized in producing blue chip wildlife documentaries with a focus on Russia and the Far East.

Ambi Creations
Address: Pune, INDIA
Main listing in 'Production Services' Page 52

Ammonite Ltd
Address: 127 Hampton Road, Redland, Bristol, BS6 6JE, UK
Phone: +44 (0)117 927 9778
Email: info@ammonite.co.uk
Website: www.ammonite.co.uk
Facebook.com/ammonite.films
Twitter.com/Ammonite_Films
Vimeo.com/ammonitefilms
Wildlife-film.com/-/Ammonite-Films.htm
MD: Martin Dohrn

Ammonite is an independent film production company. We have been in existence since 1994 making high quality, high definition films about science and natural history. Ammonite develops highly specialised and innovative equipment such as image intensified night vision cameras and motion control systems. Ammonite's kit can be hired. We also have an extensive library of high definition film clips available for sale.

9

Aquaterrafilms
Address: Durham, Maine, USA
Phone: +1 207 504 0733
Email: dp@aquaterrafilms.com
Website: www.aquaterrafilms.com
Facebook.com/Aquaterrafilms
Instagram.com/aquaterrafilms
Vimeo.com/aquaterrafilms
Cinematographer / DP: Mauricio Handler

Aquaterrafilms Underwater DP/ Cinematographer Mauricio Handler specializes in footage acquisition for documentary and commercial production. Underwater specialist. He is a Red Epic owner/ operator and acquiring content in 5k R3d format. Always looking for ideas and collaborations across the US and the rest of the world. Not offering work experience at the moment (2017).

Aquavision TV Productions (Pty) Ltd
Address: 144 Western Services Road, Woodmead, Johannesburg 2191, SOUTH AFRICA
Phone: +27 (0)11 275 0900
Fax: +27 (0)11 656 2701
Email: info@aquavision.co.za
Websites: www.aquavisionshop.co.za & www.lionmountain.tv
Wildlife-film.com/-/Aquavision-Productions.htm
CEO: Peter Lamberti – peter@aquavision.co.za
General Manager: Dave Keet – dave@aquavision.co.za
Head of Library: Christo Ras – christo@aquavision.co.za

A proudly South African film and television production company, Aquavision has been servicing international clients for over 24 years. With award-winning footage of the highest caliber, we create a range of films from wildlife documentaries to corporate videos and beyond. Our passion and respect for wildlife is central in forging lasting friendships with prominent nature conservationists, scientists, politicians and law-enforcement agencies. We also offer our clients the biggest library of natural stock footage in the Southern Hemisphere representing many leading cinematographers. Specialties: 4K Production House, HD and 4K Stock Footage, Equipment Rental, Underwater Filming. 5.1 Surround Sound. We accept CV's for work experience enquiries by email.

Aqua Vita Films
Address: 12 Dowry Square, Bristol, BS8 4SH, UK
Phone: +44 (0)117 373 0833 or +44 (0)797 367 7249
Email: contact@aquavitafilms.com
Website: www.aquavitafilms.com
Facebook.com/pages/Aqua-Vita-Films/46831648141
Twitter.com/aquavitafilms
MD and Creative Director: Bernard Walton – bernard@aquavitafilms.com

Award winning producer of wildlife and people documentaries for all the major broadcasters in the world. We are looking for talent who can offer their specialism to new ideas and projects. We are interested in collaborative and co-production. We accept CVs by email only.

Aquila Films
Address: 19 Bishops Road, London N6 4HP, UK
Phone: + 44 (0)208 340 9500
Main Email: info@aquilafilms.com

Website: www.aquilafilms.com
Wildlife·film.com/·/Aquila·Films.htm
Executive Producer: Andrea Florence – andrea@aquilafilms.com

An established independent production company based in London. We create powerful factual and factual entertainment programming with strong stories that engage a wide audience. Specialising in producing high impact adventure, science, travel and wildlife documentaries for key broadcasters worldwide including BBC and National Geographic. From blue·chip wildlife shows and 3D specials to high volume presenter·led series we aim to push the boundaries with inventive use of stunning computer graphics and multi·platform applications. Aquila collaborates with the world,s best cameramen and some of the most creative and innovative directors and editors to produce shows with compelling visuals and strong storytelling. Open to collaborations on all ideas/proposals related to * wildlife, science and conservation.

Arctic Bear Productions
Address: CANADA/USA
Email: abp@arcticbearproductions.com
Website: www.arcticbearproductions.com
Producers/Cinematographers: Adam Ravetch and Sarah Robertson

For over 20 years Arctic Bear Productions has been an award winning independent production team telling natural history, science and adventure stories. We are specialists in directing, shooting and producing polar narratives. We create one of a kind imagery to transform and engage audiences. Our films have Impact! Working in 4K and 8K, Large Screen, Exhibit, Virtual Reality and long and short form TV, Arctic Bear is a nimble and versatile team interested in fresh perspectives and innovative narratives. Arctic Bear houses a large stock footage library of polar imagery and marine creatures.

¿are u happy? films
Address: Freiburg, GERMANY
Phone: +49 177 761 6263
Email: werner@areuhappyfilms.com
Website: www.areuhappyfilms.com
Facebook.com/passionforplanetfilm
imdb.com/title/tt5138572
Contact: Werner Schuessler – Director, Writer, Producer, DOP

Werner is a multiple award winning director, writer, producer and director of photography, fueled by passion. Holding a MFA from the American Film Institute in Hollywood, his main focus is storytelling about things that matter in life: nature, wildlife, or fundamental questions about our existence. Always portrayed in an inspiring, uplifting yet thought·provoking manner. His latest works included the award winning theatrical documentary PASSION FOR PLANET which followed five of the world's leading wildlife filmmakers around the world on their quest to find out how to save their love: our environment. I only do films I am personally involved in (e.g. as director, writer or DOP). So if you are looking for someone in these functions, I am happy to hear from you. (I don't do co·financing/co·productions of external productions! Please refrain from asking.) Nature, Wildlife, Environment, Human Interest, Ecology, Society, Spirituality – Sponsors with a sustainable approach are welcome. Not offering work experience placements. Most of the time I am working as a one·man·band, only during productions I hire additional freelancers.

11

ArgoFilms
Address: Brewster, MA, USA
Email: info@argofilms.com
Website: www.argofilms.com
Facebook.com/EmmyWinningArgoFilms
Twitter.com/TheStoryofDao
Wildlife-film.com/·/ArgoFilms.htm
Contact: Allison Argo

ArgoFilms is dedicated to producing television programming that makes a difference.

Artists in Motion
Address: Suite 323, 19-21 Crawford Street, London W1H 1PJ, UK
Phone: +44(0) 7973 754 759 (Mark) & Phone: +44(0) 7545 564 728 (Keith)
Email: info@artistsim.com
Website: www.artistsim.com
Facebook.com/artistsim
Twitter.com/ArtistsInM
Youtube.com/ArtistsIM
Managing Director: Mark Wild – mark@artistsim.com
Managing Director: Keith Rooney – keith@artistsim.com

Artists in motion is a 21st century media company positioned to take advantage of the myriad opportunities thrown up by the brave new digital world. A recent series shot in the jungles of Indonesia entitled "Tarsier Tails" premiered on Channel 5.

Asian Wildlife Films
Country: THAILAND
Phone: +66 81 532 0303
Email: darrylsweetland@yahoo.com
Wildlife-film.com/·/DarrylSweetland.htm
Cameraman/Biologist/Writer: Darryl Sweetland

Darryl offers a wide range of services to film crews wishing to work in Thailand.

Atlantic Ridge Productions
Nuno Sá - Cameraman / Director
Address: Praceta José Florindo n. 20 , 2750 · 402, Cascais. Vila do Porto, AZORES 9580-529, PORTUGAL
Phone: +351 918 017 869
Email: fotonunosa@gmail.com
Website: www.atlanticridgepro.com
Facebook.com/AtlanticRidge
Cameraman/Director: Nuno Sá

Our Office is located in the middle of the Atlantic Ocean, smack on top of the Mid-Atlantic Ridge, more precisely in the Azores Archipelago. Led by awarded photographer and videographer Nuno Sá, we have over a decade of experience diving and capturing images of Oceanic life in its most extreme environments. Equipped with the best gear in the

Professional market we are prepared to deliver imagery in Ultra High Definition, 5 K resolution, as well as provide full expedition logistics, cameraman and DOP services. We regularly recruit junior cameraman, assistant producers or security divers, CV are welcome.

Babul Films
Address: S-4, Saregama Apts, Shaikpetnala, Chitrapuri Colony Post, Andhra Pradesh 500104, INDIA
Phone: +91 961 808 2288
Email: babulfilms@yahoo.com
Website: www.babul.ngo
www.imdb.com/name/nm1574535
Facebook.com/Babulfilms
Twitter.com/BabulFilms
President: Gangadhar Panday – gangactor@gmail.com

We make short videos for awareness on environment, biodiversity and sustainable development. We follow the best practices of sustainable filmmaking. We are recognised as one of the top 3 NGOs in South Asia in 2013, 2015 for using ICT tools for Advocacy by eNGO Challenge. We are open to co-production. We are planning to organize a Biodiversity / Environment film festival on permanent basis at Hyderabad, India. We offer internships and projects for students. We also provide consultancy for Eco film making

Baloo Films
Address: Berlin 14199, GERMANY
Email: baloofilms@live.co.uk
Website: www.baloofilms.org
Director: Bruce Phillips

Baloo films provide value for money film services and stock footage for charities, science education providers, and environmental groups with small budgets but big messages to get across to their audiences. With two decades of HD film experience, a network of local help, an extensive HD stock footage library and a talent for exploring unusual locations on four continents, we have provided our clients with value for money and a friendly service. We can provide everything from full film production, research and script-writing to educational expertise and ideas. At our core is a recognition of the importance of the natural world and a fascination for it which is why we aim to be the smallest footprint team out there. We make films for as little as 100 Euros per day.

Banksia Films
Address: Manaus, Amazonia, BRAZIL
Phone: +55 92 99152 0962 & +55 92 3321 4138
Email: carolina@banksiafilms.com
Website: www.banksiafilms.com
Facebook.com/BanksiaFilms
Instagram.com/banksiafilms
Vimeo.com/carolinafilms
Main Contact: Carolina Fernandes – carolinabanksiafilm@gmail.com

LOCAL KNOWLEDGE: A fund of knowledge of Amazon Forest, its people, language, geography, flora, fauna and geology. A wide network of contacts, and introductions to experts in every field. Up-to-date knowledge on all wildlife projects, such as translocations and research being undertaken in the region. PERMITS AND LICENCES: Licenses to film from the Ministry Information and Communications; permits to film in National Parks and Reserves, and any other permits necessary from Immigration, Museums, Railways, etc.

ARRIVAL AND DEPARTURE FORMALITIES: All import, clearing, export and freighting of equipment, plus personal airport assistance with immigration, customs, etc. EQUIPMENT: Assistance in hiring equipment locally: lighting, generators, etc and recruitment of local cameramen and other crew if required. ACCOMMODATION AND TRAVEL: All hotel/lodge bookings at residents rates. Arrangement of specialised camp facilities, vehicle hire, internal flights, air charter (including helicopters), and all travel including personal holiday itineraries. Confirmation of outward air tickets and all transfers to and from hotels/airports. THE ADVANTAGES OF USING OUR SERVICES: All your requirements can be handled quickly and efficiently, and as cheaply as possible, under one roof. Our cheerful participation as part of your team will save you hours of finding your way around. Our personal involvement will ensure that you get the very best advice and information throughout your time in Brazil. I want to get involved in films that make the difference. Films that educate people and respect the animals. I'm looking for collaborators to make films related with the biodiversity of the Amazon and I strongly consider co-productions. I offer work experience in the Amazon for who have the interest in coming to here. I accept CVs by email. Enjoy Nature!

BBC Natural History Unit
Address: BBC Broadcasting House, Whiteladies Road, Bristol BS8 2LR, UK
Phone: +44 (0)117 973 2211
Website: www.bbc.com/earth/uk
Facebook.com/bbcearth
Instagram.com/BBCEarth
Twitter.com/BBCEarth
Youtube.com/user/BBCEarth
Head of BBC NHU: Julian Hector – julian.hector@bbc.co.uk
Head of Natural History and Specialist Factual Commissioning: Tom McDonald
Commissioning Editor, Science, Natural History and Factual Scotland: Craig Hunter

All proposals need to be sent through the e-commissioning system.
Visit: https://www.bbc.co.uk/commissioning/tv/pitching-ideas/e-commissioning.shtml

BeeFly Studios
Address: 64 Kings Park, Thundersley, Benfleet, Essex SS7 3BA, UK
Phone: +44 (0)1268 759 203 Email: info@beeflyaerials.com
Website: www.beeflystudios.co.uk
Contact: Ross Birnie
Wildlife-film.com/-/RossBirnie.htm

Big Wave Productions
Address: 156 St Pancras, Chichester, West Sussex, PO19 7SH, UK
Phone: +44 (0)1243 532 531
Email: office@bigwavetv.com
Website: www.bigwavetv.com
Facebook.com/pages/Big-Wave-TV/515520428485398
Twitter.com/BigWaveTV
Exec Producer/MD: Sarah Cunliffe
Director/Producer: Nick Stringer
Director/Producer: Mark Woodward
Head of Development: Emma Ross

Big Wave are multi-award winning producers of science, wildlife and adventure documentaries for broadcasters worldwide. We have more than 80 awards and nominations. Big Wave offers a limited number of 1-week work experience placements throughout the year. To apply, please email office@bigwavetv.com

Blue Ant Media
Address: Toronto, Ontario, CANADA
Main listing in 'Distributers' on Page 74

BMP Filmproduksjon
Bernhard M. Pausett – Camera / Producer / Fixer / Assistant
Address: Oslo, NORWAY
Wildlife-film.com/·/BernhardMPausett.htm
Main listing in 'Production Managers' on Page 199

Brian Leith Productions
Address: 59 Cotham Hill, Bristol BS6 6SX, ENGLAND
Phone: +44 (0)117 906 4339
Email: info@brianleith.tv
Website: www.brianleith.tv
Facebook.com/BrianLeithProductions
Twitter.com/BrianLeithPro
Wildlife-film.com/·/BrianLeithProductions.htm
Executive Producer: Brian Leith
Managing Director: Mandy Leith

Brian Leith Productions was set up in 2006 and is based in Cotham, Bristol, Bristol, UK. Brian has won numerous awards over a long career as a radio and television presenter, producer, director, and Executive Producer of programmes and series for a variety of broadcasters including BBC, PBS, Discovery Channel, Nat Geo and Animal Planet, as well as many European broadcasters. Brian was an Executive Producer and Board member of the BBC Natural History Unit between 2006 and 2012, working on several major series and specials: *Wild China*, *Human Planet*, *Nature's Great Events*, *Ganges*, *Charles Darwin and the Tree of Life*, · written and presented by Sir David Attenborough. Brian Leith Productions are currently producing a series for National Geographic Wild; *China's Hidden Kingdoms* following on from the success of their Disneynature feature film *"Born in China"* released in cinemas worldwide in 2017. Other successful productions in recent years are *Wild Canada* a four-part series for the CBC in Canada, and UKTV in the UK and *Killer Whales Fins of Change* produced and directed by Ben Wallis. We do no accept unsolicited proposals, but are interested in collaborations and co-production with other international producers. Anyone sending in a CV to us must clearly state that they give their consent to us holding it on file. After six months it will be deleted from our records.

Carles Castillo Nature Productions
Address: C/Farigola, 5 "El Temple", Santa Mª de Palautordera 08460 SPAIN
Phone: +34 670 898 490
Email: info@carlescastillo.com
Website: www.carlescastillo.com
Twitter.com/carlescastillo_
Youtube.com/channel/UCUdOfQOvQMQoNJENFeaGK1A

Thematic documentaries production company specialists in underwater and nature documentaries for thematical channels or other clients. We work for the main televisions of different countries and we sell the documentaries in DVD´s (home video). We are looking for camera work in nature documentaries as well as making our own productions. We are looking for sponsors and collaborators and we consider co-productions. At this moment we don't accept CV.

Conservation Media
Address: P.O. Box 7061, Missoula, MT 59807, USA
Phone: +1 406 360 9684
Email: jroberts@conservationmedia.com
Website: www.ConservationMedia.com
Facebook.com/ConservationMedia
Instagram.com/conservation.media
Twitter.com/naturefilmmaker
Wildlife-film.com/-/Conservation-Media.htm
Owner/Producer: Jeremy R. Roberts

Conservation Media specializes in helping scientists and general conservationist share their stories through short form web films and photography. We also host storytelling workshops, provide stock footage, and provide support for third-party productions. All CM producers have science and filmmaking degrees. We are committed to telling compelling conservation stories. We don't do hyper-sensational, tooth and claw broadcast work. Always looking for sponsors to our work. Co-productions considered. Limited internship opportunities are generally sourced locally.

Content Media
Address: Sos Colentina Nr 4, Bl 3, Sc A, Ap 44, Sector 2, Bucharest 021173, ROMANIA
Phone: +40 721 89 64 97
Email: octavian@contentmedia.ro
Website: www.fixer.contentmedia.ro and www.contentmedia.ro
Facebook.com/pages/Fixers-in-Romania/187871544593986
Owner and Editor-in-Chief: Octavian Coman

Content Media is a film, television and radio production company that provides production services in Romania, a country with a rich variety of rare wildlife, including Europe's highest concentration of bears, wolves and lynx. We produce our own documentaries but we are also glad to lend you our knowledge and experience in order to bring interesting projects to life. Our researchers can get the information you need about any story in Romania. We will obtain all the necessary filming permits and we can plan your trip.

Cristian Dimitrius Productions
Address: Sao Paulo, BRAZIL
Wildlife-film.com/-/CristianDimitrius
Director: Cristian Dimitrius
Main listing in 'Production Services' on Page 54-55

Crossing the Line Productions
Address: Barr an Uisce, Killincarrig Road, Greystones, Co. Wicklow, IRELAND
Phone: +353 1 287 5394
Fax: +353 1 287 2910
Email: info@ctlfilms.com
Website: www.ctlfilms.com & www.highspeedireland.com
Facebook.com/pages/Crossing-the-Line-Films/10150120434115613
Twitter.com/CTLFilms

MD/Producer: John Murray · johnmurray@ctlfilms.com
Wildlife Producer: Cepa Giblin · cepagiblin@ctlfilms.com
Wildlife-film.com/·/CTL-Productions.htm

Crossing the Line Productions is an award-winning production company specialising in wildlife, travel and historical documentaries. The company won two best of festivals back to back at the Jackson Hole Wildlife Film Festivals and the Golden Panda at Wildscreen for their films 'Broken Tail' and 'On a River in Ireland'. They produce for the world's leading wildlife broadcasters including the BBC, PBS, ORF, NDR and France TV. They offer 4K & HD equipment rental, which includes specialist wildlife lenses and the only Phantom 4k Flex and 2K Flex High Speed cameras in Ireland.

Darlow Smithson Productions
Address: Shepherds Building Central, Charecroft Way, London W14 0EE, UK
Phone: +44 207 482 7027
Email: reception@dsp.tv
Website: www.dsp.tv

DSP is one of the world's leading television production companies. We have achieved widespread recognition for producing films and television programmes of the highest quality for UK, US and international broadcasters. From our base in London, we produce more than 100 hours of high-quality programmes every year for many of the world's leading broadcasters, including Discovery, C4, BBC, National Geographic, PBS, Five and Smithsonian Channel.

Deeble & Stone Productions
Country: UK
Email: hello@deeblestone.com
Website: www.deeblestone.com
Blog: www.markdeeble.wordpress.com
Facebook.com/theelephantmovie
Twitter.com/markdeeble1

Mark Deeble and Victoria Stone are Emmy award-winning film-makers, celebrated for their quality, story-driven wildlife films.

Dominique Lalonde Productions
Address: Québec, CANADA
Email: info@dominiquelalonde.com
Website: www.dominiquelalonde.com
Facebook.com/naturesauvageducanada
Twitter.com/explonature
Youtube.com/user/Explorationnature
Producer: Dominique Lalonde
Wildlife-film.com/·/DominiqueLalonde.htm

Dominique is an independent wildlife documentary producer specializing in wildlife of Eastern North America. I produce a web series on Canada Wildlife on Youtube. I invite you into nature with me to discover the wilderness of Canada throughout the seasons. One episode a week. Explorationnature

17

Dusty Foot Productions
Address: D-2/2123 Vasant Kunj, New Delhi 110070, INDIA
Phone: +91 11 41 081 846/7
Email: dustyfootindia@yahoo.com
Website: www.dustyfootindia.com
Facebook.com/pages/Dusty-Foot-Productions/118489981545808
Facebook.com/thegreenhubner
Facebook.com/greenhubfestival
Director/Cameraperson: Rita Banerji – ritabanerji@gmail.com
Director: Imrana Khan – imranarkhan@gmail.com

Dusty Foot Productions (DFP), established in 2002 and based in New Delhi, India, focuses on wildlife and environment films and outreach work. Their film 'The Wild Meat Trail' won the Panda Award at Wildscreen 2010 and the Earth Vision Award in 2011. In 2015 DFP collaborated with North East Network to set up the Green Hub Project, the first youth and community-based video for change and documentation fellowship program in the northeast of India. In 2017 the Green Hub Project received the Manthan Award for leveraging the power of youth through the digital medium in the field of environment. Rita Banerji was conferred the National Geographic - CMS Prithvi Ratna award for contribution towards environment conservation through films in 2017. DFP also looks at communication strategy projects related to environment. DFP has an in-house team to manage complete productions.

Earthmedia Film AS
Address: Svarttrostveien 7B, 0788 Oslo, NORWAY
Phone: +47 95 479 708
Email: james@earthmedia.co.uk
Website: www.earthmedia.co.uk
Lighting Cameraman: James Ewen

Earthmedia is an award winning media Production Company run by James Ewen. James is a UK native with a wide-ranging experience of high-end documentary production. See 'Camera Operators' listing on Page 147

Earth-Touch
Countries: SOUTH AFRICA, UK, USA
Website: www.earthtouchnews.com/contribute
Main listing in 'Broadcasters/Channels' on Page 80-81

Edge 2 Edge Films Ltd
Richard Hughes – DOP / Cameraman
Address: Kent, UK
Wildlife-film.com/-/RichardHughes.htm
Main listing in 'Camera Operators' on Page 153

18

Erik Fernström Film & Video AB – wildlifefilm.com
Address: Simonsgårdsgränd 5, SE-563 32 Gränna, SWEDEN
Phone: +46 70 669 7143
Email: info@wildlifefilm.com
Website: www.wildlifefilm.com

Wildlife documentaries , Scandinavian wildlife , illegal hunting etc. Human- interest in connection to sustainable hunting in Europe and elsewhere. Sponsors · yes. I am open for proposals, will consider co-productions. Not offering work experience at the moment (2017).

Elkins Eye Visuals
Address: Northern California, USA
Phone: +1 707 280 1648
Email: david@elkinseye.com
Website: www.elkinseye.com
Facebook.com/ElkinsEyeVisuals
Twitter.com/DavidElkins
Cinematographer/Filmmaker: David Elkins

Elkins Eye Visuals has been creating stunning visual content for well over a decade behind the creative talents of cinematographer and filmmaker David Elkins. Please contact David for your production needs throughout North America. Not looking for proposals or offering work experience.

Ember Films
Country: UK
Phone: +44 (0)844 8099 567 (Global) & +44 (0)7810 002 083 (UK)
Email: info@emberfilms.co.uk
Website: www.emberfilms.co.uk
Facebook.com/EmberFilms
Instagram.com/ember_Films
Twitter.com/emberfilms
Vimeo.com/emberfilms
Wildlife-film.com/-/Ember-Films.htm
DOP: Jonathan (Jip) Jones

Ember Films is an Emmy award winning Production Company based in the UK with a global reach. We work with international broadcasters and advertising agencies to produce and develop high end content from concept through to delivery using only the very best people and technology. Our full time specialist crew has traveled the world to capture remarkable images for major UK and US broadcasters such as the BBC, National Geographic Channel and the Discovery Channel. From Macro to Long Lens photography and everything in between our work has earned us multiple awards for Innovation and Cinematography. We use leading technology and equipment on all productions from independent corporate clients to international broadcasters and advertising agencies. Ember owns a vast array of camera equipment and lenses, including the RED EPIC 5K resolution film camera. Additional Sliders, Motion Control rigs and Jibs Arms are used to capture stunning cinematic images. We have Canon C300 + C100 full shooting kits including 5D's and 7D bundles plus vast ranges of lights, tracks and dollies, mini cams, sound equipment and loads more. All of this technology can be handled with ease in our post-production facilities.

Environment Films
Address: London & Sussex, UK
Email: info@environmentfilms.org
Website: www.environmentfilms.org
Facebook.com/Environment.Films
Twitter.com/environmentfilm
Wildlife-film.com/-/Environment-Films.htm

Environment Films is an award winning production company - a collective of creative and broad thinking individuals, all with a deep-rooted passion for the environment, human and animal ethics. EF produce films, documentaries and viral campaigns for organisations whose work and interests are connected to the natural world. Founded on ethical principle in 2008, EFs concern was that many charities and NGOs were not able to enjoy the benefits of quality media, because of the cost implications and as a result often failed to reach the all-important audience to which their critical campaigns were aimed. To ensure EF was a sustainable model (enabling the company to continue providing a non profit service to charities), in 2010 EF initiated a department to produce media for select corporate clients and operate a strict Social and Environmental Responsibility criteria whilst doing so. The success and quality of all EF productions; their far reaching impact and the increased awareness they have brought to a range of important campaigns has made EF the first choice for many of the UK's leading charities and ethical businesses.

Esprit Film and Television Limited
Address: Gloucestershire, UK.
Main listing in 'Equipment' on Page 123

Excelman Productions
Address: 67, rue Traversiere, Paris 75012, FRANCE
Phone: +33 6 0742 7838 and +33 5578 2700
Fax: +33 5578 2701
Email: takezo5@mac.com
Websites:
for Paris, France & Europe: www.excelman.com/en.index.html
and for Africa: www.excelman.jpn.com/en.index.html
Facebook.com/ExcelmanProductions
Linkedin.com/company/excelman-productions
Wildlife-film.com/-/Excelman-Productions.htm
Producer, Director, CEO: Douglas Lyon
Research & Logistics: Albert Laloy – laloy@excelman.com

We are Producers, Production Managers, Line Producers, Field Producers, Journalists and Directors! We have 20 years of experience in more than 50 different countries... The primary vocation of Excelman Productions ranges from the conception and complete production to simply the logistic management and co-ordination, of a wide spectrum of primarily audio-visual projects in video or film: hard news, documentaries, live satellite broadcasts, variety shows, reality shows, sports events, TV films, commercials, etc. In the world of Japanese television we have come to be known as "Africa specialists", but actually we began with Fashion and News, then Variety shows and Reality Shows, and although we love it all, but we must confess a particular passion for Broadcast News, Documentaries, and... well, you guessed it : Africa. We have built our reputation for excellence, innovation, creativity & reliability through years of working throughout Europe and Africa. Our multi-skilled and multicultural staff bring a wealth of knowledge and experience as well as a vast network of local contacts, developed over many years of television production.

Existential Productions
Jesse Blaskovits – Cinematographer/Producer/Writer
Address: Vancouver, CANADA
Main listing in 'Camera Operators' on Page 140

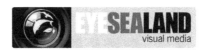

EYESEALAND Visual Media
Pieter Huisman – Freelance (wildlife) Documentary Cameraman
Address: Soest, the NETHERLANDS
Wildlife-film.com/·/PieterHuisman.htm
Main listing in 'Camera Operators' on Page 153

Fabio Borges Fotografia / Hydrosphera
Fabio Borges Pereira – Photographer & Filmmaker
Address: Alameda da Harmonia 565, Fernando de Noronha, PE, BRAZIL
Phone: +55 (81) 99 994 8281 & +55(81) 3610 1973
Email: fabioborges@me.com
Website: www.fabioborgesfotografia.com.br & www.hydrosphera.com.br
Facebook.com/FabioBorgesFotografia
Wildlife-film.com/·/FabioBorges.htm
Main listing in 'Camera Operators' on Page 140

Factual TV
Address: Kuala Lumpur 50460, MALAYSIA
Phone/Fax: +603 2276 3183
Email: info@factualtv.asia
Website: www.factualtv.asia
Contact: HonYuen Leong

We help broadcasters, production companies and organisations create documentaries and content in Asia. We are also licensed to provide production support to foreign production companies wishing to film their factual programmes in Malaysia.

CREATE | CONSERVE | CONNECT
www.felis.in

Felis Creations
Address: Bangalore, INDIA
Phone: +91 94835 21578
Email: info@felis.in
Website: www.felis.in
Facebook.com/FelisCreations
Youtube.com/user/feliscreationsindia
Director & Chief Cameraman: Sandesh Kadur
Wildlife-film.com/·/SandeshKadur.htm
Production Head: Adarsh N.C
Production Manager & Creative Head: Vydhehi Kadur

Felis Creations is a media and visual arts company based in Bangalore, India that focuses on creating natural history content that inspires conservation.
Felis offers a complete documentary production service with the ability to acquire permits, research & recce, shoot & direct and deliver a completed programme. It also houses a growing collection of stock footage in high-definition, time-lapse photography and still imagery from all over the Indian subcontinent, housed under Felis Images.
We offer 3-month unpaid internships. Interested applicants must have relevant visas (if they are not Indian) and may apply through the following link: www.felis.in/internships

Films@59
Address: Bristol, UK
Main listing in 'Production Services' on Page 56

Five Films
Address: Bristol, UK
Email: verity@fivefilms.org
Website: www.fivefilms.org
Facebook.com/fivefilms
Wildlife-film.com/·/Five-Films.htm
Director: Verity White

At Five Films we make short films for charities, NGOs and generally good causes. Our passion is to communicate strong messages to a wide audience by making beautiful, funny and entertaining films.

Frog Films
Country: Montana, USA & UK
Phone: +1 406 599 2670 (USA) & +44 (0)7736 217 235 (UK)

Email: phil@philsavoie.com
Website: www.philsavoie.com
Contact: Phil Savoie – philshoots@gmail.com

Fuzzfox
Address: Nottingham, UK
Phone: +44 (0)7948 377 224
Email: hello@fuzzfox.com
Website: www.fuzzfox.com
Facebook.com/FuzzFoxFilms
Twitter.com/Fuzzfoxfilms
Wildlife-film.com/-/LauraTurner.htm
Owner/Filmmaker: Laura Turner

We specialise in online videos for charities, non-profits and businesses, as well as animations and whiteboard animations. We love to make videos for good causes and offer discounts to charities. Laura from Fuzzfox also runs The Wildlife Garden Project, who produce video tutorials advising on how to help garden wildlife (see our listing in the Organisations section!). To find out more about how an online video can help your charity or business, please visit our website or give us a bell!

Geonewmedia
Address: 20 Martin Place, Glen Waverley, Melbourne, Victoria 3150, AUSTRALIA
Phone: +61 425 371 812
Email: info@geonewmedia.com
Website: www.geonewmedia.com & see: secrets-of-the-kimberley.html
Facebook.com/trevor.almeida.5
Twitter.com/GeonewmediaInfo
Linkedin.com/in/geonewmedia
Producer/DOP: Trevor Almeida – trevor@geonewmedia.com

Documentaries; E Learning; TV documentaries; Environmental; Training videos; Museum video and interactive media; Time lapse photography; Aerial photography; Language services; Video editing; Online training videos; Wildlife Film making workshops. We are constantly looking for film ideas on wildlife, character driven stories, children and environmental stories. We also would like to work with other producers on TV series development. We are open to co-productions and collaborations. We offer work experience and internships. Please send CV by email.

Green TV
Countries: UK, SWITZERLAND & JAPAN
Main listing in 'Distributers' on Page 75

Grey Films India Pvt Ltd
Address: F 88, Sector 21, Jalvayu Vihar, Noida 201301, INDIA
Phone: +91 120 429 8073
Email: info@greyfilms.com
Website: www.greyfilms.com

Grey Films is your single window solution in India and Asia for wildlife, factual programming and feature films. Our renowned wildlife and documentary cinematographer, Nalla is a pioneer of HD in India. Be it cinematography, still photography, research or equipment rental, we ensure that your productions are made to international standards. We also undertake co-productions for documentary and feature films.

Gulo Film Productions
Address: Hamburg, GERMANY
Website: www.gulofilm.de
Wildlife-film.com/·/Gulo-Film-Productions.htm
Contacts: Oliver Goetzl & Ivo Nörenberg

Wildlife Film Productions world-wide. Specialized on Mammal behavior.

 Hairy Frog Productions Ltd
Address: Church View, Heydon, Norfolk NR11 6AD, UK
Phone: +44 (0)7885 964 790
Email: mike@hairy-frog.co.uk
Website: www.hairy-frog.co.uk
Twitter.com/hairyfrogltd
Wildlife-film.com/·/Hairy-Frog-Productions.htm
Director/Producer/Cameraman: Mike Linley · mike_linley@yahoo.co.uk

Wildlife Production Company with full HD kit (BBC specs) + gopro heroes in flat optic housing + video-microscope and endoscopes + Canon 7D time-lapse kit. Over 400 credits mainly as a Producer for Survival/Anglia Television. Now also producing Wildlife Interactive touch-screens. Over 40 International awards to date. Specialist in Herpetology, Entomology and UK wildlife. Large video, sound and stills library. Always happy to co-produce. Limited work experience opportunities, depending on current projects.

Homebrew Films
Address:
Physical: 7 Montague Drive, Montague Gardens, Cape Town 7441, SOUTH AFRICA
Postal: Postnet Suite 248, Private Bag X1,Vlaeberg 8018, SOUTH AFRICA
Phone: +27 (0)21 422 3452
Fax: +27 (0)21 422 3425
Website: www.homebrewfilms.tv
CEO: Jaco Loubser

Homebrew Films is a television production house specializing in natural environment, lifestyle, youth, fashion, entertainment and cooking programmes.

Humble Bee Films
Address: 32 Whiteladies Road, Clifton, Bristol BS8 2LG, UK
Website: www.humblebeefilms.com
Facebook.com/humblebeefilms

Twitter.com/HumbleBeeFilms
Wildlife-film.com/-/HumbleBee-Films.htm
Creative Director: Stephen Dunleavy
Head of Production: Lisa Walters · lisa@humblebeefilms.com

Humble Bee Films is a vibrant producer of fresh and imaginative broadcast films.

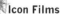## Icon Films

Address: 3rd Floor, College House, 32-36 College Green, Bristol BS1 5SP, UK
Phone: + 44 (0)117 9 10 20 30
Email: info@iconfilms.co.uk
Website: www.iconfilms.co.uk
Twitter.com/iconbristol
Managing Director: Laura Marshall
Creative Director: Harry Marshall
Director of Production: Andie Clare
Commercial Director: Lucy Middelboe

Icon Films is an award-winning UK production company with a reputation for originality, excellence, and entertainment across the breadth of factual genres including science, history, exploration and natural history. We bring together international funders working with BBC1, BBC2, BBC4, ITV1, ITV4, Channel 4, five, National Geographic Channels, Discovery Networks and PBS. Our work is internationally distributed by ITV Studios Global Entertainment, BBC Worldwide and Zodiak Rights. Icon Films offers 2 week work experience placements, continually looks for talent and accept CV's by email.

IdeaVideo.it

Address: Via Caose, 21, 31030, ITALY Phone: +34 71 597 760
Email: manfred@ideavideo.it
Website: www.ideavideo.it
Facebook.com/manfred.bortoli
Twitter.com/MANFREDBORTOLI
Youtube.com/user/manfredfilm
Contact: Manfred Bortoli

Manfred Bortoli is a professional underwater and topside cameraman.
He is also a documentary producer & freelancer for TV productions in all world waters, from iced to tropical. He has worked on the major Italian TV programs for ten years and co-operates with many top international production companies. His films have won many International Underwater Competitions. He is a Member of Ocean Artists Society.
Broadcast Service:
- Underwater and topside video service.
- Underwater stock footage video/photo.
- Underwater photographer.
- Documentary production.
Interested in working on Underwater Nature Projects.
Interested in Festival categories only if cash prize or really valuable.
I consider co-productions. Not offering work experience.

IMAGEWORKS MULTIMEDIA Pty Ltd

Country: SOUTH AFRICA
Phone: +27 (0)83 634 2182 (Mobile) & +27(0)11 022 5571 (Landline)
Email: info@imageworks.co.za
Website: www.imageworks.co.za
Producer/Director: Anthony Irving

We are producers and facilitators of wildlife and environmental programming across Africa. We have 4K camera kits, 4 Media Composer edit suites, 4x4 vehicle and camping equipment for bush shoots.

Jack Perks Wildlife Media
Address: 9 Brookthorpe Way, Silverdale, Nottingham NG11 7FB, UK
Phone: +44 (0)7722 536 029
Email: jackperksphotography@hotmail.co.uk
Website: www.jackperksphotography.com
Facebook.com/JackPerksPhotography
Twitter.com/JackPerksPhoto
Showreel: youtu.be/b0z1l039IEo
Wildlife-film.com/·/JackPerks.htm
Camera Operator/Photographer/Presenter/Researcher: Jack Perks

Primarily working underwater in freshwater habitats and experienced with trail cams, time lapse and topside pieces. I enjoy making thought provoking films especially for wildlife often over looked, like fish and amphibians. Filmed for various natural history and angling programmes like *Springwatch*, *Countryfile*, *The One Show*, *Mr Crabtree goes fishing*.

John Downer Productions
Address: Leighside, Bridge Road, Leigh Woods, Bristol BS8 3PB, UK
Phone: +44 (0)117 923 8088
Fax: +44 (0)117 974 1612
Email: jdp@jdp.co.uk
Website: www.jdp.co.uk
Facebook.com/JohnDownerProductions
Twitter.com/JohnDownerProd
Youtube.com/JohnDownerProd
Flickr.com/photos/johndownerproductions
Producer/Director: John Downer

A media company specialising in wildlife television, feature films and commercials. It has won numerous international awards for its innovative approach to filmmaking. It made its name by abandoning the traditional style of nature documentary and pioneering a highly inventive subjective approach. Through the use of new dramatic techniques it was possible, for the first time, to plunge the audience into the animal world.

Jungle Run Productions
Address: Jalan Raya Sanggingan #1. Ubud 80571, Bali 80571, INDONESIA
Phone: +62 812 381 3887 & +62 361 979 109
Fax: +62 361 975 378
Email: info@jungle-run.com
Website: www.jungle-run.com
Wildlife-film.com/·/JoeYaggi.htm
Head Creative Dude/Director/DOP: Joe Yaggi · joe@jungle-run.com
Jungle Run Productions offers complete production services for Indonesia and SE Asia including:

· 4K & HD crews, drones, lighting and grip
· location and production management, fixers, translators
· film permit facilitation
· post-production, graphics, animation
· stock footage

We also have excellent contacts for:· aircraft & watercraft, scientists and business leaders, government and NGO sector, search and rescue We've been based in Indonesia since 1993 and have worked with broadcasters, private sector, and govt clients from around the globe. We're documentary filmmakers, producers and directors and have recently begun expanding our horizons into animation and live action projects as well. On the production side we're keen to collaborate with broadcasters and serious producers to make great programs in Indonesia and SE Asia. We specialise in remote region work, but we're just as comfortable in the concrete jungles of Asia. We distribute environment, wildlife, and social issue films to local television stations across Indonesia and are actively seeking partners in that work. Representing over 75 local television stations, we're also keen to meet partners looking to build a media presence in one of Asia's expanding television markets.

Lemuria TV
Address: Tisá, CZECH REPUBLIC
Phone: +420 603 450 580
Email: jiri.balek@lemuriatv.cz
Website: www.lemuriatv.cz
Facebook.com/lemuriatv
Youtube.com/user/wwwLemuriatvcz
Owner/Cameraman/DOP/Zoologist/Editor: Jiri Bálek

Cameraman and zoologist with thirty years of experience in filming wildlife. Filming rhinos in Kenya and Tanzania, other animals in Madagascar, SAR, Namibia, Zimbabwe, Botswana, Mauritius, Malaysia, Indonesia, Costarica etc.

Lighthouse Films
Address: Lincolnshire PE12 9QJ, UK
Phone: +44 (0)1406 351 522 & +44 (0)7850 054 590
Email: simon@lighthouse-films.co.uk
Website: www.lighthouse-films.co.uk
Director/Cameraman/Sound Recordist: Simon Normanton

Lighthouse has experience of making factual films in many countries around the world; films of a wide variety of subjects and styles but predominately character-driven 'travel and exploration' and 'people and wildlife', the world through other's eyes and experience.

Light & Shadow GmbH
Address: Badestraße 19a, 48149 Münster, GERMANY
Phone: +49 251 41 441 670
Email: info@lightandshadow.tv
Website: www.lightandshadow.tv
Director/Producer/DoP: Christian Baumeister – christian@lightandshadow.tv

Light & Shadow is a young and accomplished independent film production company known for stunning wildlife photography and unique stories. Headed by internationally-acclaimed director/cinematographer Christian Baumeister, Light & Shadow has shot in countries the world over, with a focus on Latin America. Co-producers include BBC, Discovery Channel, National Geographic Channel, NDR, ZDF, Arte, ORF and others. For

more than a decade Light & Shadow specializes in South American wildlife.

Liquid Motion – Film - Photography Academy - Foundation - Underwater Imaging
Address: Cozumel Island, 77664, MEXICO Phone: + 52 1 987 878 9690
Email: info@liquidmotion.com.mx
Website: www.liquidmotion.com.mx & www.liquidmotionfilm.com
Facebook.com/LiquidMotion
Twitter.com/LiquidMotionMX
Linkedin.com/company-beta/10537466
Owner/CEO/Filmmaker/Underwater Cinematographer: Anita Chaumette
Owner/VP/Film Director/Filmmaker/Artist/Photographer/Underwater
Specialist/Underwater Cinematographer/Underwater Photographer: Guy Chaumette

Liquid Motion is an internationally acclaimed, multi-faceted production company specialising in underwater and wet work, led by globally acclaimed, award-winning Filmmaker pioneers Guy and Anita Chaumette. World leaders in Underwater Cinematography, decades of experience worldwide as Underwater DP. Liquid Motions Filmmaking arm (www.liquidmotionfilm.com) is one of the most unique, creative influences in blue chip underwater filmmaking today, producing high-end films for private clients, corporate clients, tourism, advertising, broadcasters such as ARTE, RAI, NRK, TVE, National Geographic Television and some of the worlds most esteemed TV channels.
Liquid Motions Underwater Photo & Film Academy (www.liquidmotionacademy.com) provides private, one-on-one tailored instruction, in Underwater Photography, Cinematography & Film.
Seeking sponsors/funding for brand new underwater feature, brand new science, exciting, landmark story! :-) Email contact is best for work experience enquires, since we are often on small islands off the beaten track!

Living Planet Productions/The Brock Initiative
Address: Dumpers Cottage, Chew Magna, Bristol BS40 8SS, UK
Phone: +44 (0)1275 333187 +44 (0)7968 365816
Email: livingplanetproductions@gmail.com & info@brockinitiative.org
Website: www.brockinitiative.org
Facebook.com/BrockInitiative
Twitter.com/BrockInitiative
Vimeo.com/brockinitiative
Youtube.com/user/brockinitiative
Wildlife-film.com/-/Brock-Initiative.htm
Executive Producer: Richard Brock

28

I try to get stuff out there that will make a difference. There are now more ways of doing that than ever before. It can be in any format, anywhere, anyhow. I will provide free footage on wildlife and environmental matters from around the world. I am always interested in issues where "Filming with Attitude" might help the planet. Just let me know. The latest and most comprehensive project is the *Wildlife Winners and Losers* film series: brockinitiative.org/about/about-wildlife-winners-and-losers Richard says "My Wildlife Winners and Losers series shows that films can be made – with basic footage filmed on any device – to help get the word out about conservation."

Love Thy Nature
Address: Los Angeles, CA, USA
Phone: +1 310 459 3842
Email: info@lovethynature.com
Website: www.lovethynature.com
Facebook.com/LoveThyNatureFilm
Instagram.com/lovethynaturefilm
Twitter.com/love_thy_nature
Filmmaker: Sylvie Rokab

LunaSea Films
Address: Appleton, Maine, USA
Cinematographer/DP: David Wright
Main listing in 'Production Services' on Page 58

Maramedia Ltd
Address: Film City Glasgow, 401 Govan Rd, Glasgow G51 2QS, UK
Phone: +44 (0)141 440 6951
Email: info@maramedia.co.uk
Website: www.maramedia.co.uk
Facebook.com/maramedia.co.uk
Instagram.com/mara_media
Twitter.com/@mara_media
Directors: Nigel Pope and Jackie Savery.

Founded in 2010 by Nigel Pope and Jackie Savery, Maramedia produces content for web, television and stage using a wide range of media and skills. We work with the very best talent in the world. The core team and our creative collaborators have won BATFA, Emmy and RTS awards and have received dozens of nominations for other prizes at festivals such as Jackson Hole, Wildscreen and Missoula. Maramedia has offices in Glasgow, but we work on projects that span the world. Do get in contact as we are always keen to hear of new ideas.

Marca D'agua Filmes
Address: São Paulo, BRAZIL
Producer: Tulio Schargel
Main listing in 'Producers/Directors' on Page 190

Marco Polo Film AG
Address: Handschuhsheimer Landstraße 73, 69121 Heidelberg, GERMANY
Phone: +49 (0)6221 400 780
Fax: +49 (0)6221 400 884
Email: office@marco-polo-film.de
Website: www.marco-polo-film.de
Contacts: Annette Scheurich CEO & Klaus Scheurich CEO

Based in Heidelberg, MARCO POLO FILM AG is one of Germanys leading nature film production companies primarily engaged in the production of TV-documentaries and feature-length documentaries focusing on the following topics: Documentaries on nature and environment; Travel and adventure stories; Scientific documentaries and reports; Nature films with historical orientation.

Mavela Media
Address: Postnet Suite 256, Private Bag X11326, Nelspruit, 1200, SOUTH AFRICA
Phone: +27 83 455 7970
Website: www.kimwolhuter.com
Facebook.com/kimwolhuter1
Twitter.com/kimwolhuter
Instagram.com/kimwolhuter
Director: Kim Wolhuter

Producer. Cameraman. Talent. I work in Southern Africa, where I'm based. My films have won 3 Emmy Awards. I work intimately with wild animals only, which I have a unique ability to bond with.

Michael Dillon Film Enterprises
Address: PO BOX 1016, Woodend, Victoria, AUSTRALIA
Phone: +61 419 249 582 (mobile) and +61 3 5427 4545 (home)
Email: mcdillon@ozemail.com.au
Website: www.michaeldillonfilms.com.au
Cameraman/Producer/Director: Michael Dillon

Specialise in Adventure and wildlife documentaries. Many Australian Cinematography awards, plus Emmy nominations for Survivor and National Geographic Special "Those Wonderful Dogs". For full CV see website. Cameras include Aaton XTR Prod plus various HD video cameras and lenses ranging from wide to 800mm plus macro probe and snorkel lenses. Looking for any projects that involve adventure, wildlife, conservation. Mostly enter into International Adventure Film Festivals. Accept CV's by email for work experience placements.

Michael Johnson Entertainment, LLC
Mike Johnson – Cinematographer / DP
Address: St. Peters, Missouri, USA
Wildlife-film.com/-/MikeJohnson.htm
Main listing in 'Camera Operators' on Page 155

Mike Birkhead Associates
Address: Hurley, Berkshire, UK
Phone/Fax: +44 (0)1628 824 351
Email: mike@mikebirkhead.com
Website: www.mikebirkhead.com
Facebook.com/pages/Mike-Birkhead-Associates/135472616549206
Producer/Director: Mike Birkhead

Mike Birkhead Associates Film & Television Production.

Mountainside Films Ltd.
Address: PO Box 2781, Sidney, British Columbia V8L 5Y9, CANADA
Phone: +1 250 217 7573 & +1 250 589 9574
Main Email: mountainsidefilms@gmail.com
Suzanne: suzanne@mountainsidefilms.com
Michael: michael@mountainsidefilms.com
Website: www.mountainsidefilms.com
Contacts:
Suzanne Chisholm, Director, Producer, Camera
Michael Parfit, Director, Writer, Editor, Camera
David Parfit, Music, Sound, Technical Supervisor

Mountainside Films Ltd. is an independent documentary film production company based near Sidney, British Columbia, Canada. Its principals are Michael Parfit and Suzanne Chisholm. We specialize in stories of the relationships between humans and our natural world. We are committed to accuracy, honesty, clarity, visual impact and compelling storytelling. We manage all aspects of film production, including research, development, shooting, sound recording, writing, editing, and music composition. We shoot and deliver in high definition. Our work has taken us to all seven continents. We are comfortable working on the ice floes of the high Arctic, on the plains of Africa, in the cloud forests of the Andes, and in our own ocean backyard on the rugged west coast of Canada. We often travel to remote locations in a single-engine plane, piloted by Michael. Our award-winning work has been shown in theatres across Canada, in IMAX theatres worldwide, on PBS, BBC, CNN, CBC, National Geographic Channel, France 2, Al-Jazeera, and NHK, and in film festivals in more than 20 countries. We have been honoured with awards from prestigious festivals and organizations around the globe. We are not currently looking for film ideas or proposals, as we do most of our development and production in-house. At this time we are not offering work opportunities.

Mystic Pictures Zambia
Address: Kitwe, ZAMBIA
Main listing in 'Location Managers/Fixers' on Page 89

NaturaHD Films
Address: Madrid, SPAIN
Phone: + 34 696 791 657 & + 34 652 114 522
Email: info@naturahd.com
Website: www.naturahd.com
Facebook.com/naturahd
Instagram.com/naturahdfilms, @albertosaiz_naturahd & @nachoruiz_naturahd
Vimeo.com/naturahd
Producer/Director: Nacho Ruiz
Producer/Cinematographer: Alberto Saiz – albertosaiz@naturahd.com

Independent documentary production company focused on wildlife and conservation. Our passion is to show the beauty and complexity of the natural world through a cinematic experience and make a difference. We love to make beautiful films with powerful storyline. Also interested in human and nature stories. Based in Spain and in Masai Mara (Kenya) we produce our own films, sequences for other international companies and assignments. Our equipment includes RED EPIC full kit, 4K drones, motion control time lapse, etc. 16 years of experience filming in all ecosystems from Antarctica to jungles. We are open to hear ideas for co-productions focused on wildlife, adventure, conservation and human and nature themed. Always looking for like-minded collaborators. Synergy is key these days. CVs accepted via email.

31

nautilusfilm GmnH - Natural History Germany
Address: Postfach 1314, Dorfen 84403, GERMANY
Phone: +49 (0)8081 959 663
Email: info@nautilusfilm.com
Website: www.nautilusfilm.com
Contacts:
Director/Camera: Jan Haft
Production Management: Melanie Haft

nautilusfilm GmbH·Natural History Germany develops and produces Blue Chip Natural History and Wildlife films.

NEDO Films
Address: Santiago, CHILE
Email: rene@nedofilms.com
Website: www.nedofilms.com
Twitter.com/renearaneda
Wildlife-film.com/·/NEDO-Films.htm
Director: René Araneda

An idea, a dream, a responsibility and an educational entertainment factory.
Multimedia production is the tool we utilize to motivate and teach: we provide positive content to an industry that needs it.

NHNZ
Address: Box 474, 5 Melville St, Dunedin 9016, NEW ZEALAND
Phone: +64 (0)3 479 9799
Fax: +64 (0)3 479 9917
Email: info@nhnz.tv
Website: www.nhnz.tv
Facebook.com/NHNZMedia
Instagram.com/nhnzmedia
Twitter.com/NHNZMedia
Managing Director and Head of Production: Kyle Murdoch – kmurdoch@nhnz.tv
Head of Development, Sales & Marketing: Anya Durling – ADurling@nhnz.tv
VP of Production and Development in the USA: Liz Brach – LBrach@nhnz.tv
Wildlife-film.com/-/NHNZ.htm

We're NHNZ, an international production company that sees the world a little differently. Maybe that's because we're located on the edge of it. Based in Dunedin, on New Zealand's south-east corner, we collaborate with some of the world's best filmmakers to make factual TV for the biggest global broadcasters. Over the years, we've made original content for PBS, Discovery Channels, Animal Planet, A&E Bio Channel, Smithsonian Channel, National Geographic Channels, NHK, CCTV, Travel Channel, Arte and France Télévisions. We've also picked up over 300 awards along the way, including the Wildscreen Panda and a number of Emmy Awards. Now part of the Blue Ant Media family, we've been sharing some of the planet's most interesting stories for 40 years. And we're as dedicated as ever to creating programmes from a different perspective.

Nutshell Productions Ltd
Address: 86 Somerton Drive, Erdington, Birmingham B23 5SS, UK
Phone: +44 (0)7770 577 549
Email: madelaine@nutshellproductions.co.uk
Website: www.nutshellproductions.co.uk
Wildlife-film.com/-/MadelaineWestwood.htm
Producer: Madelaine Westwood

Nutshell Productions produces wildlife and conservation films for international broadcasters and conservation charities. Recent productions are 3 x 1 hour broadcast series 'Invisible Photographer' for Europe through Cello Media and Red Kite Runner for RSPB UK. Based in the UK, we work with talented creative teams across the world. Nutshell Productions creates and hosts conservation film and production training courses for a range of clients including non-governmental organisations in the field. Nutshell Productions is open to co-production partners and currently works with a number of companies in Europe. A key partner of the Great Apes Film Initiative, Nutshell produces films about specific environmental and conservation issues for local communities and ngo's across Africa and SE Asia.

Ocean Media Institute
Address: Bozeman, Montana, USA
Phone: +1 347 678 4569
Email: oceans@oceanmediainstitute.org
Website: www.oceanmediainstitute.org
Facebook.com/oceanmediainstitute Twitter.com/OceanMediaInst
Linkedin.com/company/ocean-media-institute
Executive Director: Gianna Savoie – gianna@oceanmediainstitute.org
Co-Director: Jeff Reed – jeff@oceanmediainstitute.org

The Ocean Media Institute is a global non-profit media collective that serves to enrich and expand the public's understanding of ocean science and conservation through the creation, exhibition, and distribution of award-winning innovative visual media as well as artistic approaches to ocean education. Our producers have over 20 years in the science and natural history broadcast industry and offer skilled production expertise, as well as workshops in visual storytelling and science communication. As a creative hub, we work with scientists and filmmakers, organizations and academic institutions, aquaria and museums to produce, exhibit, and distribute science-based media. We are currently looking to work with organizations or scientists at the grant application level to design, create, and distribute compelling and comprehensive outreach components and visual media that compliments their research. These may include beautifully produced short films, web-companions, animation and graphics, and interactive elements that visualize the science. We are also seeking royalty-free ocean-related content for a database that we can make available for free to scientists. We are always looking for collaborators and sponsors and co-producers who share our mission. We offer unpaid media internships for college/graduate credit. We hope to offered paid internships in the future. Please feel free to contact via email.

Offspring Films Ltd
Address: St Nicholas House, 31-34 High Street, Bristol BS1 2AW, UK
Phone: +44 (0) 117 315 5180
Email: info@offspringfilms.com
Website: www.offspringfilms.co.uk
Facebook.com/offspringfilms
Instagram.com/offspring_films
Twitter.com/offspringfilms
Founder and Creative Director: Alex Williamson
Managing Director: Isla Robertson
Head of Production: Helen Barraclough

Offspring Films is a BAFTA nominated production company, specializing in factual programmes and natural history. We make extraordinary films that stand out for their strong visual style and clear engaging storytelling. Since launching in 2014, Offspring has delivered over 20 hours of high-end programming for the UK and international markets. Our output includes 4K landmark series, gritty access documentaries and children's formats.

Off The Fence BV (Head Office)
Address: Herengracht 105-107, 1015 BE Amsterdam, NETHERLANDS
Phone: +31 20 5200 222 Fax: +31 20 5200 223
Email: info@offthefence.com
Website: www.offthefence.com
Twitter.com/offthefence
CEO: Ellen Windemuth – Ellen@offthefence.com

Off The Fence Productions Ltd.
Address: 20 Elmdale Road, Tyndalls Park, Bristol BS8 1SG, UK
Phone: +44 117 909 7571
Email: info@offthefence.com
Website: www.offthefence.com
MD: Allison Bean – Allison@offthefence.com

Established in 1994, Off the Fence is an independent television distribution and production company, specialising in nonfiction programming for the international marketplace.

One Tribe TV
Addresses: The Glass House, Charlcombe Lane, Bath BA1 5TT, UK
& The Maltings, East Tyndall Street, Cardiff CF24 5EA, UK
Phone: +44 225 469 507
Email: dale.templar@onetribetv.co.uk
Website: www.onetribetv.co.uk
Facebook.com/onetribetv
Twitter.com/onetribetv
Contacts:
Managing Director: Dale Templar
Creative Director: Owen Gay · Owen.Gay@onetribetv.co.uk

One Tribe TV is a production company based in Bath and Cardiff . Set up in 2011 after MD Dale Templar left the BBC Natural History Unit having series produced the landmark series *Human Planet*. Owen Gay, ex-BBC and Icon films has now joined OTTV as creative director, bringing his wealth of experience in popular factual programme making. OTTV makes a wide range of specialist and popular factual shows while specialising in adventure, expeditions, anthropology, travel and natural history. We work with a range of presenters and on-screen talent. Proposals: We will consider a limited number of properly worked out ideas with access or talent attached. We will consider Co-productions.

Oxford Scientific Films Limited (OSF)
Address: 4th Floor, 21 Berners Street, London W1T 3LP, UK
Phone: +44 (0)20 3551 4600
Fax: +44 (0)20 3551 4601
Email: info@oxfordscientificfilms.tv
Website: www.oxfordscientificfilms.tv
Twitter.com/oxfordsf
Wildlife-film.com/-/Oxford-Scientific-Films.htm
Chief Executive: Clare Birks – cbirks@oxfordscientificfilms.tv
Creative Director: Caroline Hawkins – chawkins@oxfordscientificfilms.tv
Head of Specialist Factual: Alice Keens-Soper

Oxford Scientific Films is a BAFTA and Emmy-award-winning producer of contemporary factual, natural history, science and history. We are known for outstanding and innovative programmes that rate. We have a passion for storytelling and we are proud of the company,s heritage as a technological pioneer. We offer Work Experience Placements. These placements are unpaid and last for a period of 2 weeks. We are committed to improving diversity in our industry. Please send your CVs to info@oxfordscientificfilms.tv

Passion Planet
Address: 33-34 Rathbone Place, London W1T 1JN, UK
Phone: +44 (0)20 7323 9933
Email: planet@passion-pictures.com
Website: www.passion-pictures.com/films/planet
Facebook.com/passionpictures
MD: David Allen

Passion Planet is master-minded by Emmy award winning producer David Allen. This department develops and produces innovative science and natural history documentaries, and combines big budget programming with more intimate narratives that are our stock in trade.

Pelagic Productions Ltd
Address: Auckland, NEW ZEALAND
Phone: +64 (0) 21 574 066 & +44 (0)7937 390 490
Email: steve@pelagicproductions.com
Website: www.pelagicproductions.com
Underwater Camera operator: Steve Hudson

Pelagic Productions is dedicated to providing a full range of professional filming and diving services. We specialise in capturing underwater and topside images in High Definition for television productions.

Penelope Films/Odd Hynnekleiv
Address: Kongensgate 4b, Pob 618 4665, NORWAY
Phone: +4746473322
Email: info@penelope.no
Website: www.penelope.no
Facebook.com/PenelopeFilm
Twitter.com/ohy

Penelope Films is an established production company based in Kristiansand, Norway. Since 1980 we have worked on more then 40 film and TV productions worldwide. Animals, birds; exclusive wolves and bears in 1080 and even 35mm.

Plimsoll Productions
Addresse: Whiteladies House, 51-55 Whiteladies Road, Bristol BS8 2LY, UK
Phone: +44 (0)117 307 2300
Email: info@plimsollproductions.com
Website: www.plimsollproductions.com
Facebook.com/plimsollproductions
Twitter.com/plimsollprods
Head of Natural History: Martha Holmes

Plimsoll Productions creates and produces non-scripted content from its offices in Bristol, Cardiff and Los Angeles. The creative team has produced many hits and won BAFTAs, Emmys and RTS awards for their work. Plimsoll controls its own distribution through a significant stake in Magnify Media. Plimsoll Productions does not accept unsolicited ideas or proposals.

PolarArt Productions - Where 5K meets the far north.
Address: Barter Island, Arctic Ocean, PO Box 96, Kaktovik, Alaska, USA
Phone: +1 907 640 6037
Emails: arthur@polarartproductions.us & jennifer@polarartproductions.us

Website: www.polarartproductions.us & www.arthurcsmithiii.us
Vimeo.com/polarart
Twitter.com/polarart
Behance.net/polarart
Contacts: Jennifer and Arthur C. Smith III

Living in northern Alaska since 2004, Jennifer and Art Smith of PolarArt Productions capture the freshest arctic natural history and documentary content available. We work on the front line of digital cinema, with the RED ONE and EPIC-X.

Por Eco Productions, One Idea/Dos Languages
Address: 6609 Gladstone Drive, Eldersburg, MD 21784, USA
Phone: +1 410 795 6374
Email: porecoproductions@verizon.net
Website: www.porecoproductions.com & www.mrbesleysforest.com
Facebook.com/PorEcoProductions.OIDL
Twitter.com/MDConserveMamma
Pinterest.com/tierrarturtle
Youtube.com/watch?v=kGI_TXtIKOU
Vimeo.com/porecoproductions
Conservation Filmmaker: Cheryle Franceschi
Environmental Español Translator: Eddie Franceschi

We write and produce educational videos focusing on conserving the resources of our natural world. Our digital content is used for e-learning, classroom engagement, and professional associations. All Spanish subtitles are done by Eddie, a former United States Department of Agriculture Certified Conservation Planner. Por Eco's documentary "Mr. Besley's Forest" was an official selection at the Utopia Film Festival (IMDd) in 2015. In 2017, Cheryle was honored with the MEL Award from the Maryland Association of Forest Conservancy District Boards. Since 2007, Por Eco Productions has been communicating content for conservation. Memberships include the Maryland Association of Environmental and Outdoor Educators and Women in Film & Video (Washington, DC Chapter).

Red Wolf Productions
Lewis Hayes – Lighting Camera Operator
Wildlife-film.com/-/LewisHayes.htm
Main listing in 'Camera Operators' on Page 151

Riverbank Studios Pvt. Ltd.
Address: C-18, Chirag Enclave, New Delhi 110048, INDIA
Phone: +91 9810 292 479
Fax: +91 11 2641 0684
Email: contact@riverbankstudios.com
Website: www.riverbankstudios.com
Facebook.com/riverbankstudios
Twitter.com/RiverbankStudio
Director: Mike Pandey · mike@riverbankstudios.com
Director: Gautam Pandey · gautam@riverbankstudios.com
Director: Doel Trivedy · doel@riverbankstudios.com

Riverbank Studios was set up in 1973 by internationally recognized filmmaker Mike Pandey. Based in New Delhi with over 40 years of experience in filmmaking, the studio is a wholly integrated set up equipped to handle the entire film pipeline from pre-production, production to post production. Our productions are diverse; wildlife and

environment, corporate and advertisement films, feature films, entertainment series for television, children's programming, animation and public awareness campaigns. We've been recognised for our work and have been awarded numerous times nationally and internationally including 3 times at the Wildscreen awards. Shooting all over India we have developed a tremendous bank of footage and stories that represent various facets of the country,s incredible natural and social heritage. Some of our other services are: HD Production and Post Production Facilities; Rentals, Production and line production for International crews and Stock Footage. This year we aim to begin shooting stock and archiving in 4K. We are interested in co-productions and are looking to collaborate on environmental and conservation films. We offer work experience placements/internships and accept CV's by email. Minimum qualification should be either education in filmmaking or work experience in filmmaking.

 The Royal Society for the Protection of Birds
Address: The Lodge, Sandy, Bedfordshire SG19 2DL, UK
Phone: +44 (0)1767 680 551
Fax: +44 (0)1767 683 262
Email: dm@rspb.org.uk
Website: www.rspb.org.uk
Facebook.com/RSPBLoveNature
Twitter.com/Natures_Voice
Vimeo.com/rspbvideo
Wildlife-film.com/-/RSPB.htm
Head of RSPB Digital Media Unit: Mark Percival
Producer: Robin Hill

The Royal Society for the Protection of Birds is a conservation organisation with over one million members. Producers of wildlife films since 1953, the RSPB Film Unit continues to create blue-chip wildlife and conservation programming today for campaigns, event presentation, online distribution and clips sales. Our aim is to showcase the RSPB's most important conservation work and to capture the spectacle of the natural world with award-winning clarity· achieved by a commitment to the principles of ethical wildlife filmmaking. Credits include: *Eagle Odyssey*, (10 awards incl. Wildscreen and Jackson Hole) *Waterlands*, (9 awards incl. Japan Wildlife Film Festival).

Rhythm Productions, LLC
Colin Ruggiero - Independent Filmmaker/DP/Photographer
Address: 245 Burlington Ave., Missoula 59801, USA

38

Phone: +1 406 570 9532
Email: ruggiero.colin@gmail.com
Website: www.colinruggiero.com
Main listing in 'Camera Operators' on Page 164-165

Scorpion TV
Address: London, UK
Main listing in 'Distributors' on Page 76

Scubazoo Images Sdn Bhd
Address: P.O. Box 15475, 88864 Kota Kinabalu, Sabah, MALAYSIA
Phone: +6 088 232068 & +6 019 861 8610
Fax: +6 088 237068
Email: info@scubazoo.com
Website: www.scubazoo.com
Wildlife-film.com/-/Scubazoo.htm
Co-Founder/Managing Director: Jason Isley - jason@scubazoo.com
Operations Director/DOP: Simon Enderby

Scubazoo is an independent production company that prides itself on providing quality footage, as well as solutions to your crewing and location management needs. We specialize in filming natural history programs and are renowned for our underwater cinematography and photography. We also have an extensive library of stills and high definition video footage of iconic underwater marine life such as sharks, turtles, rays and whales shot in locations around the world with a large selection being sourced on the rich reefs of South East Asia's Coral Triangle. Scubazoo is based in Kota Kinabalu, Sabah, Malaysian Borneo, and we have over 14 years production experience in Borneo and beyond. Whether you are a corporate body, an NGO, or a broadcast production company, Scubazoo is ideally placed to handle your filming and production requirements.
We offer work experience as a Stock Library Intern: Scubazoo are looking for young, motivated individuals to join our stock footage and photography team in Kota Kinabalu. Applicants should be:
 * College student or recent college graduate
 * Students of biological sciences or interested in marine life
Details of the position:
 * Full time (40 hours/week)
 * Unpaid
 * Duration of 12 weeks
 * Intern responsible for travel expenses
 * Preference will be given to Malaysian candidates

The position is unpaid. Interns will work under our stock footage and stock photo library managers, gaining experience in skills such as keywording, CMS, basic photoshop, Final Cut Pro editing and more. This is a great opportunity to learn real world skills and work as part of a team in a dynamic business environment. Applicants should send a cover letter and CV to info@scubazoo.com or roger@scubazoo.com

Shake The Tree Productions
Address: Keeper's Cottage, Rectory Road, Suffield, Norfolk, NR11 7ER, UK
Phone: +44 (0)1263 731659
Email: carolinebrett@mac.com
Wildlife-film.com/·/ShakeTheTreeProductions.htm
Company Director: Caroline Brett
Company Secretary: Alan Miller – alanmiller@mac.com

The Production Company behind Caroline Brett and Alan Miller. See their individual listings.

Silverback Films
Address: 1 St Augustine's Yard, Gaunts Lane, Bristol BS1 5DE, UK
Phone: +44 (0) 117 9927 220
Email: info@silverbackfilms.tv
Website: www.silverbackfilms.tv
Wildlife-film.com/·/Silverback-Films.htm

Silverback Films specialises in the production of high quality wildlife films for both television and the cinema. Formed in 2012 by Alastair Fothergill and Keith Scholey, the company brings together a world-class team of wildlife film-makers to create the highest quality natural history films. If you would like to work for Silverback Films please send an email to info@silverbackfilms.tv and include an up to date CV along with a description of which position you would like to be considered for.

Simon King Wildlife
Address: Frome, Somerset, UK
Email: support@simonkingwildlife.com
Website: www.simonkingwildlife.com
Facebook.com/simonkingwildlife
Twitter.com/TVsSimonking
Youtube.com/simonkingwildlife

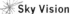

Sky Vision

Addresses:
Head Office: Sky Central · 1st Floor, Grant Way, Osterley TW7 5QD, UK
Offices in New York, Munich and Singapore: skyvision.sky.com/contact
Phone: +44 (0)207 032 3000
Email: skyvisionmarketingmailbox@sky.uk
Website: www.skyvision.sky.com/production

Created following the acquisition of Parthenon Media Group in 2012. Sky Vision is a world-class creator and distributor of multi-platform entertainment, bringing content to life for audiences around the world. Sky Vision's aim is to deliver growth through a strategic focus on content creation for multimedia platforms targeted at today's audiences, continued expansion of global distribution channels and new market penetration. Proposals: Natural History and Science. Co-productions: Always looking for new and exciting ways to work together. Work experience: Always looking for talent · in screen and off. Emailed CVs are best. Minimum qualifications · a background in Science.

Song Thrush Productions
Abbie Barnes - Film-maker, Presenter and Conservationist
Country: United Kingdom
Wildlife-film.com/·/AbbieBarnes.htm
Main listing in 'Presenters' on Page 212-213

Spier Films

Addresses: Cape Town, SOUTH AFRICA, London, UK & Reykjavik, ICELAND
Phone: +27 21 461 0925 (SA) & +44 20 3509 8744 (UK + I)
Email: contact@spierfilms.com
Website: www.spierfilms.com
Facebook.com/spierfilms
Twitter.com/spierfilms

Production, financing and sales company with offices in Cape Town, Reykjavik and London. We are looking to work with Directors with great stories to tell for an international audience but also with producers who are developing either one-off docs or series and would like us to work with them to raise finance and to make sales and pre-sales. We are looking for all types of film ideas and finished films. We prefer stories with some human interest or stories that are conservation related which we can campaign around, but the bottom line is entertaining television and that is what we are looking for. Whether fast-paced, presenter-led or slow moving wildlife we can help to raise finance and to sell the finished product. We are open to co-productions and we attend most festivals and markets including IDFA, Hot Docs, Mipcom, MipTV and some of the factual congresses. We are always looking for collaborators and sponsors. We have a small operation but could offer work experience for graduates and CVs can be emailed to us.

Studio Ray
Address: Sarasota, Florida, USA
Phone: +1 941 228 7288
Email: earthcare@aol.com
Website: www.studiorayproductions.com
Filmmaker/Composer: Darryl Saffer · datearthcare@gmail.com
Producer: Diane Cirksena · dian.ec@hotmail.com
Wildlife-film.com/·/DarrylSaffer.htm
Main listing in 'Producers/Directors' on Page 189

Sustainability Television
Address: Vancouver, CANADA
Main listing in 'Broadcasters' on Page 83

Table Mountain Films
Addresse: PO Box 469, Sea Point, 8060 Cape Town, SOUTH AFRICA
Phone: +27 (0)21 434 8398
Email: info@tablemountainfilms.com
Website: www.tablemountainfilms.com
Wildlife-film.com/·/Table-Mountain-Films.htm
Producer/Creative Director: Joe Kennedy – joe@tablemountainfilms.com
Producer/Managing Director: Katharina Pechel – katharina@tablemountainfilms.com

Table Mountain Films is a Cape Town based production company, specialising in documentary and wildlife filmmaking. Whether it's making films of our own, facilitating overseas productions or helping to get the ideas of others to the screen, we have a specialist for every stage of the production process. Our highly experienced team has a core of two very talented and diversely skilled individuals, both with their own unique background in filmmaking. Joe Kennedy is from Canada and Katharina Pechel from Germany.

Talking Pictures
Address: P.O. Box 782283, Sandton 2146, SOUTH AFRICA
Phone: + 27 11 880 1911
Fax: + 27 11 880 2290
Email: info@talkingpics.com
Website: www.talkingpics.com
Directors: Garth Lucas and Ann Strimling

Talking Pictures Is A Specialist Production Company Situated In South Africa Focusing On Natural History, Cultural And Wildlife Related Productions Ranging From Feature Documentaries To Social Awareness And Educational Programmes.

Terra Conservation Films
Address: Via XXV Aprile, 24, Fiesole 50014, ITALY
Phone: +39 333 108 2482
Email: giuseppe@terraconservationfilms.com
Website: www.terraconservationfilms.com
Vimeo.com/terraconservationfilms
Wildlife-film.com/·/TerraConservationFilms.htm
Producer/DOP: Giuseppe Bucciarelli

Terra Conservation Films is an award-winning production company specialized in working with non-profit organizations and nature enterprises to make documentaries focusing on the conservation of the natural world and the interaction between people and the environment. If you need a video to fundraise, increase your outreach, raise awareness and promote action, Terra Conservation Films can assist you in finding the best approach through films of unique visual and conceptual impact. We use broadcast-quality audio and video equipment to always deliver to you top quality services. We are looking for proposals about conservation films, human-wildlife conflict films, human-environment interaction films and everything dealing with the intimate relationship between humans and wildlife. We consider co-productions and we are looking for sponsors to produce conservation and raise-awareness films on the interaction/conflicts between people and nature.

Terra Mater Factual Studios
Address: Wambachergasse 2, 1130 Vienna, AUSTRIA
Phone: +43 1 870030
Fax: +43 1 87003 27609
Email: office@terramater.at
Website: www.terramater.at
CEO: Walter Köhler

Terra Mater Factual Studios' (TMFS) commitment to the highest production values results in premium factual programming for TV and theatre release. Our core genres are wildlife and nature, science and history presented in blue-chip primetime series and specials. We also bring together a wide array of genres and styles to create exciting new factual and entertainment formats. And in our large cinematic projects the borders between fiction and 'faction' become seamless and sometimes dissolve at all resulting in a different take on feature film production. TMFS collaborates with the best producers, cameramen and directors worldwide and uses the latest cutting-edge equipment to realise its cinematic dreams.

The Really Interesting Picture Company
Address: 33-21 163rd Street, Flushing, New York 11358, USA
Phone: +1 646 797 3171
Email: Tom.Veltre@TheReallyInterestingPictureCompany.com
Website: www.thereallyinterestingpicturecompany.com
Twitter.com/TRIPCo1
Vimeo.com/user1001210
Wildlife-film.com/-/TheReallyInterestingPictureCompany.htm
Director: Thomas Veltre

Founded by Filmmaker and Communication Scholar Thomas Veltre, The Really Interesting Picture Company is exactly what it claims - a creative production company dedicated to exploring really interesting ideas and untold stories through a broad range of media. Our work embraces Arts, Science, Wildlife & Environment, News, Broadcast, On-line, Museum Exhibit and other non-fiction applications. Based in New York City and around the world, The TRIPCo Team includes some of the most interesting artists and craftspeople working in digital media today. Thomas Veltre brings more than two decades of media production experience to his role as proprietor of The Really Interesting Picture Company.

Tigress Productions
Address: Second Floor, Embassy House, Queens Avenue, Bristol, BS8 1SB
Phone: + 44 (0)117 933 5600
Email: general@tigressproductions.co.uk
Website: www.tigressproductions.co.uk

43

Twitter.com/tigresstv
Youtube.com/tigressbristol
Production Executive: Isa Snow-Campbell

Tigress Productions has a worldwide reputation for outstanding and innovative programmes. The Company makes a wide range of adventure, science, and wildlife documentaries, from the extraordinary series following climbers on Everest for Discovery to rigging remote control cameras around a dead hippo to see what comes to eat the two million calorie feast. From its early beginnings making its acclaimed celebrity wildlife series, In the Wild, Tigress is now one of Britain's largest and best known specialist factual producers working with most major UK and international broadcasters. For recruitment enquiries email: recruitment@tigressproductions.co.uk

TRE Productions
Tania Rose Esteban – Wildlife Filmmaker/Zoologist
Address: Bristol, UK
Website: www.treproductions.co.uk
Wildlife-film.com/-/TaniaEsteban.htm
Main listing in 'Researchers' on Page 201

True To Nature Ltd
Address: 59 Cotham Hill, Bristol, BS6 6JR, UK
Phone: +44 (0) 7874 369424
Email: info@truetonature.co.uk
Website: www.truetonature.co.uk
Founder and CEO: Wendy Darke
Head of Production: Helena Berglund

TRUE TO NATURE is a Bristol-based Independent Production Company founded by Dr Wendy Darke, former Head of the BBC Natural History Unit. We specialise in innovative, world-class natural history content and TV production using great story telling to build lifelong relationships between people and the natural world.

Two Horseshoe Productions
Country: UK
Phone: +44 (0)7384 586 897
Email: info@twohorseshoe.co.uk
Website: www.twohorseshoe.co.uk
Facebook.com/pages/Two-Horseshoe-Productions/457535870937817
Vimeo.com/twohorseshoe
Wildlife-film.com/-/OliviaPrutz.htm
Producer: Olivia Prutz

A small, UK production company working mainly for charities and SMEs. Based in London and able to travel. Available to film, edit and produce a variety of short format programmes, documentaries and promotional videos.
Reasonable rates and reliable and experienced service. Open to all small scale projects and collaborations, with particular interest in conservation, human interest and travel/adventure docs.

Untamed Science
Address: 2430 Belmeade Dr, Charlotte, NC 28214, USA
Phone: +1 719 362 7334
Email: untamedscience@gmail.com

Website: www.untamedscience.com
Facebook.com/pages/Untamed-Science/169220075768
Twitter.com/UntamedScience
Youtube.com/UntamedScience
Producer: Rob Nelson – robnelsonfilms@gmail.com

We make short natural history videos for Youtube and act as on camera experts for science docs. We occasionally take interns.

Va.Le.Cinematografica 78
Address: Rome, ITALY
Phone/Fax: +39 063 231 665
Email: cv.valefilm@gmail.com
Website: www.claudio-valerio.com
Vimeo.com/claudiovalerio
Contact: Claudio Valerio
Underwater/topside crew for documentaries

VFX Productions
Address: P.O. Box 49265, 3A Al Qouz, Shaikh Zayed Road, Interchange 3, Behind Times Square, Dubai DXB, UAE
Phone: +971 43 471 248 & +971 506 521 931
Fax: +971 43 479 335
Email: vfxdubai@gmail.com
Website: www.vfxme.com
Wildlife-film.com/-/VFX.htm
Producer/Director: Yusuf Thakur · yusufwings@gmail.com

Visual Effects & Productions (VFX) is a 14 year old company based in Dubai and headed by Yusuf Thakur. We have been producing natural history based documentaries since our inception and have produced four HD based films in 2011. The last two have been shot on 4K RED ONE camera, which we own. All our work is based on subjects in the Middle-East and specifically UAE. We have comprehensive production and post production facilities including real time 2K/4K edit suites. Our work in the past has won awards at Jackson Hole, IWFF Montana, and Earth-vision. We have one of most comprehensive footage library on subjects from the region, 90% of which is HD/2K/4K. We would like to produce, work, collaborate, co-produce films on Conservation, pure wildlife, children's based program. We would specifically work on films based on the Middle-East, and the Indian Subcontinent. Past films have been based on birds, dugongs, islands, mangroves and deserts. We attend Pure Wildlife Film Festivals. Would love to work with broadcasters/sponsors on co-productions. Will except Interns who will work in the Middle East region... Email CV's.

45

Videodiver.ru
Kiril Ivanov
Address: Moscow, RUSSIA
Wildlife-film.com/·/Kirillvanov
Main listing in 'Camera Operators' on Page 154

Virgo Productions
Address: 27 Joondanna Drive, Joondanna, WA 6060, AUSTRALIA
Phone: +61 410 491 449
Email: info@virgoproductions.com.au
Website: www.virgoproductions.com.au
Producer/Director: Cathy Henkel · cathyhenkel@virgoproductions.com.au

Virgo Productions is a boutique screen industries company, specialising in feature documentaries that tell inspiring, positive, global stories with cross-platform delivery to engage audiences through cinema, television, online and DVD release. Best known for 'The Burning Season', which won the IF Award for Best Documentary and the Audience Choice Award at the Brisbane International Film festival and was nominated for an EMMY Award (Outstanding Documentary on a Business Topic), two ATOM Awards and a Golden Panda Award. In 2009 Cathy was awarded Documentary Producer of the Year at SPAA for her work on The Burning Season. We are not looking for proposals. Virgo's festival categories are Conservation Documentary, and Business Documentary. We are looking for sponsors with an interest in a proactive response to conservation. We consider co-productions. We do not offer work experience.

Visionquest Entertainment International Pty Ltd
Address: 25 Elesbury Avenue, Victoria, 3057, AUSTRALIA
Phone: +61 402 058 863
Email: norm@visionquest.com.au
Website: www.visionquest.com.au
CEO/Producer: Norm Wilkinson

We are producers and executive producers. We are constantly looking for new ideas in all areas, including children's, of natural history, science, adventure and history storytelling. We are always looking for co-productions, consider sponsors/collaborations and prefer CVs to be delivered by email.

VisionHawk Films
Casey Anderson – Camera Operator/Presenter/Naturalist
Address: 30 Shawnee Way, Unit 30, Bozeman, Montana 59715, USA
Phone: +1 406 202 3306
Email: info@visionhawkfilms.com
Website: www.visionhawkfilms.com & www.caseyanderson.tv
Facebook.com/VisionHawkFilms
Twitter.com/visionhawkMT
CEO: Deny Staggs

Vision Hawk Films is dedicated to changing the way the world sees wildlife in nature and its interaction with the human species. Utilizing the highest quality gear, VH creates original programing and also utilizes this kit to provide professional support for other companies and projects.

Visual Africa Films Ltd
Feisal Malik - Line Producer/Director/Camera/Fixer/Producer
Address: Nairobi, KENYA
Wildlife-film.com/-/Visual-Africa-Films.htm
Main listing in 'Location Managers/Fixers' on Page 91

Wallacea-films
Address: Jakarta & Bali, INDONESIA
Phone: +62 813 3859 3933
Email: info@wallacea-films.com
Website: www.wallacea-films.com
Twitter.com/WallaceaFilms
Footage-Indonesia.com
Producer/Filmmaker/Owner: Mr. Alain Beaudouard

Since 20 years in Indonesia. Documentary & Fixing/Scout: Wallacea-films.com
Fixing & Scouting in Indonesia and East-Timor: Footage-indonesia.com Open to all ideas and cooperation. Specialized in wildlife in Indonesia and East-Timor. Considering all co-productions and Sponsors.
Also see in 'Stock Footage' on Page 73 & 'Location Managers' on Page 91

Warehouse 51 Productions Ltd
Address: 20 Greek Street, London W1D 4DU, UK
Phone: + 44 (0)20 7851 1300
Email: info@W51P.com
Website: www.w51p.com
Instagram.com/W51Productions
Wildlife-film.com/-/Warehouse51Productions.htm
Managing Director: Carl Hall

Warehouse 51 Productions work with the very best production talent to produce the highest quality Factual and Factual Entertainment programming.

Waxwing Wildlife Productions Ltd
Address: Ballymacahill, Tulla Road, Ennis, Co. Clare, IRELAND
Phone: +353 86 370 5875
Email: snugent.ennis@eircom.net
Facebook.com/Waxwing-Wildlife-Productions-Ltd-1549693595357663
Company Director: Stan Nugent

Waxwing Wildlife Productions Ltd is a video production company specialising in the environment, nature and wildlife. Customers include TG4, SSE and IFI. I would consider co-productions.

WildCAM Australia
Address: PO BOX 510, Smithfield 4878, AUSTRALIA
Phone: +61 412 632 328
Email: av@wildcamaustralia.com
Website: www.wildcamaustralia.com
Vimeo.com/wildcamaustralia
Director: Alberto Vale

Specialising in natural history documentaries on tropical Australian wildlife.
See our website for more details.

47

Wild Creature Films
Address: 25 Salvator Rd, Hobart, Tasmania, AUSTRALIA
Phone: +61 428 104 313
Cinematographer: Nick Hayward · nick.hayward@wildcreaturefilms.com
Main listing in 'Camera Operators' on Page 151

Wild Horizons® Productions
Address: 5757 West Sweetwater Drive, Tucson, Arizona 85745, USA
Phone: +1 520 743 4551 Fax: +1 520 743 4552
Email: info@wildhorizons.com
Website: www.wildhorizons.com
Linkedin.com/company/wild-horizons
Owner/Producer: Thomas Wiewandt
Underwater Still Photographer: Barry Brown

Wild Horizons Productions is an educational media company, specializing in natural history films, publications, and consulting. Founder Thomas Wiewandt has received an Emmy Nomination in cinematography, four CINE Golden Eagles, a Gold Apple Award, and for his books, five top publishing honors. His 2012 production *DESERT DREAMS* (www.DesertDreams.Org) · screened in seven international film festivals, winning awards in three – was adopted by national Public Television for fund-raising campaigns. *DESERT DREAMS* and his new release *COSMIC FIRE* (2016) are immersive videos without narration. Wild Horizons contributor Barry Brown is an expert underwater photographer working on deep-sea research projects with the Smithsonian. FESTIVAL CATEGORIES: documentary, nature, experimental, independent, multimedia, low budget.

Wildlife Film Productions
Alex Jones - Wildlife Cinematographer
Address: 734 Esther Way, Redlands, California 92373, USA
Wildlife-film.com/-/AlexJones.htm
Main listing in 'Camera Operators' on Page 156

Wildlife Films
Address: Kasane, BOTSWANA
Website: www.wildlifefilms.co
Contacts: Dereck & Beverly Joubert
Film, Photography and Publishing by Derek and Beverly Joubert.

Wildlife Pictures Institute
Address: No 738, Imam Khomeini St., Tehran, IRAN
Phone: +98 919 459 0273 Fax: +98 21 6636 3519
Email: Info@wildlifepictures.ir
Website: www.wildlifepictures.ir
Facebook.com/WildlifePicturesInstitute
Instagram.com/wildlife.pictures.institute
Youtube.com/user/iranwildlifepictures
Vimeo.com/wildlifepictures
Wildlife-film.com/-/Wildlife-Pictures-Institute.htm
CEO: Fathollah Amiri – Mostanad@gmail.com
Art Director & Editor: Majid Mohammad Doust – mohammaddoost.majid@gmail.com
Cinematographer: Nima Asgari

Wildlife Pictures is an independent and non-governmental organisation specialised in making documentaries focusing on Iranian wildlife and has been working in this field for many years now with legit authorisations and permits form the Ministry of Culture and

48

Islamic Guidance of Iran. WPI has been awarded more than 40 national and international awards, among them rank 1 in every single one of the Iranian national festivals for at least once. We do offer work experience to some people.

Wild Logic LLC
Address: 1482 East Valley Road, Suite 625, Santa Barbara, CA 93108, USA
Phone: +1 805 969 1699
Email: katya.shirokow@wildlogic.net
Website: www.wildlogic.net
Managing Director: Katya Shirokow

Wildlife film producers and distributors.

Wild Planet Productions
Address: RAK Media City, UNITED ARAB EMIRATES
Phone: +971 5 5101 6245
Email: jak@wildplanetfilms.org
Website: www.wildplanetfilms.org
Managing & Creative Director: Jonathan Ali Khan
Facebook.com/pages/Wild-Planet-Productions/127211820701265
Twitter.com/WildPlanetFilms

Wild Planet Productions is the MENA region's only independent natural history TV production company created to service regional and international TV markets. Our goal is to position Middle Eastern, Indian Ocean and Arab world natural history content into international mainstream media and new-media channels. We aim to highlight & develop regional stories for international & regional TV markets, to be followed by synergistic educational campaigns using the TV films as their core value for distribution to schools & educational authorities in order to increase awareness of Arabia,s fragile natural world; in effect harnessing the power of media & new media in support of conservation.
We are looking for sponsors for our own projects or channel commissions and possible co-production.

Wildstep Productions
Address: Mogofores, PORTUGAL
Email: wildstepproductions@gmail.com
Phone: +351 96 437 6768
Website: www.daniel-pinheiro.com
Facebook.com/wildstepproductions
Wildlife-film.com/-/DanielPinheiro.htm
Producer / Director: Daniel Pinheiro

Wildstep Productions is an independent film production company focusing in natural history. The company is based in Portugal and was founded in 2014 by Daniel Pinheiro, wildlife photographer and filmmaker. Our productions have been broadcasted in Portuguese television (SIC, RTP and TVI), obtaining audience records in natural history in Portugal and awarded in several film festivals in the country, highlighting: "Mondego" ; "Alentejo, the song of the Earth" ; "Portugal, the wild side "and more recently "A Meeting of Waters · Secrets of Wild Portugal". In 2016, the company invested in top of the notch equipment and is now filming in Ultra High Definition with the new Red Epic W 8K. Wildstep produces factual, commercial and science programs, offering all the phases of the production and delivering up to 6K. We specialize in animal behaviour, 4K drone aerials, macro, timelapse and long lenses. Working together with universities, scientists and naturalists, our aim is to reach global audiences by connecting art, science and conservation.

49

Cinematic stories of nature and the ones who preserve it

Wild Step
Address: Den Bosch, The Netherlands
Phone: +31 614 905 819
Email: visser.tim87@gmail.com
Website: www.wildstep.nl
Facebook.com/wildstepfilm
Instagram.com/wild.step
Vimeo.com/wildstepfilm
Wildlife-film.com/-/Wild-Step.htm
Founder, Wildlife Cameraman, Producer: Tim Visser
Wildlife Cameraman: Dick Harrewijn
Researcher, Wildlife Cameraman: Roel Diepstraten
Producer, Light, Color Grading: Remco Hekker

Cinematic stories of nature and the ones who preserve it.
Wild Step is an independent production company specialised in wildlife and conservation filmmaking based in The Netherlands.
It is our mission to activate a sense of wonder for nature through our films. Show the viewers the highly diverse wild planet we live on and the people who step up in order to protect it. We believe that the use of high-end wildlife and conservation films can trigger people's love for nature. We are all formed by media and communication, Wild Step push the viewers a step in the right direction in order to preserve our environment.
Wild Step is founded by Dutch wildlife cameraman Tim Visser who has set up a small team of high-character individuals. We are a production team with a wide range of experience in natural history filmmaking for cinema, internet, video installation and TV production. We search for the creative boundaries in order to use great storytelling for the best possible format.
Not currently looking for proposals. We would like to find sponsors/collaborators and co-productions. For nature film festivals we develop blue chip short films and feature conservation films. Not currently offering work experience/internships.

Wild Visions, Inc.
Address: PO Box 42194, Phoenix, AZ 85080, USA
Phone: +1 623 512 9810
Email: mike@wildvisions.net
Website: www.wildvisions.net
President/Owner: Michael Pellegatti
Wildlife-film.com/-./Wild-Visions.htm

Wild Visions, Inc., located in Phoenix, Arizona, is a full service, award winning, video production company specializing in HD productions. We have 24 years experience in producing network television productions, sports, documentary, interviews, commercials, infomercials, product promotion videos, public service announcements (PSA), web and internet videos, and corporate video productions for local, national, and international clients. When Wild Visions was started, the focus was on wildlife, nature, and outdoor video productions. Filming the splendor of God's natural world has always been inspiring, motivating, and breath taking. We are looking for proposals and sponsors for adventure, conservation-themed, environmental, and social commentary films. We would consider collaborators/sponsors and co-production with the right individuals and film topic.

Windfall Films
Address: One Underwood Row, London N1 7LZ, UK
Phone: +44 (0)20 7251 7676
Fax: +44 (0)20 7253 8468
Email: enquiries@windfallfilms.com
Website: www.windfallfilms.com
CEO: David Duggan

Windfall Films has earned an international reputation as a producer of innovative, award-winning television.

PRODUCTION SERVICES

Aaduki Multimedia Insurance
Address: Bridge House, Okehampton, Devon EX20 1DL, UK
Phone: +44 (0)1837 658 880
Email: info@aaduki.com
Manager: Darryl Probert
Customer Service: Paul Newberry and Aiden Gerry
Website: www.aaduki.com
Facebook.com/aadukimultimediainsurance
Twitter.com/aaduki

Leading UK insurance provider for photographers and video makers. Recommended by major UK trade associations. Insurance for equipment, liability and professional indemnity. Also available is specialist travel insurance and drone insurance.

Achtel Pty Limited
Address: PO BOX 557, Rockdale, NSW 2216, AUSTRALIA
Wildlife-film.com/·/PawelAchtel.htm
Director: Pawel Achtel, ACS
Main listing in 'Equipment Hire/Sales' on Page 122

We specialise in underwater and wildlife cinematography, particularly for IMAX and Giant Screen. Not offering work experience.

AfriScreen Films
Address: Maun, BOTSWANA
Wildlife-film.com/·/AfriScreen-Films.htm
Main listing in 'Production Companies' on Page 8-9

Alien Sound Inc.
Address: North Olmsted, Ohio, USA
Wildlife-film.com/·/JonathanAndrews.htm
Contact: Jonathan D. Andrews · CAS, Mixer
Main listing in 'Sound Operators' on Page 172

Ambi Creations
Address: 201, Raman Residency, ekata Park, Wakadewadi, Pune 411003, INDIA
Phone: +91 982 252 2134
Email: ambicreations@gmail.com
Website: www.ambicreations.com
Facebook.com/ambicr
Producer/Proprietor: Bipinchandra Chaugule – cbipin@gmail.com

We offer video camera crew and production services almost anywhere in India and neighbouring countries for documentary, nature, wildlife and news filming crews. We are not looking for proposals, co-productions and we do not offer work experience. No funding available from us. Otherwise we are ready for any collaboration.

Ammonite Ltd
Address: Bristol, UK
Wildlife-film.com/-/Ammonite-Films.htm
MD: Martin Dohrn
Main listing in 'Production Companies' on Page 9

Animals of Montana Inc.
Address: 170 Nixon Peak Road, Bozeman, Montana 59715, USA
Phone: +1 406 686 4224 and +1 406 548 1455
Email: animals@animalsofmontana.com
Website: www.animalsofmontana.com
Facebook.com/pages/Animals-of-Montana-Inc/178568025571506
Instagram.com/Animals_of_Montana_Inc
Owner/Animal Trainer: Troy Hyde
Animals Consultant/Coordinator/Trainer: Meghan Riley

Animals of Montana, Inc. is a full service wildlife-casting agency located in SW Montana near Yellowstone National Park; nestled between three spectacular mountain ranges and several beautiful wilderness areas for convenient on-location filming, or off location worldwide. With experienced animal trainers and enthusiastic staff, we pride ourselves on giving you the best in trained animals, service and hospitality.

Aquavision TV Productions (Pty) Ltd
Address: Johannesburg, SOUTH AFRICA
Websites: www.aquavisionshop.co.za & www.lionmountain.tv
Wildlife-film.com/-/Aquavision-Productions.htm
Main listing in 'Production Companies' on Page 10

Specialties: 4K Production House, HD and 4K Stock Footage, Equipment Rental, Underwater Filming. 5.1 Surround Sound.

¿are u happy? films
Address: Freiburg, GERMANY
Contact: Werner Schuessler – Director, Writer, Producer, DOP
Main listing in 'Production Companies' on Page 11

Asian Wildlife Films
Country: THAILAND
Wildlife-film.com/-/DarrylSweetland.htm
Cameraman/Biologist/Writer: Darryl Sweetland
Main listing in 'Production Companies' on Page 12

Baloo Films
Address: Berlin, GERMANY
Main listing in 'Production Companies' on Page 13

Andrew Bell – Producer/ Cameraman / Editor
Address: London, UK
Main listing in 'Producers/Directors' on Page 179

Big Gecko
Adam Britton (Crocodile Specialist), Erin Britton (Biologist)
Address: Humpty Doo, Northern Territory, AUSTRALIA
Main listing in 'Experts/Scientists' on Page 241

BMP Filmproduksjon
Bernhard M. Pausett – Camera / Producer / Fixer / Assistant
Address: Oslo, NORWAY
Wildlife-film.com/·/BernhardMPausett.htm
Main listing in 'Production Managers' on Page 199

Brollyman Productions
Country: UK
Wildlife-film.com/·/Brollyman.htm
Main listing in 'Music Composers' on Page 230

Adrian Cale – Cameraman
Address: London, UK
Wildlife-film.com/·/AdrianCale.htm
Main section in 'Producers/Directors' on Page 181-182

An accomplished filmmaker and artistic cameraman with an eye for a shot, Adrian often leads projects from a simple idea right through the edit.

Camera Den Ltd
Country: UK
Phone: +44 (0)7973 137991
Email: info@cameraden.co.uk
Website: www.cameraden.co.uk

Camera Den is a facility house offering Camera, Lighting and Grip Equipment. We are specialists in the New Red EPIC Camera. We have first hand experience of shooting with Red, and will be able to advise you about shooting with Red and the post-production workflow. We can supply comprehensive Red shooting kit as well as Lighting Cameramen, Sound Recordists and Assistants thoroughly versed in all things Red. We also offer HD shooting kits, lights and ancillary equipment. We have on our books highly experienced crews that will bring their talents to your production. We can offer you flexible tailor made packages that take into consideration your technical and creative needs within the Broadcast, Commercial and Corporate fields. Please browse our site and contact Robin or Emma to discuss your requirements.

Karla Munguia Colmenero - Camerawoman/Presenter/AP
Address: Cancun, MEXICO
Wildlife-film.com/·/KarlaMunguiaColmenero.htm
Main listing in 'Presenters' on Page 215

Content Media
Address: Bucharest, ROMANIA
Main listing in 'Production Companies' on Page 16

Cristian Dimitrius Productions
Address: Alameda Manacá da Serra 15 · Itapevi · SP 06670-150, BRAZIL
Phone: +55 11 98906 7626 & +55 11 4680 9037
Email: cdimitrius@yahoo.com
Website: www.cristiandimitrius.com
Facebook.com/cdimitrius
Twitter.com/crisdimitrius
Vimeo.com/cristiandimitrius
Wildlife-film.com/·/CristianDimitrius.htm
Director: Cristian Dimitrius

Cristian Dimitrius Productions is a Brazilian media company specializing in capturing wildlife images for featured films, documentaries, commercials, internet and press media. We always seek to bring an innovative approach, using the latest techniques, equipment and revolutionary creative resources to plunge the audience into the animal world. We invite you to discover a little about us.

DOER Marine
Country: USA
Main listing in 'Equipment' on Page 122

Edge 2 Edge Films Ltd
Richard Hughes – DOP / Cameraman
Address: Kent, UK
Wildlife-film.com/·/RichardHughes.htm
Main listing in 'Camera Operators' on Page 153

EPM Asia Ltd
Address: HONG KONG
Wildlife-film.com/·/EPM-Asia.htm
CEO/Producer: Steven Ballantyne
Main listing in 'Location Managers' on Page 87

EPM Asia · Asia's leading Pre-production, location and production management service · with offices in Hong Kong, Shanghai and the Philippines.

Excelman Productions
Address: Paris, FRANCE
Wildlife-film.com/·/Excelman-Productions.htm
Main listing in 'Production Companies' on Page 20

engcrew.tv
Jesper Sohof – DoP
Address: Hinnerup, DENMARK
Main listing in 'Camera Operators' on Page 167

Esprit Film and Television Limited
Address: Gloucestershire, UK.
Main listing in 'Equipment' on Page 123

Evolutions Post Production
Addresses London: 2 Sheraton Street, W1F 8BH & 4-7 Great Pulteney Street, W1F 9NA & 59 Berwick Street London W1F 8SR, UK
Email: info@evolutions.tv
Phone: +44 (0)20 7580 3333
Website: www.evolutions.tv
Addresses Bristol: 11-13 Whiteladies Road, BS8 1PB & 38 Whiteladies Road, Clifton, BS8 2LG & 1 St Pauls Road, Clifton, Bristol BS8 1LX, UK
Phone: +44 (0)117 20 33 400

Email: info@evolutionsbristol.tv
Website: www.evolutions.tv/bristol
Facebook.com/evolutions.tv & Facebook.com/EvolutionsBristol
Twitter.com/evolutions_tv
Linkedin.com/company/evolutions

We are one of the largest independent post houses in the UK. We offer full TV post production services with an emphasis on service and talent!
Evolutions Bristol has state-of-the-art tapeless technology and includes cutting rooms, Avid Symphony online suites, ProTools audio suites and a Baselight colour grading suite. Supported by the latest technical infrastructure, it is equipped to the highest standards. Coupled with this huge investment in equipment, the facility offers the same commitment to your experience as its London counterpart. A high level of customer service throughout and the best creative talent offering fresh ideas and a new approach, ensure the best possible results for each and every project that comes to us.

Existential Productions
Jesse Blaskovits – Cinematographer/Producer/Writer
Address: Vancouver, CANADA
Main listing in 'Camera Operators' on Page 140

EYESEALAND Visual Media
Pieter Huisman – Freelance (wildlife) Documentary Cameraman
Address: Soest, the NETHERLANDS
Wildlife-film.com/·/PieterHuisman.htm
Main listing in 'Camera Operators' on Page 153

Factual TV
Address: Kuala Lumpur, MALAYSIA
Main listing in 'Production Companies' on Page 21

Fabio Borges Fotografia / Hydrosphera
Fabio Borges – Filmmaker / Photographer
Address: Fernando de Noronha, PE, BRAZIL
Main listing in 'Camera Operators' on Page 140

Felis Creations
Address: Bangalore, INDIA
Felis offers a complete documentary production service with the ability to acquire permits, research & recce, shoot & direct and deliver a completed programme.
Main listing in 'Production Companies' on Page 22

Films@59
Addresses: 59 Cotham Hill, Clifton, Bristol BS6 6JR, UK
55 Whiteladies Road, Clifton, Bristol BS8 2LY, UK
Unit N2, Cardiff Bay Business Centre, Lewis Road, Ocean Park, Cardiff, UK
Phone: +44 (0)117 906 4300 (Bristol) & 0117 906 4354 (Cardiff)
Fax: +44 (0)117 923 7003
Email: info@filmsat59.com
Website: www.filmsat59.com
Facebook.com/filmsat59
Twitter.com/filmsat59

Films at 59 provides a creative and cost-effective range of pre and post production services for film and TV programme makers.

Garage Studio di Comazzi Carlo
Carlo Comazzi - Sound Engineer
Address: Milan, ITALY
Main listing in 'Sound Operators on Page 173

Geonewmedia
Address: Glen Waverley, Melbourne, Victoria, AUSTRALIA
Main listing in 'Production Companies' on Page 23

Grey Films India Pvt Ltd
Address: Jalvayu Vihar, Noida, INDIA
Main listing in 'Production Companies' on Page 23

Della Golding – Presenter / Writer / Producer / Expert
Address: Ormeau, Queensland, AUSTRALIA
Main listing in 'Presenters' on Page 217

Steve Hamel – Biologist/Camera Operator/Sound Recordist
Address: Montreal, Quebec, CANADA
Main listing in 'Camera Operators' on Page 150

Harbour Studio
Ben Please - Composer/Sound-design/Camera-person/Editor
Address: Wigtown, Dumfries and Galloway, Scotland, UK
Main listing in 'Music Composers' on Page 233

HexCam
Address: Norwich, Norfolk, UK
Phone: +44 (0)1603 881985
Email: office@hexcam.co.uk
Website: www.hexcam.co.uk
Facebook.com/HexCam
Twitter.com/hexcam
Managing Director: Elliott Corke
Technical Director: Roland Cory·Wright
Creative Director: Andy Bodycombe
Heavylift Drone Specialist: Jonathan Carter

HexCam offers drone filming services within the UK and internationally. We work with a carefully chosen network of operators to complement our core team and have operated on location on a broad range of creative and technical projects. As a team, we have the experience and drones to meet most production budgets, from Phantoms up to the Inspire 2 and Freefly ALTA. In the last two years our team have worked in the UK, Panama, Dubai, Malta, Switzerland, Democratic Republic of Congo, Sierra Leone and more. We are experienced in international drone legislation and the logistics of transporting equipment and batteries to remote locations. We love to push the drones to new levels of technical difficulty and pilot skill so, if you have an idea (and a sensible budget!), get in touch. We are not accepting internships this year (2017/18).

Jungle Run Productions
Address: Bali, INDONESIA
Wildlife-film.com/·/JoeYaggi.htm
Main listing in 'Production Companies' on Page 26-27

Jungle Run Productions offers complete production services for Indonesia and SE Asia including:
· 4K & HD crews, drones, lighting and grip
· location and production management, fixers, translators
· film permit facilitation
· post-production, graphics, animation
· stock footage
We also have excellent contacts for:
· aircraft & watercraft, scientists and business leaders, government and NGO sector, search and rescue

Lemuria TV
Address: Tisá, CZECH REPUBLIC
Main listing in 'Production Companies' on Page 27

Liquid Motion – Film - Photography Academy - Foundation - Underwater Imaging
Address: Cozumel Island, MEXICO
Main listing in 'Production Companies' on Page 28

LunaSea Films
Address: Appleton, Maine, USA
Phone: +1 912 230 4019
Email: hdcamera@me.com
Website: www.expeditioncamera.com
Twitter.com/LunaSeaFilms
Linkedin.com/in/expeditioncamera
Cinematographer/DP: David Wright

An Award winning cameraman / producer. Worked in over 60 countries and now based in the US. Science, adventure, history and natural history. Intern opportunities are very rare.

Angela McArthur – Sound Recordist/Designer/Mixer
Address: Rochester, Kent, UK
Main listing in 'Sound Operators' on Page 175-176

Marca D'agua Filmes
Address: São Paulo, BRAZIL
Producer: Tulio Schargel
Main listing in 'Producers/Directors' on Page 190

micromacro
Sinclair Stammers – Cameraman/Scientific Photographer
Address: Newcastle Emlyn, Ceredigion, UK
Main listing in 'Camera Operators' on Page 167

Mystic Pictures Zambia
Address: Kitwe, ZAMBIA
Main listing in 'Location Managers/Fixers' on Page 89

NaturaHD Films
Address: Madrid, SPAIN
Producer/Director: Nacho Ruiz
Producer/Cinematographer: Alberto Saiz – albertosaiz@naturahd.com
Main listing in 'Production Companies' on Page 31

Ranger Expeditions Ltd
Address: High Peak Derbyshire, UK
Wildlife-film.com/-/StuartWestfield.htm
Main listing in 'Training' on Page 110

Riverbank Studios Pvt. Ltd.
Address: New Delhi, INDIA
Main listing in 'Production Companies' on Page 37-38

Rhythm Productions, LLC
Colin Ruggiero - Independent Filmmaker/DP/Photographer
Address: Missoula, USA
Main listing in 'Camera Operators' on Page 164-165

Silverscore Productions Ltd
Matt Norman - Composer
Country: UK
Wildlife-film.com/-/MattNorman.htm
Main listing in 'Music Composers' on Page 231-232

Sound Ark
Address: Enniskillen, Co. Fermanagh, UK
Director: Angel Perez Grandi
Main listing in 'Sound Operators' on Page 174

Steve Cummings Sound
Steve Cummings – Sound Recordist – Camera Operator
Address: Halifax, UK
Main listing in 'Sound Operators' on Page 173

The Sound Farmer – Location, Studio and Post Production Sound
Address: London, UK
Wildlife-film.com/-/GregoryOvenden.htm
Location Sound Recordist: Gregory Ovenden
Main listing in 'Sound Operators' on Page 176

TRE Productions
Tania Rose Esteban – Wildlife Filmmaker/Zoologist
Address: Bristol, UK
Website: www.treproductions.co.uk
Wildlife-film.com/·/TaniaEsteban.htm
Main listing in 'Researchers' on Page 201

Twisted Jukebox Ltd.
Address: London, UK
Music Director and Management: Matt Welch
Main listing in 'Music Composers' on Page 234

VFX Productions
Address: Dubai, UAE
Wildlife-film.com/·/VFX.htm
Main listing in 'Production Companies' on Page 45

VisionHawk Films
Casey Anderson – Camera Operator/Presenter/Naturalist
Address: Bozeman, Montana, USA
Main listing in 'Production Companies' on Page 46

Visual Africa Films Ltd
Feisal Malik - Line Producer/Director/Camera/Fixer/Producer
Address: Nairobi, KENYA
Wildlife-film.com/·/Visual-Africa-Films.htm
Main listing in 'Location Managers/Fixers' on Page 91

Waxwing Wildlife Productions Ltd
Address: Ennis, Co. Clare, IRELAND
Main listing in 'Production Companies' on Page 47

Western Science Events CIC
David Spears – Director/Specialist Macro Cameraman
Address: Taunton, Somerset, UK
Main listing in 'Experts' on Page 244-245

Wildblood Marine Services
Address: Gouvia, Corfu, GREECE
Phone: +44 (0)7899 922 522
Email: chris@marineservices.tv
Website: www.marineservices.tv
Facebook.com/wildbloodMS
Contact: Chris Wildblood · cwildblood@mac.com

Based in the Ionian Sea but easily re-located, we are a unique marine service for the film, TV and photographic industries. Stay onboard while you film your next production and move your base to wherever you need to be. Fully re-fitted for film crews, with a dedicated battery charging station, full HD1080 monitors for rushes, aluminium hulled RIB for getting to difficult places, Land Rover Defender with filming platform for terrestrial excursions, 1,700 nautical mile range, and a crew that thrives on sorting out impossible situations with over 25 years experience. Try us. You will not be disappointed...

Wild Creature Films
Address: 25 Salvator Rd, Hobart, Tasmania, AUSTRALIA
Phone: +61 428 104 313
Cinematographer: Nick Hayward · nick.hayward@wildcreaturefilms.com
Main listing in 'Camera Operators' on Page 151

Wildlife Pictures Institute
Address: Tehran, IRAN
Wildlife-film.com/·/Wildlife-Pictures-Institute.htm
Main listing in 'Production Companies' on Page 48-49

Wild Step
Address: Den Bosch, The Netherlands
Wildlife-film.com/·/Wild-Step.htm
Main listing in 'Production Companies' on Page 50

Wounded Buffalo Sound Studios
Address: 19a Hampton Lane, Cotham, Bristol BS6 6LE, UK
Phone: +44 (0)117 946 7348
Fax: +44 (0)117 970 6900
Email: info@woundedbuffalo.co.uk
Website: www.woundedbuffalo.co.uk
Facebook.com/WoundedBuffaloSoundStudios
Instagram.com/woundedbuffalosound
Twitter.com/Wounded_Buffalo
Linkedin.com/in/wounded-buffalo-a1560036

Multi award-winning post-production audio facility in Bristol.

61

ZED Creative
Address: Trefriw, Wales, UK
Phone: +44 (0)7789 071 038
Email: anthony@iamzed.co.uk
Website: www.iamzed.co.uk
Facebook.com/ZED.Creative.Anthony
Twitter.com/ZedAnthony
Vimeo.com/anthonyzed
Linkedin.com/in/anthonyrobertszed
Wildlife-film.com/·/AnthonyRoberts.htm
Creative Director: Anthony Roberts

Motion Graphics, CGI Model Creation, Animation and Timelapse. Motion Graphics: for information interpretation. CGI: to re-create (chiefly) prehistoric creatures. Timelapse: Location photography chiefly in the UK, but happy to travel. Please see my showreel: vimeo.com/174491132

Stock Footage/Sound Libraries

ABC Library Sales
Address: 120 Southbank Blvd, Southbank, VIC 3006, AUSTRALIA
Phone: +61 3 8646 2273
Email: librarysales@your.abc.net.au
Website: www.abccommercial.com/librarysales/collection/wildlife-1
Library Sales Managers: Anne Gilbee & Cyrus Irani

ABC Library Sales is home to one of Australia's largest collections of natural history footage. We do not offer work experience.

Achtel Pty Limited
Address: Tasmania, AUSTRALIA
Wildlife-film.com/-/PawelAchtel.htm
Director: Pawel Achtel, ACS
Main listing in 'Equipment Hire/Sales' on Page 122

Ammonite Ltd
Address: Bristol, UK
Wildlife-film.com/-/Ammonite-Films.htm
Main listing in 'Production Companies' on Page 9

Aquaterrafilms – Mauricio Handler
Country: USA
Underwater Specialist
Main listing in 'Production Companies' on Page 10

Aquavision TV Productions (Pty) Ltd
Address: Johannesburg, SOUTH AFRICA
Website: www.aquavisionshop.co.za
Wildlife-film.com/-/Aquavision-Productions.htm
Head of Library: Christo Ras – christo@aquavision.co.za
Main listing in 'Production Companies' on Page 10

Biggest library of natural stock footage in the Southern Hemisphere.

Arctic Bear Productions
Address: CANADA/USA
Main listing in 'Production Companies' on Page 11

Baloo Films
Address: Berlin, GERMANY
Main listing in 'Production Companies' on Page 13

BBC Motion Gallery
Website: www.gettyimages.co.uk/bbcmotiongallery
See Getty Images below.

Big Gecko
Adam Britton (Crocodile Specialist), Erin Britton (Biologist)
Address: Humpty Doo, Northern Territory, AUSTRALIA
Main listing in 'Experts/Scientists' on Page 241

Brock Initiative/Living Planet Productions
Address: Dumpers Cottage, Chew Magna, Bristol, BS40 8SS, UK
Wildlife-film.com/-/Brock-Initiative.htm
Main Listing in 'Organisations' on Page 28-29

Adrian Cale – Cameraman
Address: London, UK
Wildlife-film.com/-/AdrianCale.htm
Main section in 'Producers/Directors' on Page 181-182

Adrian has a strong stock footage library.

Content Mint
Address: Sydney, NSW, AUSTRALIA
Phone: +61 29 212 1135
Email: sales@contentmint.com.au
Website: www.contentmint.com.au

Content Mint is your online stock footage library, with thousands of hours of HD and 4k footage. Featuring spectacular wildlife behaviour, time lapse, image stabilised aerials, high speed and also travel, worldwide locations and scenics. The focus of our business is to provide you a one-stop shop for footage of the natural world and beyond, delivered to your inbox.

Steve Cummings – Camera Operator – Sound Recordist
Steve Cummings Sound
Address: Halifax, UK
Main listing in 'Sound Operators' on Page 173

Earth-Touch
Addresses:
16 Cranbrook Park, Douglas Saunders Drive, La Lucia Ridge, 4051, SOUTH AFRICA
Phone: +27 (0)31 582 0800 Fax: +27 (0)31 582 0900
5th Floor, Fairgate House, 78 New Oxford Street, London, WC1A 1HD, UK
Phone: +44 (0)20 7612 1084 Fax: +44 10 7612 1081
4833 Rugby Ave., Suite 600, Bethesda, MD 20814, USA

Phone: +1 301 657 7450 Fax: +1 301 657 7457
Email: info@earthtouchsa.com
Website: www.earthtouchtvsales.com/about-us/footage-sales
Facebook.com/EarthTouch
Instagram.com/earthtouch
Twitter.com/EarthTouch
Vimeo.com/earthtouchonline
Youtube.com/earthtouch

The Earth Touch archive is filled with exceptional HD footage of superb wildlife and diverse habitats from around the globe. From the scorched Savannah to the icy Antarctic, our intrepid crew's venture to some of the highest places withstanding the lowest temperatures to the deepest parts of the ocean to bring you fascinating and entertaining footage. We offer you the services of our archive team absolutely free with no tech fees. Screeners are easily downloadable via FTP. Our rates are are negotiable on bulk purchases. All Earth Touch footage is sold to a minimum charge of 30 seconds, on a non-exclusive basis.

Environmental Investigation Agency (EIA)
Address: 62-63 Upper Street, London N1 0NY, UK
Phone: +44 (0)20 7354 7960
Email: ukinfo@eia-international.org
Website: www.eia-international.org
Facebook.com/environmentalinvestigationagency
Twitter.com/EIAinvestigator
Vimeo.com/eia
Wildlife-film.com/-/EIA.htm
Contacts:
Head of Operations: Bill Dishington
Press & Communications Officer: Paul Newman · paulnewman@eia-international.org
Visual Communications Editor: Chris Milnes · chrismilnes@eia-international.org

EIA produces hard-hitting campaign films on a wide range of environmental crimes, as well as bespoke training films for enforcement agencies. It also has one of the world's largest archives of footage devoted to the illegal trade in wildlife products and other environmentally damaging commodities. The collection is data-based and is available on a professional basis to journalists, publishers and programme-makers. All the funds raised from the sale of this archive help to fund future campaigns. The visual media you see on this website is indicative of what is available in the whole collection. We are always prepared to listen to programme pitches from media professionals with a view to highlighting our work. Applications for work experience welcomed; CVs by email please.

Erik Fernström Film & Video AB – wildlifefilm.com
Address: Gränna, SWEDEN
Main listing in 'Production Companies' on Page 19

EYESEALAND Visual Media
Pieter Huisman – Freelance (wildlife) Documentary Cameraman
Address: Soest, the NETHERLANDS
Wildlife-film.com/·/PieterHuisman.htm
Main listing in 'Camera Operators' on Page 153

Fabio Borges Fotografia / Hydrosphera
Fabio Borges Pereira – Photographer & Filmmaker
Address: Fernando de Noronha, PE, BRAZIL
Main listing in 'Camera Operators' on Page 140

CREATE | CONSERVE | CONNECT
www.felis.in

Felis Creations
Address: Bangalore, INDIA
Has a growing collection of stock footage in high-definition, time-lapse photography and still imagery from all over the Indian subcontinent, housed under Felis Images.
Main listing in 'Production Companies' on Page 22

FootageBank
Address: 12240 Venice Blvd, #23, Los Angeles, CA 90066, USA
Phone: +1 310 313 0220
Fax: +1 310 313 0232
Email: info@footagebank.com
Website: www.footagebank.com
Contacts:
Founder and President: Paula Lumbard – paulal@footagebank.com
Vice President: Carol Martin – carolm@footagebank.com

Worldwide representation of blue chip natural history cinematographers and footage. We are actively looking for footage for clip representation.

Footage Indonesia
wallacea-films
Jakarta & Bali, INDONESIA
Phone: +6281338593933
Email: info@wallacea-films.com
Website: www.wallacea-films.com
Twitter.com/WallaceaFilms
Footage-Indonesia.com
Producer/Filmmaker/Owner: Mr. Alain Beaudouard

Since 20 years in Indonesia. Reportage & Magazine: Reportage4You.com
Fixing & Scouting in Indonesia and East-Timor: Footage-indonesia.com
Also see in 'Production Companies' on Page 47 & 'Fixers' on Page 91

Getty Images
Address: 101 Bayham Street, London NW1 0AG, UK
Advertising & design customers: 0800 376 7977 (+44 (0)20 7428 6109)
Newspapers, Magazines, Books & Broadcast: 0800 376 7981 (+44 (0)20 7579 5759)
Email: sales@gettyimages.co.uk
Website: www.gettyimages.co.uk & www.gettyimages.co.uk/bbcmotiongallery

From the BBC's first broadcast in 1922, up to yesterday's news, BBC Motion Gallery gives you exclusive access to the world's most comprehensive collection of unique motion imagery. Spanning news, sport, natural history, wildlife, locations, celebrities, culture and more, there is a wealth of content just waiting to be discovered. There are 100,000+ digitised clips available for online licensing, but that is only the tip of the iceberg. Our text-based research tool puts the BBC Broadcast Archive at your fingertips. You can now easily and quickly explore over a million hours of footage that has defined the television industry as we know it.

Global Focus Royalty Free Stock Footage
Address: PO Box 3008, Northcliff 3008, SOUTH AFRICA
Phone: +27 82 400 5525
Fax: +27 11 789 4003
Email: sales@globalfocus.co.za
Website: www.globalfocus.co.za

Our footage is the perfect addition to your production. Travel, Scenics, Cities, Landscapes, Timelapses & Wildlife. Shot around the globe in 4K, 2K, HD 1080p|25 & 29.97 fps footage, as well as Std Def PAL. Contact us for any of your footage needs.

Grey Films India Pvt Ltd
Address: Jalvayu Vihar, Noida, INDIA
Main listing in 'Production Companies' on Page 23

Hairy Frog Productions Ltd
Address: Church View, Heydon, Norfolk NR11 6AD, UK
Phone: +44 (0)7885 964 790
Email: mike@hairy-frog.co.uk
Website: www.hairy-frog.co.uk
Twitter.com/hairyfrogltd
Wildlife-film.com/·/Hairy-Frog-Productions.htm
Director/Producer/Cameraman: Mike Linley · mike_linley@yahoo.co.uk

Specialist in Herpetology, Entomology and UK wildlife. Large video, sound and stills library.
Main listing in 'Production Companies' on Page 24

Steve Hamel – Biologist/Camera Operator/Sound Recordist
Address: Montreal, Quebec, CANADA
Main listing in 'Camera Operators' on Page 150

HD Nature Footage
Address: 4302 Timberlane Place, Rapid City, South Dakota, USA
Phone: +1 605 390 7398
Email: sales@hdnaturefootage.net
Website: www.hdnaturefootage.net

HD Nature Footage provides affordable and professional high definition stock video footage of nature and wildlife with an emphasis on wildlife of the Great Plains, Rocky Mountains, and Africa, from Pronghorn Productions. We have especially large collections of bison, wolf, coyote, prairie dog, elk, antelope, and bear.

Jungle Run Productions
Address: Bali, INDONESIA
Wildlife-film.com/-/JoeYaggi.htm
Main listing in 'Production Companies' on Page 26-27

Manfred Bortoli
IdeaVideo.it
Country: ITALY
Main listing in 'Production Companies' on Page 25

Mark Emery Films
Address: 246 NE 59th Street, Ocala, Florida 34479, USA
Phone: +1 352 622 3412
Email: info@markemeryfilms.com
Website: www.markemeryfilms.com
Wildlife Films & Photography from Alaska to Florida by Mark Emery

NaturaHD Films
Address: Madrid, SPAIN
Main listing in 'Production Companies' on Page 31

NaturalHistoryFilm.com
Address: Hof van Batuwe 1A, 3412JB Lopikerkapel, THE NETHERLANDS
Phone: +31(0)643 029 201
Fax: +31(0)87 784 9920
Email: info@naturalhistoryfilm.com
Website: www.naturalhistoryfilm.com
Manager and Cameraman/Editor: Raldi Somers

NaturalHistoryFilm.com provides high quality stock footage of wildlife and nature worldwide. NaturalHistoryFilm.com works with producers that have experience in filming on remote location locations, mostly in the polar regions and Africa. Our producers/cameramen are available for freelance assignments, which we can arrange upon request.

NatureFootage – Footage Search
Address: 810 Cannery Row Monterey, CA 93940, USA
Phone: +1 831 375 2313
Fax: +1 831 621 9559
Email: support@footagesearch.com
Website: www.naturefootage.com
Facebook.com/naturefootage
Twitter.com/naturefootage

Footage Search provides leading broadcasters, advertising agencies and production companies worldwide with a unique and outstanding service for online search, preview, purchase and delivery of the highest quality stock footage.

Nature Picture Library Limited
Address: 5a Great George Street, Bristol BS1 5RR, UK
Phone: +44 (0)117 911 4675
USA Toll-free: 1 866 508 8473
Email: admin@naturepl.com
Website: www.naturepl.com
French Site: www.naturepl.fr
Facebook.com/pages/Nature-Picture-Library/138777089486841
Twitter.com/naturepl
Youtube.com/natureplbristol
Wildlife-film.com/·/NaturePictureLibrary.htm
Sales Manager: Tim Harris – timharris@naturepl.com
TV and Film Sales: Giles Manning – gilesmanning@naturepl.com

Nature Picture Library represents more than 500 of the world's leading wildlife and nature photographers, including many cameramen and film producers, supplying still images and video clips for a variety of media. We are experienced at licensing for television and film projects. If you cannot find the content you need on our website, please contact us and we will be happy to do research from your brief.
We are interested in receiving submissions of nature and wildlife video clips. Make contact by email initially to request submission guidelines.

Nature Stock Shots
Address: Sedona, AZ 86339, USA
Phone: +1 928 282 0804
E-mail: info@naturestockshots.com
Website: www.naturestockshots.com

Nature Stock Shots is a nature stock footage library of film, video, and photographs. Top nature cinematographers have captured more than 400 hours of stock footage in North and South America, Kamchatka, and Bering Island, some of it never before photographed.

NHNZ Moving Images
Address: Box 474, 5 Melville St, Dunedin 9016, NEW ZEALAND
Phone: +64 (0)3 4799799
Fax: +64 (0)3 4799917
Email: images@nhnz.tv
Website: www.nhnzmovingimages.com
Wildlife-film.com/·/NHNZ.htm
Stock Footage Content Specialist: Olly Rudd · orudd@nhnz.tv
Stock Footage Content Specialist: Jamie Thorp · jthorp@nhnz.tv

NHNZ Moving Images; We live in an HD World. Our library represents exceptional HD stock footage across all genres produced by NHNZ and over 20 other leading filmmakers from around the world, including the National Geographic Channels Library. We are focused on finding the best shots to meet your creative, editorial and technical requirements, your deadlines and budget. This means offering you free research for most enquiries, offering full length shots for you to view online, no minimum sale requirements, and we sell by the second. Our footage is made for the international broadcast market and is of the highest production values.

Riverbank Studios Pvt. Ltd.
Address: New Delhi, INDIA
Main listing in 'Production Companies' on Page 37-38

Robert Harding World Imagery
Address: Nicholsons House, Nicholsons Walk, Maidenhead, Berkshire, SL6 1LD, United Kingdom
Phone: +44 (0)20 7478 4000 (UK) +1 800 878 2970 (USA)
Fax: +44 (0) 20 7478 4161
Emailed: sales@robertharding.com
Website: www.robertharding.com/Nature-and-Environment.php
Facebook.com/roberthardingworldimagery
Twitter.com/RH_WorldImagery
Youtube.com/RobertHardingVideo
Vimeo.com/robertharding

Robert Harding is a leading supplier of high quality nature stock photos featuring animals, birds, insects, plants, marine life and landscapes.

The Royal Society for the Protection of Birds
Address: Sandy, Bedfordshire, UK
Main listing in 'Organisations' on Page 38

Rhythm Productions, LLC
Colin Ruggiero - Independent Filmmaker/DP/Photographer
Address: Missoula, USA
Main listing in 'Camera Operators' on Page 165-165

SCIENCEphotoLIBRARY

Science Photo Library
Address: 327-329 Harrow Road, London W9 3RB, UK
Phone: +44 (0)20 7432 1100 & US toll free +1 844 677 4151
Email: info@sciencephoto.com
Website: www.sciencephoto.com/motion
Instagram.com/sciencephotolibrary
Facebook.com/SciencePhotoLibrary
Twitter.com/sciencephoto

Science Photo Library is a leading stock archive of footage and images of the natural world, and all aspects of science. We license stock footage to a diverse range of clients in production, publishing and the commercial sector. Our collection is growing all the time, and we are happy to arrange commissions for specific projects.

Scubazoo Images Sdn Bhd
Address: Kota Kinabalu, Sabah, MALAYSIA
Wildlife-film.com/-/Scubazoo.htm
Main listing in 'Production Companies' on Page 39-40

SubSeaTV
Andy Jackson – Underwater Cameraman
Address: Scarborough, North Yorkshire, UK
Wildlife-film.com/-/AndyJackson.htm
Main listing in 'Camera Operators' on Page 155

I film underwater in UHD with a Sony FS7. I specialise in intimate encounters with unusual UK marine life. I hold a great deal of UK stock footage.

Twisted Jukebox Ltd.
Address: Suite 34, 272, Kensington High Street, London W8 6ND, UK
Phone: +44 (0)20 3397 4848
Email: contact@twistedjukebox.com
Website: www.twistedjukebox.com
Soundcloud.com/twisted-jukebox
Facebook.com/twistedjukebox
Twitter.com/TwistedJukebox
Music Director and Management: Matt Welch - matt@twistedjukebox.com

Twisted Jukebox is a music publishing and production music library. We have a range of music suitable for nature themed documentaries that cover different moods and scenarios as well as a team of talented composers that can write bespoke music to fill clients briefs.

Ultimate Chase
Address: P.O. Box 233 Key Largo, Florida 33037, USA
Phone: +1 305 394 6000
Email: mike@ultimatechase.com
Website: www.ultimatechase.com
Founder: Mike Theiss

Stock Footage and Storm Video Production Services. Specializing in licensing severe weather video for Documentaries, TV Commercials, Corporate Video, Feature Films, Breaking News, & More... Wildlife footage: www.ultimatechase.com/Wildlife_Video.htm

VFX Productions
Address: Dubai, UAE
Wildlife-film.com/-/VFX.htm
Main listing in 'Production Companies' on Page 45

We have one of most comprehensive footage library on subjects from the region, 90% of which is HD/2K/4K.

Video-film.no
Country: Norway
Phone: +47 93 438 903
Email: firmapost@video-film.no
Website: www.video-film.no
Contact: Per Johan Naesje

Our firm offers stock video of wildlife from Scandinavia. Many different species of "hard to find" footage. More info' at our website!

wallacea-films
Address: Jakarta & Bali, INDONESIA
Producer/Filmmaker/Owner: Mr. Alain Beaudouard
Footage-Indonesia.com
Also see in 'Production Companies' on Page 47 & 'Fixers' on Page 91

Waxwing Wildlife Productions Ltd
Address: Ennis, Co. Clare, IRELAND
Main listing in 'Production Companies' on Page 47

WildCAM Australia
Address: Smithfield, AUSTRALIA
Main listing in 'Production Companies' on Page 47

Wild Horizons® Productions
Address: Tucson, Arizona, USA
Main listing in 'Production Companies' on Page 48
Inquire about stock video clips.

Wild Kenya Safaris
Shazaad Kasmani – Photographer, Presenter, Expert
Address: Mombasa, KENYA
Wildlife-film.com/·/ShazaadKasmani.htm
Main listing in 'Location Managers/Fixers' on Page 92
Wildlife Stock Photos.

Wildlifeinmotion.com – Gareth Trezise
Address: Bristol, UK
Phone: +44 (0)7921 517 420
Email: garethtrezise@wildlifeinmotion.com
Website: www.wildlifeinmotion.com
Facebook.com/gareth.trezise
Twitter.com/GarethTrezise
Pond5.com/artist/wildlifeinmotion
Wildlife-film.com/·/GarethTrezise.htm

I'm a wildlife cameraman with many hours of stock footage specialising in African & British wildlife, particularly big cats & butterflies. I can supply direct or there is a growing library available on Pond5, which will be significantly expanded during 2017/2018 & will also become available on other platforms like Shutterstock.

DISTRIBUTORS

African Environmental Film Foundation
Address: Nairobi, KENYA
Main listing in 'Organisations' on Page 114

Blue Ant Media
Address: 130 Merton Street, Suite 200 Toronto, Ontario, M4S 1A4, CANADA
Phone: +1 416 646 4434
Website: www.blueantmedia.com
Twitter.com/BlueAntMedia
Instagram.com/blueantmedia

Blue Ant Media is a privately held, international content producer, distributor and channel operator. From our production houses around the world, we create content for multiple genres including factual, factual entertainment, short-form digital series and kids programming. Our distribution business, Blue Ant International, offers a catalogue of 3,000+ hours of content, including the largest 4K natural history offering on the market. Blue Ant Media's international channel business offers a portfolio of media brands such as Love Nature (International), ZooMoo Networks (International), Smithsonian Channel Canada, BBC Earth (Canada), Blue Ant Entertainment (International), Blue Ant Extreme (International) and HGTV (New Zealand). Blue Ant Media is headquartered in Toronto, with operations in Los Angeles, Singapore, Auckland, Dunedin, London, Sydney, Washington, Beijing and Taipei.

Dogwoof
Address: Ground Floor ,19 · 23 Ironmonger Row, London EC1V 3QN, UK
Phone: +44 (0)20 7253 6244
Email: info@dogwoof.com
Website: www.dogwoof.com
Facebook.com/dogwoof
Iinstagram.com/dogwoof
Twitter.com/dogwoof

Dogwoof is regarded as the foremost documentary specialist brand in the world, and is a stamp of the highest quality content. We sell worldwide, distribute theatrically in the UK and invest in the production of creative feature docs and docu-series. Founded in 2004, notable releases include theatrical hits such as *Blackfish*.

Earth-Touch
Countries: SOUTH AFRICA, UK, USA
Website: www.earthtouchtvsales.com/distribution
Main listing in 'Broadcasters/Channels' on Page 64-65

Green Planet Films
Address: PO Box 247, Corte Madera, CA 94941, USA
Phone: +1 415 377 5471
Email: service@greenplanetfilms.org
Website: www.greenplanetfilms.org
Facebook.com/pages/Green-Planet-Films/154610532290
Twitter.com/greenplanetfilm

Green Planet Films is a non-profit distributor of nature and environmental DVDs from around the globe. We promote environmental education through film. We seek to preserve and protect our planet by collecting and distributing documentaries that can be used to educate the public about the science, beauty, and fragility of the natural world. Our mission is to grow our web-based DVD library, and provide a channel that connects these films to schools, organizations, businesses, government agencies, and individuals worldwide.

Green TV
Addresses:
Ground Floor Office, Folly Bridge, Oxford OX1 4LB, UK
The Impact Hub, 1 rue Fendt, 1201 Geneva, SWITZERLAND
2F Blanche Kamakura, Onari, Kamakura, Kanagawa, JAPAN
Phone: +44 (0)1865 236167 (UK)
Email: hello@green.tv
Website: www.green.tv
Facebook.com/greentv
Twitter.com/green_tv

GREEN.TV is a strategy, production and distribution agency specialized in environmental and sustainable development videos.

Jungle Run Productions
Address: Bali, INDONESIA
Wildlife-film.com/·/JoeYaggi.htm
Main listing in 'Production Companies' on Page 26-27

We distribute environment, wildlife, and social issue films to local television stations across Indonesia and are actively seeking partners in that work. Representing over 75 local television stations, we're also keen to meet partners looking to build a media presence in one of Asia's expanding television markets.

Magnify Media
Address: Locks Mead, Malthouse Lane, Hurstpierpoint, BN6 9JZ, UK
Phone: +44 (0)1273 833838
Email: info@magnifymedia.co.uk
Website: www.magnifymedia.co.uk
Twitter.com/magnify_media
CEO: Andrea Jackson

Magnify began with a clear and simple vision, to work with shows we LOVE, from people we LIKE. Magnify launched in 2015 as a specialist distribution and rights management company working with producers, rights owners and broadcasters to develop and exploit rights across content platforms on a global basis. We have a carefully curated catalogue of high quality programmes and formats · and our mission is to ensure BEST POSSIBLE exploitation of these rights. We care about about the producers we represent and we care about delivering on their shows.

Octapixx Worldwide
Address: P.O. Box 314 Don Mills, Toronto, ON, Canada M3C 2S7, CANADA
Phone: +1 416 449 9400
Email: info@octapixx.com
Website: www.octapixx.com
Twitter.com/octapixx

Worldwide Distribution of Quality Television Programming
Representing top-notch producers and libraries from around the globe.

Off The Fence BV
Address: Herengracht 105-107, 1015 BE Amsterdam, NETHERLANDS
Phone: +31 20 5200 222 Fax: +31 20 5200 223
Email: info@offthefence.com
Website: www.offthefence.com

A dynamic and global force, Off the Fence's sales team distributes programmes to over 7000 clients from all around the world in all media. Speaking a total of 15 languages, their reach is second to none. With a passion for television and armed with Off the Fence's impressive catalogue, our sales executives are adept at finding the perfect programming for every audience.

Scorpion TV
Address: 3a, 140 Gray's Inn Road, London WC1X 8AX, UK
Phone: +44 (0) 207 833 0940/1228
Email: production@scorpiontv.com
Website: www.scorpiontv.com
Managing Director: David Cornwall – david@scorpiontv.com
Facebook.com/scorpiontvdistribution
Twitter.com/scorpion_tv
Linkedin.com/company/scorpion-tv

Scorpion TV is an international production and distribution company dedicated to the worldwide sales of award-winning documentaries, films and television shows. Working closely with the independent film and television community, the productions represented by Scorpion are creative and often critically acclaimed. With a focus on culturally diverse content Scorpion TV was founded to fulfill the needs of producers small and large to maximise their audience and of broadcasters looking for the most fascinating and inspiring stories to drive audiences to their channel.

Sky Vision
Addresses: UK, USA, SINGAPORE & GERMANY
skyvision.sky.com/distribution/finished-programmes/1102/1112
Main listing in 'Production Companies' on Page 41

Spier Films
Countries: SOUTH AFRICA, UK &, ICELAND
Main listing in 'Production Companies' on Page 41

Terranoa
Address: 155 rue de Charonne, 75011 Paris, FRANCE
Phone: +33 (0)1 55 25 59 37
Email: communication@terranoa.com
Website: www.terranoa.com
Managing Director: Emmanuelle Jouanole – ejouanole@terranoa.com

Terranoa is a documentaries distribution company. It has become a benchmark for innovative, high-profile factual productions to broadcasters worldwide and has attracted outside producers who share the values and quality of our brand. Each year the productions distributed by Terranoa are awarded internationally. Today with a catalogue of over 800 hours covering Science & History, Nature & Environment, Travel & Adventure and Sports, we supply broadcasters and other media platforms worldwide with an attractive choice of factual programmes.

Wild Logic LLC
Address: 1482 East Valley Road, Suite 625, Santa Barbara, CA 93108, USA
TEL: +1 805 969 1699
EMAIL: katya.shirokow@wildlogic.net
Website: www.wildlogic.net
Managing Director: Katya Shirokow

Wildlife film producers and distributors.

BROADCASTERS/CHANNELS

ABC - Australia Broadcasting Corporation
Address: ABC Ultimo Centre, 700 Harris Street, Ultimo NSW 2007, AUSTRALIA
Phone: +61 (0)2 8333 1500
Fax: +61 (02) 8333 5344
Website: www.abc.net.au
Twitter.com/ABCTV
Facebook.com/abc
Youtube.com/NewOnABCTV

Animal Planet
Countries: Animal Planet USA; CANADA; UK & IRELAND; NORDIC; AUSTRALIA & NEW ZEALAND; GERMANY; EUROPE; POLAND; INDIA; ASIA: LATIN AMERICA
Websites: wikipedia.org/wiki/Animal_Planet
USA: www.animalplanet.com
Canada: www.animalplanet.ca
UK: www.discoveryuk.com
Latin America: www.latam.discovery.com
Twitter.com/animalplanet
Facebook.com/AnimalPlanet

There are several different Animal Planet channels around the world, owned by the Discovery Communications networks.

BBC Earth
Address: Television Centre, 101 Wood Lane, London W12 7FA, UK
Website: www.bbcearth.com
Facebook.com/bbcearth
Instagram.com/bbcearth
Twitter.com/BBCEarth
Youtube.com/user/EarthUnpluggedTV

BBC Earth takes audiences on a thrilling journey of discovery. Sharing the incredible wonders of our universe, this channel promotes the work of the world's foremost factual film makers. From the smallest creature under the microscope to the limitless expanses of space, BBC Earth brings viewers face-to-face with heart-pounding action, mind-blowing ideas and the wonder of being human.

BBC Natural History Unit
Address: BBC Broadcasting House, Whiteladies Road, Bristol BS8 2LR, UK
Phone: +44 (0)117 973 2211
Website: www.bbc.com/earth/uk
Youtube.com/user/BBCEarth
Head of BBC NHU: Julian Hector – julian.hector@bbc.co.uk
Head of Natural History and Specialist Factual Commissioning: Tom McDonald
Commissioning Editor, Science, Natural History and Factual Scotland: Craig Hunter

All proposals need to be sent through the e-commissioning system.
Visit: https://www.bbc.co.uk/commissioning/tv/pitching-ideas/e-commissioning.shtml

BBC Studios

Address: Television Centre, 101 Wood Lane, London W12 7FA, UK
Email: bbcstudioscareers@bbc.com
Website: www.careers.bbcstudios.com
Instagram.com/lifeatbbcstudios

BBC Studios is a powerhouse of bold British creative content. We lead the way in creative storytelling, and we're known and celebrated around the world for the quality of our programmes.

Blue Ant Media

Address: Toronto, Ontario, CANADA
Main listing in 'Distributers' on Page 74

Channel 4

Address: Channel 4 Headquarters, 124 Horseferry Road, London SW1P 2TX, UK
Website: www.channel4.com
www.channel4.com/info/commissioning/4producers/specialist-factual
Facebook.com/Channel4
Twitter.com/channel4

For Channel 4, Specialist Factual is the genre that explores and explains the world and makes us think about it differently. The department's programmes encompass all the traditional SF subjects - history, science, arts, religion - but also include anthropology, psychology, criminology, economics, engineering etc. - in other words, any approach to a story, event or precinct that goes beyond simply telling personal stories and gets its teeth into how and why things work.

Channel 5 Television Ltd

Address: Hawley Cres, Camden Town, London NW1 8TT, UK
Phone: +44 (0)20 3580 3600
Email: customerservices@channel5.com
Website: www.channel5.com

Channel 5 launched as Britain's fifth public service broadcaster in March 1997 and reaches 4 in 5 of the UK viewing public each month with a broad mix of popular content, including quality factual programmes, entertainment, reality, sport, 5 News. Channel 5 does not currently make the majority of its own programmes. They are either commissioned from independent production companies or acquired readymade. This means that we do not accept programme pitches from individuals.

CBC – Canadian Broadcasting Corporation
Science and Natural History, Documentary Unit

Address: PO Box 500, Stn A, Toronto, Ontario M5W 1E6, CANADA
Phone: +1 416 205-6894
Website: www.cbc.ca/natureofthings
www.cbc.ca/independentproducers
Facebook.com/cbcdocs
Instagram.com/cbcdocs
Twitter.com/cbcdocs

The CBC is Canada's public broadcaster. The Documentary Science & Natural History Unit's flagship program *The Nature of Things* with David Suzuki is an award-winning series broadcast across Canada, as well as many countries around the world. The series explores issues, discoveries and events in the worlds of science, medicine, technology,

wildlife and the environment. Analytic and humanist in perspective, it documents our increasingly complicated and interconnected world, seeking to interpret both advances and setbacks, at a time when the speed of change is ever accelerating. Proposals can be submitted to vance.chow@cbc.ca. If there is interest in a project, you will be contacted for further discussion and refinement of the program proposal. (General response time 4- 6 weeks) We currently work with independent producers from Canada who have International Treaty Co-productions with non-Canadian independents or broadcasters.

Discovery Communications, Inc.
DCI World Headquarters
One Discovery Place, Silver Spring, MD 20910, USA
Phone: +1 240 662 2000
Worldwide Offices: corporate.discovery.com/contact/locations
Website: corporate.discovery.com & discovery.com
Facebook.com/DiscoveryIncTV
Instagram.com/DiscoveryIncTV
Twitter.com/DiscoveryIncTV
Youtube.com/DiscoveryNetworks
Linkedin.com/company/discoveryinc

Discovery, Inc. (Nasdaq: DISCA, DISCB, DISCK) is a global leader in real life entertainment, serving a passionate audience of superfans around the world with content that inspires, informs and entertains. Discovery delivers over 8,000 hours of original programming each year and has category leadership across deeply loved content genres around the world. Available in 220 countries and territories and 50 languages, Discovery is a platform innovator, reaching viewers on all screens, including TV Everywhere products such as the GO portfolio of apps and Discovery Kids Play; direct-to-consumer streaming services such as Eurosport Player and Motor Trend OnDemand; and digital-first and social content from Group Nine Media. Discovery's portfolio of premium brands includes Discovery Channel, HGTV, Food Network, TLC, Investigation Discovery, Travel Channel, Turbo/Velocity, Animal Planet, and Science Channel, as well as OWN: Oprah Winfrey Network in the U.S., Discovery Kids in Latin America, and Eurosport, the leading provider of locally relevant, premium sports and Home of the Olympic Games across Europe.
Visit: corporate.discovery.com/careers

Earth-Touch
Addresses:
16 Cranbrook Park, Douglas Saunders Drive, La Lucia Ridge, 4051, SOUTH AFRICA
Phone: +27 (0)31 582 0800 Fax: +27 (0)31 582 0900
5th Floor, Fairgate House, 78 New Oxford Street, London, WC1A 1HD, UK
Phone: +44 (0)20 7612 1084 Fax: +44 10 7612 1081
4833 Rugby Ave., Suite 600, Bethesda, MD 20814, USA
Phone: +1 301 657 7450 Fax: +1 301 657 7457
Email: info@earthtouchsa.com
Website: www.earthtouchnews.com
Earthtouchnews.com/video-on-demand
Facebook.com/EarthTouch
Instagram.com/earthtouch
Twitter.com/EarthTouch
Vimeo.com/earthtouchonline
Youtube.com/earthtouch

Earth-Touch aspires to be the pre-eminent multimedia company that brings matters of the Earth (including wildlife and the environment) into the offices, homes and daily lives of people around the world by using cutting-edge technology. Our mission is to both educate and entertain as we strive to raise awareness and provoke reaction to a range of environmental matters. We aim to achieve this mission by disseminating our media across multiple platforms, including television networks, video and DVD, the Internet and mobile phones. We are a South African company with a head office in Durban and satellite offices in the USA and London, UK.

Eden TV channel - UKTV
Address: 245 Hammersmith Rd, London W6 8PW, UK
Phone: +44 (0)845 734 4355
Email: viewers@uktv.co.uk (Viewer Enquiries)
Recruitment queries: recruitment@uktv.co.uk
Submit a programme idea: submissions@uktv.co.uk
corporate.uktv.co.uk/commissioning/article/commissioning-process
Website: www.eden.uktv.co.uk
Facebook.com/edentvchannel
Twitter.com/EdenChannel

Eden offers the best in breed in natural history and science programming. Expect the best quality images, the most authoritative guides and the most breathtaking natural wonders. Our shows guarantee our viewers a bigger, bolder, brighter version of the world.

Green TV
Countries: UK, SWITZERLAND & JAPAN
Website: www.green.tv/watch
Main listing in 'Distributers' on Page 75

Lemuria TV
Address: Tisá, CZECH REPUBLIC
Main listing in 'Production Companies' on Page 27

Life on TERRA
Address: Montana State University, School of Film and Photography, P.O. Box 173350, Bozeman 59717, USA
Phone: +1 406 994 2484
Email: info@lifeonterra.com
Website: www.lifeonterra.com
Facebook.com/pages/Life-On-TERRA/109479045747876
Twitter.com/lifeonterra
Youtube.com/LifeOnTERRAVideos
Vimeo.com/lifeonterra/videos
Wildlife-film.com/-/LIFEonTERRA.htm

Life on TERRA is the award-winning science and natural history podcast series that explores the natural connections that propel life on Earth. Overseen by graduate students in the MFA in Science and Natural History Filmmaking Program at Montana State University, TERRA distributes independently produced science, nature, and environmental films. We are proud to bring you these unique stories from around the globe that celebrate the wonders of the natural world.

National Geographic Channel
US HQ: 1145 17th Street N.W., Washington, D.C. 20036-4688, USA
Phone: +1 202 912 6500
EU: Third Floor, 10 Hammersmith Grove, Hammersmith, London, W6 7AP, UK
Phone: +44 (0)207 751 7700
Email: askngs@nationalgeographic.com
Websites: www.channel.nationalgeographic.com & nationalgeographic.co.uk
Facebook.com/natgeo & Facebook.com/NatGeoUK
Twitter.com/NatGeo & Twitter.com/NatGeoUK
Instagram.com/natgeo & Instagram.com/natgeouk
Youtube.com/user/NationalGeographic & Youtube.com/user/natgeoUK

Unfortunately, we do not accept unsolicited show proposals. Any unsolicited ideas, pitches or material will be returned or discarded unread. The National Geographic Channels will accept proposals only from established production companies that have previously discussed their idea with a network development representative. help.nationalgeographic.com/customer/portal/articles/1926460-do-you-have-a-story-idea-or-show-proposal-

Nat Geo Wild
Website: www.natgeotv.com/uk/wild and channel.nationalgeographic.com/wild
Facebook.com/natgeowild & Facebook.com/NatGeoWildUK
Twitter.com/natgeowild
Instagram.com/natgeowild & Instagram.com/natgeowilduk
Youtube.com/user/NatGeoWild

Nat Geo Wild provides a unique window into the natural world, the environment and the amazing creatures that inhabit Planet Earth. From the most remote environments to the forbidding depths of our oceans, from protected parks to domestic doorsteps, Nat Geo Wild uses spectacular cinematography and compelling storytelling to take viewers on unforgettable journeys. Nat Geo Wild is part of National Geographic Channels International (NGCI) and is available in Australia, Hong Kong, India, Indonesia, Israel, Jordan, Macau, Malaysia, Maldives, Myanmar, Papua New Guinea, Philippines, Singapore, South Korea, Taiwan, Thailand, UAE, U.K., U.S., France, Italy, Portugal, Turkey, Germany, Latin America and other territories in Europe. Nat Geo Wild HD launched in the UK in March 2009, and is also available in Greece, Latin America, Poland, and Russia. Further expansion is expected globally.
For careers with the National Geographic Channel/WILD, visit: foxcareers.com

PBS - Nature
Address: WNET, 825 Eighth Avenue, New York, NY 10019-7435, USA
Phone: +1 212 560 3000
Website: www.pbs.org/wnet/nature
Facebook.com/PBSNature
Instagram.com/pbsnature
Twitter.com/PBSNature
Youtube.com/user/NaturePBS
www.video.pbs.org/program/nature

As one of the most watched documentary film series on public television, NATURE delivers the best in original natural history films to audiences nationwide. Celebrating its 36th Season in Fall 2017, NATURE is a production of THIRTEEN in association with WNET New York Public Media, the parent company of THIRTEEN and WLIW21, New York's public television stations and operator of NJTV. For more than 50 years, WNET has been producing and broadcasting national and local documentaries and other programs

for the New York community. Over the years, NATURE has brought the beauty and wonder of the natural world into American homes, becoming in the process the benchmark of natural history programs on American television. The series has won more than 700 honors from the television industry, the international wildlife film community, parent groups, and environmental organizations – including 18 Emmy Awards, three Peabody Awards, and the first honor ever given to a program by the Sierra Club.

SKY (British SKY Broadcasting)
Address: BSkyB Ltd, Grant Way, Isleworth, Middlesex, TW7 5QD, UK
Phone: +44 (0)333 100 0333
Contacts: www.skygroup.sky/corporate/contact-us/our-locations
Website: www.sky.com
Work for Sky: careers.sky.com

Commissioning and Ideas submission: www.skygroup.sky/corporate/about-sky/commissioning-and-ideas-submission/commissioning-and-ideas-submission
Production: www.skygroup.sky/corporate/about-sky/production
Facebook.com/sky
Twitter.com/SkyOceanRescue

Launched on 24th January 2017, Sky Ocean Rescue aims to shine a spotlight on the issues affecting ocean health, find innovative solutions to the problem of ocean plastics, and inspire people to make small everyday changes that collectively make a huge difference: skyoceanrescue.com

South African Broadcasting Corporation (SABC)
Address: Private Bag X1, Auckland Park, Johannesburg 2006, SOUTH AFRICA
Phone: +27 (0)11 714 9111 Fax: +27 (0)11 714 9744
Email: contactcentre@sabc.co.za
Website: www.sabc.co.za
Commissioning Briefs: www.sabc.co.za/sabc/commissioning-briefs
Facebook.com/SABCPortal
Twitter.com/sabcportal

SABC will receive only submitted material that is embodied in written form in hard copy. Facsimiles and e-mail submissions will not be considered. SABC will consider your submission only at your request and only with your assurance that to the best of your knowledge you are the sole originator of the idea and that you have the legal right to submit it to SABC for evaluation.

Sustainability Television
Address: Vancouver, CANADA Phone: +1 604 685 8846
Email: info@sustainabilitytelevision.com
Website: www.sustainabilitytelevision.com
Facebook.com/pages/Sustainability-Television/116135154828
Twitter.com/STVNetwork
Founder & CEO: Jason Robinson

Sustainability Television is a net-based broadcaster & social media network with thousands of ideas for improving your health, your home, and community. Film production centres on positive solution-oriented topics in areas of health, community, science & technology, the built environment, community inclusion, and environmental benefit. Founded by: Linkedin.com/pub/jason-robinson/9/521/563. We welcome co-productions and collaborators. Check for Internship and Employment postings here: www.SustainabilityTelevision.com/career

TVNZ
Address: Auckland, NEW ZEALAND
Website: www.tvnz.co.nz
Commissioning: tvnz.co.nz/tvnz-corporate-comms/commissioning-programmes-4973913
Facebook.com/TVNZOnDemand
Instagram.com/tvnz.official
Twitter.com/tvnz

TVNZ's all about sharing the moments that matter to New Zealanders - whether we're breaking news, following adventures, sharing stories or putting smiles on faces.

LOCATION MANAGERS/FIXERS

African Environments

African Environments
Address: Arusha, TANZANIA
Phone: +255 (0)784 506 600 & +255 (0)784 700 100
Email: janiceb@africanenvironments.com
Website: www.africanenvironments.com
Facebook.com/AfricanEnvironments
Twitter.com/afrenv
Wildlife-film.com/-/African-Environments.htm
Director: Janice Beatty – Linkedin.com/in/janice-beatty-183b212b
Director: Richard Beatty – beatty@africanenvironments.com
Director: Wesley Krause – wkrause@africanenvironments.com
GM: Tara Crowe – tara@africanenvironments.com

African Environments has been operating in Tanzania since 1983. We are a safari and mountain tour operator that has also been outfitting for Film Crews for 20 years. We have our own fleet of safari vehicles and well equipped filming Land Rovers as well as camps that can be tailored to any project. Our experience lends itself to any fixing, outfitting or logistics support for film and photography projects. In 2013 we won the Tanzania Tourist Board's Humanitarian Award and pride ourselves on being both ethical and environmentally minded. We have worked on hundreds of films - a few examples are: BBC *Top Gear Africa Special*, Nat Geo *Kingdom of the Apes*, BBC World Service *Zeinab Badawi* News item, Nat Geo *Secret Life of Predators*, Tigress *Natures Shock*, Brian Leith Prods *Looking for Elsa*, Buffalo Pictures *Lion Man*, BBC *Taking The Flak* Comedy Series, Harry Hook *Photographing Africa*, Earth's Touch *Game of Prides + Speed*, to name but a few. We are not looking for proposals and we do not offer work experience, sorry.

AfriScreen Films
Address: Maun, BOTSWANA
Wildlife-film.com/-/AfriScreen-Films.htm
Main listing in 'Production Companies' on Page 8-9

Ambi Creations
Address: Pune, INDIA
Main listing in 'Production Services' Page 52

Asian Wildlife Films
Country: THAILAND
Wildlife-film.com/·/DarrylSweetland.htm
Cameraman/Biologist/Writer: Darryl Sweetland
Main listing in 'Production Companies' on Page 12

Atlantic Ridge Productions
Address: AZORES, PORTUGAL
Main listing in 'Production Companies' on Page 12-13

Banksia Films
Address: Manaus, Amazonia, BRAZIL
Main Contact: Carolina Fernandes
Main listing in 'Production Companies' on Page 13-14

BMP Filmproduksjon
Bernhard M. Pausett – Camera / Producer / Fixer / Assistant
Address: Oslo, NORWAY
Wildlife-film.com/·/BernhardMPausett.htm
Main listing in 'Production Managers' on Page 199

Conservation Media
Address: Missoula, MT, USA
Wildlife-film.com/·/Conservation-Media.htm
Owner/Producer: Jeremy R. Roberts
Main listing in 'Production Companies' on Page 16

Content Media
Address: Bucharest, ROMANIA
Main listing in 'Production Companies' on Page 16

Cristian Dimitrius - Director/Filmmaker/Photographer
Cristian Dimitrius Productions
Address: Sao Paulo, BRAZIL
Wildlife-film.com/·/CristianDimitrius.htm
Main listings in 'Camera Operators' on Page 144-145 or 'Services' on Page 54-55

engcrew.tv
Jesper Sohof – DoP
Address: Hinnerup, DENMARK
Main listing in 'Camera Operators' on Page 167

Excelman Productions
Address: Paris, FRANCE
Wildlife-film.com/·/Excelman-Productions.htm
Main listing in 'Production Companies' on Page 20
Research & Logistics: Albert Laloy – laloy@excelman.com

"Africa specialists"

EPM Asia Ltd
Address: 703 Beautiful Group Tower, 77 Connaught Rd, Central, HONG KONG
Phone: +852 6992 2571
Email: steven.epm@gmail.com
Website: www.epmasialtd.com
Facebook.com/epmasia
Twitter.com/epmasia
Wildlife-film.com/·/EPM-Asia.htm
CEO/Producer: Steven Ballantyne – See in 'Producers/Directors' on Page 178

EPM Asia · Asia's leading Pre-production, location and production management service · with offices in Hong Kong, Shanghai and the Philippines, EPM offers a bespoke and comprehensive service to Wildlife and Factual program producers across Pacific, Central and East Asia · Remote and challenging locations is our specialty · Credits include, Disney Nature *'Born in China'*, BBC NHU – RITUAL, BBC NHU – MOUNTAINS, Nat Geo · *One Strange Rock*

Fabio Borges Fotografia / Hydrosphera
Fabio Borges Pereira – Photographer & Filmmaker
Address: Fernando de Noronha, PE, BRAZIL
Wildlife-film.com/·/FabioBorges.htm
Main listing in 'Camera Operators' on Page 140

Facilitation Southern Africa
Address: Johannesburg, SOUTH AFRICA
Phone: +27 83 259 6324
Skype: karenmaxbrooks
Email: karenvbrooks@gmail.com
Website: www.linkedin.com/in/karenbrookstv
Wildlife-film.com/·/KarenBrooks.htm
Producer/Researcher/Facilitator: Karen Brooks

Facilitation for all southern African countries, South Africa, Swaziland and Lesotho; Botswana Namibia Zimbabwe Mozambique and Zambia. Madagascar. Wildlife films, documentaries and commercials. Over 25 years' experience in South African television.

Factual TV
Address: Kuala Lumpur 50460, MALAYSIA
Phone/Fax: +603 2276 3183
Email: info@factualtv.asia
Website: www.factualtv.asia
Contact: HonYuen Leong

We help production companies and broadcasters create documentaries in Asia. We have worked with regional broadcasters such as A+E Networks, Discovery Channel, National Geographic Channel and Walt Disney Television as well as local and foreign production companies. We are licensed by the National Film Development Corporation Malaysia to

87

provide fixing services to foreign production companies wishing to film in Malaysia, which includes arranging for the necessary permits (if given sufficient time), crewing, equipment rental, transport and accommodation arrangements and location reconnaissance.

Fixer in Spain
Address: C/Alta 37, Valencia 46003, SPAIN
Phone: +34 666 915 039
Email: rafa@fixerinspain.com
Website: www.fixerinspain.com
www.kftv.com/blog/2013/07/16/Striking-filming-locations-in-Spain
Facebook.com/fixerinspain
Instagram.com/fixer_in_spain
Linkedin.com/in/fixerinspain
Vimeo.com/fixerinspain
Fixer/Production Manager: Rafael del Vigo

Fixer in Spain provides services across all media projects - commercials, fashion photo-shoots, television, corporate online content, corporate events and music videos in Spain. We have an extensive network of local fixers, location managers, journalists and film crews, operating all over Spain. They are all friendly, English speaking professionals, armed with a can-do attitude, helpful and will go the extra mile to make your shoot in Spain a happy and productive one.

Ricardo Guerreiro - Filmmaker (photography, editing, fixer)
Address: Lisbon, PORTUGAL
Wildlife-film.com/-/RicardoGuerreiro.htm
Main listing in 'Camera Operators' on Page 149

Steve Hamel – Biologist/Camera Operator/Sound Recordist
Address: Montreal, Quebec, CANADA
Main listing in 'Camera Operators' on Page 150

Jungle Run Productions
Address: Bali, INDONESIA
Wildlife-film.com/-/JoeYaggi.htm
Main listing in 'Production Companies' on Page 26-27

Jungle Run Productions offers complete production services for Indonesia and SE Asia including:
- 4K & HD crews, drones, lighting and grip
- location and production management, fixers, translators
- film permit facilitation
- post-production, graphics, animation
- stock footage

We also have excellent contacts for:
- aircraft & watercraft, scientists and business leaders, government and NGO sector, search and rescue

Magic Touch Films
Address: PO Box 2209, Swakopmund, NAMIBIA
Phone: +264 81 243 3447
Fax: +264 88 650 3916
Email: info@magictouchfilms.com
Website: www.magictouchfilms.com
Wildlife-film.com/-/Magic-Touch-Films.htm
Contact: Nadia van den Heever

Services: Permits/Work Visas, Recces/Locations, Risk Assessments, Insurance, Crew Hire, Equipment Hire, Accommodation, Transport and everything else your production requires!

Jim Manthorpe - Freelance Wildlife Film-maker
Address: Scotland, UK
Wildlife-film.com/-/JimManthorpe.htm
Main listing in 'Camera Operators' on Page 158

Mystic Pictures Zambia
Address: Kitwe, ZAMBIA
Phone: +260 955 558 259 & +260 976 851 420
Email: info@mysticpictureszambia.co.zm
Website: www.mysticpicturesfilms.webs.com
Production Consultant: Joseph Muwowo: mysticpictureszambia@gmail.com

Mystic Pictures Zambia is a registered Zambian Production company working with international Film / Television crew as Fixers and Field Producers in Africa.

NEDO Films
Address: Santiago, CHILE
Wildlife-film.com/-/NEDO-Films.htm
Main listing in 'Production Companies' on Page 32

Vivian A. N. Nuhu – Coordinator
Address: P. O. Box OS3053, Osu-Accra, GHANA, WEST AFRICA
Phone: +233 244799749
Email: vannuhu@yahoo.co.uk

Coordinating notably for outside filming crews among them, BBC and NHK on wildlife locations, permits and local casts and logistics. As an experience wildlife conservationist, specialized in communication and education, I have been and still available as a presenter in wildlife adventure documentaries for general public and especially youth cum school groups. As a trained wildlife film maker without own equipment/facilities have facilitated in the production of overseas documentaries for awareness creation in my home country, Ghana. Not looking for proposals. Have already a number of ideas and proposals for wildlife adventure particularly for children and general Ghanaian public with conservation theme. Collaborators/sponsors most needed. Will welcome co-productions if it comes with funding.

Bernhard M. Pausett – Camera / Producer / Fixer / Assistant
BMP Filmproduksjon
Address: Oslo, NORWAY
Wildlife-film.com/·/BernhardMPausett.htm
Main listing in 'Production Managers' on Page 199

Ranger Expeditions Ltd
Stu Westfield
Address: High Peak Derbyshire, UK
Wildlife-film.com/·/StuartWestfield.htm
Main listing in 'Experts/Scientists' on Page 245

Scubazoo Images Sdn Bhd
Address: Kota Kinabalu, Sabah, MALAYSIA
Wildlife-film.com/·/Scubazoo.htm
Main listing in 'Production Companies' on Page 39-40

Viewfinders Kenya Ltd
Address: PO Box 14098, Nairobi 00800, KENYA
Phone: +254(0)717 305750, +254 (0)722 516039 & +254 (0)733741167 Email: info@viewfindersltd.com
Website: www.viewfindersltd.com
Wildlife-film.com/·/ViewFinders.htm
Director: Sajid Darr

The original wildlife film fixers, founded in 1988. Top quality wildlife films are our speciality, also documentaries on nature, science, medicine, conservation, etc. Operating in Kenya, we are the leaders in our field. Founded by Jean Hartley and the legendary Alan Root, the directors include ornithologist extraordinaire Leon Bennun, photographer, anthropologist and film maker Mia Collis and wildlife manager and guide Sajid Darr. Operating in Kenya, with associated colleagues in neighbouring countries, we facilitate for natural history and documentary film crews from all over the world. Our service includes the 'normal' fixer things · obtaining all permits, licences and permissions, as well as arranging temporary importation of equipment, transport, hotel/lodge or private camp accommodation, internal flights and air charters, aerial filming, etc. We go the extra mile · logistical challenges are our speciality · nothing is impossible and we never take 'no' for an answer.

For employment and work experience, it would be very rare for us to take on anyone who is not locally based with an exceptional knowledge of wildlife.

Visual Africa Films Ltd
Address: Nairobi, KENYA
Phone: +254 733 722 818 & +254 721 431 432
Email: feisal@visualafrica.tv
Website: www.visualafrica.tv
Facebook.com/visualafrica
Twitter.com/films_africa
Wildlife-film.com/-/Visual-Africa-Films.htm
Line Producer/ Director/ Camera/ Fixer/ Producer: Feisal Malik

We are registered Filming Agents in Kenya, enabling us to handle ground work for international productions shooting in Kenya. We can find you access to some of the least visited destinations in Kenya, and set up a fully-fledged camp for you, as per your requirements. We are members of Kenya Film & TV Professionals Association (KFTPA), East African Film Network (EAFN), Foreign Correspondents Association of East Africa (FCAEA), Natural History Network (NHN) and Wildlife-film.com. We also produce our own content and have all the necessary equipment and technical know to produce broadcast content. We also offer photography services. We are currently developing an idea for a travel series in Kenya. We are looking for commissioners/ sponsors/ co-production possibilities for it. It will be presenter led with adventure, photography and cooking. We are looking for collaborators/sponsors and we will consider co-productions. We are not offering internships or work experience opportunities.

wallacea-films
Address: Jakarta & Bali, INDONESIA
Producer/Filmmaker/Owner: Mr. Alain Beaudouard
Since 20 years in Indonesia. Documentary & Fixing/Scout: Wallacea-films.com
Also see in 'Production Companies' on Page 47 & 'Stock Footage' on Page 67

Wildblood Marine Services
Address: Corfu, GREECE
Main listing in 'Production Services' on Page 61

Wild Kenya Safaris
Photographer, Presenter, Expert: Shazaad Kasmani
Address: P.O. Box 98593, Mombasa, Coast 80100, KENYA
Phone: +254 735353589 & +254 728888889
Email: info@wildkenyasafaris.com & shazaad.kasmani@gmail.com
Website: www.wildkenyasafaris.com
www.wildkenyasafaris.blogspot.com
Facebook.com/WildKenyaSafaris
Linkedin.com/in/shazaadkasmani
Wildlife-film.com/-/ShazaadKasmani.htm

Wild Kenya Safaris is recognized as a reputable and professional safari agent in Kenya. With over 10 years experience in the field, we are specialized in Natural History Photography and Filmmaking consulting for all the major National Parks as well as Marine Parks in Kenya. Our expertise includes but is not limited to:
- Location Scouting.
- Wildlife Conservation.
- Organizing and facilitating documentary interviews with the locals and/or KWS.
- Fixing and Facilitation Services.
- Wildlife Photography and filmmaking safaris with professional driver guides who speak English, German, French and Italian.
- Wildlife Stock Photos
- Lodge and Camp accommodation arrangements.
- Location recommendations and research.
- Conducting and leading Wildlife Photography workshops.
- Video Presenting.
- Location logistics and management by Road, Air and Boat.
- Safari vehicle rentals with experienced local drivers.
- Swahili translations.
- and much much more...

Please feel free to get in touch with us, we love to be of service!

Wildlife Pictures Institute
Address: Tehran, IRAN
Wildlife-film.com/-/Wildlife-Pictures-Institute.htm
Main listing in 'Production Companies' on Page 48-49

FILM FESTIVALS/COMPETITIONS

Abbeville Bird and Nature Festival
(Festival de L'Oiseau et de la Nature)
Address: 20 rue du Chevalier de la Barre 80142 Abbeville Cedex, FRANCE
Phone: +33 3 22 24 02 02
Fax: +33 3 22 25 47 97
Email: film@festival-oiseau-nature.com
Website: www.festival-oiseau-nature.com
Facebook.com/festivaloiseaunature
Twitter.com/FestivalOiseau
Wildlife-film.com/-/Abbeville-Bird-and-Nature-Festival.htm
Contacts:
Festival Director: Marie-Agnès Boche
Assistant: Sophie Delsaut: sophie@festival-oiseau-nature.com

Our Festival takes place every April. Fiction or commercials not allowed. Online entry is free of charge, open from late August to early November. DVD or streaming link requested for pre-selection. Directors of selected films are invited for the Award Night.
Prizes (for 2017):
GRAND PRIX OF THE BIRD AND NATURE FESTIVAL Award of €4,000
THE WILDLIFE PRIZE Award of €2,000
SPECIAL JURY PRIZE Award of €2,000
THE ENVIRONMENT PRIZE Award of €2,000
AMATEUR PRIZE Award of €2,000
PUBLIC PRIZE Award of €1,500
The professional entrants can register their film in 2 categories: bird/wildlife or environment (any duration). Amateur category: film with a maximum duration of 13 minutes.

Albert International Wildlife Film Festival
(Festival International du Film Animalier)
Address: 55 rue de Birmingham, Albert 80300, FRANCE
Email: contact@fifa.com.fr
Website: www.fifa.com.fr
Wildlife-film.com/·/FIFA.htm

The festival is an official competition in which each selected movie is presented to an international jury composed of personalities known for their competence, commitment and knowledge of wildlife and environment.

American Conservation Film Festival
Address: PO Box 889, Shepherdstown, WV 25443, USA
Email: info@conservationfilmfest.org
Website: www.conservationfilmfest.org
Facebook.com/conservationfilmfest
Twitter.com/ConservationFF
Wildlife-film.com/·/American-Conservation-Film-Festival.htm

The American Conservation Film Festival presents entertaining films with a wide range of issues that often focus on the relationships between people and the environment.

Babul Films
Address: Andhra Pradesh, INDIA
Main listing in 'Production Companies' on Page 13

We are planning to organize a Biodiversity film festival on permanent basis at Hyderabad.

BLUE Ocean Film Festival & Conservation Summit
Address: 646 2nd Ave. South, Saint Petersburg, Florida 33701, USA
Phone: +1 727 388 6682
Email: info@blueoceanfilmfestival.org
Website: www.blueoceanfilmfestival.org
Facebook.com/BlueOceanFilm
Instagram.com/blueoceanfilmfest
Twitter.com/BlueOceanFilm
Youtube.com/user/BLUEfilmfest

BLUE Ocean Film Festival is a global film festival and conservation summit for underwater filmmakers and marine researchers. A simultaneous community festival will share the best of the film competition with the public and will include presentations from the filmmakers and scientists who created them. Following the festival, a selection of winning films will tour the world, providing those who may not otherwise have access to these great films a chance to learn more about our oceans.

BRITISH WILDLIFE PHOTOGRAPHY AWARDS

British Wildlife Photography Awards
Country: United Kingdom
Email: mail@maggiegowan.co.uk
Website: www.bwpawards.org
Facebook.com/BWPAwards
Instagram.com/bwpawards
Twitter.com/BWPAwards
Vimeo.com/bwpawards
Wildlife-film.com/·/BWPA.htm
Director: Maggie Gowan

The **British Wildlife Photography Awards** were established to recognise the talents of wildlife photographers of all nationalities practising in Britain, whilst at the same time highlighting the great wealth and diversity of Britain's natural history. The driving motivation to set up the Awards evolved through the nation's growing awareness of the local environment and the need for its protection. Now in its ninth year (2018), this highly acclaimed and unique wildlife photography competition has captivated the nation with outstanding and beautiful imagery. It is a celebration of British wildlife as well as a showcase for nature photographers, both amateur and professional.

With fifteen separate categories the subject matter covers everything from marine life and animal behaviour to creepy crawlies and urban wildlife.

Wildlife in HD is a special award for Video and will be awarded to the most inspirational and dynamic film, which clearly illustrates the unique power of moving images as a medium for capturing British Wildlife. We do not offer work experience at present but we are always looking for sponsors.

Cinemambiente Environmental Film Festival
Address: via Montebello, 15, 10124 Torino, ITALY
Phone: +39 011 81 38 860
Email: festival@cinemambiente.it
Website: www.cinemambiente.it
Facebook.com/cinemambientetorino
Instagram.com/cinemambiente
Youtube.com/user/cinemambientefest
Twitter.com/Cinemambiente
Contact: Gaetano Capizzi

Since its' debut in Turin in 1998, CinemAmbiente Environmental Film Festival has presented outstanding environmental films in a year-round program of initiatives that promote cinema and green awareness. FESTIVAL SECTIONS: International Documentary Competition; Italian Documentary Competition; One Hour · International Short Film Competition/Medium-Length Documentary Competition; Non-competitive sections.

CMS Vatavaran Environment & Wildlife Film Festival & Forum
Address: Research House, Saket Community Centre, New Delhi 110017, INDIA
Phone: +91 11 2685 1660 & +91 11 2685 6429
Fax: +91 11 2696 8282
Email: info@cmsvatavaran.org
Website: www.cmsvatavaran.org
Festival Manager: Mr. Sabyesachi Bharti - sabyesachi@cmsvatavaran.org

CMS VATAVARAN is India's homegrown international Competitive and Travelling Festival of Environment and Wildlife Films.

Deutsche Naturfilmstiftung
Darßer Naturfilmfestival - Deutscher Naturfilmpreis
Address: Bliesenrader Weg 2, 18375 Wieck, Darß, GERMANY
Phone: +49 38233 703810
Email: film@arche-natura.de
Website: www.deutscher-naturfilm.de
Facebook.com/naturfilmfestival
Contact: Kai Lüdeke

The "German Nature Film Award" have sat at the heart of the Darßer Naturfilmfestival. The festival presents the best nature films from Germany and outstanding international productions beyond the competition.

EcoCinema
Country: ISRAEL
Email: ecocinema@gmail.com
Website: www.ecocinema.org.il
Facebook.com/ecocinema

EcoCinema, which began operating in 2004, screens festival films in cinemas around Israel. Its' goals are to bring films dealing with the environment in all forms to Israel, and help Israeli artists to produce such films.

Ecozine: The International Film Festival and Environment of Zaragoza
Address: EcoZine Cultural Association PO Box 293, 50,080 Zaragoza, SPAIN
Phone: +34 617 946 303 & +34 976 205 640
Email: info@festivalecozine.es or direccion@festivalecozine.es
Website: www.festivalecozine.es
Facebook.com/FestivalEcozine
Twitter.com/ecozinefilmfest
Youtube.com/user/ecozinefest

Ecozine, takes place in May, and we want to bring stories that talk about our Earth and how humans interact with it, loving it and, unfortunately, many times, wounding her. Our fundamental goal remains to show, support and promote films made in the world on the environment. Being a free and open space from which to inform, disseminate, awareness and, of course, contribute to a world ever more just and sustainable, which sometimes is difficult. We want to keep on being an open window to provide a space for all those realities, so different, we talk about the difficulties but also the solutions with an active and critical cultural attitude that promotes respect and conservation of our natural environment and all walks of life that respects our environment.

EKOFILM - International Film Festival on the Environment and Natural and Cultural Heritage
Address: Chelčického 531/3, 702 00 Moravská Ostrava, CZECH REPUBLIC
Phone: +420 777 890 271
Email: produkce@ekofestival.cz
Website: www.ekofestival.cz
Facebook.com/ekofilm

EKOFILM is the International Film Festival about the Environment and our Natural and Cultural Heritage. It brings the latest information about the state of nature and the environment in various countries of the world and in many instances even facts about the resolution of particular situations to a wide audience.

Environmental Film Festival in the Nation's Capital
Address: 1224 M Street NW, Suite 301, Washington, DC 20005, USA
Phone: +1 202 342 2564
Email: info@dceff.org
Website: www.dceff.org
Facebook.com/dcenvirofilm
Twitter.com/dcenvirofilm
Instagram.com/dcenvirofilm
Director of Public Relations: Helen Strong · helen@dceff.org
Wildlife-film.com/·/DCEFF.htm

Founded in 1993, the Environmental Film Festival in the Nation's Capital has become one of the world's largest and most influential showcases of environmental film and a major collaborative cultural event in Washington, D.C. Each March the Festival presents a diverse selection of high quality environmental films, including many Washington, D.C., U.S. and world premieres. Documentaries, narratives, animations and shorts are shown, as well as archival, experimental and children's films at venues throughout the city. Films are screened at partnering museums, embassies, libraries, universities and local theaters and are attended by large audiences. Selected to provide fresh perspectives on global environmental issues, most Festival films are accompanied by discussions with filmmakers, environmental experts and special guests, including national decision makers and thought leaders, and are free to the public. The Festival's Web site serves as a global resource for environmental film throughout the year. Year-round Internship Opportunities Offered.

Green Screen – International Wildlife Film Festival
Address: Frau-Clara Straße 18, 24340 Eckernförde, GERMANY
Phone: +49 4351 47 00 43
Fax: +49 4351 47 68 36
Email: info@greenscreen-festival.de
Website: www.greenscreen-festival.de
Facebook.com/greenscreenfestival
Instagram.com/greenscreen_festival
Wildlife-film.com/·/GreenScreen.htm

Since 2007, the idyllic town of Eckernförde on the Baltic coast hosts the International Wildlife Film Festival GREEN SCREEN each year in September. Meanwhile, it has grown to become the largest annual wildlife film festival in Europe. Festival dates for 2018 are 12th- 16th September. Submissions doe the next festival edition will open in December 2018.

Innsbruck Nature Film Festival
Address: Tiroler Umweltanwaltschaft, Meranerstrasse 5, 6020 Innsbruck, AUSTRIA
Phone: +43 512 508 3492
Email: hello@inff.eu
Website: www.inff.eu/en
Facebook.com/inff.eu
Instagram.com/inff_eu
Twitter.com/inff_eu
Festival Director: Johannes Kostenzer
Organiser: Liesa Jirka – liesa.jirka@inff.eu
Organiser: Christoph Fintl – christoph.fintl@inff.eu

The Innsbruck Nature Film Festival is an international nature film competition, offering motivated filmmakers a platform for presenting their latest work. Four film festival days with film presentations and a high-quality side program are the framework for an on-topic, ecological, and artistic discourse.
We are looking for films that deal with the general topic of nature and environment! We are interested in different approaches to the topic, not only in classical documentaries!
Festival Categories:
– ENVIRONMENTAL DOCUMENTARY
– NATURE DOCUMENTARY
– SHORT FICTION FILM (max. 30')
– SHORT DOCUMENTARY FILM (max. 30')
– YOUNG TALENT (max 20', up to 25 years old)
Sponsors are welcome!

International Ocean Film Festival (IOFF)
Address: 1007 General Kennedy Avenue San Francisco, California 94129, USA
Phone: +1 415 561 6251
Email: info@oceanfilmfest.org
Website: www.intloceanfilmfest.org
Facebook.com/oceanfilmfest
Instagram.com/oceanfilmfest
Twitter.com/oceanfilmfest
Youtube.com/OceanFilmFestival
Vimeo.com/user21783508

Ocean lovers of all species find a second home on both sides of the screen at the International Ocean Film Festival (IOFF), the first, largest, and most influential showcase of its kind in North America. Themes range from marine science and industry to wildlife, conservation, coastal culture, exploration, adventure, and salt-water sports.

International Nature Film Festival Gödöllő
Address: Jászdózsa street 30, Budapest, HUNGARY
Email: info@godollofilmfest.com
Website: www.godollofilmfest.com/en
Facebook.com/godollofilmfest
Instagram.com/godollofilmfest

An international nature film festival in Hungary, Gödöllő. For amateur and professional nature film-makers.

International Underwater Film Festival Belgrade
Address: Pop Lukina 4 , Beograd 11000, SERBIA
Phone: + 381 63 861 1455

Email: dive.kpa.bgd@gmail.com
Website: www.kpa.co.rs
President: Milorad Djuknic

The International Underwater Film Festival in Belgrade is a unique opportunity to peek into the underwater world, to find out more about it through films, photos, meetings with authors and other underwater adventurers and enthusiasts. As usual, the Festival program encompassed film contest and film revue, underwater photography contest and exhibition, children drawings exhibition, art students, poster contest and exhibition, lectures, presentations and many other events.

International Wildlife Film Festival (IWFF)
Address: 718 South Higgins Ave, Missoula, MT 59801, USA
Phone: +1 406 728 9380
Fax: +1 406 728 2881
Email: iwff@wildlifefilms.org
Website: www.wildlifefilms.org
Facebook.com/InternationalWildlifeFilmFestival
Instagram.com/wildlifefilmfest
Twitter.com/IntlWldFilmFest
Wildlife-film.com/-/IWFF.htm
Executive Director: Mike Steinberg

Founded in 1977 at The University of Montana, IWFF was the first juried Wildlife Film Festival in the world. Established by a group of Wildlife Biology students, a renowned Wildlife Biologist and a television Executive Producer, IWFF was at the time, an all-volunteer organization. This was at a time when wildlife films were just becoming popular on a limited scale and there was a growing sense of urgency that films, television and media all together, were a critical component of education, awareness and the protection of species and habitat. IWFF was founded in part to be a watchdog of this growing wildlife film industry. Over the years, IWFF grew and evolved and today, it is known as The International Wildlife Media Center & Film Festivals. This is the umbrella, for the now longest running wildlife film festival in the world IWFF or The International Wildlife Film Festival Ltd., a not for profit organization. Founded and based in Missoula, Montana in the heart of the Northern Rockies, the mission of the International Wildlife Media Center & Film Festivals is to promote awareness, knowledge and understanding of wildlife, habitat, people and nature through excellence in film, television, and other media.

Jackson Hole Wildlife Film Festival
Address: Suite 240 S. Glenwood Suite 112, Jackson, WY 83001, USA
Phone: +1 307 200 3286
Email: info@jhfestival.org
Website: www.jhfestival.org
Facebook.com/jhwff
Twitter.com/jacksonholeWILD
Wildlife-film.com/-/JHWFF
Executive Director: Lisa Samford
Operations: Christie Quinn
Film Competition: Dana Grant
Tour Operations: Melanie Judd

Internationally recognized as the premier event of its genre, the Jackson Hole Wildlife Film Festival (held in the odd years) is an unparalleled industry gathering of more than 700 broadcast and media stakeholders, writers, leading scientists and conservationists. They converge from around the world to hone skills, explore emerging technologies and

99

marketing opportunities, network with professional associates and honor notable achievements within the industry. The Grand Teton Awards, a nature film awards equivalent to the Oscars®, honors top films selected from over 600 entries into categories including Best Animal Behavior, Best Visualization and Best Interactive storytelling. In the even years, Jackson Hole moves to Boston for SMASH · a unique forum to network with top scientists and top science media makers from around the world to share new work, new approaches, new ideas. The unique collaboration with WGBH Boston brings together a diverse crowd of 250+ scientists and science media stakeholders from around the world. Jackson Hole WILD On Tour is shares the best wildlife, nature & science films from our competitions to a larger audience year-round, connecting more people to the natural world through media. We're eager to partner with non-profits, universities, organizations and venues to bring the best of Jackson Hole to your community!

Japan Wildlife Film Festival (JWFF)
Address: 205 Ranjo, Tonami-Shi, Toyama-Ken, 939-1431, JAPAN
Phone: +81(0)3 6419 7503
Fax: +81(0)3 6419 7510
Email: jwff@naturechannel.jp
Website: www.naturechannel.jp/JWFFE/index.html
Facebook.com/japanwff
Twitter.com/JWFF1
Youtube.com/JapanWFF
Wildlife-film.com/-/JWFF.htm

The festival hopes to increase understanding and awareness of the urgent need to protect and care for the natural world. It was established in 1993, and is held biennially.

Matsalu Nature Film Festival
Address: Tallinna mnt 25, 90303 Lihula, ESTONIA
Phone: +372 477 5141
Email: info@matsalufilm.ee
Website: www.matsalufilm.ee/en
Facebook.com/matsalufilm
Twitter.com/matsalufilm
Wildlife-film.com/-/MatsaluNatureFilmFestival.htm
Festival director: Silvia Lotman

The Matsalu Nature Film Festival (MAFF) is an annual nature film event held in Estonia. It is named after the nearby Matsalu National Park, one of Europe's largest bird sanctuaries and a wetland environment of global significance. The MAFF is organized by the Matsalu Nature Film Festival non-profit organization in cooperation with the Lihula municipal government. The festival promotes nature-oriented and sustainable ways of life and respect for the nature-connected traditions of indigenous people. It showcases a variety of new international films about nature, wildlife, expeditions, environment, sustainability, biodiversity, conservation · films that depict nature in its diversity and films about the coexistence of man and nature.
The festival hosts also various art and photography exhibitions, photo presentations and meetings of both professional and amateur nature photographers. The program includes also screenings, activities and workshops for schoolchildren, roundtable discussions on different nature-related topics and other cultural events.
The MAFF takes place in the idyllic town of Lihula in Western Estonia. A selection of films are also shown in Haapsalu and Tallinn.
The Call for Entries is open from March 1st to June 1st. Films can be submitted in one of two categories:
A – NATURE B – MAN AND NATURE

Festival International Nature Namur
Address: Rue Léon François 6-8, 5170 Bois-de-Villers, BELGIUM
Phone: +32 (0)81 432 420
Email: info@festivalnaturenamur.be
Website: www.festivalnaturenamur.be
Facebook.com/LeFestivalNatureNamur
Twitter.com/FestivalNature Youtube.com/FestivalNatureNamur
Plus.google.com/+festivalnaturenamur
Wildlife-film.com/-/Festival-Nature-Namur.htm

The Festival International Nature Namur is one of the top 5 European festivals dedicated to nature and wildlife. It has become, over the years, a must-see event for nature enthusiasts and beautiful images, gathering more than 20,000 spectators every year over 10 days. Articulated around three international competitions, professional films, amateur films and photos, the Festival offers nearly 60 films on more than 40 sessions, about forty photo exhibitions as well as the hundred photos selected for the contest. Many activities always dedicated to nature are grafted to offer what nature has more beautiful. The 24th edition of the Festival will be held from 12 to 21 October 2018 in Namur, Belgium. Discover the following activities at the Festival : Screenings of films in cinema complex, Photo exhibitions, Guided walks in nature, Village nature, Conferences and meetings, Initiations photos & Youth Animations.

NaturVision Filmfestival
Address: Arsenalstr. 4, Ludwigsburg 71638, GERMANY
Phone: +49 (0)7141 992 248 0
Email: info@natur-vision.org
Website: www.natur-vision.de
Facebook.com/NaturVision
Instagram.com/naturvisionfilmfestival
Wildlife-film.com/-/NaturVision.htm
Festival Director: Ralph Thoms

Unforgettable film images, emotional moments, critical information: NaturVision is THE film festival for nature and the environment. With our international film competition, each year we showcase the latest films around nature, wildlife and the environment, honouring the best among them with prestigious awards. NaturVision brings the beauty of nature to the big screen, shows the vulnerability of our world, and reports on new and promising solutions for environmental issues. NaturVision stands for the art of film, sustainability and future-proof development. NVision the future! Competition categories and awards:
German Conservation and Sustainability Film Award (Prize Money 10.000 Euro)
German Wildlife Film Award (Prize Money 10.000 Euro)
German Biodiversity Film Award (Prize Money 10.000 Euro)
NaturVision Camera Award
NaturVision Best Story Award
NaturVision Film Music Award (Prize Money 1.000 Euro)
NaturVision Bavarian Film Award (Prize Money 3.000 Euro)
NaturVision Childrens' Film Award (Prize Money 2.000 Euro)
NaturVision Newcomer Award (Prize Money 1.000 Euro)
NaturVision Short Film Award (Prize Money 5.000 Euro)
NaturVision Youth Jury Award (Prize Money 2.000 Euro)
NaturVision Audience Award
NaturVision Honorary Award

New York WILD Film Festival
Address: 23 W. 73rd St., #1201, New York, NY 10023, USA
Phone: +1 212 877 6364
Email: nywildff@gmail.com
Website: www.nywildfilmfestival.com
Facebook.com/NewYorkWILD
Instagram.com/nywildfilmfest
Twitter.com/NYWildFilmFest
Vimeo.com/user20835386
Wildlife-film.com/-/NYWildFilmFestival.htm
Founder and Executive Director: Nancy Rosenthal

The New York WILD Film Festival is the first annual documentary film festival in New York to feature a spectrum of topics, from exploration and adventure to wildlife, conservation and the environment, bringing all things WILD to one of the most urban cities in the world. By showcasing films, bringing together filmmakers, scientists, explorers, sponsors, partners and our audience, NY WILD provides a platform to exchange ideas, celebrate the wild and affect vital change. Through a juried selection NY WILD presents awards for winners in various categories. Festival categories: Exploration, adventure, wildlife, conservation and the environment, feature length and shorts.
We are looking for sponsors and partners. If you are interested in volunteering or interning please send CV by email.
An interest/experience in film/exploration/conservation helpful, as well as development and marketing.

Ottawa International Vegan Film Festival
Address: Ottawa, Ontario, CANADA
Website: www.oivff.com
Facebook.com/OIVFF
Instagram.com/oivff
Twitter.com/veganfilmfest
Wildlife-film.com/-/OIVFF.htm

Taking place in Canada's capital city Ottawa, the Ottawa International Vegan Film Festival showcases short and full-length films with a vegan subject matter from filmmakers around the world.

Planet in Focus International Environmental Film Festival
Address: 192 Spadina Ave, Suite 407, Toronto, Ontario M5T 2C2, CANADA Phone: +1 416 531 1769 Toll Free: 1 855 531 1769
Email: info@planetinfocus.org
Website: www.planetinfocus.org
Facebook.com/planetinfocus
Twitter.com/PlanetinFocus
Instagram.com/planetinfocus
Executive Director: Jordana Aarons

Submissions open each January for Canada's largest environmental film festival.

San Francisco Green Film Festival
Address: Ninth Street Independent Film Center, 145 9th St., Ste. 220, San Francisco, CA 94103, USA
Phone: +1 415 767 1977
Email: info@greenfilmfest.org
Website: www.greenfilmfest.org
Facebook.com/greenfilmfest
Instagram.com/greenfilmfest
Twitter.com/greenfilmfest
Linkedin.com/company/san-francisco-green-film-festival
Youtube.com/user/sfgreenfilmfest
Founder & Executive Director: Rachel Caplan · rachel@greenfilmfest.org

Launched in 2011, the San Francisco Green Film Festival is a non-profit organization dedicated to screening compelling environmental films; connecting audiences to filmmakers and experts; and sparking green ideas & actions. Our signature program is the annual Green Film Fest and we also screen films and support filmmakers throughout the year. As the West Coast's leading event for films & discussions about people and the planet, Green Film Fest is bringing audiences the most vital stories from the environmental frontlines. Find out how you can get involved and take action! The Festival takes place annually in September and film submissions are accepted March-May (please check the website at greenfilmfest.org/filmmakers for more details). To qualify, productions must feature an aspect of sustainability or of the relationship between people and the planet. There are no restrictions on length or genre: Documentaries, narratives, animations, features, shorts, student works, trans media projects, music videos, installations, games and experimental genres will be considered. Awards are given for: Best Feature Award, Best Short Award, Inspiring Lives Award, Green Tenacity Award, Audience Award. Generous Sponsor packages are available · please visit greenfilmfest.org/involved#Sponsor for more information. In addition to financial contributions, the festival is seeking in-kind sponsors to support festival production, promotion, food and beverage, travel, and hospitality. Festival volunteers donate their time to help us run our busy schedule of screenings and events during the annual festival. Volunteers help with will-call, ticket taking, ushering, event set-up/break-down, and myriad other tasks! Office interns and volunteers contribute between one and three days a week administrative support: answering queries, processing film entries, and office tasks. There is also the opportunity to get involved with festival programming and help out with longer-term projects. This is great for people who are studying, have just graduated, or who have some down-time between productions. Individuals with specialized skills contribute to projects or committees such as marketing, publicity, graphic design, fundraising, event production, programming and various other special projects. For current information, please visit greenfilmfest.org/volunteer

Scandinavian Wildlife Film Festival
Address: Hunnebostrand and Nordens Ark, SWEDEN
Phone: swff.se/kontakt.html
Email: info@swff.se
Website: www.swff.se
Facebook.com/Scandinavian-Wildlife-Film-Festival-806337509463066

The Scandinavian Wildlife Film Festival is a festival held annually.

Sondrio Festival - International Documentary Film Festival on Parks
Address: Via Perego 1, Sondrio 23100, ITALY
Phone: + 39 0342 526 260
Fax: + 39 0342 526 437
Email: info@sondriofestival.it
Website: www.sondriofestival.it
Wildlife-film.com/-/Sondrio-Festival.htm

Annual documentary film festival focusing on aspects of National Parks, Nature Reserves and Protected Areas, with further sections on environment, human activities and sustainable development. It takes place every year for a week at the beginning of October. First Prize: 5,000 Euros. Stelvio National Park Award: 3,000 Euros.

SunChild International Environmental Film Festival
Address: Khanjyan street 47/1, ap.15 001, Yerevan, ARMENIA
Phone: +374 (0)10 585884
Email: film@sunchild.org
Website: www.sunchild.fpwc.org
Facebook.com/fpwc.arm
Instagram.com/fpwc
Twitter.com/fpwc_news

The SunChild Festival was established in 2007 by the Foundation for the Preservation of Wildlife and Cultural Assets (FPWC). The festival is a biennial event and the only wildlife/environmental festival in the entire South Caucasus region.

Wilderland Festival
Address: Bristol, UK
Email: info@wilderlandfestival.com
Website: www.wilderlandfestival.com
Facebook.com/wilderlandfest
Instagram.com/wilderlandfest
Twitter.com/WilderlandFest
Co-Founders: Dan O'Neill & Isaac Rice

Wilderland is a unique film festival with roots in the international capital of wildlife filmmaking · Bristol, UK

Wild & Scenic Film Festival
Address: 313 Railroad Ave, Nevada City, CA 95959, USA
Phone: +1 530 265 5961 x215
Email: stephanie@wildandscenicfilmfestival.org
Website: www.wildandscenicfilmfestival.org
Facebook.com/WildScenicFilms
Twitter.com/WildScenicFilms
Youtube.com/channel/UCLWw-8KaYfc0TeAK_6Dbozw
Festival Coordinator: Stephanie Romanella

At our festival, you'll witness how individuals and communities across the globe are taking action and becoming part of the solution on issues ranging from energy, food systems, biodiversity, climate change and the protection and restoration of wild lands and wild waters. You'll experience the adrenaline of kayaking the wildest rivers, climbing the highest peaks and trekking across the globe with adventure films from around the world. You'll explore the issues and movements with leading environmental activists and professionals, filmmakers and celebrities. And you'll celebrate the natural and human world in all its diversity, in 9+ venues for films and workshops, a children's Saturday morning cartoons program, art shows, wine tastings, a Gala Event and awards ceremony. Considered one of the nations' premiere environmental and adventure film festivals, this years' films combine stellar filmmaking, beautiful cinematography and first-rate storytelling to inform, inspire and ignite solutions and possibilities to restore the earth and human communities while creating a positive future for the next generation. Festival-goers can expect to see award winning films about nature, community activism, adventure, conservation, water, energy and climate change, wildlife, environmental justice, agriculture, Native American and indigenous cultures. Award Categories: Peoples' Choice Award; Best of Festival Award; Best in Theme; Most Inspiring Adventure Film; Best Short; Jury Award; Student Filmmaker Award; John de Graaf Environmental Filmmaking Award; Honorable Mentions; Kids Jury, Best Film

WILDLIFE FILM FESTIVAL
ROTTERDAM

Wildlife Film Festival Rotterdam
Address: Brandingdijk 112, Rotterdam 3059, THE NETHERLANDS
Phone: +31(0)6 1406 0229
Email: info@wffr.nl
Website: www.wffr.nl
Facebook.com/wildlifefilmfestivalrotterdam
Twitter.com/wffr_nl
Instagram.com/wildlifefilmfestivalrotterdam
Wildlife-film.com/-/WFFR.htm
Festival Director: Raymond Lagerwaard

The Netherlands' main wildlife film festival is held in the city center of Rotterdam each last weekend of October. WFFR creates a unique platform in the Netherlands for wildlife filmmakers. WFFR screens movies with a central focus on the natural world, but also critical and informative documentaries on raising awareness, the environment and sustainability. Professional and non-professional filmmakers from all over the world can submit their film free of charges. The competition offers awards in a wide range of categories. Selected filmmakers are invited to the festival to meet other filmmakers, professionals and our audience. Many other activities are scheduled around the festival

like photo exhibitions, an educational kids program, a gathering for filmmakers and a Nature Cafe. The competition offers Awards in the following categories:
Best Film Professional
Best Film Non-Professional
WFFR Environmental/Sustainability Award
WFFR Underwater Award
WFFR Newcomer Award
WFFR Virtual Reality
Award WFFR Awareness Award
Volunteers are needed at the festival, so please contact info@wffr.nl if keen!

Wildlife Vaasa - International Nature Film Festival
Address: Vaasa Culture services and Libraries, Kirjastonkatu 13, 1st floor, 65100 Vaasa,
FINLAND Phone: +358 400 800 302
Email: ilias.missyris@vaasa.fi
Website: www.wildlife.vaasa.fi
Facebook.com/vaasawildlifefestival
Festival Producer: Ilias Missyris

Wildlife Vaasa Festival located on the West Coast of Finland is held every second year in the city of Vaasa. Since its conception in 2002, it has grown in stature receiving commendation from participants, delegates, media and the public world-wide.
Next festival dates are 26-30th September 2018.
Themes: Climate Change, Energy, China.
Festival Categories:
1. NATURAL HISTORY FILMS
2. ENVIRONMENT & CONSERVATION FILMS
3. NORDIC FILMS
4. SHORT FILMS
5.UNDERWATER FILMS
6. SCIENCE FILMS
7. SPECIAL AWARDS (Energy, Climate change, Animation, Jury's Special award (The call of entries has expired on May 1st)

Wildscreen Festival
Address: 4th Floor, 36 King Street, Bristol BS1 4DZ, UK
Phone: +44 (0)117 929 1222
Email: hello@wildscreen.org
Website: www.wildscreen.org
Facebook.com/wildscreenfest
Twitter.com/WildscreenFest
Wildlife-film.com/-/Wildscreen.htm

Wildscreen Festival is the world's leading international festival celebrating and advancing storytelling about the natural world through visual media. For over 30 years the prestigious biennial Festival has been convening and celebrating the world's best natural world storytellers, it is home to the illustrious Wildscreen Panda Awards, the highest accolade in the wildlife film and TV industry. Through collaboration with an ever-growing community of filmmakers, photographers, broadcasters, technologists and conservation organisations we aim to transform the craft of natural world storytelling across platforms and across audiences, ensuring as many people as possible experience the natural world, feel part of it and want to help protect it. Submissions for the 2018 Panda Awards will be opening in October 2017. Panda Awards categories cover technical, craft, genre, subjects and format aspects of wildlife film. Wildscreen take on a team of volunteers for the festival week, applications are open around 5 months prior to the festival.

106

Wlodzimierz Puchalski Nature Film Festival
Address: 93-106 Lodz, ul. Kilinskiego 210, POLAND
Phone: +48 42 689 23 45
Fax: +48 42 689 23 46
Email: wfo@wfo.com.pl
Website: www.festiwalpuchalskiego.pl/en Facebook.com/WytworniaFilmowOswiatowych
Plus.google.com/111730533362026282085

The festival is a biennial event (odd years) that takes place in Lodz. The festival programme includes an international competition of films that deal with nature and environmental issues. The festival screens more than 40 films in competition and awards several prizes. festiwalpuchalskiego.pl/en/about-the-festival

EDUCATION/TRAINING

American University's Center for Environmental Filmmaking
Address: 4400 Massachusetts Avenue, NW, Washington DC 20016-8017, USA
Phone: +1 202 885 3408
Fax: +1 202 885 2019
Email: palmer@american.edu
Website: www.environmentalfilm.org
Facebook.com/groups/170481313030202
Twitter.com/chrispalmer_au
Youtube.com/AUSOCMedia
Wildlife-film.com/·/ChrisPalmer-AUCEF.htm
Director: Professor Chris Palmer – www.chrispalmeronline.com

Films and new media are essential educational and political tools in the struggle to protect the environment. Our mission is to train filmmakers to produce films and new media that effectively strengthen the global constituency for conservation. The world faces immense environmental challenges. We are fouling our own nest to an unprecedented degree. Powerful, emotive, and affecting images and films can play a key role in raising the importance of conservation and bringing about change. We are committed to raising awareness and empowering action through the innovative use of media.

Andrew Bell – Producer/ Cameraman / Editor
Address: London, UK
Main listing in 'Producers/Directors' on Page 179

Makes training films for UK Universities, Maritime and Environmental, Aeronautical industries as part of his wide repertoire covering a range of subjects either as a series or a one off for broadcast. In addition Andrew teaches at colleges in Media or support lecturers teaching a range of subjects up to MA level in supplying them with video teaching aides.

Ed Drewitt – Naturalist/Broadcaster/Wildlife Detective/Consultant
Address: Bristol, UK
Main listing in 'Experts/Scientists' on Page 242

Felis Creations
Address: Bangalore, INDIA
Main listing in 'Production Companies' on Page 22

Geonewmedia
Address: Glen Waverley, Melbourne, Victoria, AUSTRALIA
Main listing in 'Production Companies' on Page 23

E Learning; TV documentaries; Environmental; Training videos; Museum video and interactive media; Time lapse photography; Aerial photography; Language services; Video editing; Online training videos; Wildlife Film making workshops.

IFFCAM
Francophone Institute of Ménigoute for Training in Animal Documentary
Address: Coutieres, Département des Deux-Sèvres, FRANCE
Phone: +33 (0)549 698 910
Email: nicole.devaux@deux-sevres.fr
Website: www.iffcam.net
Facebook.com/iffcam
Main contact: Nicole Devaux

Trainings in methods and techniques for directing animal documentary. Master 2 with Poitiers University. Technical trainings. Different workshop training weeks open to everyone over 15 years old. Fluent French is necessary.

Jackson Hole Wildlife Film Festival
Address: Wyoming, USA
Wildlife-film.com/-/JHWFF.htm
Main listing in 'Film Festivals' on Page 99-100

Liquid Motion Underwater Film Academy
Address: Cozumel Island, 77664, MEXICO
Phone: + 52 1 987 878 9690
Email: info@liquidmotionacademy.com
Website: www.liquidmotionacademy.com
Facebook.com/LiquidMotionAcademy
Twitter.com/PhotoFilmSchool
Anita Chaumette – Owner/Underwater/Marine Environment Expert

Providing private instruction and consultation in the fields of professional photography, filmmaking, underwater imaging and editing, Cozumel's award-winning Photo & Film School is the worlds *only* Private Underwater Photo & Film School and is fully committed to you realizing your dream, in your time, at your speed.

Martyn Harries Sound
Address: University of the West of England, Frenchay Campus , Bristol BS16 1 QY, UK
Phone: +44 (0)7973 733 615
Email: martyn@martynharries.co.uk
Website: www.martynharries.co.uk

Martyn is an internationally respected BAFTA and EMMY award winning Re-recording Mixer with a track record of dubbing high-profile programmes including Sir David Attenborough,s Natural History documentaries. A craft professional, with more than 25 years experience in the BBC delivering high-quality sound tracks for Radio as well as Television, exceeding the needs and aspirations of clients across a wide variety of genres. He has now embarked on a new chapter as a University Lecturer and Freelance Dubbing Mixer and sees this as a chance to "give back" to the business and is committed to bringing on the next generation of sound professionals as a senior lecturer in Audio and Music Technology at the University of the West of England.

MFA Program in Science and Natural History Filmmaking
Address: School of Film & Photography, P.O. Box 173350, Visual Communications
Building #202, Bozeman, Montana 59717-3350, USA
Phone: +1 406 994 2484
Fax: +1 406 994 6214
Email: snhf@montana.edu
Website: sfp.montana.edu/sciencenaturefilm
The graduate program in Science and Natural History Filmmaking at Montana State
University is the first program of its type in the world and remains the largest and the
most well-known.

Ocean Media Institute
Address: Bozeman, Montana, USA
Main listing in 'Production Companies' on Page 34

Ranger Expeditions Ltd
Address: High Peak Derbyshire, UK
Phone: +44 (0)7890 620 274
Email: rangerexped@hotmail.co.uk
Website: www.rangerexped.co.uk
Facebook.com/rangerexpeditions
Linkedin.com/in/stuartwestfield
Wildlife-film.com/·/StuartWestfield.htm
Mountain Leader & Expedition Skills Trainer: Stuart Westfield

Pre-expedition skills training from qualified and experienced professional Mountain
Leader.
Courses available year round, Peak District.
Expedition leader - Countries: Tanzania, Uganda, Kenya, Namibia, Rwanda, South Africa,
Swaziland, Iceland. Environments: Altitude, mountain, savanna, volcanic desert, jungle.

The Aerial Academy
Address: Norwich, Norfolk, UK
Phone: +44 (0)1603 881985
Email: elliott@dronetraining.co.uk
Website: www.dronetraining.co.uk
Facebook.com/aerialacademy
Twitter.com/aerialacademy
Training Director: Elliott Corke

The Aerial Academy offers drone flight training and our instructors have experience
training both beginner and experienced pilots and camera operators. We are approved
run the full CAA training to achieve a permission for commercial drone operations in the
UK. The Aerial Academy has an expanding number of training locations across the UK. We
can also provide equipment advice and supply drone equipment.

Underwater Wildlife Film-making Courses
Address: Penzance, Cornwall, UK
Phone: +44 (0)1736 788 705
Email: jeffgoodman@supanet.com
Website: www.jeffgoodman.co.uk/landunderwatercoursesintropage2.html
See listing in 'Camera Operators' on Page 148

Jeff Goodman, director and award-winning TV cameraman, leads a series of courses
aimed at improving the art of good underwater video production while at the same time

realising the incredible wealth and diversity of our planet's marine life. Jeff has over 35 years experience in wildlife and underwater filming. Credits include the BBC, Channel 4, National Geographic, Discovery, Animal Planet and many others. He has twice been nominated for BAFTA Award Cameraman and won Montana Festival Best Series Director / Cameraman. Designed for both advanced users and enthusiastic beginners. Award-winning cameraman Jeff Goodman will take you through the practical side of good camera techniques, story creation, sequence structure, editing, script and much more. The workshop also shows you how to look for wildlife behaviour and locations suitable for filming. Contact Jeff for dates. Courses are held throughout the year in Cornwall (UK) and special trips can be arranged to more exotic locations with groups of at least 5 people.

University of Cumbria – BA (Hons) Wildlife and Media
Address: Brampton Road, Carlisle, Cumbria CA3 9AY, UK
Phone: +44 (0)1228 400 300
Email: enquirycentre@cumbria.ac.uk
Website:
www.cumbria.ac.uk/Courses/Subjects/CreativeArts/Undergraduate/WildlifeMedia.aspx
Instagram.com/uocwildlifemedia
Twitter.com/uocwildlife

The use of media technology stimulates people's interest in the natural world at a time when environmental issues are at the forefront of public thinking. The media therefore plays a crucial role in the understanding and conservation of the world's wildlife. The Brampton Road campus has for a long time had a strong reputation for its media provision offering a wealth of expertise and practical learning opportunities. Cumbria provides a range of diverse wildlife habitats both inside and outside the Lake District National Park. This course takes full advantage of its unique location and the easy access this offers students for Wildlife and Media based learning opportunities. Central to the design of this course is the development of students' employability. We are one of the only universities in the country to offer a BA in Wildlife and Media.

University of Otago – Graduate courses in Science and Natural History Filmmaking
Address: Centre for Science Communication, University of Otago, P.O. Box 56 Dunedin 9054, NEW ZEALAND
Phone: + 64 3 479 7939
Fax: +64 3 479 4512
Email: sciencecommunication@otago.ac.nz
Website: www.otago.ac.nz/science-communication

The University of Otago's Science Communication programmes in Science and Natural History Filmmaking range from a one year Postgraduate Diploma through to a Full Research Masters and has been developed in partnership with Natural History New Zealand Ltd.

University of Salford - Wildlife Documentary Production MA
Address: The University of Salford, The Crescent, Salford M5 4WT, UK
Phone: +44 (0)161 295 5000 or +44(0) 161 295 4545
Email: enquiries@salford.ac.uk
Website: www.salford.ac.uk/pgt-courses/wildlife-documentary-production

This course aims to develop skills in video production applied to wildlife alongside a scientific understanding of animal behaviour, biodiversity, ecology and environment. You will make a number of wildlife films through research, scriptwriting and production, throughout the duration of the course. The course is delivered through lectures, team-based projects, and case studies. Visiting external professionals with links to the television industry will contribute to the teaching in masterclasses. There is an extensive programme of field trips, including individual and group projects to a range of different habitats. You will work on a range of specialist techniques including long-lens and time-lapse photography, alongside close-up sound recording. We put emphasis on professional practice with project outcomes meeting scientific scrutiny, and both exhibition and broadcast standards.

Untamed Science
Address: Charlotte, NC, USA
Producer: Rob Nelson
Main listing in 'Production Companies' on Page 44-45

UWE MA Wildlife Filmmaking
Address: Bower Ashton Campus, Kennel Lodge Road, off Clanage Road, Bower Ashton, Bristol BS3 2JT, UK
Phone: +44 (0)117 965 6261
Email: admissions@uwe.ac.uk
Website: courses.uwe.ac.uk/D4P31
Twitter.com/MA_WildFilm
Programme leader: Susan McMillan

This exciting and unique programme has been co-designed by UWE academics and current and former producers, directors and production managers from the BBC's world-leading Natural History Unit to identify the future skills requirements for multi-platform broadcasters and their support. We aim to produce graduates with a industry skills and understanding suitable for entry level posts in wildlife, natural history and specialist factual programming (including conservation, environmental, adventure, expedition and travel). Above all students will develop storytelling, commercial and technical skills; learning how to make intelligent and distinctive programmes that will captivate audiences and inspire them to engage with the natural world. The course provides a unique learning experience, with visiting speakers and mentors from the industry supporting the delivery of an intensive, practice-based curriculum.

Wildeye – The International School of Wildlife Film-making
Address: Scribes House, The Street, Booton, Norfolk NR10 4NT, UK
Phone: +44 (0)1603 857 155
Email: courses@wildeye.co.uk
Website: www.wildeye.co.uk
Facebook.com/Wildeye.co.uk
Instagram.com/wildeye.co.uk
Twitter.com/wildeye
Wildlife-film.com/·/Wildeye.htm
Contact: Simon Beer

Established in 1999, Wildeye is the leading independent provider of wildlife and conservation filmmaking training. Throughout the year we run a number of short courses based in the UK as well as longer overseas training tours and expeditions. Our friendly tutors are working industry professionals who share their enthusiasm, tips, tricks and techniques to provide an educational and enjoyable experience. Whether you are pursuing a career in wildlife filmmaking or simply want to make better films for your own enjoyment we offer courses to suit all ability levels, starting with our popular "Introduction to Wildlife Filmmaking" weekend. Visit our website today to learn why so many have chosen Wildeye.

Wild Kenya Safaris
Shazaad Kasmani – Photographer, Presenter, Expert
Address: Mombasa, KENYA
Wildlife-film.com/·/ShazaadKasmani.htm
Main listing in 'Location Managers/Fixers' on Page 92

Conducting and leading Wildlife Photography workshops.

ORGANISATIONS

21st Paradigm
Address: 1714 NW Quincy Ave, Bend, Oregon, 97703, USA
Email: info@21Paradigm.com
Website: www.21paradigm.com
Facebook.com/21paradigm
Twitter.com/21paradigm
Contact: Vanessa Schulz

21st Paradigm is a non-profit group that produces award-winning films to raise awareness of crucial issues censored by mainstream networks. Our films are available for streaming via our website at www.21paradigm.com.

African Environmental Film Foundation
Address: PO Box 953, 00502 Karen, Nairobi, KENYA
Phone: +254 726 445195
Email: aeff@africaonline.co.ke
Website: www.africanenvironmentalfilms.squarespace.com or www.aeffonline.org
Facebook.com/AEFFonline
Youtube.com/AEFFonline
Chairman & Executive Producer: Simon Trevor
Vice Presidents: Tanya Saunders and Ian Saunders
Distribution & AEFF Nairobi Office Manager: Lucy Woki Muhindi

Since its launch in 1998, AEFF has been producing and distributing educational films about environmental issues in Africa, for the people of Africa, in their own languages. These films are distributed free of charge, and are seen by millions of people, predominantly in East Africa, but also a growing number further afield on the continent, and internationally.

Babul Films
Address: Andhra Pradesh, INDIA
Main listing in 'Production Companies' on Page 13

British Wildlife Photography Awards
Country: United Kingdom
Main listing in 'Film Festivals/Competitions' on Page 95

The Brock Initiative
Address: Dumpers Cottage, Chew Magna, Bristol BS40 8SS, UK
Phone: +44 (0)1275 333187 +44 (0)7968 365816
Email: livingplanetproductions@gmail.com & info@brockinitiative.org
Website: www.brockinitiative.org
Facebook.com/BrockInitiative
Twitter.com/BrockInitiative
Vimeo.com/brockinitiative
Youtube.com/user/brockinitiative
Wildlife-film.com/·/Brock-Initiative.htm
Executive Producer: Richard Brock

I try to get stuff out there that will make a difference. There are now more ways of doing that than ever before. It can be in any format, anywhere, anyhow. I will provide free footage on wildlife and environmental matters from around the world. I am always interested in issues where "Filming with Attitude" might help the planet. Just let me know. The latest and most comprehensive project is the *Wildlife Winners and Losers* film series: brockinitiative.org/about/about-wildlife-winners-and-losers Richard says "My Wildlife Winners and Losers series shows that films can be made – with basic footage filmed on any device – to help get the word out about conservation."

Conservation Atlas
Address: Georgetown, Texas, USA
Phone: +1 312 823 9917
Email: justinlotak@gmail.com
Website: www.conservationatlas.org & www.conservationatlas.com
Facebook.com/conservationatlas
Twitter.com/Conservationatl
Instagram.com/conservationatlas
Linkedin.com/company-beta/16192389
Co-Founders: Justin Lotak & Andreea Lotak

We are sharing stories, photos and videos of lesser-known conservation destinations around the world, especially of ones that can benefit from increased visitation and public awareness. If you have a conservation project that fits this category (private lands, lesser known national parks, opportunities for wildlife photography, opportunities for adventure tourism), please let us know and we'd be happy to discuss working together.

Environmental Investigation Agency (EIA)
Address: 62-63 Upper Street, London N1 0NY, UK Phone: +44 (0)20 7354 7960
Email: ukinfo@eia-international.org
Website: www.eia-international.org
Facebook.com/environmentalinvestigationagency
Twitter.com/EIAinvestigator
Vimeo.com/eia
Wildlife-film.com/-/EIA.htm
Contacts:
Head of Operations: Bill Dishington
Press & Communications Officer: Paul Newman · paulnewman@eia-international.org
Visual Communications Editor: Chris Milnes · chrismilnes@eia-international.org

EIA produces hard-hitting campaign films on a wide range of environmental crimes, as well as bespoke training films for enforcement agencies.
Main listing in 'Stock Footage' on Page 65

Filmmakers For Conservation (FFC)
Country: USA
Website: www.filmmakersforconservation.org
Email: BoardFFC@gmail.com
Coordinator: Jeremy Roberts
Facebook.com/FilmmakersForConservation
Instagram.com/filmmakersforconservation
Twitter.com/filmmakers_cons
Youtube.com/user/FilmsForCons
Wildlife-film.com/-/FFC.htm

FFC is a US-based non-profit dedicated to the use of film as a means to conserve the natural world, its people, and its cultures. We are an historically recognized voice for wildlife filmmakers, conservation issues, sustainability in filmmaking and supporting conservation filmmakers. Upcoming initiatives include micro grants, scholarships, facilitating apprenticeships, and hosting workshops for filmmakers and conservationists alike.

Films That Make A Difference!
Country: UK/WORLDWIDE
Email: jason@filmsthatmakeadifference.org
Website: www.filmsthatmakeadifference.org
Facebook.com/FilmsThatMakeADifference
Twitter.com/Films_That_MAD
Project Coordinator: Jason Peters

An online directory of effective conservation films. A project set up in collaboration with Wildeye, The Brock Initiative, AU's Centre for Environmental Filmmaking, Wildlife-film.com and Filmmakers for Conservation. It is an expanding catalogue of films that have made, or are intent on making, a difference. The database can be used by anyone looking for models for their own productions, for proof that filmmaking can make a difference, and will potentially lend strength to funding applications etc... The database will, over time, become a valuable resource for showing how best to make a difference using film... We will not tell people how to do this, the films will speak for themselves! The project is looking for funding.

Great Apes Film Initiative (GAFI)
Address: 86 Somerton Drive, Erdington, Birmingham B23 5SS, UK
Phone: +44 (0)7770 577 549
Email: m.westwood@btinternet.com
Website: www.gafi4apes.org
Facebook.com/GAFI4Apes

117

Twitter.com/GAFl4Apes
Wildlife-film.com/-/MadelaineWestwood.htm
Director: Madelaine Westwood

The Great Apes Film Initiatives uses the power of film and media in support of conservation. Many people living in depleted habitats alongside critically endangered species have never seen wildlife or conservation films and therefore have no access to accurate information on protection measures or local solutions that could make an enormous difference to their lives. GAFI distributes film to three target groups a) Government ministers b) National Television audiences c) Local communities, schools, wildlife management centres, park rangers and the army - anyone who can be empowered to make a difference. So far 300 million people have seen the films through road shows, river shows, TV broadcast and now by the innovative pedal powered cinema shows which brings films to remote communities where there is no electricity. GAFI also trains NGO's to make their own films on local issues in local languages. In 2011 GAFI extended its template to include elephant and tiger conservation, and it is intended to include all endangered species by 2020. GAFI actively encourages film submissions for its library, which are rights free or assigned. Any format is invited; animation and non-languages versions are particularly welcome or versions in a number of languages. GAFI has a legal agreement document that is used for all films giving security to copyright owners. GAFI makes local issue conservation films for its partners, and co-productions are welcome. GAFI took its first volunteers to the field in July 2011 to assist with pedal powered cinema screenings and filming promotional material for websites. If you would like the opportunity to volunteer please contact Madelaine Westwood.

International Association of Wildlife Film-Makers (IAWF)
Address: 11 East Shrubbery, Redland, Bristol BS6 6SX, UK
Phone: +44 (0)781 809 8546
Website: www.iawf.org.uk
Facebook.com/wildlifefilmmakers

The International Association of Wildlife Film-makers (IAWF) was founded in 1982 to encourage communication and co-operation between people who are often isolated in the field. We are an association for professional camera men and women and sound recordists earning most of our income from making wildlife films. Our worldwide membership includes many of the leading names in our industry.

International League of Conservation Photographers (iLCP)
Address: 1003 K St NW, Suite 404, Washington, DC 20001, USA
Phone: +1 202 347 5695
Email: info@ilcp.ngo
Website: www.conservationphotographers.org
Facebook.com/conservationphotography
Instagram.com/ilcp_photographers
Twitter.com/ILCP
Executive Director: Alexandra Garcia

The iLCP was established in 2005 with the simple goal of enlisting the skills and expertise of some of the best photographers in the world to advance conservation efforts around the globe. We are a project-driven organization that partners with leading scientists, policy makers, government leaders and conservation groups to produce the highest-quality documentary images of both the beauty and wonder of the natural world and the challenges facing it. Though our main focus is photography, our conservation expeditions regularly include film projects as well. Our multi-award wining documentary film *Spoil* is an example of this.

Lemuria TV
Address: Tisá, CZECH REPUBLIC
Main listing in 'Production Companies' on Page 27

NHBS - Everything for Wildlife, Science & Environment
Address: Totnes, Devon, UK
Website: www.nhbs.com
Main listing in 'Equipment Hire/Sales" on Page 125-126

Ocean Media Institute
Address: Bozeman, Montana, USA
Main listing in 'Production Companies' on Page 34

Ranger Expeditions Ltd
Stu Westfield
Address: High Peak Derbyshire, UK
Wildlife-film.com/-/StuartWestfield.htm
Main listing in 'Education/Training' on Page 110

The Royal Society for the Protection of Birds
Address: The Lodge, Sandy, Bedfordshire SG19 2DL, UK
Main listing in 'Production Companies' on Page 38

Untamed Science
Address: Charlotte, NC, USA
Producer: Rob Nelson
Main listing in 'Production Companies' on Page 44-45

vEcotourism.org
Email: jay@vecotourism.org
Website: www.vecotourism.org
Facebook.com/vEcotourism
Twitter.com/vEcotours
Youtube.com/vEcotours
Wildlife-film.com/-/vEcotourism.htm

Innovative, immersive storytelling combining short video clips and images with full-spherical panoramas in wildlife conservation hotspots. The Virtual Ecotourism project uses interactive on-line tours to connect the general public with conservation projects and local communities in ecologically and culturally sensitive areas worldwide. We aim to nurture curiosity about the natural world, promote effective world citizenship, contribute to alternative livelihoods for communities living in areas of high conservation importance, and combat environmental degradation.

Wild & Scenic Film Festival
Address: Nevada City, CA, USA
Main listing in 'Film Festivals' on Page 104-105

The Wildlife Garden Project
Address: Nottingham, UK
Phone: +44 (0)7948 377 224
Email: contact@wildlifegardenproject.com
Website: www.wildlifegardenproject.com
Facebook.com/wildlifegardenproject
Twitter.com/WildlifeGardenP
Wildlife-film.com/·/LauraTurner.htm
Founder and Filmmaker: Laura Turner

Here at The Wildlife Garden Project, our aim is to provide the information and inspiration for people across the country to create their own little patch for wildlife. We regularly make video tutorials on all aspects of wildlife gardening: everything from making a bird box to growing a wildflower meadow! On our website you can get practical advice and information on gardening, and identify and discover more about the creatures who have visited your garden. We hope to offer a friendly place where people can support and help each other: our own little wildlife gardening community. It doesn't matter whether you live in the countryside or in a city, whether you own 50 acres or just a balcony, everyone can do their bit. So watch the videos, read the articles, but most importantly, **GET WILDLIFE GARDENING!** We are always looking for volunteers who want to help us with our cause and gain some experience along the way. If you would like to help out with filmmaking or fundraising, contribute photos or articles for us to use on our website or absolutely anything else, please send us an email!

Wildlife Media Ltd
Address: 56 Vale Road, Haywards Heath, West Sussex RH16 4JS, UK
Phone: +44 (0)1444 390 790
Email: info@wildlife-media.co.uk
Website: www.wildlife-media.co.uk
Facebook.com/WildlifeMediaUK
Instagram.com/WildlifeMediaUK
Twitter.com/Wildlife_Media

We are a wildlife/natural history film, photo & information services company.

120

Wildlife Sound Recording Society
Country: UK/Worldwide
Email: membership@wildlife-sound.org
Secretary: secretary@wildlife-sound.org
Web Officer: webofficer@wildlife-sound.org
Website: www.wildlife-sound.org
Facebook.com/WildlifeSound
Twitter.com/WildlifeSound
Wildlife-film.com/-/WSRS.htm

The Society was founded in the UK in 1968 and has a global membership of well over 300. Our aims are to: encourage the recording of wildlife sounds, up-skill recordists and promote bioacoustic study. Annually we organise: Members' Day /AGM, spring and winter field recording meetings plus local meetings. Dedicated residential technical workshop courses are held every year. Each year members receive four newsletters, two editions of our magazine 'Wildlife Sound', plus four CDs of members' work. We have strong links with the British Library where many thousands of our members' recordings are deposited. New members are welcome. We are always interested to hear from people wishing to use high quality wildlife sound recordings in their projects. WSRS is a society run by volunteers. As such we are unable to offer work experience/internships.

Wildscreen
Address: 4th Floor, 36 King Street, Bristol BS1 4DZ, UK
Phone: +44 (0)117 929 1222
Email: hello@wildscreen.org
Website: www.wildscreen.org
Facebook.com/wildscreenorg
Twitter.com/Wildscreen_org
Wildlife-film.com/-/Wildscreen.htm
Director: Lucie Muir

Wildscreen's goal is to convene the best photographers, filmmakers and creative professionals with the most committed conservationists to create compelling stories about the natural world; that inspire the wider public to experience it, feel part of it and protect it. Key initiatives: Wildscreen Arkive - the world's leading online natural world encyclopaedia; Wildscreen Exchange - A unique global hub that empowers conservation organisations by connecting them with world-leading filmmakers and photographers to create ground-breaking communications about our natural world. Wildscreen Festival - the internationally renowned festival that celebrates and advances the art of natural world storytelling.

Equipment Hire/Sales

Achtel Pty Limited
Address: PO BOX 557, Rockdale, NSW 2216, AUSTRALIA
Phone: +61 407 472 747
Email: pawel.achtel@24x7.com.au
Website: www.achtel.com
Facebook.com/Underwater3D
Twitter.com/PawelAchtel
Linkedin.com/in/pawel-achtel-acs-31bba31
Wildlife-film.com/-/PawelAchtel.htm
Director: Pawel Achtel, ACS

We specialise in underwater and wildlife cinematography, particularly for IMAX and Giant Screen. Not offering work experience.

Ammonite Ltd
Address: Bristol, UK
Wildlife-film.com/-/Ammonite-Films.htm
MD: Martin Dohrn
Main listing in 'Production Companies' on Page 9

Aquavision TV Productions (Pty) Ltd
Address: Johannesburg, SOUTH AFRICA
Wildlife-film.com/-/Aquavision-Productions.htm
Main listing in 'Production Companies' on Page 10

Atlantic Ridge Productions
Address: AZORES, PORTUGAL
Main listing in 'Production Companies' on Page 12-13

Adrian Cale – Cameraman
Address: London, UK
Wildlife-film.com/-/AdrianCale.htm
Main section in 'Producers/Directors' on Page 181-182

Adrian has a broad range of kit for hire.

Camera Den Ltd
Country: UK
Main listing in Production Services: Page 54

DOER Marine
Address: 650 W Tower Ave, Alameda, CA 94501, USA
Phone: +1 510 530 9388 & +1 209 482 1020
Email: info@doermarine.com
Website: www.doermarine.com
Facebook.com/pages/DOER-Marine-Operations/135087663207466
President/CEO: Liz Taylor – liz@doermarine.com

DOER builds a variety of subsea systems including ROVs, HOVs, landers and

custom/purpose built vehicles for basic wet terrain applications and up to full ocean depth. The company has integrated many camera and lighting packages to existing platforms and has built fiber optic/ethernet based systems for real time "telepresence" feeds. Custom housings for everything from Go-Pro to RED. DOER is looking for projects where our subsea and harsh environment operational expertise can be of service. Adventure, wildlife, conservation, archeology, etc. DOER has worked on *Blue Planet II*, Shark Week and with 60 min, Discovery, Nat Geo and others in past. Looking for collaborators. We offer engineering and machining internships from time to time.

Esprit Film and Television Limited
Address: Gloucestershire, GL2, UK
Phone: +44 (0)1452 741 240
Email: daveblackham@mac.com
Website: www.espritfilm.co.uk
Facebook.com/espritfilm.co.uk
Instagram.com/espritfilm
Twitter.com/espritfilmtv
Wildlife-film.com/-/Esprit-Film.htm
Director: Dave Blackham

Esprit Film and Television provide advanced, state of the art Location Filming equipment and Filming services to create must watch content for the worlds best Film makers and Broadcasters. Whilst Esprit are leaders in Underwater Cinematography Esprit also work in the most remote, hostile but beautiful locations, filming the creatures and people with which we share our planet. We also facilitate recording wildlife sound and acoustic music. Esprit work to the highest standards creatively and technically, using both off the shelf equipment and also our own specially developed systems for stills, 2D and 3D photo-cinematography. Clients of Esprit can hire equipment and services as a package or we can design and build systems and facilities for individual projects.

Felis Creations
Address: Bangalore, INDIA
Main listing in 'Production Companies' on Page 22

Films@59
Address: Bristol & Cardiff, UK
Email: hire@filmsat59.com & hire-cardiff@filmsat59.com (Cardiff)
Website: www.filmsat59.com/kit
Main listing in 'Production Services' on Page 56

Gardenature
Address: 801 Fowler Road, Oakwood Business Park North, Clacton on Sea, Essex CO15 4AA, UK
Phone: +44 (0)1255 514451
Email: sales@gardenature.co.uk
Website: www.gardenature.co.uk
Facebook.com/Gardenature.facebk
Twitter.com/GARDENATURE
Managing Director: Simon Byland, Director: Angela Byland

Who we we? Gardenature is a family run business which has fast become Europes No 1 manufacturer and supplier of high quality products designed specifically for watching all forms of wildlife from the relaxed comfort of your armchair, your garden, out in the wild, or any other natural habitat. We have one of the most comprehensive websites available of its kind, dedicated to bringing you a diverse range of easy to use products from Wildlife Cameras to Wildlife Habitats, Eco Friendly and Garden Recycling products, to Garden Furniture for public and domestic use. As a successful family run business with over 45 years' combined experience in the design, development and manufacturing industry, we demonstrate a firm commitment to offering hand built market leading products at an affordable price without compromising reliability or quality. We recognise the need to build relationships through a good customer experience based on old fashioned values, so when you talk to us you know that we are a company you can trust. Gardenature started trading in 2004 and since that time we have carefully grown the business to a leading supplier status. As well as providing product and service directly through our website, our business has also become very well established with County Councils, Local Authorities, Schools and Colleges throughout the UK and today this market continues to grow Europe wide.

Handykam.com
Address: Harmony House, Treleigh Industrial Estate, Jon Davy Drive, Redruth, Cornwall TR16 4DE, UK
Phone: +44 (0)1209 313 579
Email: sales@handykam.com
Website: www.handykam.com
Directors: Mike Nash & Linda Nash

First choice for wildlife cameras, bird box cameras, nest box cameras, trail cameras and more. Visit Handykam.com for all types of cameras for wildlife and commercial applications. Based in Cornwall UK, we are one of the leading specialist camera companies in the world. Trading over 10 years, our products have been used and trusted by experts in 100+ leading worldwide institutions like BBC, UK Wildlife Trusts, RSPB, WWF, Oxford University, London Zoo, World Parrot Trust to name a few. We have featured throughout the media including BBC, Daily Mail, The Guardian for our high quality, value for money products with leading customer service.

HighSpeedIreland
Crossing the Line Productions
Address: Barr an Uisce, Killincarrig Road, Greystones, Co. Wicklow, IRELAND
Website: www.highspeedireland.com
Wildlife-film.com/-/CTL-Productions.htm
Main listing in 'Production Companies' on Page 16-17

Joe's Location-Sounds
Address: Vienna, AUSTRIA
Main listing in 'Sound Operators' on Page 175

JrF - Hydrophones, Contact microphones & specialist audio products
Address: East Yorkshire, UK
Email: tempjez@hotmail.com
Website: www.jezrileyfrench.co.uk
Twitter.com/jezrileyfrench
Wildlife-film.com/-/JezrileyFrench.htm
Owner/Maker: Jez riley French

As well as my work as a field recordist, specialising in explorative sound, I make & sell a range of acclaimed hydrophones, contact microphones & other specialist audio products. My products are used by location sound crews, artists, composers, aquariums, universities & other organisations around the world. I also lecture & tutor on the subject of field recording.

Jungle Run Productions
Address: Bali, INDONESIA
Wildlife-film.com/-/JoeYaggi.htm
Main listing in 'Production Companies' on Page 26-27

LunaSea Films
Address: Appleton, Maine, USA
Cinematographer/DP: David Wright
Main listing in 'Production Services' on Page 58

Own equipment usually available when hired as DP.

Moving Picture Hire Ltd
Address: Bristol, UK
Phone: +44 (0)117 373 0915
Gavin Thurston: +44 (0)7802 158 055
Tom Thurston: +44 (0)7929 131 956
Email: info@movingpicturehire.com
Website: www.movingpicturehire.com
Facebook.com/movingpicturehire
Instagram.com/movingpicturehire
Twitter.com/mphnews

Moving Picture Hire Ltd can supply cable dollies, straight and curved lightweight track, motion control, time-lapse kits, LED lighting, video assist microwave links, remote hotheads, specialist lenses, custom grip design and build, and much more...

NHBS - Everything for Wildlife, Science & Environment
Address: 1-6 The Stables, Ford Road, Totnes, Devon TQ9 5LE, UK
Phone: +44 (0)1803 865 913
Fax: +44 (0)1803 865 280
Email: customer.services@nhbs.com
Website: www.nhbs.com
Facebook.com/pages/NHBS-Everything-for-wildlife-science-environment/120171464674249
Twitter.com/nhbsNews
Linkedin.com/company/nhbs---everything-for-science-wildlife-&-environment
Senior Managers: John Eskilsson, Steve Hazell, Anneli Meeder

We stock equipment for wildlife photography and film including trail cameras and camera triggers, binoculars, waterproof stationery, travel accessories and more. Company ethos:

To contribute to the discovery, understanding and conservation of biodiversity and natural ecosystems. Key subjects: Ecology & conservation books and equipment: natural history, ornithology, zoology, botany, entomology, aquatic ecology, bat detectors, field kit, photography, survey and monitoring. Other services: Search and browse our full online catalogue of books, equipment and gifts at www.nhbs.com. Opening times for customer service: Mon-Fri 8.30am-5pm (UK).

Pink Noise Systems Ltd
Address: Unit 21, The Glenmore Centre, Jessop Court, Waterwells Business Park, Quedgeley, Gloucestershire GL2 2AP, UK
Phone: +44 (0)1453 825802
Email: sales@pinknoise-systems.co.uk
Website: www.pinknoise-systems.co.uk
Facebook.com/PinknoiseSystems
Instagram.com/pinknoisesystems
Twitter.com/PinknoiseSystem
Youtube.com/user/PinknoiseSystem
Wildlife-film.com/-/PinkNoise.htm
Contact: John McCombie

Pink Noise Systems is an independent location audio specialist, renowned for their in-depth knowledge and impartial expert advice on all things audio in the video and DSLR markets. We are a leading UK based supplier of Pro-Audio Equipment for Location Sound Recording. We offer expert advice and training based on many years of practical professional experience. We have a superb product range with most items in stock. We can tailor packages and build bespoke kits to suit all budgets.

Production Gear Ltd
Address: Unit 12 & 13, Wrotham Business Park, Barnet EN5 4SZ, UK
Phone: +44 (0) 20 8275 1070
Email: sales@productiongear.co.uk
Website: www.productiongear.co.uk
Facebook.com/progearuk
Twitter.com/progear
Wildlife-film.com/-/Production-Gear.htm
Company Director: Steven Graham – steve@productiongear.co.uk

We are a UK based company who import, distribute and resell broadcast and professional video and film production equipment, comprising cameras, optics, grip, audio, lighting and much more. Our staff are highly experienced, knowledgeable and are keen to help you with your enquiry no matter how large or small it may be. We are a real company, not just a website we advertise our address, contact numbers and email addresses and encourage you to talk to and visit us. We keep a stocked 1000 square foot showroom as well as selling online as we realise the importance of you getting hands on with the equipment that we sell to ensure that is entirely suits your application.

Riverbank Studios Pvt. Ltd.
Address: New Delhi, INDIA
Main listing in 'Production Companies' on Page 37-38

Rycote Microphone Windshields Ltd
Address: Libby's Drive, Slad Road, Stroud, Gloucestershire GL5 1RN, UK
Phone: +44 (0)1453 759 338
Email: sales@rycote.com
Website: www.rycote.com
Facebook.com/Rycote
Instagram.com/rycoteuk
Twitter.com/rycoteuk

Rycote Microphone Windshields Ltd is a manufacturer of accessories, mic windshields windscreens, suspensions & shock mounts for both professional & consumer broadcast microphones and camcorder mounted microphones.

SeeSense Ltd
Address: Unit 4c Woodley Park Estate, 59-69 Reading Road, Woodley, Berkshire RG5 3AW, UK
Phone: +44 (0)203 468 2250 (Office UK) +44 (0)7967 445829 (Mobile UK) +421 (0)917 163 367 (Mobile Slovakia)
Email: sales@seesense.eu
Website: www.seesense.eu
Facebook.com/pages/SeeSense/272329619610667
Twitter.com/Seesense_mini
Linkedin.com/pub/seesense-minicams/61/87/124
Youtube.com/seesense1
Wildlife-film.com/-/SeeSense.htm
Managing Director: Nigel Paine

SeeSense are suppliers of specialist camera solutions to the Natural History / Wildlife film-making industry across Europe. SeeSense offer a wide range of 4K and HD miniature cameras including remote head or lipstick camera solutions. They also supply "Ribcage" modified cameras (GoPro, Xiaomi, Sony DSC-RX0, etc) that now accept interchangeable lenses. Specialist suppliers of 360VR and 180VR cameras and low cost time-lapse camera solutions. Other solutions include low light, EM-CCD, IR sensitive, SWIR and thermal imaging cameras as well as compact high speed (slo-mo) and high quality sub-miniature cameras. Official distributers for Back-Bone, Bushman, CamDo, Entaniya, Fujinon (lenses), Kandao, Kowa, Marshall, Ricoh, Theia, ZCAM and many more. Offices in the UK and Slovak Republic.

SlowMo
Address: 84 Thorley Lane, Timperley, Altrincham WA157AN, UK
Phone: +44 (0)7961 483 137
Email: info@slowmo.co.uk
Website: www.slowmo.co.uk
Facebook.com/pages/Slowmo-High-Speed-Camera-Specialists/242738085778049

Youtube.com/SlowMoHighSpeed
Vimeo.com/user13348066
Director: Mark Johnson
High Speed Cameraman: Ed Edwards

Hire of Photron high speed cameras, with or without operator.
We don't currently offer work experience.

Sound Ark
Address: Enniskillen, Co. Fermanagh, UK
Director: Angel Perez Grandi
Main listing in 'Sound Operators' on Page 174

Stratosphere Sound
Address: 18 Wandel Street, Gardens, Cape Town 8001, SOUTH AFRICA
Phone: +27 (0)87 551 1034 & +27 (0)82 561 0011
Email: info@stratosphere.co.za or jeff@stratosphere.co.za
Website: www.stratosphere.co.za

Stratosphere Sound, owned and managed by well known sound specialist Jeff Hodd, has grown from strength to strength since it was established in 2004. Jeff Hodd has been supplying a superior standard of location sound management for over 32 years on international and local commercials, documentaries, wildlife/natural history, reality TV, verité, live studio broadcast, multicam wireless, TV drama, feature films and live events.

The Aerial Academy
Address: Norwich, Norfolk, UK
Training Director: Elliott Corke
Main listing in 'Education/Training' on Page 110

We can also provide equipment advice and supply drone equipment.

Tshed Ltd.
Address: 8 Upper Dorrington Terrace, Stroud, Gloucestershire GL5 2JE, UK
Phone: +44 (0)845 680 9862 and +44 (0)7956 229 591
Email: hire@tshed.co.uk
Website: www.tshed.co.uk
Facebook.com/TshedLtd
Twitter.com/Tshed1
Director: Nick Turner

Tshed is where film-makers find or commission the clever kit and expertise that lets them get the pictures which make productions memorable. Longer, higher, deeper, darker, safer, sharper. Tshed develops and hires out specialist broadcast equipment from Starlight HD cameras to Camblock motion control systems and more.

VFX Productions
Address: Dubai, UAE
Wildlife-film.com/·/VFX.htm
Main listing in 'Production Companies' on Page 45

VisionHawk Films
Casey Anderson – Camera Operator/Presenter/Naturalist
Address: Bozeman, Montana, USA
Main listing in 'Production Companies' on Page 46

VI Rental
Address: 4 Charnwood House, Marsh Road, Ashton, Bristol BS3 2NA, UK
Phone: +44 (0)117 939 3333
Fax: +44 (0)117 939 3339
Email: bristol@virental.co.uk
Website: www.virental.co.uk
Facebook.com/virental
Twitter.com/virental
Wildlife-film.com/·/VI-Rental.htm
Hire Manager: Nick Hill · nickh@virental.co.uk

Building on VI Rental's established Camera Hire reputation, our technical hire department has a long-standing history of working closely with the BBC Natural History Unit and Independent Wildlife production companies throughout the UK. With a wide range of the latest camera equipment available for hire, whether looking for large scale or bespoke needs, VI Rental makes sure clients are able to create and deliver the content they want within budget. Our in-house industry experts are available from enquiry to the final shot, giving you all the support and expertise you need whilst shooting. VI Rental hire equipment for some of the UK's leading Natural History programs and Wildlife TV programs. The Bristol department are fast becoming the Go-To rental house for all things Natural History and Wildlife. Hiring technical equipment for the filming of; BBC's *Wonders of Life*, BBC's *Japan: Earth's Enchanted Islands*, *Elephant Family and Me*, *Earth's Wildest Waters The Big Fish* to name a few. Whether filming Foxes in Bristol or Polar Bears in the Arctic, we have a proven track record in supplying not only the equipment, but the knowledge that is required to get the best result. Call us now to find out how we can help you get the results you want within budget or visit www.virental.co.uk to view our current equipment available.
We do offer work experience, so please get in touch.

VMI.TV Ltd
Address: Unit 5 Dragon Court, Crofts End Road, St George, Bristol BS5 7XX, UK
Phone: +44 (0)1179 277 473
Email: bristol@vmi.tv
Websites: www.vmi.tv & vmedia.digital
Facebook.com/vmihire
Twitter.com/vmitv
Linkedin.com/company/vmi-broadcast
Wildlife-film.com/·/VMI-TV.htm
Director: Barry Bassett
Bristol Branch Manager: Gary Davis – gd@vmi.tv

Established in 1979 in London and now in our 3rd year in Bristol, VMI specialise in supplying quality digital camcorder packages hire for Documentary, Natural History, Commercials, Drama, Promos and Corporate TV productions. Having supplied camera equipment for the BBC *Earth*, BBC *Oceans*, BBC *Mountains*, and BBC *Dynasty* series recently as well equipment for many other Natural History productions for Off Spring Films, Icon Films, Warehouse 51 and others, we are now firmly established in Bristol. We support every HD and 4K camera format for hire from DSLR to ARRI Alexa with everything in between. VMI's product range also includes lighting, grip & sound to support location

productions. What stands us apart from other suppliers is our meticulous attention to detail, high level of presentation, generously accessorised packages and fanatical level of customer service. Please also visit our sister company vmedia.digital, who rents out media storage.

Wild Creature Films
Address: Hobart, Tasmania, AUSTRALIA
Main listing in 'Camera Operators' on Page 151

Wildlife Watching Supplies
Address: Tiverton Way, Tiverton Business Park, Tiverton, Devon EX16 6TG, UK
Phone: +44 (0)1884 254 191
Fax: +44 (0)1884 250 460
Email: enquiries@wildlifewatchingsupplies.co.uk
Website: www.wildlifewatchingsupplies.co.uk
Contact: Kevin Keatley

All you need to get closer to the wildlife. Designed and developed by wildlife photographer Kevin Keatley. Our designs are made in our workshop in Devon but a lot of our products are exported around the world. We also have dealers throughout Europe. The most popular products that we make are our Dome hides, Bag hides, Lens and Camera covers and Double bean bags. We sell to wildlife filmmakers and film production companies, the BBC, RSPB, Universities, Police units, Security companies and British Forces. Wildlife Watching Supplies have supplied the UK Special Forces and NATO with camouflage kit for over 15 years. Our products have been tried and tested in some of the harshest climates around the world.

Wildtronics
Address: PO Box 376, Newton Falls, Ohio 44444, USA
Phone: +1 330 577 8814
Email: customersvc@wildtronics.com
Website: www.wildtronics.com
Facebook.com/WildtronicsLLC
Owner: Bruce Rutkoski

Manufacturer and sales of a line of professional parabolic dish microphones, and other specialized microphones. Purchase from us direct for your lowest cost. We ship worldwide, and most orders ship within one day of the order. Visit our website for complete information on our quality products.

Publications/Resources

BBC Wildlife Magazine
Address: Tower House, Fairfax Street, Bristol BS1 3BN, UK
Phone: +44 (0)117 314 7366
Email: wildlifemagazine@immediate.co.uk
Website: www.discoverwildlife.com
Facebook.com/wildlifemagazine
Twitter.com/WildlifeMag
Editor: Sheena Harvey – sheena.harvey@immediate.co.uk
Features editor: Ben Hoare – ben.hoare@immediate.co.uk
Environment editor: James Fair – James.Fair@immediate.co.uk
Picture Editor: Tom Gilks

We publish articles on natural history, species, conservation and ecology for a mass market audience. We welcome pitches from freelance writers and photographers for features on species, habitats, conservation and natural history filming projects. We particularly welcome contact from filmmakers working on programmes destined for BBC channels.

British Wildlife Photography Awards: Collection 8
Country: United Kingdom
Website: www.bwpawards.org
Wildlife-film.com/·/BWPA.htm
Main listing in 'Festivals/Competitions' on Page 95

British Wildlife Photography Awards 8, published by Ammonite Press, showcases the very best entries from the British Wildlife Photography Awards in 2017. This stunning coffee table book is a celebration of British Wildlife as captured on camera by today's best amateur and professional photographers.

Conservation Atlas
Address: Georgetown, Texas, USA
Website: www.conservationatlas.org & www.conservationatlas.com
Main listing in 'Organisations' on Page 115

Films That Make A Difference!
Country: UK/WORLDWIDE
Email: jason@filmsthatmakeadifference.org
Website: www.filmsthatmakeadifference.org
Facebook.com/FilmsThatMakeADifference
Twitter.com/Films_That_MAD
Project Coordinator: Jason Peters

An online directory of effective conservation films. A project set up in collaboration with Wildeye, The Brock Initiative, AU's Centre for Environmental Filmmaking, Wildlife-film.com and Filmmakers for Conservation. It is an expanding catalogue of films that have made, or are intent on making, a difference. The database can be used by anyone looking for models for their own productions, for proof that filmmaking can make a difference, and will potentially lend strength to funding applications etc... The database will, over time, become a valuable resource for showing how best to make a difference using film... We will not tell people how to do this, the films will speak for themselves! The project is looking for funding.

Natural History Network
Address: Bristol, UK
Email: info@naturalhistorynetwork.co.uk
Website: www.naturalhistorynetwork.co.uk
Owners/Directors: Lizzie Green & Vicky Halliwell

NHBS Ltd
Address: Totnes, Devon, UK
Website: www.nhbs.com
Main listing in 'Equipment Hire/Sales' on Page 125-126

Realscreen
Address: Suite 100, 366 Adelaide St. W, Toronto, Ontario M5V 1R9, CANADA
Phone: +1 416 408 2300 & +1 888 988 7325 (Toll Free)
Fax: +1 416 408 0870
Email: press@realscreen.com (for press releases)
Website: www.realscreen.com
Facebook.com/realscreen
Instagram.com/realscreen
Twitter.com/realscreen
Editor and Content Director: Barry Walsh – bwalsh@brunico.com
Managing Editor: Darah Hansen · dhansen@brunico.com

Realscreen is the only international magazine devoted exclusively to the non-fiction film and television industries. Realscreen aims to bring diverse communities together for dialog, debate and discussion about the global business of factual entertainment. This is achieved through various printed publications, interactive media and live events.

Travel For Wildlife
Address: PO Box 17117, Asheville, NC 28816, USA
Phone: +1 828 279 3376
Email: TravelForWildlife@gmail.com
Website: www.travelforwildlife.com
Facebook.com/Travel4Wildlife
Twitter.com/Travel4Wildlife

Travel For Wildlife is a website dedicated to adventure wildlife travelers.
Zoologist Cristina Garcia and her husband, wildlife photographer Hal Brindley, provide inside tips about how to see the world's most amazing wild animals. Their goal is to share their passion for nature and to promote conservation through responsible wildlife tourism.

Wildeye Publishing
Email: books@wildeye.co.uk
Website: www.wildeye.co.uk/publishing
Contact: Piers Warren

Wildeye Publishing has become the world leader in producing publications for wildlife film-makers worldwide. See some of our publications in the Further Reading section of this directory. We started with the guide *Careers in Wildlife Film-making*, which became essential reading for anyone wishing to get into the industry, and now have a growing list of useful books such as this guide!

Wild Horizons® Productions
Address: Tucson, Arizona, USA
Main listing in 'Production Companies' on Page 48

Wildlife-film.com
Country: UK/WORLDWIDE
Email: info@wildlife-film.com
Phone: +44 (0)1444 390 790
Website: www.wildlife-film.com
Facebook.com/WildlifeFilm
Instagram.com/wildlife_film
Twitter.com/Wildlife_Film
Pinterest.com/wildlifefilm
Youtube.com/WildlifeFilmTube
Vimeo.com/wildlifefilms
Editor/Producer: Jason Peters

THE international website for wildlife film-makers - All the latest news about wildlife film festivals, personnel wanted, equipment for sale, courses, footage wanted, new productions, competitions and much more. Specialist directories of companies, organisations and people connected with the wildlife film and TV industry. Incorporating the acclaimed free newsletter *Wildlife Film News* emailed monthly to subscribers. Come and join us!

Wildlife Films
Address: Kasane, BOTSWANA
Website: www.wildlifefilms.co
Contacts: Dereck & Beverly Joubert

Film, Photography and Publishing by Derek and Beverly Joubert.

Wildscreen Arkive
Address: 4th Floor, 36 King Street, Bristol BS1 4DZ, UK
Phone: +44 (0)117 929 1222
Email: arkive@wildscreen.org.uk
Website: www.arkive.org
Facebook.com/arkive.org
Twitter.com/arkive
Wildlife-film.com/·/Wildscreen.htm

Arkive is an initiative of the UK-based charity Wildscreen – which uses the power of wildlife films and photos to promote a greater understanding of the natural world and the need for its' conservation. Arkive (www.arkive.org) is the world's leading online encyclopaedia about the natural world with over 16,000 in-depth species fact-files and more than 100,000 films and photos. It's renowned for the depth of information provided and for its accuracy, with fact-files sourced from, or checked by, academic experts. To find out more about Wildscreen please visit www.wildscreen.org or the 'Organisations' section within this directory.

Wildscreen Exchange
Address: 4th Floor, 36 King Street, Bristol BS1 4DZ, UK
Phone: +44 (0)117 929 1222
Email: Exchangeinfo@wildscreen.org.uk
Website: www.wildscreenexchange.org
Facebook.com/wildscreenexchange
Twitter.com/WildscreenEx
Wildlife-film.com/·/Wildscreen.htm

Wildscreen Exchange empowers conservation organisations by connecting them with world-leading filmmakers and photographers to create ground-breaking communications about our natural world. Photographers and filmmakers donate images and footage free for use by not-for-profit organisations in their online and offline communication campaigns. Working with the most influential content creators in the natural history genre and the conservation organisations with the greatest tales to tell, Wildscreen Exchange documents, crafts and shares exclusive, untold stories that the world needs to see, motivating meaningful change and hope for the future.

See the 'Further Reading' section for recommended books.

Since the late 1990s **Wildlife-film.com** has been the leading source of information for the wildlife film-making industry worldwide. For over eighteen years the site has been Google's number one ranking site for 'wildlife film' and related searches. The website is viewed in over 185 countries.

The newsletter, *Wildlife Film News*, is read every month by thousands of people involved in wildlife film-making · from broadcasters and producers to freelancers and newcomers · we encourage readers to submit their news.

Wildlife-film.com also serves as an online resource for industry professionals and services. Find producers, camera operators, editors, presenters and more in the **Freelancer** section, and find out about festivals, services, training and conservation in **Organisations**. We encourage amateur and professional freelancers to join our network and welcome all wildlife-film-related organisations to join our team.

Get 50% discount on your first year by clicking on the NZ fur seal! Code: WP3
www.wildlife-film.com/discountedmembership.htm

www.wildlife-film.com

Freelancers

Director of Photography/Camera Operators

(Lighting Camera/Director Camera/Cinematographer)

Pawel Achtel, ACS
Achtel Pty Limited
Country: AUSTRALIA
Wildlife-film.com/·/PawelAchtel.htm
Main listing in 'Equipment Hire/Sales' on Page 122
Underwater specialist.

John Aitchison – Wildlife Filmmaker
Country: Scotland, UK
Email: info@johnaitchison.net
Website: www.johnaitchison.net
Twitter.com/johnaitchison1

John is a wildlife filmmaker who works for the independent production company Otter Films Ltd. Otter Films has worked with the BBC, National Geographic, PBS and Discovery Channel on series including *Planet Earth II*, *The Hunt*, *Frozen Planet*, *Life Stories*, *Life*, *Big Cat Diary*, *Springwatch* and *Yellowstone*. He is the author of *The Shark and the Albatross*.

James Aldred – Natural History/Expedition Cameraman
Address: Bristol, UK
Website: www.jamesaldred.com
Twitter.com/jraldred
Instagram.com/jamesaldred1

EMMY award winning and multi BAFTA / RTS nominated cameraman. Trained by BBC with 20 years experience specialising in natural history and filming at height in remote locations worldwide.

Doug Allan – Topside and Underwater Cameraman
Tartan Dragon Ltd
Address: 13 Rockleaze Court, Rockleaze Avenue, Bristol BS9 1NN, UK
Phone: +44 (0) 117 968 3996 & +44 (0)787 603 2608
Email: dougallancamera@mac.com
Website: www.dougallan.com
Facebook.com/DougAllanCamera
Twitter.com/dougallancamera
Contacts:
Cameraman: Doug Allan
Stills: Sue Flood

Filming for wildlife, scientific and expedition documentaries, underwater and topside;

stock footage and stills library; multiple award winning team with 4 BAFTA's, 4 Emmy's, 4 Wildscreen Pandas.
We are open to any new film proposals that need top quality filming.

Trevor Almeida – Producer / DOP / Editor
Geonewmedia
Address: Melbourne, AUSTRALIA
Main listing in 'Production Companies' on Page 23

Casey Anderson – Camera Operator/Presenter/Naturalist
VisionHawk Films
Address: 30 Shawnee Way, Unit 30, Bozeman, Montana 59715, USA
Phone: +1 406 202 3306
Email: info@visionhawkfilms.com
Website: www.visionhawkfilms.com & www.caseyanderson.tv
Facebook.com/GrizGuy
Twitter.com/Grizanderson

Casey is a fifth generation Montanan who was born and raised in East Helena, Montana. He has been involved in film and television production for over eighteen years. As a wildlife naturalist, host and actor, Casey has worked on numerous feature films, television wildlife documentaries, and non-profit educational programs.

Paul Atkins – Director/DOP/Cinematographer
Address: PO Box 25955, Honolulu, Hawaii 96825, USA
Phone: +1 808 284 1395
Fax: +1 808 395 7418
Email: paulatkins@aol.com
Website: www.paulatkins.com

Director/DOP-Cinematographer working in 35mm film and IMAX, RED EPIC, ARRI ALEXA, Canon 5-D and smaller digital formats. Made ocean, underwater and wildlife films for years with the BBC-NHU and National Geographic TV. Now shooting documentary segments, commercials, American TV series and feature films. Credit list and awards on webpage. Feature credits include "Master and Commander" and three Terrence Malick movies, including "The Tree of Life". Developing a feature film based on the book by Susan Casey: "The Devil's Teeth" Also in development, "This Time for Africa" · as director/DP. CVs accepted by email.

Jiri Bálek - Cameraman/DOP/Zoologist/Editor
Lemuria TV
Address: Tisá, CZECH REPUBLIC
Phone: +420 603 450 580
Email: jiri.balek@lemuriatv.cz
Website: www.lemuriatv.cz
Facebook.com/lemuriatv

Cameraman and zoologist with thirty years of experience in filming wildlife. Filming rhinos in Kenya and Tanzania, other animals in Madagascar, SAR, Namibia, Zimbabwe, Botswana, Mauritius, Malaysia, Indonesia, Costarica etc.

Nick Ball - Wildlife Cameraman
Address: Hampshire, UK
Phone: +44 (0)7729 201 391
Email: nick@nickball.tv

Website: www.nickball.tv
Linkedin.com/in/nickhyena
Twitter.com/hyena1

Nick is a highly experienced cameraman and zoologist. He delivers cutting-edge, quality footage for documentaries that entertain, inspire and educate. Having filmed for the BBC, Channel 4, Nat Geo Wild, Animal Planet, Discovery, Smithsonian Channel, etc,. Nick specialises in Wildlife, Presenter-led, OBS-DOC, Feature and Human Interest programming. In his quest to bring exciting themes to the fore, he has honed a multitude of versatile skills.

Abbie Barnes - Film-maker, Presenter and Conservationist
Song Thrush Productions
Country: United Kingdom
Wildlife-film.com/·/AbbieBarnes.htm
Main listing in 'Presenters' on Page 212-213

Christian Baumeister – Producer / Director / DoP
Light & Shadow GmbH
Address: Badestraße 19a, 48149 Münster, GERMANY
Phone: +49 251 41 441 670
Email: christian@lightandshadow.tv
Website: www.lightandshadow.tv

Christian Baumeister is the founder of LIGHT & SHADOW and the creative head behind the company. Both a cinematographer and a highly successful director/producer, Christian has been recognised internationally for his exceptional artistry, storytelling and vision. Christian Baumeister studied biology at Westfälische Wilhelms University in his native Germany and filmmaking at Derby University, UK. For more than a decade Light & Shadow specializes in South American wildlife.

Simon Beer – Camera Operator/Technical Specialist
Address: Norfolk, UK
Phone: +44 (0)1603 857 155 Mobile: +44 (0)7934 010 000
Email: sbeer@mac.com
Website www.simonbeer.com
Twitter.com/wildfilming
Youtube: www.simonbeer.tv
Wildlife-film.com/·/SimonBeer.htm

Multi-skilled camera operator with over 25 years industry experience. Technical specialist, consultant and owner of RED DSMC2, ENG, DSLR and Pro cameras. Specialist kit includes infrared, full spectrum, thermal, live video encoders and KA Satellite dishes for remote live streaming. Drone operator, gimbals, sliders and more · HD, 4K and Beyond.

Andrew Bell – Producer/ Cameraman / Editor
Address: London, UK
Main listing in 'Producers/Directors' on Page 179

Raymond Besant – Long Lens Cameraman
Address: Kirkwall, Orkney Islands, UK
Phone: +44 (0)7713 328 493
Email: raybesant@gmail.com
Website: www.raymondbesant.com
Facebook.com/raymondbesant
Twitter.com/RaymondBesant
Wildlife-film.com/·/RaymondBesant.htm

Raymond is a widely travelled cameraman specialising primarily in long lens behavioural work with a particular interest and knowledge of bird behaviour and marine topics. His first film documenting the effects of plastic pollution on seabirds won a best of category prize at the IWFF in Montana in 2008 and he has since gone on to work on a wide range of productions for the BBC NHU, BBC Scotland as well as a host of independent productions. Credits include *The Natural World, Highlands · Scotland's Wild Heart* for Maramedia and BBC Scotland, multiple films for Plimsoll Productions in Sri Lanka and Zambia as well as regularly filming on the 'watches' strand for the BBC. He holds a commercial drone pilots license, owns a Sony FS7 camera and motion time-lapse kit. He has experience of using the latest cameras including RED Dragon, Arri Amira, Sony F-55 and Varicam as well as the Ronin gimbal and Ammonite thermal cameras. Excellent identification skills and experience of spending long periods in the field. Keen diver with PADI Rescue and Nitrox qualifications.

Julie Bills – Camera Operator/Cinematographer
Address: Edinburgh, UK
Phone: +44 (0)7802 443 067
Email: juliebills1@gmail.com
www.imdb.com/name/nm0082610
Wildlife-film.com/·/JulieBills.htm

Freelance Camera Operator/ Cinematographer with 20 years + experience in camera department. Extensive experience shooting both film and digital formats. Experience in long lens and high speed filming. Qualified First Aider, Padi Open Water Diver, advanced skier, with both SUP and Kayak experience. Interested in all natural history, documentary and adventure work.

Jesse Blaskovits – Cinematographer/Producer/Writer
Existential Productions
Address: Vancouver, BC V7L 2J8, CANADA
Phone: +1 778 868 3468
Email: Jesse@systemsmovie.com
Vimeo.com/user45686950

Jesse is a passionate and enduring nature and wildlife cinematographer. Specializing in outdoor environments, from Europe to South Africa, and all the way to the mighty Yukon, Jesse's dedication and precision to detail is apparent in his successful roster of international work. He's been in the game a long time, with a hugely successful track record to prove it. If you're seeking someone with a calm and positive attitude during the most hostile and enduring conditions, while also providing top-tier quality work, than be sure to consider Jesse for your next project. Please see a new show set in Africa, in which Jesse is credited as a cam op: Youtube.com/watch?v=4aQSWzk5GRk Please also have a look at Jesse's most recent demo reel featuring nature and wildlife footage from Saskatchewan and the Yukon: Vimeo.com/210396370

Andy Bodycombe – Drone Operator
HexCam
Address: Norwich, Norfolk, UK
Main listing in 'Production Services' on Page 57

Fabio Borges – Filmmaker / Photographer
Fabio Borges Fotografia / Hydrosphera
Address: Alameda da Harmonia 565, Fernando de Noronha, PE, BRAZIL
Phone: +55 (81) 99 994 8281 & +55(81) 3610 1973
Email: fabioborges@me.com
Website: www.fabioborgesfotografia.com.br & www.hydrosphera.com.br
Facebook.com/FabioBorgesFotografia
Wildlife-film.com/·/FabioBorges.htm

Working as a wildlife filmmaker and photographer for 20 years, Fabio Borges has traveled the world, mostly (but not limited to) for underwater shoots. His footage has been seen in all major nature / wildlife TV channels, beside cinema (best photography awards in cinema) and advertising. He has also worked as local fixer and expedition leader for many multi-purpose projects (biology research and film-making, for instance). As a still photographer and writer, Fabio contributes to magazines and sites. Interested in proposals for: Adventure, presenter-led, conservation-themed, pure wildlife, human-interest. Co-productions: Underwater and Wildlife.

Howard Bourne – Lighting Cameraman
Address: Bristol, UK
Phone: +44 (0)7969 293 026
Email: howardbourne@gmail.com
Website: www.howardbourne.co.uk

Howard Bourne is a freelance Lighting Cameraman who has filmed on a variety of commercials, promos and documentaries all over the world. Often using unique camera systems he has been integral to designing and building, Howard is comfortable with shoots covering any subject and is competent using a wide range of camera formats to suit any production. Howard started his career as a freelance Camera Assistant working on feature films before landing his dream job at a wildlife film production company. After working 5 years as staff for innovative Ammonite, Howard went freelance as a Lighting Cameraman. Howard has USA / UK dual citizenship and so is available to work in the states immediately without an I-Visa.

Bevis Bowden – Independent Cinematic Filmmaker
Address: 14 Pine Lodge, Whitefield Close, London SW15 3SS, UK
Phone: +44 (0)7530 068 050
Email: bevisbowdenfilms@gmail.com
Website: www.bevisbowdenfilms.co.uk
Wildlife-film.com/·/BevisBowden.htm

Cinematographer and Self-Shooting Director working on all filmmaking projects with a focus on documentary and natural history.
Bevis' involvement in wilderness adventure has been fundamental in guiding his choices and decisions in all filmmaking projects, whether in art films, commercials, music videos or documentary work. He approaches every filmmaking project as he would when setting out to climb a mountain. Its success depends on a wide-ranging and tested technical background and a clarity of purpose and vision. Bevis Bowden lives in London and is a Fine Art Film graduate from Central St.Martins.

Emma Brennand – Self-Shooting Producer/Director
Address: Bristol, UK
Main listing in 'Producers/Directors' on Page 180

Hal Brindley – Producer, Cinematographer, Photographer, Editor, Presenter
Travel For Wildlife
Address: PO Box 17117, Asheville, NC 28816, USA
Phone: +1 828 279 3376
Email: halbrindley@hotmail.com
Website: www.travelforwildlife.com
Facebook.com/TravelForWildlife
Twitter.com/halbrindley

Hal Brindley is co-editor of Travel For Wildlife (www.travelforwildlife.com) an award-winning website dedicated to promoting responsible wildlife tourism destinations. He is a wildlife photographer, film-maker, writer, presenter, host, editor, producer. Stock wildlife footage, short films, non-profit campaign media, wildlife travel films, wilderness lodge and hotel promotional videos, wildlife tour promotional films. Wildlife documentary, wildlife travel films, wildlife adventure experiences, travel destination promotion, wildlife tour company promotional videos, lodging promotional films, commercials.

John Brown – Wildlife Cameraman/Director
Address: Oxford, UK
Phone: +44 (0)1993 878 072 & +44 (0)7710 443 347
Email: info@johnbrownimages.co.uk
Website: www.johnbrownimages.co.uk
Facebook.com/JohnBrownImages
Twitter.com/JohnBrownImages

Multi award winning documentary cameraman, director, and stills photographer based in Oxfordshire, UK.

Giuseppe Bucciarelli – Producer/DOP
Terra Conservation Films
Address: Fiesole, ITALY
Wildlife-film.com/·/GiuseppeBucciarelli.htm
Main listing in 'Production Companies' on Page 42-43

Adrian Cale – Cameraman/Producer/Director
Address: London, UK
Wildlife-film.com/·/AdrianCale.htm
Main section in 'Producers/Directors' on Page 181-182

Adam L Canning – Presenter & Filmmaker
Address: West Midlands, UK
Main listing in 'Presenters' on Page 214

Jonathan Carter – Drone Operator
HexCam
Address: Norwich, Norfolk, UK
Main listing in 'Production Services' on Page 57

Andy Brandy Casagrande IV – Cinematographer / Producer / Presenter
ABC4EXPLORE
Address: Naples, Florida, USA
Main listing in 'Production Companies' on Page 8

Guy Chaumette – Underwater Filmmaker / Cinematographer / Photographer
Liquid Motion Film
Address: Cozumel, MEXICO
Phone: + 52 1 987 878 9690
Email: production@liquidmotionfilm.com
Website: www.liquidmotionfilm.com
Facebook.com/LiquidMotionFilm
Twitter.com/LiquidMotionMX

One of the most unique, creative influences in underwater filmmaking today, Liquid Motion Film produces award-winning films for broadcast media, corporate, commercial, advertising, private clients and the worlds most esteemed TV channels. Spectacular cinematography, spellbinding stories and cutting edge science have garnered them the highest accolades and numerous prestigious international awards. Available to travel as Underwater DP/Cameraman, can shoot 4K, red, many rigs, decades of experience. Looking for collaborators/Sponsors for film production.

Alice Clarke – Self-shooting PD/FCP Editor/Scriptwriter.
Address: Bristol, UK
Wildlife-film.com/·/AliceClarke.htm
Main listing in 'Propducers/Directors' on Page 183

Martyn Colbeck
Address: Bristol, UK
Email: info@martyncolbeck.com
Website: www.martyncolbeck.com
www.mikebirkhead.com/MartynColbeck.html

Martyn Colbeck is an internationally recognized and award winning photographer and cinematographer and has been filming wildlife for over 20 years, working mainly in association with the BBC's world-renowned Natural History Unit.

Elliott Corke – Drone Operator
HexCam
Address: Norwich, Norfolk, UK
Main listing in 'Production Services' on Page 57

Roland Cory-Wright – Drone Operator
HexCam
Address: Norwich, Norfolk, UK
Main listing in 'Production Services' on Page 57

Martin Cray – Cameraman/Director
Address: Ffawydden Cottage, Llandewi Rhydderch, Abergaveny NP79TH, UK
Phone: +44 (0)7970 375 316
Email: martincrayfilm@gmail.com
Vimeo.com/user5139062
Linkedin.com/in/martin-cray-6414b427

High-speed, long-lens and aerial. Specialties: birds of prey and adventure sports. I also light interviews. Awards: BAFTA Cymru Cinematography
Coupe Icare (St Hilaire); Merit for conservation IWFF Missoula.

Robin Crofoot – Camera Man
Address: Dorfstrasse 87, Rossow, Mecklenburg-Vorpommern 17322, GERMANY
Phone: +49 16 06 685 897
Email: robin.crofoot@gmail.com or robin.crofoot@t-online.de

Nature films · short documentaries. Interested: traveling in Europe, video, filming Nature and Wildlife.

143

Christopher Crooks
Address: London, UK
Wildlife-film.com/·/ChristopherCrooks.htm
Main listing in 'Researchers' on Page 201

Steve Cummings – Camera Operator – Sound Recordist
Steve Cummings Sound
Address: Halifax, UK
Main listing in 'Sound Operators' on Page 173

Sue Daly - Film-maker
Address: La Retraite, Sark GY10 1SF, BRITISH CHANNEL ISLANDS
Phone: +44 1481 832175
Email: sue@suedalyproductions.com
Website: www.suedalyproductions.com

Underwater photographer & film-maker, writer & editor. I also run underwater photography workshops in the Channel Island of Sark.

Sophie Darlington – Wildlife Cinematographer
Address: London, UK
Email: sophie@sophiedarlington.com
Website: www.sophiedarlington.com
Twitter.com/S_Darlington

Since 1991 Sophie has worked happily as a filmmaker and cinematographer specialising in natural history in remote locations throughout the world from Africa and The Americas to Nepal and Mongolia.

Shekar Dattatri – Director Camera
Country: INDIA
Website: www.shekardattatri.com

Shekar Dattatri is one of India's leading wildlife filmmakers. An internationally respected and frequently awarded producer/director/cameraman of blue chip natural history films.

Cristian Dimitrius – Director of Photography
Cristian Dimitrius Productions
Address: Alameda Manacá da Serra 15 · Itapevi · SP 06670-150, BRAZIL
Phone: +55 11 98906 7626 & +55 11 4680 9037
Email: cdimitrius@yahoo.com
Website: www.cristiandimitrius.com
Facebook.com/cdimitrius
Twitter.com/crisdimitrius
Vimeo.com/cristiandimitrius
Wildlife-film.com/·/CristianDimitrius.htm

Cristian Dimitrius is an Emmy Award Winning cinematographer, multi-task cameraman (top side and underwater), biologist, experience drone pilot and television presenter specializing in wildlife and natural history. In addition to several film credits including IMAX films, Cristian has shot and produce for the world's top television networks including the BBC, National Geographic, Discovery Channel, History Channel, Arte, Animal Planet, Smithsonian, NHK and many others. With a large experience in the Brazilian Biomes, especially Amazon and the Pantanal, he is the right man to help you to get that stunning image your land mark series or any production working in Brazil. Due to its versatility and adaptation to different natural environments, Cristian has the ideal profile to get a better and more complete result in a shorter time. Cristian Dimitrius Productions also has experience getting ANCINE permits, equipment through the Brazilian customs, contact with local fixers and a large selection of camera kits. Contact us if you shoot destination is Brazil.

Mark Dodd – Director/Cameraman.
1080 Film and Television
Address: 26 Blackthorn Way, Poringland, Norfolk NR14 7WD, UK
Phone: +44 7973 521 409
Email: markdodd@1080films.co.uk
Website: www.1080films.co.uk
Facebook.com/1080FilmsUK
Twitter.com/1080films

Multi award-winning director specialising in production of human interest environmental films. Very high production values. Able to offer cost-effective director/cameraman services to other production companies.

Catherine Doherty – Camera Operator, Floor Manager, Researcher, Assistant/Runner
Country: London, UK
Main listing in 'Assistants' on Page 206

Martin Dohrn – Cameraman/Producer
Ammonite Ltd
Address: Bristol, UK
Wildlife-film.com/-/Ammonite-Films.htm
Main listing in 'Production Companies' on Page 9

Steve Downer - Specialist Wildlife Cameraman & DOP
Steve Downer Wildlife Cinematography
Address: Birmingham, UK Phone: +44 (0)7706 014 301
Email: stevedownerfilms@gmail.com
Website: www.wildlife-cinematography.co.uk
Facebook.com/steve.downer.16
Twitter.com/SteveDownerFilm
Linkedin.com/in/stevedowner
Youtube.com/user/stevedownerfilms

Highly experienced Cameraman and DOP with special skills in macro & small animal filming. Credits on over 100 international television programmes and winner of numerous awards for cinematography including two News & Documentary EMMY's. Has worked on blue chip series including BBC's *PLANET EARTH* & *BLUE PLANET* and *THE NATURAL WORLD*, and National Geographic's *EXPLORER*, filming a diverse range of animals · from big cats to microscopic mites. Specialist in macro & micro filming, chromakey, timelapse, deep focus optics, and filming using large sensor cameras, especially RED EPIC and Sony FS7. Recent clients include BBC NHU, RSPB, Discovery, Warner Brothers.

145

Rob Drewett - Cameraman
Address: Gloucestershire, UK
Phone: +44 (0)1666 890 358 & +44 (0)7595 371 144
Email: robthecameraman@gmail.com
Website: www.robthecameraman.co.uk
Facebook.com/Robthecameraman
Twitter.com/robthecameraman

Rob Drewett is a natural history and documentary cameraman.

James Dunbar – Camera Operator/Photographer/Assistant
Address: Bristol, UK
Phone: +44 (0)7794 798 430
Email: james@jamesdunbarphotography.com
Website: www.jamesdunbarphotography.com
Facebook.com/jamesdunbarphotography
Twitter.com/jamesadunbar
Wildlife-film.com/·/JamesDunbar.htm

Photographer of insects, spiders and small things in general.

Paul Duvall – Drone Operator / Photographer
Address: 8 Ferring Lane, Worthing, West Sussex BN12 6QU, UK
Phone: +44 (0)1903244638 & +44 (0)7815 088 537
Email: paul@paulduvallphotography.co.uk
Website: www.paulduvallphotography.co.uk
Facebook.com/PaulDuvallPhotography
Instagram.com/_higherperspective
Twitter.com/_PaulDuvall
Linkedin.com/in/paul-duvall-02b52a62

I offer High end drone operations. Full PFCO CAA accreditation and fully insured to 5 million pounds public liability. I love to shoot natural history projects. My passion is the natural world and I want my audience to feel the majesty and mysticism I feel when I'm shooting on location. I would definitely consider Collaborative projects and co-productions

Ed Edwards – High Speed Camera Operator
Address: North Wales, UK
Phone: +44 (0)7786 007 060
Email: edwardedwards@mac.com
Website: www.slowmo.co.uk
Wildlife-film.com/·/EdEdwards.htm

David Elkins – Cinematographer/Filmmaker
Elkins Eye Visuals
Address: Northern California, USA
Phone: +1 707 280 1648
Email: david@elkinseye.com
Website: www.elkinseye.com
Facebook.com/ElkinsEyeVisuals
Twitter.com/DavidElkins

David is highly creative and award winning director of photography and camera operator with a wide range of experience on a variety of documentary, broadcast and commercial productions.

146

Tania Escobar – Cinematographer / Camera Operator / Filmmaker
Address: Foz do Iguazu, BRAZIL
Phone: Brazil. +55 45 91 58 06 24 & Mexico. +52 55 444 10 708
Email: tania.escobar.ori@gmail.com
Website: www.deepearthmedia.com
Facebook.com/taniaescobar

Freelance Camera Operator and Cinematographer from Mexico, working all over the world, based in Foz do Iguazu, Brazil. Interested in wildlife, scientific, expedition, conservation and underwater documentaries. Experience filming with hides, long lens and remote control cameras, as well as interviews, presenters, motion control time-lapse, gimbals and drones. Qualified First Aider and diver certified ** by the CMAS World Underwater Federation. Experience with field logistics and spending long periods in hostile locations, primly jungles, deserts, islands and at sea.

Tania Rose Esteban – Wildlife Filmmaker/Zoologist
TRE Productions
Address: Bristol, UK
Wildlife-film.com/·/TaniaEsteban.htm
Main listing in 'Researchers' on Page 201

Justine Evans – Director/Lighting Camera
Country: UK
Email: justine@justineevans.com
Website: www.justineevans.com
Twitter.com/jussyevans

A wildlife film maker who spends much of her time recording images of the wonderful life here on Planet Earth in the hope that we won't let it all slip away...

James Ewen – Lighting Cameraman
Earthmedia Film AS
Address: Svarttrostveien 7B, 0788 Oslo, NORWAY
Phone: +47 95 479 708
Email: james@earthmedia.co.uk
Website: www.earthmedia.co.uk

James is a specialist lighting cameraman and producer based in Oslo, Norway but with experience from all over the world. Primarily a long lens cameraman he also has extensive experience with macro, Infrared and lowlight, lighting, set building, jibs, dollies, sliders, drones and gimbals. Owner operator of a Varicam LT and HJ18 plus a lot of other specialist kit.

Erik Fernström
Address: Gränna, SWEDEN
Main listing in 'Production Companies' on Page 19

Simon de Glanville – Cameraman
Address: London, UK
Phone: +44 (0)7734 052 712
Email: simon@simondeglanville.co.uk
Website: www.simondeglanville.co.uk

Bob Glowacky – Assistant/Camera Operator/Editor
Address: New Hampshire, USA
Wildlife-film.com/-/RobertGlowacky.htm
Main listing in 'Assistants' on Page 206-207

Will Goldenberg
Address: California, USA
Phone: +1 530 318 3427
Email: willgoldenberg@yahoo.com
Website: www.willgoldenberg.com
Twitter.com/goldenbergwill
Linkedin.com/in/will-goldenberg-71269a82
Wildlife-film.com/-/WillGoldenberg.htm

I am a behavioral ecologist and cinematographer building a career in natural history filmmaking. I have an MSc in Wildlife Management as well as an MA in Wildlife Filmmaking. I am well traveled as a camera assistant and have learned craft technique from seasoned wildlife cinematographers. My student films have received international awards and I have experience producing media for State/Federal agencies, non-profit organizations, NGO's, academic institutions and production companies in the US and UK. I am closely linked with the scientific community in the US Pacific Northwest and have specialist knowledge of Redwood forest environments. I am available as camera operator, camera assistant, researcher or runner for natural history/ expedition programs.

Jeff Goodman – Cameraman/Director
Address: The High Barn, Sancreed, Penzance, Cornwall TR20 8QY, UK
Phone: +44 (0)1736 788 705
Email: jeffgoodman@supanet.com
Website: www.jeffgoodman.co.uk
Facebook.com/jeff.goodman.1420

Award Winning TV Cameraman. Documentary, Wildlife, Underwater, Aerials, Sound Sync, adventure. Presenter led Programming, Science & Features.
I also run video and editing courses both for underwater and land based filming. Not offering work experience or accepting CVs.

Neil Grubb
Roslin Nature
Address: Edinburgh, Scotland, UK
Wildlife-film.com/-/NeilGrubb.htm
Main listing in 'Producers/Directors' on Page 185

148

Ricardo Guerreiro - Filmmaker (photography, editing, fixer)
Address: R. Dom João V, 10 · R/CH·ESQ, 1250·090 Lisboa, PORTUGAL
Phone: +351 910 732 177
Email: mail@rguerreiro.com
Website: www.rguerreiro.com
Facebook.com/rguerreirofoto
Vimeo.com/rguerreirofilm
Wildlife-film.com/·/RicardoGuerreiro.htm

Born in Funchal, 1977, based in Lisbon, Portugal. Freelance filmmaker/photographer specializing in the natural world and rural heritage themes. His picture stories have been published in books and magazines of the kind, such as National Geographic Portugal. He's the author of Almada Nature Uncovered, a photographic book about urban wildlife, and co-authored the natural history films *Arrábida - from the Mountain to the Sea*, *Almada - Between the River and the Sea*, *Portugal's Mountains of Wonder* (worldwide distribution by Off the Fence), all aired on Portuguese television. Available as freelance natural history cameraman specializing in Portugal (Madeira and Azores included), and as editor. Available also as a fixer and/or fieldwork assistant.

Samuel Guiton – Director/Cameraman
Address: Montreuil, FRANCE
Phone: +33 66 431 9816
Email: s.guiton@gmail.com
Facebook.com/samuel.guiton
Linkedin.com/in/samuel-guiton-0a43712a

After a master degree in behavioural biology, I decided to combine my two passions for nature and photography and obtained a master degree as wildlife filmmaker in a French University. Through ten years experience in the film industry I've developed a broad range of skills, from long lens shooting to motion control time-lapse photography, and specialised in macro photography (wild and studio). I especially worked on sequences for the: "France: the Wild Side" series, as an author, director and DOP (dragonflies, toads, butterflies, cranes...). Fluent in French and English, I'm looking for opportunities with foreign production companies.

Dominique Gusset – DOP/Cinematographer/Researcher
Address: Duncans Cove, Nova Scotia, CANADA
Email: dominiquegusset@gmail.com
Twitter.com/DGinDC
Linkedin.com/in/dominiquegusset

DOP/Camera Operator >35 years documentary, drama, corporate.

149

Steve Hamel – Biologist/Camera Operator/Sound Recordist
Address: Montreal, Quebec, CANADA
Phone: +1 514 475 8539 & +1 514 507 8539
Email: steve.hamel.2017@gmail.com
Vimeo.com/206717443

Steve Hamel, a wildlife biologist, has been working in Canada's backcountry since 1990. From British Columbia's west coast to Quebec's northern regions, he has specialized in working for long periods under demanding conditions, in some of this country's remote and challenging terrain. Having taken up photography and videography years ago, he is now combining his two passions into a new career: working as a freelance camera operator and sound recordist. His short wildlife video clips have already been featured in a Canadian wildlife documentary. Skills: FCPX, editing, photography, time-lapse, DSLR video. Bilingual (French/English). He is looking for short or long-term projects on wildlife conservation. For the next few years I am only interested to work as a camera operator or sound recordist. Not offering internships.

Mauricio Handler – Cinematographer / DP
Aquaterrafilms
Address: Durham, Maine, USA
Phone: +1 207 504 0733
Email: dp@aquaterrafilms.com
Website: www.aquaterrafilms.com
Facebook.com/Aquaterrafilms
Instagram.com/aquaterrafilms
Vimeo.com/aquaterrafilms

Aquaterrafilms Underwater DP/ Cinematographer Mauricio Handler specializes in footage acquisition for documentary and commercial production. Underwater specialist. He is a Red Epic owner/ operator and acquiring content in 5k R3d format. Always looking for ideas and collaborations across the US and the rest of the world. Not offering work experience at the moment (2017).

Dick Harrewijn – Freelance Cameraman
Lutra Films
Address: Rhenen, NETHERLANDS
Phone: +31 618 182 655
Email: ik@dickharrewijn.com
Website: www.dickharrewijn.com
Twitter.com/dickharrewijn
Instagram.com/dickharrewijn
Linkedin.com/in/dickharrewijn
Wildlife-film.com/-/DickHarrewijn.htm

Over the last 8 years Dick Harrewijn has been working on big budget documentary films,

produced for cinema release. Dop credits range from short documentary to feature length wildlife film. Dick has filmed and traveled all around the globe. See website for credit list. With a big knowledge of wildlife and strong sence for technique Dick has proven to be a cameraman one of a kind. Next to the camerawork he has been involved in the design of various technical elements like new lenses and starlight cameras that continue to push the boundaries of wildlife cinematography. "I love film and love the outdoors even more. Over the last few years I've come to realise that documentary and especially wildlife film means more than just pretty pictures. For me everything starts from the story, from ecology or conservation to the everyday life of the subject of the film. I've come to see that we as filmmakers have an obligation to bring these stories to the public. Whether it's wildlife or people we're filming, whenever the story is good and I'm able to tell it in the most cinematographic way, I'm completely in my element."

Lewis Hayes – Lighting Camera Operator
Red Wolf Productions
Address: Hersham, UK
Phone: +44 (0)7727 210 225
Email: lewisahayes@hotmail.com
Website: www.redwolfproductions.co.uk
Linkedin.com/in/lewisahayes
Wildlife-film.com/-/LewisHayes.htm

I am a freelance Lighting Camera Operator with full 4K Camera, lighting and sound recording kit. I own a selection of lens, from Canon Cine's, B4 HJs, Primes and Zooms. I am also a fully trained Jimmy Jib assistant. I love all things wildlife, whether it be films aimed towards the Conservation of the Natural World or simply pure wildlife films. I also film Live Events, Broadcast and Corporate. Recent credits include *Springwatch*, *Nocturnal Britain*, *Wildlife SOS - Skomer Island* and I also demonstrated High-Speed cameras at the Bristol Festival of Nature. I'm looking at making films that aid the Conservation of the Natural World. I am also very interested Adventure shows, Presenter-led Wildlife and of course pure wildlife films. Not offering work experience.

Nick Hayward – Cinematographer
Wild Creature Films
Address: 25 Salvator Rd, Hobart, Tasmania, AUSTRALIA
Phone: +61 428 104 313
Email: nick.hayward@wildcreaturefilms.com & info@nickhayward.com.au
Website: www.nickhayward.com.au

I am a Tasmanian based wildlife cinematographer recent work includes the young devil sequence in the BBC's "Seven Worlds" and on David Attenborough's Tasmania in 2016 I completed filming on a 50-minute programme on the Tasmanian Devil commissioned by National Geographic, ZDF and ARTE. This program was co-produced by Wild Creature Films (a company founded by myself and Simon Plowright) and WH51. It is the story of the last DFTD Devils of Tasmania with the first ever wild den scenes and is filmed in a blue chip cinematic style. My other notable recent productions include *Wild Australia* (Vimeo.com/176376832 Password: NH) Throughout my career I have worked extensively on BBC production some of the titles include; *Wildlife on One*, *The Natural World*, *Life of Birds*, *Life in the Undergrowth*, *Dragons Alive*, *Battle of the Sexes*. The Lyrebird sequence I filmed for *Life of Birds* was voted by the British public as their favourite Attenborough moment: Youtube.com/watch?v=VjEOKdfos4Y My passion is to create blue chip cinematic wildlife sequences and I would be very interested to discuss working with you on any productions you may have planned in the Southern Hemisphere.

151

Agneta Heuman
Address: Alte Landstrasse 100, Zollikon 8702, SWITZERLAND
Phone: +41 793 659 350
Email: heuman@gmx.net
Wildlife-film.com/·/AgnetaHeuman.htm

Conservation biologist, natural history guide in the mountains. Large science network in Switzerland. Enthusiastic, flexible, weather-, mountain- and high altitude-proof. Eager to do research and camera operation. Special knowledge: Alps, particularly Swiss Alps, including species such as Alpine ibex, chamois, Bearded Vulture, Golden Eagle, red deer and wolves. Fluent in German, English, French, Swedish, and good in Spanish and Italian. Particular interest in conservation topics.

Skip Hobbie – Camera/Field Producer
Address: Austin, Texas, USA
Phone: +1 512 293 7547
Email: skizip@gmail.com
Website: www.skipswildlife.com
Wildlife-film.com/·/SkipHobbie.htm

Freelance wildlife cameraman, field producer, and all around field production specialist. Experienced with long lens, macro, set work, rope access, and high speed. Emmy award winner for his work as part of National Geographic's Untamed Americas team.

Sam Hopes
Address: Bristol, UK
Wildlife-film.com/·/SamHopes.htm
Main listing in 'Assistants' on Page 207

Steve Hudson – Assistant/Underwater Camera operator
Pelagic Productions Ltd
Address: Auckland, NEW ZEALAND
Main listing in 'Production Companies' on Page 36

Richard Hughes – DOP / Cameraman
Edge 2 Edge Films Ltd
Address: Beckenham, Kent, UK Phone: +44 (0)7787 548 659
Email: richard@edge2edgefilms.co.uk
Website: www.richardshughes.co.uk
Twitter.com/rich_tv
Wildlife-film.com/-/RichardHughes.htm

I am an experienced and confident DOP / Cameraman and Shooting Director, who has worked in over 19 countries. Specialising in Natural History and Factual Documentary. CAA permission to fly drones. Credits include: BBC NHU, BBC 1, BBC2, Chan 5, Animal Planet. Highly Commended, British Wildlife Photographer of the Year 2016 Video category. Not looking for proposals or co-productions. Not offering work experience.

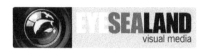

Pieter Huisman – Freelance (wildlife) Documentary Cameraman
EYESEALAND Visual Media
Address: Soest, the NETHERLANDS
Phone: +31 6 5539 8685
Email: pieterhuisman@eyesealand.com
Website: www.eyesealand.com
Facebook.com/EYESEALAND
Instagram.com/eyesealife
Tumblr.com/dashboard/blog/eyesealife
Wildlife-film.com/-/PieterHuisman.htm

Pieter Huisman has a background in documentaries, having filmed in over 30 countries since 1998. He enjoys working as part of team, as well as on projects that require self-motivation and an independent mindset. Pieter's love for nature, determination and patience are endless. Skills include using extreme telephoto lenses, macro, underwater, high speed filming, infrared nocturnal, remote controlled cameras and HD and 4K stock shots. He is also proficient as an editor and colourist. References include Channel 4, Animal Planet, Nature Conservation Films and National Geographic.

Jack Hynes
Address: Bristol, UK Phone: +44 (0)7920 141 168
Email: jack@jackhynes.com
Website: www.jackhynes.com

Award-winning natural history cameraman with experience all over the world. PFCO drone pilot.

Cristian Ilea – Director of Photography / Filmmaker
Address: Al. F.C. Ripensia Nr.18 Ap.39 Timisoara 300584, ROMANIA
Phone: +40 723226640
Skype: cristilealin
Email: cristilealin@gmail.com
Website: www.wildliferomania.com & www.cristianilea.com
Facebook.com/cristilealin
Twitter.com/cristilealin
Wildlife-film.com/-/CristianIlea.htm

He is the only director of photography in Romania specialized in wildlife film. For the past 20 years he has been working for the Romanian National Television (TVR), filming for TV shows, documentaries, and fiction series. In 2008 he graduated from a course endorsed by Animal Planet and NHU Africa, at the Wildlife Film Academy in South Africa. Afterwards, with his Wild Watch Association, he founded wildliferomania.com and filmed "Danube Delta. Paradise almost Lost", a documentary about the delta's nature and people. He has been supporting several wildlife projects, including WWF's Open Borders for Bears in the Romanian and Ukrainian Carpathians, by filming the capture of the monitored bears.

Kiril Ivanov
Videodiver.ru
Address: Moscow, RUSSIA
Email: videodiver@mail.ru
Website: www.videodiver.ru
Facebook.com/Videodiverru
Youtube.com/videodiverru
Vimeo.com/videodiverru
Wildlife-film.com/·/Kirillvanov.htm

Underwater/wildlife camera operator and film editor.

Hilco Jansma – Camera Operator / Editor
Address: Groningen, THE NETHERLANDS
Phone: +31 614 152 270
Email: hilcojansma@hotmail.com
Website: www.hilcojansma.com
Facebook.com/hilcojansmafilm
Twitter.com/HilcoJansma
Linkedin.com/in/hilcojansma
Vimeo.com/animallife
Wildlife-film.com/·/HilcoJansma.htm

The natural world has my greatest interest, hence I studied biology. After earning my MSc I started developing skills for filming and editing. In 2014 I decided to make an urban nature documentary *Het Noorderplantsoen*, fully in charge of the camera, script, editing and production. My goal is to show people that nature is everywhere. This documentary was selected for several wildlife film festivals, receiving an honourable mention at Greenscreen 2016. Although I am researching new projects, I enjoy participating in additional projects to put my edit and camera skills, including aerial and underwater filming, to good use. Primarily interested in: Wildlife & urban nature.

Andy Jackson – Underwater Cameraman
SubSeaTV
Address: Scarborough, North Yorkshire, UK
Phone: +44 (0)7597 573 627
Email: andy@subseatv.com
Website: www.subseatv.net
Vimeo.com/subseatv/videos
Facebook.com/subseatv
Twitter.com/Subseatv
Linkedin.com/in/andy-jackson-85453b32
Wildlife-film.com/·/AndyJackson.htm

I film underwater in UHD with a Sony FS7. I specialise in intimate encounters

Gail Jenkinson – Camerawoman
Address: Bristol, UK
Email: gailjenkinson1@me.com
Website: www.gailjenkinson.co.uk
Twitter.com/gailiejenks
Instagram.com/gailiejenks
Linkedin.com/in/gail-jenkinson-85938111
IMDb.com/name/nm2615045

Camerawoman working in natural history, adventure and documentary filmmaking. HSE part 4, advanced bush craft, specialist at working at sea.

Mike Johnson – Cinematographer / DP
Michael Johnson Entertainment, LLC
Address: St. Peters, Missouri, USA
Phone: +1 636 577 3994
Email: mike@mikejohnson.video
Website: www.mikejohnson.video
Facebook.com/mikejohnsonvideopro
Instagram.com/mikejohnsonvideo
Linkedin.com/in/mikejohnsonvideo
Wildlife-film.com/·/MikeJohnson.htm

Mike is a highly skilled cinematographer/DP experienced in travel/adventure shoots focusing on wildlife, nature, travel, SCUBA, and adventure. Conveniently located in the central US, he is available for worldwide travel. There is no location too remote or too extreme. Mike owns and operates the following cameras: Sony FS7, Sony a7S II, Sony FS700, and Canon 5D Mark III. The a7S is outfitted with an Ikelite dive housing, complemented with Light & Motion underwater video lights. As an active PADI Divemaster in good standing, Mike has the training and experience for underwater work in nearly all open water environments worldwide. Actively working to build on my underwater photo and video experience. Any project with a scuba element is of interest.

Alex Jones - Wildlife Cinematographer
Wildlife Film Productions
Address: 734 Esther Way, Redlands, California 92373, USA
Phone: +1 949 547 1892
Email: wildlifefilmproductions2@yahoo.com and alexjones@wildfp.com
Website: www.wildlifefilmproductions.com
Facebook.com/jonestheadventurer
Twitter.com/AJTheAdventurer
Youtube.com/wildlifefilmpro
Wildlife-film.com/·/AlexJones.htm

Alex Jones is one of the few blue-chip wildlife cinematographers based in Southern California. As principal cinematographer for his sequences assigned, Alex is a four-time nominee and Panda Award Winner for the world renowned "Wildscreen Film Festival" 2016, 2014 and the "Wild and Scenic Film Festival" in Nevada City, USA. Alex specializes in top-side animal behavior and macro wildlife cinematography. He's worked on multiple TV shows, films and commercials in Los Angeles as director of photography and in addition, Alex produces his own blue-chip wildlife films under his company Wildlife Film Productions. Alex's client list includes BBC Natural History Unit, Nat Geo Wild, National Geographic, Discovery, BBC Earth, Smithsonian Earth and Curiosity Stream. Alex Jones is a skilled wildlife cinematographer with an adventurous spirit, an inquisitive mind and a passion for cinematic wildlife content. Alex's cinematic passion, work-ethic and eye for detail makes him one of the best cinematographers in the industry and an exceptionally hard working asset to any team.

Jonathan Jones – Lighting Cameraman
Ember Films
Address: Bristol/Norfolk, UK
Wildlife-film.com/·/Ember-Films.htm
Main listing in 'Production Companies' on Page 19

Richard Jones - Cameraman
Address: Bristol, UK
Phone: +44 1179 732 117 & +44 7905 803 997
Email: richard@rmjfilming.com
Website: www.rmjfilming.com

As a highly experienced, award winning wildlife and documentary cameraman I have worked extensively on high end natural history filming during a career spanning more than 25 years. Recently I have racked up over 2000hrs filming on Stabilised Gimbals (ShotoverF1) mainly mounted on Vehicles and boats.I have been nominated for Cinematography awards at some of the most prestigious Wildlife Film Festivals, such as Wildscreen and Jackson Hole. Credits include Principal Cameraman on the Large Format Film (Imax) Roar Lions of the Kalahari, which was nominated for three Cinematography Awards.

156

Sandesh Kadur - Camera Operator
Felis Creations
Address: Bangalore, INDIA
Phone: +91 944 805 9209
Email: sandesh@sandeshkadur.com
Website: www.sandeshkadur.com
Facebook.com/SandeshKadur
Twitter.com/SandeshKadur
Wildlife-film.com/·/SandeshKadur.htm

Experienced Freelance natural history camera-operator having captured rare sequences of King Cobras to Tigers in the jungles of India. Filmed on various shoots for BBC Natural World, National Geographic, Discovery and Animal Planet. Specialize in Natural History and crave to film new behaviour of rarely seen species. Experience with Camera-traps and have worked extensively with various configurations.

Dave Keet – Producer/DOP/Editor
Aquavision TV Productions (Pty) Ltd
Address: Johannesburg, SOUTH AFRICA
Wildlife-film.com/·/Aquavision-Productions.htm
Main listing in 'Production Companies' on Page 10

Simon King – Cameraman/Presenter
Simon King Wildlife
Address: Frome, Somerset, UK
Main listing in 'Production Companies' on Page 40

Dominique Lalonde – Producer/DOP/Editor/Photographer
Dominique Lalonde Productions
Address: Québec, CANADA
Wildlife-film.com/·/DominiqueLalonde.htm
Main listing in 'Production Companies' on Page 17

Peter Lamberti – Producer/DOP/Editor
Aquavision TV Productions (Pty) Ltd
Address: Johannesburg, SOUTH AFRICA
Wildlife-film.com/·/Aquavision-Productions.htm
Main listing in 'Production Companies' on Page 10

Mike Linley – Director/Cameraman
Hairy Frog Productions Ltd
Address: Norwich, Norfolk, UK
Wildlife-film.com/·/Hairy-Frog-Productions.htm
Main listing in 'Production Companies' on Page 24

Justin Lotak – Photographer, Videographer
Conservation Atlas
Address: Georgetown, Texas, USA
Phone: +1 312 823 9917
Email: justinlotak@gmail.com
Main listing in 'Organisations' on Page 115

Arthur Machado – DOP/Producer/Editor/Photographer
Address: Christchurch, New Zealand
Vimeo.com/arthurmachado
Wildlife-film.com/·/ArthurMachado.htm
Main listing in 'Producers/Directors' on Page 186-187

Justin Maguire - Wildlife Cameraman
Address: Vancouver, CANADA
Phone: +1 604 990 1045
Email: justin@justinmaguire.co.uk

Multi Award winning wildlife cameraman.

Feisal Malik - Line Producer/Director/Camera/Fixer/Producer
Visual Africa Films Ltd
Address: Nairobi, KENYA
Wildlife-film.com/·/Visual-Africa-Films.htm
Main listing in 'Location Managers/Fixers' on Page 91

Jim Manthorpe - Freelance Wildlife Film-maker
Address: Scotland, UK
Phone: +44 (0)7935 368 202
Email: info@jimmanthorpe.com
Website: www.jimmanthorpe.com/cameraman
Facebook.com/manthorpe.wildlife
Twitter.com/KnoydartJim
Vimeo.com/manthorpe
Wildlife-film.com/·/JimManthorpe.htm

I am a wildlife camera operator based in the West Highlands of Scotland, near the Isle of Mull. I specialise in Highland wildlife but have travelled as far afield as Yellowstone, Patagonia and the Himalayas. Camera operating credits include 'The Watches' (Springwatch etc) for the BBC, Highlands · Scotland's Wild Heart (Maramedia / BBC), Into the Wild with Gordon Buchanan (Hello Halo / BBC) and One Strange Rock (Nutopia / NatGeo). I own a Sony FS7 and motion timelapse and drone equipment. I also have experience with the Arri Amira, Sony F5/55 and P2 Varicam.

158

Angels Melange – Cinematographer/Filmmaker
Address: Barcelona, SPAIN
Phone: +34 62 246 1114
Email: angels_g.e@hotmail.com
Vimeo.com/melange

Cinematographer / Filmmaker based in Spain (would love to relocate) · Experience includes short, feature films and documentaries, as well as shooting with the awarded filmmaker Werner Herzog. · Passionate about travel, animals, nature in general, but mostly avid for beautiful images.

Sam Meyrick – Wildlife Cameraman
Country: London, UK
Phone: +44 (0)7706 368 410
Email: sam.meyrick@gmail.com
Website: www.sammeyrick.co.uk
Twitter.com/sam_meyrick
Linkedin.com/in/sam-meyrick-90653b51
thetalentmanager.co.uk/talent/21221/sam-meyrick

Wildlife cameraman, with an MA in Wildlife Filmmaking and BSc in Geography. I have worked on various natural history shows, including BBC *Springwatch* and a Natural World with David Attenborough. I spent 4 months in Zambia working for Plimsoll Productions in 2015 and in 2016 I spent time filming in South Korea, Holland and Vietnam. I have experience shooting long lens 4K sequences, using cameras including Varicam 35 and Red Dragon. I am a CAA qualified drone pilot, proficient with timelapse/hyperlapse photography & remote cameras, as well as data management.

Faye Minister – Camera Assistant/Runner
Address: Milton Keynes, UK
Main listing in 'Assistants' on Page 207

Jessica Mitchell – Underwater Camera Operator/Assistant
Earth Motion Pictures
Address: Bristol, UK
Phone: +44 (0)7527 964 684
Email: jess@earthmotion.co.uk
Website: www.earthmotion.co.uk
Facebook.com/earthmotionpictures Twitter.com/earthmotionpics
Linkedin.com/in/jessica-mitchell-a5413050

Jessica is an underwater Camera Operator. She also assists specialist camera operators. Whilst being extremely passionate about the underwater realm, Jessica has spent a number of years specialising in Macro photography and is also a commercial diver. She is a versatile addition to any team and can multi-task across a number of roles in natural history filming.

Mihali Moore
Address: 70 Millfield Road, Faversham, Kent ME13 8DQ, UK
Phone: +44 (0)7971 534 485
Email: mihali.moore@gmail.com
Website: www.mihalimoore.co.uk
Twitter.com/MihaliMoore
Vimeo.com/mihalimore
Wildlife-film.com/-/MihaliMoore.htm

I have extensive experience as a Lighting Cameraman and keep up to date with all current recording formats. I have rigged and operated remote cameras in various locations and am familiar with a range of mini-cams and specialist cameras for high speed, time-lapse & macro filming. I am a confident self-shooter and have produced videos for a variety of clients, of note I spent several weeks in Zambia producing films for a Safari company. I hold a HSE Pro Scuba (Part IV) license with a valid medical, as well as a PADI Divemaster qualification and have completed a BBC approved hostile environment course. Recent completion of my license to fly drones commercially means I can also provide high quality aerial footage. I also have experience of long lens filming and sitting in a hide for many hours. Would love to hear from people who require a experienced cameraman for their projects.

Oliver Mueller
Address: Bristol & Manchester, UK
Phone: +44 (0)7787 342 889
Email: oliver_mueller01@hotmail.com
Twitter.com/Oli_Mueller01
Vimeo.com/olivermueller

Oliver is an award-winning filmmaker based in Bristol and Manchester, with awards from the 39th International Wildlife Film Festival, The American Conservation Film Festival 2016, Wild Film Fest 2016 and Vimeo staff Pick.
He is currently working as a freelance camera assistant/operator.

Rob Nelson – DOP/Producer/Marine Biologist/Host
Untamed Science
Address: Charlotte, NC, USA
Main listing in 'Production Companies' on Page 44-45

Wolfgang Neun – Macro Cameraman / Zoologist
Address: Würzburg, GERMANY
Wildlife-film.com/-/WolfgangNeun.htm
Main listing in 'Experts/Scientists' on Page 244

Will Nicholls – Camera Operator / Camera Assistant
Address: Bristol, UK
Phone: +44 7854 148 817
Email: will@willnicholls.co.uk
Website: www.willnicholls.co.uk
Facebook.com/NichollsPhotography
Twitter.com/WRNicholls
Wildlife-film.com/-/WillNicholls.htm

Will is a Zoologist and wildlife film-maker based in Bristol, UK. A new face in the wildlife film industry, Will specialises in rainforest environments and speaks Spanish and Indonesian. He is also Rainforest Canopy Access qualified and loves a challenge.

Pim Niesten – Award-winning Wildlife Camera Operator, Filmmaker and Zoologist
Address: Kadodderstraat 98, 2800 Mechelen, BELGIUM
Phone: +32 (0)485 593 049
Email: pimniesten@hotmail.com
Website: www.pimniesten.wixsite.com/wildlifefilm
Wildlife-film.com/-/PimNiesten.htm

Pim is an award-winning camera operator and filmmaker specializing in Natural History and with a background · Masters · in Zoology and Marine Biology. He has filmed worldwide for wildlife series and documentaries for BBC, National Geographic, NDR and many others. 'Megeti, Africa's Lost Wolf', a wildlife documentary on the Ethiopian wolves has been awarded 8 times at festivals worldwide. The BBC series 'New Zealand' won the Best Cinematography award at Green Screen Festival and the Deutsher Naturfilmpreis and was nominated for Outstanding Cinematography at the International Emmy Awards 2017. Being a professional wildlife camera operator since 2006 (more than 12 years of experience) Pim has built up a large variety of wildlife filming experience including long lens, macro, drone, set work, high speed, time-lapse, infrared. Besides being multi-skilled he is also proactive and creative in thinking and executing and has a great eye for detail. His social skills, knowledge of various languages (fluent in Dutch, French and English, notions of Spanish) and passion for both nature and film makes Pim a trustworthy and very valuable team member. He can easily merge his extensive knowledge as a biologist with the technical approach and visual language required in filmmaking. Blessed with a strong endurance and a good shape, Pim is able to cope ·both physically and mentally· with very demanding situations and hostile locations, while always maintaining a positive attitude. Please have a look on his website for more information and examples of his work: pimniesten.wixsite.com/wildlifefilm

Ivo Nörenberg - Cameraman
Gulo Film Productions
Address: Bornholdts Treppe 3, Hamburg 22587, GERMANY
Phone: +49 4082 3036 & +49 1793 996 264
Fax: +49 4086 642 611
Email: ivowildlife@gmail.com
Website: www.gulofilm.de/en
Wildlife-film.com/-/Gulo-Film-Productions.htm

Long Lens Cameraman. Experience all over the world.

Simon Normanton – Director/Cameraman/Sound Recordist
Lighthouse Films
Address: Based in SE Asia and the Pacific as of April 2018
Phone: +44 (0)7850 054 590
Email: simon@lighthouse-films.co.uk
Website: www.lighthouse-films.co.uk

161

Lighthouse has experience of making factual films in many countries around the world; films of a wide variety of subjects and styles but predominately character-driven 'travel and exploration' and 'people and wildlife', the world through other's eyes and experience.

Stan Nugent – Camera Operator / Producer / Editor
Waxwing Wildlife Productions Ltd
Address: Ennis, Co. Clare, IRELAND
Main listing in 'Production Companies' on Page 47

Sam Oakes – Camera Operator / Assistant
Address: Richmond, North Yorkshire, UK
Phone: +44(0)7979 845 190
Email: sam@samoakesfilms.co.uk
Website: www.samoakesfilms.co.uk
Facebook.com/samoakesfilms

Sam is an enthusiastic and motivated wildlife camera operator/assistant. With a passion for producing meaningful and visually stunning work, Sam has worked on a range of wildlife film projects in the UK and overseas. His resilience and ability to thrive in the toughest conditions are vital when telling the stories of enigmatic species living on the edge. A strong academic background and wide range of research experience are applied to Sam's work, complimenting technical skills and a meticulous attention to detail.

Frederique Olivier
Address: PO Box 147 South Hobart, Tasmania 7004, AUSTRALIA
Phone: +61 400 511 800
Email: pagodroma@gmail.com
Website: www.fredpics.com
Photolibrary: www.fredpics.smugmug.com
Facebook.com/frederique.olivier.5
Linkedin.com/pub/frederique-olivier/25/aa0/12a
Wildlife-film.com/·/FrederiqueOlivier.htm

I have over 15 years experience in documentary production and worked in various positions from field logistic support, photography, sound recording and now mostly cinematography. I am catering production styles for both web/multimedia and standard broadcast. I have solid guiding and expedition background, am used to working in remote areas and certainly an extreme environment specialist from polar to tropical with a variety of species. Programs were essentially natural history (BBC NHU), science, various human documentaries (ABC, SBS), conservation and educational programs. Specific recent camera experience includes remotely controlled cameras, stabilized systems and drones (licensed operator). RED Scarlet W owner. Recent shoots were for BBC Spy in the Wild and a Disney Nature feature film. Looking for proposals in wildlife, conservation, adventure or the combination of the three!

Bernhard M. Pausett – Camera / Producer / Fixer / Assistant
BMP Filmproduksjon
Address: Oslo, NORWAY
Wildlife-film.com/·/BernhardMPausett.htm
Main listing in 'Production Managers' on Page 199

Rubén Duro Pérez – Camera Operator/Scientific Advisor/Scientific Photographer/Producer/Director
Address: Dosrius, SPAIN
Wildlife-film.com/·/RubenDuroPerez.htm
Main listing in 'Producers/Directors' on Page 188

Jack Perks – Camera Operator/Photographer/Presenter/Researcher
Jack Perks Wildlife Media
Address: Nottingham, UK
Wildlife-film.com/·/JackPerks.htm
Main listing in 'Production Companies' on Page 26

Daniel Pinheiro – Producer / Director
Wildstep Productions
Address: Mogofores, PORTUGAL
Wildlife-film.com/·/DanielPinheiro.htm
Main listing in 'Production Companies' on Page 49

Ben Please - Composer/Sound-design/Camera-person/Editor
Harbour Studio
Address: Wigtown, Dumfries and Galloway, Scotland, UK
Main listing in 'Music Composers' on Page 233

Olivia Prutz – Freelance Camera Operator and Editor
Country: London, UK
Phone: +44 (0)7384 586 897
Email: contactme@oliprutz.co.uk
Website: www.oliprutz.co.uk
Twitter.com/OliPCameraman
Facebook.com/oliprutz.cam
Wildlife-film.com/·/OliviaPrutz.htm

Freelance camera operator and editor based in London, working nationally and internationally. Experienced with a wide range of camera and lighting equipment and various post production software as well as being qualified for aerial work. Up-to-date HEFAT training (Hazardous Environment and Emergency First Aid) and currently undergoing Medic training with the UK Army Reserves. Particularly interested in working on conservation, environmental advocacy and human interest documentaries as well as adventure/expedition projects.

Jeff Reed – Chief Operations Officer/Producer/DOP/Editor
Ocean Media Institute
Address: Bozeman, Montana, USA
Email: jeff@oceanmediainstitute.org
Main listing in 'Production Companies' on Page 34

Will Ridgeon – Cameraman/Producer/Director
Address: Bristol, UK
Main listing in 'Producers/Directors' on Page 188

163

Anthony Roberts
ZED Creative
Address: Trefriw, Conwy, UK
Phone: +44 (0)7789 071 038
Email: anthony@iamzed.co.uk
Website: www.iamzed.co.uk
Facebook.com/ZED.Creative.Anthony
Twitter.com/ZedAnthony
Wildlife-film.com/·/AnthonyRoberts.htm

Independent Motion Graphics designer, covering 2D animation, 3D modelling and animation. Also wildlife and landscape photography and Timelapse. Showreel available here: Vimeo.com/174491132

Tom Rowland – Camera Operator/Assistant & Researcher
Address: Bristol, UK
Main listing in 'Assistants' on Page 208

Patrick Rouxel
Tawak Pictures
Address: Paris, FRANCE
Email: patrickrouxel@hotmail.com

Freelance cameraman or director for environmental conservation films.

Colin Ruggiero - Independent Filmmaker/DP/Photographer
Rhythm Productions, LLC
Address: 245 Burlington Ave., Missoula 59801, USA Phone: +1 406 570 9532
Email: ruggiero.colin@gmail.com

Website: www.colinruggiero.com
Facebook.com/colinruggierophotography
Twitter.com/RuggieroColin
Instagram.com/colinruggiero
Linkedin.com/in/colinruggiero

I'm an independent filmmaker and photographer in Missoula, Montana. I received my M.F.A. in Science and Natural History Documentary Filmmaking from Montana State University in 2005 and since then have produced a variety of award-winning independent films and shorts for both broadcast and independent release and shot for National Geographic, Discovery, and the BBC, among many others. My love of the ocean led to my award-winning 2014 film, *Exuma*, about the Bahamas, as well as underwater cinematography work for clients such as the Bahamas National Trust, The Canadian Film Board, The Mexican Board of Tourism and National Geographic Wild. I am currently a filmmaking instructor at the Rocky Mountain School of Photography where I teach workshops for their Advanced Intensive program and am the workshop instructor for the Ocean Media Institute. Current projects include a short film about the reintroduction of bison to the American West for the National Wildlife Federation, a short film about the Exuma Cays Land and Sea Park for the Bahamas National Trust and an ongoing series of short videos about shooting timelapses called, *Chasing Light*, for the State of Montana. I'm available for freelance camera and production work and complete film production as well as workshops and teaching.

Alberto Saiz – Producer / Cinematographer
NaturaHD Films
Address: Madrid, SPAIN
Main listing in 'Production Companies' on Page 31

Nuno Sá - Cameraman / Director
Atlantic Ridge Productions
Address: AZORES, PORTUGAL
Main listing in 'Production Companies' on Page 12

John Samuels
Address: Glastonbury, Somerset, UK
Phone: +44 (0)1458 860103 and +44 (0)7974 354660
Email: john@johnsamuels.co.uk
Website: www.johnsamuels.co.uk

Documentary and natural history lighting cameraman /DOP, with 30 years experience. Versatile; creative; flexible bringing experience from a wide cross section of work from past projects. I like to work on travel and adventure filming or any human interest films. I have a particular interest in ecological and environmental and human interest films. Three times RTS winner for factual productions. Taking commissions and collaborations from any global location. I can supply my on Panasonic Varicam 4K camera kit.

Phil Savoie – Director/Camera
Frog Films
Country: Montana, USA & UK
Main listing in 'Production Companies' on Page 22

Tulio Schargel – Camera Operator/Producer
Marca D'agua Filmes
Address: São Paulo, BRAZIL
Main listing in 'Producers/Directors' on Page 190

Werner Schuessler – Director/Producer/Writer/DOP
¿are u happy? films
Address: Freiburg, GERMANY
Main listing in 'Production Companies' on Page 11

Gavin Shand
Address: Glasgow, Scotland, UK
Phone: +44 (0)7732 412 950
Email: gpshand@hotmail.co.uk
Facebook.com/gavinshandphotography
Twitter.com/gpshand
Linkedin.com/in/gavin-shand-4ab548104
Wildlife-film.com/·/GavinShand.htm

Shooting Junior Researcher with a MA in Wildlife Filmmaking and a BSc in Earth Science. I am reliable, organised and motivated. I am very comfortable working with contributors and experienced with a range of cameras and editing software. I have experience in location shooting for BBC One Scotland's *Landward* and for *David Attenborough's Natural Curiosities*.

Mark Sharman – CINEMATOGRAPHY • UNDERWATER • PEOPLE • WILDLIFE
Address: West Sussex, UK
Phone: +44 (0)7779 227 307
Email: mark@sharmancam.co.uk
Website: www.marksharman.co.uk
Facebook.com/marksharmancinematography
Twitter.com/MarkSharmanCam
Instagram.com/marksharmancam

Mark is an in-demand cameraman best known for creating cinematic visuals and sequences in wildlife film-making, experienced with the demands of underwater, topside and aerial camerawork. As comfortable filming presenters and contributors as creating pure wildlife sequences, Mark is a highly skilled and incredibly versatile cameraman, working on mainstream presenter-led programmes to blue chip wildlife sequences. Mark is an experienced HSE Commercial Diver, rebreather diver / owner and CAA qualified drone pilot. Mark provided the underwater cinematography for the award-winning film *Jago: A Life Underwater*, which included: Winner of the Grand Teton Award at Jackson Hole Wildlife Film Festival, 2015; Winner of the Cinematography (small crew) Panda Award at Wildscreen Festival, 2016; Winner of the Cinematography Award at Royal Television Society West of England Awards, 2017

Tim Shepherd - Specialist Cameraman
Email: timshepherd5@aol.com

Specialist plant timelapse and macro cameraman. Fully equipped studio with Digital SLR cameras for timelapse. Timelapse motion control capability. Experienced with 3D and IMAX timelapse. Emmy awards for cinematography · BBC series *Private Life of Plants* and BBC series *LIFE*. 33 years experience.

Steven Siegel – Videographer/Producer/Director/Expert
Raven On The Mountain Video
Address: Placitas, New Mexico, USA
Main listing in 'Producers/Directors' on Page 190

Mark Slemmings – Underwater/Topside Cameraman/Photographer
Country: UK
Phone: +44 (0)7799 525 216
Email: cameraman@slemmings.com
Website: www.slemmings.com

Ettiene Snyman - Cameraman
Address: PO Box 1846, Jukskeipark, Randburg, Gauteng 2153, SOUTH AFRICA
Phone: +27 82 445 1356
Email: etticam87@gmail.com

DOP for all your Southern African productions/adventures... Conservation related adventures. Wildlife with human-interest as main theme. Pure wildlife.

Yann Sochaczewski – Camera/Producer
Altayfilm GmbH
Address: Gruenheide, GERMANY
Main listing in 'Production Companies' on Page 9

Jesper Sohof – DoP
engcrew.tv
Address: Skoletoften 6, Hinnerup 8382, DENMARK
Phone: +45 6113 5933
Email: info@engcrew.tv
Website: www.engcrew.tv and www.visualizacomunicacion.com
DoP: Jesper – jesper@engcrew.tv

DoP Services.

David Spears – Director/Specialist Macro Cameraman
Western Science Events CIC
Address: Taunton, Somerset, UK
Main listing in 'Experts' on Page 244-245

Sinclair Stammers – Cameraman/Scientific Photographer
micromacro
Address: Cilgwyn Mill, Ardwyn Terrace, Adpar, Newcastle Emlyn, Ceredigion SA38 9EF, UK
Phone: +44 (0)1239 711 643 & +44 (0)7977 090 163
Email: sinclair@micromacro.co.uk & ampyx1@mac.com
Facebook.com/sinclair.stammers
Twitter.com/micromacro
Website: www.micromacro.co.uk

Services include specialist camerawork such as filming through the microscope and macro photography. Quality is everything and the High Definition footage is recorded to a 10 bit recorder. Scientific film making is my main interest. Internships are welcome.

Christian Stehlin – Cameraman & Crew
Address: Balearic Islands, SPAIN
Phone: +34 871 151 207 Mobile: +34 635 995 232 (WhatsApp)
Skype: tv-cameraman_spain
Email: ces-contact@xdcam-cameracrew.eu
Website: www.xdcam-cameracrew.eu
Xing.com/profile/Christian_Stehlin
Linkedin.com/pub/christian-stehlin/56/535/489
Wildlife-film.com/-/ChristianStehlin.htm

Services all year round in Mallorca/Spain: Cameraman / Camera Crew (XDcam Broadcast & F5 Cine). NLE-Cutter (FCP, DaVinci). Mobile operation of ENG-Editing. Documentary Film/TV Comment/Live Report/Short Film/Scenic Shooting/Making-of/2nd Unit Camera.

Darryl Sweetland – Cameraman/Biologist/Writer
Asian Wildlife Films
Country: THAILAND
Phone: +66 81 532 0303
Email: darrylsweetland@yahoo.com
Wildlife-film.com/-/DarrylSweetland.htm

Biologist, writer, and cameraman, Darryl has lived and worked in Thailand since 1996. He speaks, reads, and writes Thai. Darryl has extensive experience of looking for and filming Thai wildlife and most often this involves spending long periods in hides and camping in the forest, which is something he loves. From Oct 2007 to March 2010 Darryl was a regular contributor to www.earth-touch.com (Wild Touch · SABC2), and some of his work can be viewed in the Thailand section of their website. Darryl offers a wide range of services to film crews wishing to work in Thailand.

Humphrey Tauro – Camera Operator
Address: 61 Marlborough Avenue, Glasgow G11 7BS, SCOTLAND, UK
Phone: +44 (0)7776 107 126 & +44 (0)1413 576 544
Email: humphrey.tauro@gmail.com

Experienced HD camera operator, having worked in extreme conditions & extreme locations.

Frederik Thoelen – Camera Operator / Editor
Wild Things
Address: Hasselt, BELGIUM Phone: +32 486 568 275
Email: frederikthoelen@yahoo.com
Website: www.wild-things.be
Facebook.com/WildThingsNatuur

I'm a graduated biologist, and an amateur wildlife filmmaker, mainly specialized in European wildlife. I have a special interest in larger mammals, like badgers, beavers,... This involves infrared filming. My first longer movie was about the life of a badger family in the fantastic Belgian Voer-region. It won some awards in Belgian and French film festivals. I'm mainly interested in small film projects concerning European wildlife. I also have a special interest in reintroduction programs.

Gavin Thurston – Cameraman/Director/DOP/Presenter/Inventor
Country: UK
Email: gavinthurston@me.com
Website: www.gavinthurston.com
Twitter.com/gavinthurston
Instagram.com/thegavinthurston

Gavin is a BAFTA, EMMY, RTS, GTC award winning veteran cameraman and presenter. He is available as cameraman, Director of Photography, Director, presenter, consultant, training, talks and university lectures. His company Moving Picture Hire Ltd for camera, lens and grip hire: www.movingpicturehire.com Instagram.com/movingpicturehire

Gareth Trezise - Cameraman
Address: Bristol, UK Phone: +44 (0)7921 517 420
Email: garethtrezise@wildlifeinmotion.com
Website: www.wildlifeinmotion.com
Facebook.com/gareth.trezise
Twitter.com/GarethTrezise
Vimeo.com/wildlifeinmotion
Wildlife-film.com/-/GarethTrezise.htm

I'm a wildlife cameraman and film-maker interested in all things wildlife, from the animals themselves to the people who help conserve them & their habitat. Along the way I have been fortunate to have worked with some great people like Sir David Attenborough, Mike Dilger, Jonathan Scott, Richard Brock. I have a strong passion for Africa. I also supply stock footage & edit.

Laura Turner – Camera Operator/Filmmaker/Editor
Fuzzfox and The Wildlife Garden Project
Address: Nottingham, UK
Wildlife-film.com/-/LauraTurner.htm
Main listing in 'Editors' on Page 228-229

Nick Turner
Address: 8 Upper Dorrington Terrace, Stroud GL5 2JE, UK
Phone: +44 (0)7956 229 591
Email: nickturnerphoto@me.com
Website: www.nickturnerphoto.com
www.iawf.org.uk/profiles/member.asp?membersid=1085
Facebook.com/nick.turner.3572 Twitter.com/nickturnercam
Linkedin.com/in/nickturnerphoto

Natural history and documentary cameraman with 17 years experience working in diverse locations worldwide. Extensive knowledge of remote camera systems, night filming techniques and motion control time-lapse. As well as undertaking sequence work I also run a specialist broadcast hire company TSHED - www.tshed.co.uk, building and hiring innovative new bits of kit including night vision cameras/time lapse gear and more.

Oliver Upton – Shooting AP / Researcher
Address: Rugeley, Staffordshire, UK
Wildlife-film.com/·/OliverUpton.htm
Main listing in 'Assistant Producers' on Page 239-240

Simon Vacher - Company and Creative Director
Simon Vacher Films Ltd
Address: Exeter Phoenix, Gandy Street, Exeter, Ex4 3LS, UK
Phone: +44 (0)7765 488 101
Email: info@simonvacherfilm.com
Website: www.simonvacherfilm.com
Facebook.com/simonvacherfilm
Twitter.com/SimonVacher
Vimeo.com/simonvacher
Linkedin.com/in/simonvacher
Wildlife-film.com/·/SimonVacher.htm

I've directed and shot epic sequences in some of the remotest, inhospitable and most challenging environments around the globe. From icy dry Antarctic tundras to humid sandy and salty environments of the Indian Ocean and Caribbean, I've also filmed in other challenging environments such as at sea in boiling oceans and deep inside bat caves. Each environment brings a unique set of challenges, from understanding what camera kit is required and how camera equipment performs, to the needs of the human body in each environment to maintain peak performance. At the heart of all my shooting work is the ability to craft sequences into a story that form the narrative of a documentary, despite sometimes being a bit uncomfortable. Only then can I say to the director, 'We've got the shot'. My camera-work has recently featured presenter-led documentary programmes for National Geographic, BBC 2 and BBC 4 and I regularly shoot for independent production companies commissioned by independent channels such as Channel 4. I have a track record for filming and producing contributor led stories for television, online, short-film and cinema. I have real-world field experience filming on a range of cameras including the Sony F5/F55, Sony FS7, Sony PDW-700, Sony PMW-500 Sony PMW-200, Sony EX1, Sony EX3, Canon C300, Canon XF305 with extensive remote field experience in data wrangling, clip review and backup. I've also undertaken professional payload training with Airborne Image Solutions for drone-based photography, and I've deployed, rigged and operated camera cranes and sliders in some of the harshest environments on the planet.

Tim Visser – Wildlife Cameraman/Producer
Wild Step
Address: Den Bosch, The Netherlands
Wildlife-film.com/·/TimVisser.htm
Main listing in 'Production Companies' on Page 50

Thomas Wiewandt – DOP/Producer
Wild Horizons Productions
Address: Tucson, Arizona, USA
Main listing in 'Production Companies' on Page 48

David Wright – Cinematographer/DP
LunaSea Films
Address: Appleton, Maine, USA Phone: +1 912 230 4019
Email: hdcamera@me.com
Website: www.expeditioncamera.com
Twitter.com/LunaSeaFilms
Linkedin.com/in/expeditioncamera

An Award winning cameraman / producer. Worked in over 60 countries and now based in the US. Science, adventure, history and natural history.

Kim Wolhuter – Producer/Cameraman/Talent
Mavela Media
Address: White River, SOUTH AFRICA
Main listing in 'Production Companies' on Page 30

Joe Yaggi - DOP
Jungle Run Productions
Address: Jalan Raya Sanggingan #1. Ubud 80571, Bali 80571, INDONESIA
Phone: +62 812 381 3887 & +62 361 979 109
Fax: +62 361 975 378
Email: info@jungle-run.com or joe@jungle-run.com
Website: www.jungle-run.com
Wildlife-film.com/·/JoeYaggi.htm
Also see in 'Production Companies' on Page 26-27

I'm a freelance director and cameraman based in Indonesia. I've worked across the Indonesian archipelago and right across the region. Projects I've worked on range from wildlife to social issues, conservation to education. I've contributed to feature docs, factual programs and educational productions as well.
Some of my recent credits include:
History of the World, BBC1 · Indonesia camera unit.
Trashed, Blenheim Films: A feature documentary presented by Jeremy Irons · Indonesia camera unit.
Alien from Earth, PBS Nova & ABC Australia · 2nd unit camera
Heads Above Water, BBC World – DOP, Co-Director Indonesia
Age of Stupid, Feature Documentary Launch USA – Greenpeace Director/DOP
Indigenous rights activist in a burned out forest beamed live to 600 screens across America. For more please see our website and IMDB.

171

SOUND OPERATORS/RECORDISTS

Alien Sound Inc.
Address: 5610 Barton Rd, North Olmsted, OH 44070, USA
Phone: +1 (216) 789 2337 (mob) +1 (440) 777 4708 (office)
Email: aliensound@mac.com
Website: www.aliensound.net
Wildlife-film.com/-/JonathanAndrews.htm
Contact: Jonathan D. Andrews - CAS, Mixer

At Alien Sound we specialize in Sound Recording for Wildlife and Expedition shoots. Whether you're looking for one Sound Mixer or a fully equipped sound crew we are the people to talk to. Recent projects include *Expedition Impossible* (ABC), *Out of the Wild: Alaska* and OTW: *Venezuela* (Discovery), *Hillbilly Hand Fishin'*, (Animal Planet), *Expedition Alaska*, *Jews on Bikes* and *Survivor* seasons 10 through 36.

Felix Blume – Sound Engineer/Sound Recordist
Address: Lieu dit Calot, Azillanet 34210, FRANCE
Phone: +33 63 736 0074 and +52 155 2694 1601
Email: felix.blume@gmail.com
Website: www.felixblume.com
Facebook.com/felixblume
Twitter.com/felixblume
Soundcloud.com/felixblume

Felix Blume is a independent sound-engineer working mostly as a sound recordist on documentary film. He has been filming in Europe, Africa and America. He currently lives between Mexico, France and Belgium.

Mike Brink – Sound Recordist/Camera Operator
Address: P.O.Box 2599, Northcliff, Johannesburg, SOUTH AFRICA
Phone: +27 82 892 0183
Email: mikebrink@lantic.net

30+ years experience in film and TV industry. Camera operator and sound recordist with wildlife and nature experience.

172

Carlo Comazzi - Sound Engineer
Garage Studio di Comazzi Carlo
Address: Milan, ITALY
Phone: +39 348 550 4006
Email: carlo.comazzi@gmail.com

Post-Production Sound, Location & Studio Recording.

Steve Cummings – Sound Recordist – Camera Operator
Steve Cummings Sound
Address: Halifax, West Yorkshire, UK
Phone: +44(0)7717 615 518
Email: steve_cummings@btinternet.com
Website: www.stephencummings.co.uk
Twitter.com/SteveLeBoom

Award winning cameraman turned sound recordist with live TV, documentary and feature film experience looking for more factual sound recording opportunities.... documentary and wildlife. Fully kitted out with Sound Devices mixers and recorders, radio mics, sync kits and specialist mics Years of fieldcraft experience in many countries, particularly arid, desert environments. Interested in all proposals of presenter-led, conservation-focused, wildlife or social commentary/human interest themes.

Axel Drioli – Sound Recordist
Address: 14C Alexandra Drive, London SE19 1AJ, UK
Phone: +44(0)7460 223 640
Email: 3dsound@axeldrioli.com
Website: www.axeldrioli.com
Twitter.com/Axel3DSound Facebook.com/profile.php?id=100009722434245
Linkedin.com/in/axeldrioli
Wildlife-film.com/·/AxelDrioli.htm

I am currently freelancing as immersive audio producer. My focus is on Immersive Storytelling/Documentaries and how to integrate Spatial Sound to make immersive experiences more convincing and emotional. The goal is to make people aware of nature, wildlife and people, using immersive audio.'
I am constantly looking for interesting projects to work on, so feel free to send me an email to discuss, there is always time to have a chat.

Tania Rose Esteban – Wildlife Filmmaker/Zoologist
TRE Productions
Address: Bristol, UK
Wildlife-film.com/·/TaniaEsteban.htm
Main listing in 'Researchers' on Page 201

Jez riley French – field recordist, composer, artist
Address: East Yorkshire, UK
Email: tempjez@hotmail.com
Website: www.jezrileyfrench.co.uk
Twitter.com/jezrileyfrench
Wildlife-film.com/·/JezrileyFrench.htm

Composer/field recordist & artist with over 30 years experience of working with & developing extended field recording methods. In collaboration with film makers, my input has been to highlight the often hidden or overlooked sounds around us. I am known in particular for my work with surface vibrations & underwater sounds. I also tutor on workshops about the art of field recording.

Angel Perez Grandi – Sound Operator
Sound Ark
Address: 22 Trustan Road, Mackan, Enniskillen, Co. Fermanagh BT92 3GJ, UK
Phone: +44 7730 368 812 (mobile) and +44 2866 349 844 (landline)
Email: contact@soundarkstudios.com
Website: www.soundarkstudios.com
Twitter.com/soundarkstudios
Soundcloud.com/angelpgrandi

We provide Location Sound Recording, Custom Sound Effects and Audio Post Production as well as Audio Equipment Hire · we are based in Ireland and deliver island-wide on short notice. We have experience ranging from independent productions to major features and primetime television shows · no project is too big or small. We are always looking to get involved in any projects relating to natural history, and the natural world in general. Currently not offering work experience.

Steve Hamel – Biologist/Camera Operator/Sound Recordist
Address: Montreal, Quebec, CANADA
Main listing in 'Camera Operators' on Page 150

Dick Harrewijn – Sound Operator/ Freelance Cameraman
Address: Rhenen, NETHERLANDS
Wildlife-film.com/·/DickHarrewijn.htm
Main listing in 'Camera Operators' on Page 150-151

Daan Hendriks - Field Recordist / Sound Designer
Country: Sheffield, UK
Phone: +44 (0)7842 917 821
Email: daan.hendriks@gmail.com
Website: www.daanhendriks.co.uk
Twitter.com/Audiodaan
Linkedin.com/in/daanhendriks
Wildlife-film.com/·/DaanHendriks.htm

I am a field recordist and sound designer. As a recordist I have extensive experience recording in remote locations in technically challenging situations. My main love and favourite recording topic is African wildlife sounds, and have to date released several sound effects libraries with African nature and wildlife as themes. I am also a qualified FGASA Level 1 guide. FGASA is the Field Guide Association of Southern Africa. As a sound designer, I have to date worked primarily in the video games industry. I am interested in any and all projects that require pristine audio recording and/or sound design/audio post production.

174

Nick Jones - Sound Recordist and Transcriber
Country: UK
Phone: +44 (0)7730 615 546
Email: nick@nickjonesmedia.com
Website: www.nickjonesmedia.com
Twitter.com/nickjonesmedia
Wildlife-film.com/-/NickJones.htm

I'm a BBC trained sound recordist with over thirteen years experience working with audio. I've mixed in both studios and on location in the UK and across Europe and have covered everything from news to reality television, drama to commercials. I have my own kit, including stereo setups and specialist mics.

Jonathan Kawchuk
Address: UK and CANADA
Email: jonathan.kawchuk@gmail.com
Website: www.jonathankawchuk.com
Film Reel: jonathankawchuk.com/reel
Twitter.com/jonathankawchuk
Instagram.com/jonathankawchuk
Wildlife-film.com/-/JonathanKawchuk.htm

Jonathan Kawchuk is an award-winning composer from Alberta. He has scored the feature films, *Memento Mori* (National Film Board of Canada), for which he was nominated for a 2017 Alberta Film and Television Award in the category of Best Original Musical Score (Non-fiction Over 30 Minutes), and *Clara* (Serendipity Point Films), as well as the Norwegian documentary web series, *Fra Ungdommen*, and a video feature for *Vogue Italia*. Kawchuk has experience writing internationally for multiple short films, theatre projects and sound installations. As a technician, he worked on albums for Nico Muhly and Ben Frost, and as an assistant sound tech for the Philip Glass Ensemble on *Music in 12 Parts*, in London. Kawchuk also is signed to Paper Bag Records as a recording artist. For his debut album, he lived and recorded in natural environments across Europe, North America and Asia. Kawchuk studied at multiple institutions and completed his Bachelor of Music, Honours, First Class, at the Liverpool Institute of Performing Arts. In addition to his formal education, he has held a recording internship in Iceland, learned gamelan in Indonesia, and studied wildlife field recording in England under Chris Watson (*Frozen Planet, Nova*).

Joe Knauer – Sound Recordist
Joe's Location-Sounds
Address: Hoetzendorfgasse 6, Vienna A-1020, AUSTRIA
Phone: +43 2242 311 61 & +43 (664) 11 22 132
Email: joe@location-sounds.com
Website: www.location-sounds.com

I'm based near Vienna, but am used to working around the globe... Location sound recording for all kind of programs with full sound kit available... Used to working under difficult conditions, like expeditions to jungles, deserts, mountains... Expedition approved. Additionally, I offer a 9m camera crane with hothead. I'd love to go to the jungles...

Angela McArthur – Sound Recordist/Designer
Address: Rochester, Kent, UK
Phone: +44 (0)7540 066 116
Email: mackangie@gmail.com
Website: www.angelamcarthur.com/audio

175

Full 3D audio pipeline. Winner of Mutiny Media award for VR sound design 2017. Location wildlife recording for spatial audio applications, working with both soundfield (ambisonics) and object based audio. Studio recording, ADR, foley and FX. Spatial audio design and outputting to headset (VR) or multichannel speaker systems. Audio post production: sound design, mixing, audio repair etc for static (DAW) and interactive (games engines) applications.

Simon Normanton – Sound Recordist/Cameraman
Lighthouse Films
Address: Lincolnshire, UK
Main listing in 'Camera Operators' on Page 161

Frederique Olivier
Address: Tasmania, AUSTRALIA
Wildlife-film.com/·/FrederiqueOlivier.htm
Main listing in 'Camera Operators' on Page 162

Gregory Ovenden – Location, Outside Broadcast and Post Production Sound
The Sound Farmer
Address: Garden Cottage, Holwood, Keston, Bromley, London, BR2 6HB, UK
Phone: +44 7732 125 827
Email: gregoryovenden@gmail.com
Website: www.thesoundfarmer.com
Facebook.com/ovendensoundfarmer
Twitter.com/thesoundfarmer
Instagram.com/thesoundfarmer
Wildlife-film.com/·/GregoryOvenden.htm

I offer location sound recording, outside broadcast sound engineering, field recording and post production sound services for television and radio. I have had a life long interest in natural history and conservation and would like to offer my skills to any and all productions in these fields. I have multiple credits for working on BBC *Springwatch*, *Autumnwatch* and *Winterwatch* for the outside broadcast element of the live shows. I have also contributed location sound and field recording on PSC shoots for VTs for the Watches, *The One Show* and *Tweet of the Day* for the BBC Natural History Unit. I have a range of sound recording equipment at my disposal for whatever the job requires!

Daniel Pinheiro – Producer / Director
Wildstep Productions
Address: Mogofores, PORTUGAL
Wildlife-film.com/·/DanielPinheiro.htm
Main listing in 'Production Companies' on Page 49

Brendan Rehill
Address: Dublin, IRELAND
Phone: +353 85 714 7757
Email: brendanjrehill@gmail.com
Website: www.brendanrehill.com
Twitter.com/BrendanJTR
Wildlife-film.com/·/BrendanRehill.htm

Location Recording and Post Production Services.

Mark Slemmings – Sound Recordist/Cameraman
Country: UK
Main listing in 'Camera Operators' on Page 167

Pete Smith
Address: Ground Floor Right, 10 Gladstone Terrace, Edinburgh EH9 1LU, UK
Phone: +44 (0)7732 283 081
Email: pete@thesoundspace.co.uk
Website: www.thesoundspace.co.uk
Twitter.com/PSoundRecordist
Wildlife-film.com/·/PeteSmith.htm

I am an experienced professional field recordist and sound designer with a keen interest in natural history and conservation. I have worked on all kinds of projects in the past including animations, feature films and documentaries and have a selection of very high quality kit. I am friendly and hard working and am used to working long hours outdoors and in harsh conditions.

Jobina Tinnemans – Wildlife Sound Recordist/Sound Production
Country: Pembrokeshire, UK
Main listing in 'Music Composers' on Page 234

Chris Watson – Sound Recordist
Country: UK
Phone: +44 (0)7976 794 638
Email: chrisw@filmcrew.co.uk
Website: www.chriswatson.net
Twitter.com/chrisrwatson
Wildlife-film.com/·/ChrisWatson.htm

Chris Watson is a sound recordist specialising in the wildlife sounds of animals and their habitats around the world. Watson also works in film and radio sound design which developed a particular interest in realising spatial sound installations for international festivals, museums and galleries.

177

PRODUCERS/DIRECTORS

Pawel Achtel, ACS
Achtel Pty Limited
Country: AUSTRALIA
Wildlife-film.com/·/PawelAchtel.htm
Main listing in 'Equipment Hire/Sales' on Page 122
Underwater specialist.

Trevor Almeida – Producer / DOP / Editor
Geonewmedia
Address: Glen Waverley, Melbourne, Victoria, AUSTRALIA
Main listing in 'Production Companies' on Page 23

Gil Arbel – Producer/Director
Address: PO Box 247, Or Akiva 3060000, ISRAEL
Phone: +972 544 527 664
Email: gilarbel@hotmail.com
Website: www.gilarbel.com

I'm a wildlife filmmaker. I'm currently working on a film about mountains gorillas in Rwanda. I'm looking for distributors/broadcasters for presale.
youtube.com/watch?v=RWWW8Sulg5o&t=24s

Steven Ballantyne – Producer, Field Director
EPM Asia Ltd
Address: 703 Beautiful Group Tower, 77 Connaught Rd, Central, HONG KONG
Phone: +852 6992 2571
Email: steven.epm@gmail.com
Website: www.epmasialtd.com
Facebook.com/epmasia
Twitter.com/epmasia
Wildlife-film.com/·/StevenBallantyne.htm

Established by Location Producer and Field Director Steven Ballantyne in 2007, EPM Asia has expanded over recent years to meet the growing needs of their blue chip production clients and in 2016 launched a dedicated office in China head-up by Mr. Weiyi Feng – "China is the ultimate filming destination with an amazing array of landscapes, cultures and wildlife"
See EPM Asia's listing in 'Location Managers' on Page 87

Abbie Barnes - Film-maker, Presenter and Conservationist
Song Thrush Productions
Country: United Kingdom
Wildlife-film.com/-/AbbieBarnes.htm
Main listing in 'Presenters' on Page 212-213

Christian Baumeister – Producer / Director / DoP
Light & Shadow GmbH
Address: Münster, GERMANY
Main listing in 'Camera Operators' on Page 138

Mr. Alain Beaudouard – Producer/Filmmaker
wallacea-films
Address: Jakarta & Bali, INDONESIA
Main listing in 'Production Companies' on Page 47

Andrew Bell – Producer/ Cameraman / Editor
Address: London, UK
Phone: +44 (0)7941 433 146
Email: ajb@andyjbell.co.uk
Website: www.andyjbell.co.uk
Linkedin.com/in/andy-bell-2398448b

Andrew is an award winning Producer/ Cameraman / Editor with considerable international media arena experience and a successful track record of delivering quality video content for broadcast over various delivery systems. Also organised and managed all aspects of international film shoots , film crews and actors. Managed administration, budgets, risk assessments, permission to film in wild locations, developed production schedules. He has produced numerous educational films winning a number of international industry awards, created documentaries to broadcast. Additionally a Multi skilled self shoot camera operator and Editor. Worked on films for the UN, Maritime industry, Underwater and Aerial films, created branded promotion films, Wildlife films, UK Government media films and a number of film shorts for festivals. Looking to make Adventure, presenter-led, conservation-themed, wildlife, fast-paced, human-interest documentaries. Will consider co-productions. Consider creating film for film festivals. Looking for Genuine business opportunities... No CVs.

Chiara A Bellati – Showrunner / Series Producer / Executive / Development
Address: SINGAPORE & UK
Email: cx@pobox.com
Linkedin.com/in/chiara-bellati-14073a1

Experienced Showrunner/Series Producer / Executive Producer and Development Lead in Specialist Factual/Natural History with knowledge or European, Asian and US Networks. Credits include BBC, Channel 4, Discovery, National Geographic, Nat Geo Wild!, UKTV, Discovery Science, Animal Planet, TVNZ, Mediacorp, Channel News Asia.

Mike Birkhead – Producer/Director
Mike Birkhead Associates
Address: Hurley, Berkshire, UK
Main listing in 'Production Companies' on Page 30

179

Jesse Blaskovits
Existential Productions
Address: Vancouver, CANADA
Main listing in 'Camera Operators' on Page 140

Emma Brennand – Self-Shooting Producer/Director
Address: Bristol, UK
Phone: +44 (0)7734 812 474
Email: emma.brennand@gmail.com
Twitter.com/brennandemma
Linkedin.com/in/emma-brennand-65228538

Emma is an experienced self-shooting producer director with experience across Live OBs, Presenter-led & Blue chip factual documentaries for BBC One & Two. She is a confident self-shooter most recently working as a self-shooting PD on *The One Show* VT inserts for the BBC NHU (2018/19 delivery). She also self-shot and edit produced the *Planet Earth 2: Mountains: Diaries*. She has a passion for combining traditional natural history filming with adventure film making to immerse an audience in a story. With a PhD in Environmental science and a back ground in journalism she has rigorous research and story finding skills. She enjoys bringing seemingly complicated stories to the screen in visual and creative ways. She has delivered original content for BBC One/Two, BBC News, BBC Earth & Radio 4. She is a visually ambitious director with experience setting up multi-camera remote and challenging shoots. Emma is an experienced scuba diving instructor, mountain leader with many years of experience working in and around boats.

Caroline Brett – Producer/Director/Writer
Shake The Tree Productions
Address: Keeper's Cottage, Rectory Road, Suffield, Norfolk, NR11 7ER, UK
Phone: +44 (0)1263 731659
Email: carolinebrett@mac.com
Wildlife-film.com/-/ShakeTheTreeProductions.htm

Caroline Brett (BSc Hons/Zoology, Bristol Uni.) is a highly experienced and award-winning producer/director/writer. She worked for 21 years for the prestigious Survival series including in Arctic Canada, in the rain forests of Sierra Leone and on a remote Vietnamese island. She also produced the highly successful *Predators* with Gaby Roslin and *Wild about Essex* with Tony Robinson. Caroline has recently produced and directed films on sharks, an island in the Indian Ocean and kestrels. She has photographs in the Robert Harding Agency, has numerous articles and eight books published. While working for Save Our Seas, the Foundation won many film awards including at Jackson Hole and Wildscreen film festivals. Caroline considers a few film proposals and co-productions on wildlife, animals and conservation for DVD, Internet, TV and cinema.

Hal Brindley – Producer, Cinematographer, Photographer, Editor, Presenter
Travel For Wildlife
Main listing in 'Camera Operators' on Page 141

Richard Brock – Executive Producer
Living Planet Productions/The Brock Initiative
Address: Chew Magna, Bristol, UK
Wildlife-film.com/-/Brock-Initiative.htm
Main listing in 'Production Companies' on Page 28-29

Karen Brooks: Researcher/Producer/Facilitator
Facilitation Southern Africa
Address: Johannesburg, SOUTH AFRICA
Wildlife-film.com/-/KarenBrooks.htm
Main listing in 'Fixers' on Page 87

John Brown – Director/Producer/Camera
Address: Oxford, UK
Main listing in 'Camera Operators' on Page 142

Giuseppe Bucciarelli – Producer/DOP
Terra Conservation Films
Address: Fiesole, ITALY
Wildlife-film.com/-/GiuseppeBucciarelli.htm
Main listing in 'Production Companies' on Page 42-43

Adrian Cale – Producer/Director/Cameraman
Address: London, UK
Phone: +44 (0)7789 205 211
Email: ade.cale@gmail.com
Website: www.adriancale.co.uk
www.dfmanagement.tv/television-presenters/adrian-cale

181

Twitter.com/AdrianPCale
Wildlife-film.com/-/AdrianCale.htm

Adrian is a highly experienced Producer, Director and Cameraman with credits across most major channels. He has also produced work for various global wildlife charities. An accomplished filmmaker and artistic cameraman with an eye for a shot, Adrian often leads projects from a simple idea right through the edit. He has a broad range of kit for hire and a strong stock footage library. He also occasionally presents and narrates. Credits include *The Great Butterfly Adventure* for BBC Four, *Panda Babies* for ITV and Nat Geo Wild and the 7-part series *Snow Leopards of Leafy London* for Animal Planet. As a freelancer Adrian is not looking for direct film proposals. Adrian does consider co-productions from fellow freelancers and production companies alike. Unfortunately Adrian does not offer work experience placements or internships.

Adam L Canning – Presenter & Filmmaker
Address: West Midlands, UK
Main listing in 'Presenters' on Page 214

Andy Brandy Casagrande IV – Cinematographer / Producer / Presenter
ABC4EXPLORE
Address: Naples, Florida, USA
Main listing in 'Production Companies' on Page 8

Mark Challender – Producer/Director/Photographer
Address: Yorkshire, UK / New York, USA
Phone: +44 (0)7976 057 682
Email: challender.mark@gmail.com
Website: www.markchallender.co.uk & www.challenderphotography.com
Twitter.com/MarkChallender
Linkedin.com/in/mark-challender-54606464

Mark Challender is a Producer/Director of Natural History, Adventure and Travel programming.
Having worked in the industry for more than twelve years and having filmed in almost every environment, he has a love of natural history and a passion for exploring the world and telling it's great stories. He's a self-shooter who operates a range of cameras and a stills photographer.
Whether in the field, or in the edit, he's created captivating content for the likes of the BBC, ITV, Channel 4, Channel 5, NBC, Discovery and Nat Geo Wild.
Not offering work experience, unfortunately, but CVs welcome.

Guy Chaumette – Underwater Cinematographer/Filmmaker/Photographer
Liquid Motion Film
Address: Cozumel, MEXICO
Main listing in 'Camera Operators' on Page 142

Diane Cirksena – Producer
Studio Ray
Address: Sarasota, Florida, USA
Main listing in 'Production Companies' on Page 41

Alice Clarke – Self-shooting PD/FCP Editor/Scriptwriter.
Address: Bristol, UK
Email: adc.super.t@gmail.com
Twitter.com/Alicatinbrizzle
Wildlife-film.com/-/AliceClarke.htm

Self-shooting PD, FCP editor and scriptwriter. Specialising in Natural History and factual documentary film production. Worked for 6 years with NHU Africa. Now freelancing for the BBC in Bristol.

Martin Cray – Director/Cameraman/DOP
Address: Abergaveny, UK
Main listing in 'Camera Operators' on Page 143

Michael Dillon - Producer/Director/Cameraman
Michael Dillon Film Enterprises
Address: Woodend, Victoria, AUSTRALIA
Main listing in 'Production Companies' on Page 30

Mark Dodd – Director/Cameraman.
1080 Film and Television
Address: Poringland, Norfolk, UK
Main listing in 'Camera Operators' on Page 145

Martin Dohrn – Director/Producer/Cameraman
Ammonite Ltd
Address: Bristol, UK
Wildlife-film.com/-/Ammonite-Films.htm
Main listing in 'Production Companies' on Page 9

Sara Douglas – Producer/Director
Address: Bristol, UK
Phone: +44 (0)7813 801 141
Email: sara.l.douglas@gmail.com
Linkedin.com/in/sara-douglas-68049a13

Producer/Director currently working on 3-parter mini-landmark series for the BBC. Previous projects include - *Big Cats*, *Big Blue Live*, *Japan: Earth's Enchanted Island's*. Extensive experience of working in remote and challenging environments.

Erik Fernström
Address: Gränna, SWEDEN
Main listing in 'Production Companies' on Page 19

Andrea Florence – Executive Producer
Aquila Films
Address: London, UK
Wildlife-film.com/·/Aquila-Films.htm
Main listing in 'Production Companies' on Page 11

Alastair Fothergill
Silverback Films
Address: Bristol, UK
Wildlife-film.com/·/Silverback-Films.htm
Main listing in 'Production Companies' on Page 40

Cheryle Franceschi – Conservation Filmmaker
Por Eco Productions, One Idea/Dos Languages
Address: Eldersburg, MD, USA
Main listing in 'Production Companies' on Page 37

Della Golding – Presenter/Producer/Remote Location Specialist
Address: Bristol, UK
Main listing in 'Presenters' on Page 217

Tamara Groves – Field Producer
Address: Bristol, UK
Phone: UK +44 7977 001 848 & US +1 34 74 764 990
Email: tamaragroves.producer@gmail.com
Website: www.tamaragrovesproductions.com
Facebook.com/tamaragrovesproductions
Instagram.com/tamarahilarygroves
Twitter.com/tamaragrovesTV
Twitter.com/TamaraLodge
Linkedin.com/in/tamara-groves-006b97149
Wildlife-film.com/·/TamaraGroves.htm

Experienced producer with strong storytelling, casting and interviewing skills . Ability to trouble shoot, work within tight budgets and creating engaging content. Loves collaborating closely with her team, writing treatments and beat sheets and working on a broad spectrum of documentary and factual including travel, food and natural history. Extensive experience setting up and producing shoots domestically and abroad (incl. hostile environments) and working with a variety of talent.

Neil Grubb
Roslin Nature
Address: 8 St Mark's Lane, Portobello, Edinburgh EH152PX, UK
Phone: +44 (0) 131 468 3201
Email: neil.grubb@virginmedia.com
Twitter.com/NeilGrubb
Vimeo.com/channels/roslinnature
Wildlife-film.com/-/NeilGrubb.htm

I am a wildlife film-maker and live in Roslin Glen in southeast Scotland. I make films to show at meetings of local and national wildlife and conservation groups and civic and community groups, including RSPB and Scottish Ornithologists Club (SOC) branch meetings. The films are about bird life and other wildlife in The Lothians, which are the counties surrounding Edinburgh in southeast Scotland. These films are made in my spare time - in my day job I work as a cardiologist at the Edinburgh Heart Centre.

Samuel Guiton – Director/Cameraman
Address: Montreuil, FRANCE
Main listing in 'Camera Operators' on Page 149

Mauricio Handler - Cinematographer / DP
Aquaterrafilms
Country: USA
Main listing in 'Camera Operators' on Page 150

Richard Hughes – DOP / Cameraman
Edge 2 Edge Films Ltd
Address: Kent, UK
Wildlife-film.com/-/RichardHughes.htm
Main listing in 'Camera Operators' on Page 153

Dr Ellen Husain
Ellen Husain Media
Address: Bristol, UK
Email: ellenhusain.media@gmail.com
Website: www.ellenhusain.com
Linkedin.com/in/ellen-husain-4475154a
Bafta.org/supporting-talent/breakthrough-brits/ellen-husain-producer
Twitter.com/ellen_husain

Ellen is an award winning freelance Producer/Director specialising in high quality underwater and terrestrial films. A BAFTA 'Breakthrough Brit' 2016/17, Ellen is a Producer on multi-award winning BBC1 Attenborough series, *The Hunt* (7 x 60' 2015), prior projects include BAFTA and Emmy-winning blue chip BBC series. Having travelled to around 40 countries she has a track record in remote locations and complex logistics. With a background in actuality and sync as well as major blue chip productions, she is a HSE-qualified professional SCUBA diver with a Ph.D. & M.Sc. in marine biology. She also writes for publication and has presented BBC output on topics of wildlife and marine conservation.

Alex Jones - Wildlife Cinematographer
Wildlife Film Productions
Address: 734 Esther Way, Redlands, California 92373, USA
Wildlife-film.com/-/AlexJones.htm
Main listing in 'Camera Operators' on Page 156

Dave Keet – Producer/DOP/Editor
Aquavision TV Productions (Pty) Ltd
Address: Johannesburg, SOUTH AFRICA
Wildlife-film.com/·/Aquavision-Productions.htm
Main listing in 'Production Companies' on Page 10

Dominique Lalonde – Producer/DOP/Editor/Photographer
Dominique Lalonde Productions
Address: Québec, CANADA
Wildlife-film.com/·/DominiqueLalonde.htm
Main listing in 'Production Companies' on Page 17

Peter Lamberti – Producer/DOP/Editor
Aquavision TV Productions (Pty) Ltd
Address: Johannesburg, SOUTH AFRICA
Wildlife-film.com/·/Aquavision-Productions.htm
Main listing in 'Production Companies' on Page 10

Mike Linley – Director/Cameraman
Hairy Frog Productions Ltd
Address: Norwich, Norfolk, UK
Wildlife-film.com/·/Hairy-Frog-Productions.htm
Main listing in 'Production Companies' on Page 24

Jaco Loubser – Senior Producer
Homebrew Films
Address: Cape Town, SOUTH AFRICA
Main listing in 'Production Companies' on Page 24

Douglas Lyon – Producer/Director
Excelman Productions
Address: Paris, FRANCE
Wildlife-film.com/·/Excelman-Productions.htm
Main listing in 'Production Companies' on Page 20

Arthur Machado – Producer/Editor/Photographer
Address: 25A Office Road, Christchurch, New Zealand
Phone: +64 22 199 2332

186

Email: arthur.machado@gmail.com
Website: www.arthurmachado.org
Linkedin.com/in/arthurmachado1
Twitter.com/arthurmachado
Vimeo.com/arthurmachado
Wildlife-film.com/-/ArthurMachado.htm

Arthur is an editor, producer, skilled photographer and enthusiastic cinematographer who is willing to work in any way related to wildlife. He is currently an advertising film producer in New Zealand.

Feisal Malik - Line Producer/Director/Camera/Fixer/Producer
Visual Africa Films Ltd
Address: Nairobi, KENYA
Wildlife-film.com/-/Visual-Africa-Films.htm
Main listing in 'Location Managers/Fixers' on Page 91

Angels Melange – Cinematographer/Filmmaker
Address: Barcelona, SPAIN
Main listing in 'Camera Operators' on Page 159

Alan Miller – Editor/Director/Writer
Shake The Tree Productions
Address: Suffield, Norfolk, UK
Wildlife-film.com/-/ShakeTheTreeProductions.htm
Main listing in 'Editors' on Page 226

Tom Mustill – Producer/Director
Address: London, UK
Email: tom.mustill@gmail.com
Website: www.grippingfilms.com
Twitter.com/tommustill
Instagram.com/tomperbole
Wildlife-film.com/-/TomMustill.htm

After a stint as a conservationist Tom has specialised in producing and directing films about people and animals, as well as occasional music videos, short docs and animations. Based out of London, most recently he's been directing on the follow-on series to *Human Planet* for the BBC. Before then he's P/D'd the BBC Natural Worlds *Giraffes: Africa's Gentle Giants*, *The Bat Man of Mexico* and *Kangaroo Dundee* which between them won multiple awards at Jackson Hole, Wildscreen, etc with *Giraffes* nominated for an Emmy. Before running his own company he worked for OSF on the RTS nominated *How To Win The Grand National* and for Windfall Films he directed the special episodes of the multi-award-winning (BAFTA, RTS, Broadcast) series *Inside Nature's Giants* for C4.

Joseph Muwowo – Production Consultant
Mystic Pictures Zambia
Address: Kitwe, ZAMBIA
Main listing in 'Location Managers/Fixers' on Page 89

Rob Nelson – Producer/Marine Biologist/Host
Untamed Science
Address: Charlotte, NC, USA
Main listing in 'Production Companies' on Page 44-45

187

Stan Nugent – Camera Operator / Producer / Editor
Waxwing Wildlife Productions Ltd
Address: Ennis, Co. Clare, IRELAND
Main listing in 'Production Companies' on Page 47

Vivian A. N. Nuhu – Producer/Coordinator
Address: Osu-Accra, GHANA, WEST AFRICA
Main listing in 'Fixers' on Page 89

Chris Palmer – Executive Producer
American University's Center for Environmental Filmmaking
Address: Washington DC, USA
Wildlife-film.com/-/ChrisPalmer-AUCEF.htm
Main listing in 'Education/Training' on Page 108

Rubén Duro Pérez
Address: Llinars, 11 CD 298, Dosrius 08319, SPAIN
Phone: +34 93 791 61 60 & +34 655 85 73 83
Email: tinyworldsmicro@gmail.com
Website: www.tinyworldsmicro.com
Twitter.com/TinyWorldsMicro
Facebook.com/tinyworldpage
Wildlife-film.com/-/RubenDuroPerez.htm

Camera operator, scientific advisor, producer, director, scientific photographer.

Daniel Pinheiro – Producer / Director
Wildstep Productions
Address: Mogofores, PORTUGAL
Wildlife-film.com/-/DanielPinheiro.htm
Main listing in 'Production Companies' on Page 49

Kate Raisz – Producer/Director/Writer
42°N Films
Address: Boston, MA, USA
Main listing in 'Production Companies' on Page 8

Jeff Reed – Chief Operations Officer/Producer/DOP/Editor
Ocean Media Institute
Address: Bozeman, Montana, USA
Email: jeff@oceanmediainstitute.org
Main listing in 'Production Companies' on Page 34

Will Ridgeon - Producer/Director/Cameraman
Address: Bristol, UK Phone: +44 (0)7940 747 526
Email: willridgeon@gmail.com
Twitter.com/Cameraman_will

I am a self-shooting Producer/Director specialising in wildlife television production and working predominantly at the BBC's Natural History Unit. Specialties: Landmark Bluechip, Presenter-led, Live Natural History, Underwater (HSE Media diver and rebreather diver), IRATA Rope Access. Recent Credits: Producer; *Blue Planet II* (BBC 1), Sequence director: *Earth, One Amazing Day* (BBC Earth), Producer; *The Great British Winter* (BBC 2), Producer; *Nature's Miracle Orphans* (BBC 1), Producer; *The Dark: Natures Nighttime* World (BBC 2).

188

Jeremy Roberts – Producer
Conservation Media
Address: Missoula, MT, USA
Wildlife-film.com/-/Conservation-Media.htm
Main listing in 'Production Companies' on Page 16

Patrick Rouxel
Tawak Pictures
Address: Paris, FRANCE
Email: patrickrouxel@hotmail.com
Wildlife-film.com/-/PatrickRouxel.htm

Freelance cameraman or director for environmental conservation films.

Colin Ruggiero - Independent Filmmaker/DP/Photographer
Rhythm Productions, LLC
Address: Missoula, USA
Main listing in 'Camera Operators' on Page 164-165

Nacho Ruiz – Producer / Director
NaturaHD Films
Address: Madrid, SPAIN
Main listing in 'Production Companies' on Page 31

Nuno Sá - Cameraman / Director
Atlantic Ridge Productions
Address: AZORES, PORTUGAL
Main listing in 'Production Companies' on Page 12

Darryl Saffer – Filmmaker/Composer
Studio Ray
Address: Sarasota, Florida, USA
Phone: +1 941 228 7288
Email: earthcare@aol.com or datearthcare@gmail.com
Website: www.thefieldjournal.net & www.wildorchidman.com
Facebook.com/darryl.saffer
Wildlife-film.com/-/DarrylSaffer.htm

Produce, shoot and edit wildlife/nature documentaries and stock footage. Compose original production music. Darryl Saffer is a filmmaker/composer and was the audio/video producer for Mind Magic Productions (RMC Interactive). There, he composed the soundtrack and edited the video (live action and animation) for the Jane Goodall environmental adventure CD-ROM *Jubilees Journey*. His camera has focused on such diverse subjects as orcas off the coast of Vancouver Island, public housing in Florida and cosmic theory. Darryl documented a botanical expedition in the cloud forest of Venezuela, produced the CD-ROM Tales Of Titans - The Amorphophallus titanum in North America and his film, Myakka River State Park is part of the permanent exhibit at the South Florida Museum. Working with filmmaker Diane Mason, the team produced Condemned, a film which exposed conditions at the Janie Poe housing complex. Darryl is the filmmaker for the Wild Orchid Man films with Stig Dalström. Saffer can be seen locally and on YouTube on the Education Channels award-winning program Florida Field Journal. Not looking for new projects at this time. Would consider a self-funded intern for editing and/or field work.

Alberto Saiz – Producer / Cinematographer
NaturaHD Films
Address: Madrid, SPAIN
Main listing in 'Production Companies' on Page 31

Gianna Savoie – Executive Director/Producer/Writer
Ocean Media Institute
Address: Bozeman, Montana, USA
Email: gianna@oceanmediainstitute.org
Main listing in 'Production Companies' on Page 34

Phil Savoie – Producer/Director/Camera
Frog Films
Country: Montana, USA & UK
Main listing in 'Production Companies' on Page 22

Tulio Schargel – Producer/DOP
Marca D'agua Filmes
Address: São Paulo, BRAZIL
Phone: +55 11 3843 5599 and +55 11 9 9451 0098
Email: tulio@marcadaguafilmes.com.br
Website: www.marcadaguafilmes.com.br and www.megafauna.com.br

Establishing a working style that combines science and nature conservation, benefiting both, Tulio Schargel has directed, photographed and/or produced 18 films to Brazilian and international production companies and TV Channels. His documentaries and TV Series were broadcasted in NHK Japan, National Geographic International, Discovery, BBCHD LatAm, Arte France, CBC, France5, RAI, RTBF, ORF, among others.

Keith Scholey
Silverback Films
Address: Bristol, UK
Wildlife-film.com/-/Silverback-Films.htm
Main listing in 'Production Companies' on Page 40

Werner Schuessler – Director/Producer/Writer/DOP
¿are u happy? films
Address: Freiburg, GERMANY
Main listing in 'Production Companies' on Page 11

Steven Siegel – Videographer/Producer/Director/Expert
Raven On The Mountain Video
Address: Placitas, New Mexico, USA
Phone: +1 305 343 2179
Email: rm4birds@yahoo.com
Website: www.ravenonthemountain.com

I specialize in wild birds, and the techniques needed for small bird close-ups and flight shots. I shoot in HD with a Sony PMW300/Nikon 80-400 combination. My films have won several awards, including 1st place in the UWOL Challenge #20 (2011). I filmed for the 2011 motion picture "The Big Year" (20th Century Fox). Being a birder, I know birds, their behavior and how to get close. Specialties include hummingbirds, songbirds (singing), and waterfowl in flight.

190

Hayley Smith – Series Producer/Director
Address: 109 Franciscan Road, London SW17 8DZ, UK
Phone: +44 7966 502 062
Email: hayleysmith@me.com

Freelance Series Producer and Producer/Director specialising in human stories and the natural world. Series Producer on Dogs with Extraordinary Jobs for BlueAntMedia 2018, Producer/Director on BBC4 90' feature doc Turtle Nursery Secrets: Inside the Nest 2017-2018, Series Producer on Arabian Inferno/Arabian Seas - 10 x 50' budget blue chip for BlueAntMedia 2016-2017, P/D on Love Your Garden with Alan Titchmarsh for ITV 2016, Great British Garden Revival (series 1&2) for BBC2 in 2014-2015. Producer/Director on 2014 NATURAL WORLD film about pygmy hippos shot in West Africa. Series Producer on WILD BRITAIN WITH RAY MEARS for ITV. Producer/Writer on wildlife 'soap' MEERKAT MANOR (winner of Grand Award NY Festival 2009); Producer/Director on psychological drama/doc FATAL ATTRACTIONS; Series Producer/Director (self-shooting) on BLONDE VS. BEAR; Series Producer on presenter-led format series WILD ON THE WEST COAST with Kate Humble & Ben Fogle.

Yann Sochaczewski – Camera/Producer
Altayfilm GmbH
Address: Gruenheide, GERMANY
Main listing in 'Production Companies' on Page 9

Kimberly Stewart – Researcher / Director
Address: Chichester, UK
Wildlife-film.com/-/KimberlyStewart.htm
Main listing in 'Researchers' on Page 204

Nick Stringer – Producer/Director
Big Wave Productions
Address: Chichester, West Sussex, UK
Main listing in 'Production Companies' on Page 14

Dale Templar – Producer/Director
One Tribe TV
Address: Bath, UK
Main listing in 'Production Companies' on Page 35

Yusuf Thakur - Producer/Director
VFX Productions
Address: Dubai, UAE
Wildlife-film.com/-/VFX.htm
Main listing in 'Production Companies' on Page 45

Gavin Thurston – Cameraman/Director/Presenter
Country: UK
Main listing in 'Camera Operators' on Page 169

Nick Upton – Photographer/Videographer/Director/Writer
Address: Corsham, Wiltshire, UK
Wildlife-film.com/-/NickUpton.htm
Main listing in 'Stills Photographers' on Page 239-240

Thomas Veltre
The Really Interesting Picture Company
Address: Flushing, New York, USA
Wildlife-film.com/·/TheReallyInterestingPictureCompany.htm
Main listing in 'Production Companies' on Page 43

Tim Visser – Producer/Wildlife Cameraman
Wild Step
Address: Den Bosch, The Netherlands
Wildlife-film.com/·/TimVisser.htm
Main listing in 'Production Companies' on Page 50

Bernard Walton – Producer
Aqua Vita Films
Address: Bristol, UK
Phone: +44 (0)117 373 0833 or +44 (0)797 367 7249
Email: bernard@aquavitafilms.com
Website: www.aquavitafilms.com
See listing in 'Production Companies' on Page 10

Bernard worked in the BBC's famous Natural History Unit as a series producer developing a wide range of programmes filmed all over the world for strands such as *Wildlife on One* with Sir David Attenborough. Over the years his experience and expertise have taken Aqua Vita Films from strength to strength, selecting a team of talented and enthusiastic researchers and producers working together to produce insightful and cutting edge documentaries for major broadcasters.

Kate Westaway – Producer, Underwater Stills Photography
Address: Clifton, Bristol, UK
Wildlife-film.com/·/KateWestaway.htm
Main listing in 'Production Stills' on Page 240

Madelaine Westwood – Producer
Nutshell Productions Ltd
Address: Birmingham, UK
Wildlife-film.com/·/MadelaineWestwood.htm
Main listing in 'Production Companies' on Page 33

Thomas Wiewandt – Producer/Director
Wild Horizons Productions
Address: Tucson, Arizona, USA
Main listing in 'Production Companies' on Page 48

Norm Wilkinson – Producer/Director/Writer
Visionquest Entertainment international Pty Ltd
Address: Victoria, AUSTRALIA
Main listing in 'Production Companies' on Page 46

Kim Wolhuter – Producer/Cameraman/Talent
Mavela Media
Address: White River, SOUTH AFRICA
Main listing in 'Production Companies' on Page 30

Mark Woodward – Producer/Director
Big Wave Productions
Address: Chichester, West Sussex, UK
Main listing in 'Production Companies' on Page 14

David Wright – Producer/Cinematographer/DP
Address: Appleton, Maine, USA
Main listing in 'Camera Operators' on Page 171

Joe Yaggi - DOP
Jungle Run Productions
Address: Ubud, Bali, INDONESIA
Wildlife-film.com/-/JoeYaggi.htm
Main listing in 'Camera Operators' on Page 171

ASSISTANT PRODUCERS

Emma Brennand – Director / Field Producer
Address: Bristol, UK
Main listing in 'Producers/Directors' on Page 180

Karla Munguia Colmenero – AP/Camerawoman/Presenter
Address: Cancun, MEXICO
Wildlife-film.com/·/KarlaMunguiaColmenero.htm
Main listing in 'Presenters' on Page 215

Christopher Crooks
Address: London, UK
Wildlife-film.com/·/ChristopherCrooks.htm
Main listing in 'Researchers' on Page 201

Claire Evans – Assistant Producer/Presenter/Editor
Address: Bristol, UK & CANADA
Email: clairepagan@hotmail.com

I specialise in Natural History and Environmental filmmaking. I have several years experience working for companies such as the BBC and Halo Films. I hold three degrees including one in biology and one in creative arts/film studies. I hold UK and Canadian passports and have experience working with British and North American wildlife. I make films for Friends of the Earth from time to time. I am frequently looking for sponsors and co-producers. I sometimes have availability to provide short-term work experience for camera operators and sound recordists. Prefer CV's by email. Some prior experience is usually necessary.

Jocelyn Murgatroyd - Manager. Undertakes research, filming and producing.
Address: Cornwall, England, UK
Main listing in 'Researchers' on Page 203

Libby Prins – Assistant Producer
Address: Bristol, UK
Phone: +44 (0)7776 344 310
Email: libbyprins@gmail.com
Linkedin.com/in/libby-prins-88a3b654
Naturalhistorynetwork.co.uk/freelancers/libby-prins

I'm an assistant producer specialising in natural history, specialist factual, and adventure filmmaking. I have 4 years experience working on presenter-led, blue-chip and live documentary programmes across all stages of production, including story development, directing on presenter-led (from scripting to through the edit) and natural history shoots, producing for live, and sound. I have wide-ranging practical and academic skills including an MSc in veterinary epidemiology, PADI Divemaster, Advanced Wilderness Medical Training, taking stills and I'm particularly interested in cinematography. My specialist interests are in African wildlife and epidemiology, and the wildlife/livestock/human interface. I carry out thorough research and have set up many shoots in the UK and abroad for topside and underwater. I have a strong eye for detail, good at logistics and comms, working with animals, and easy to work with. I'm looking to develop my skills in directing and writing, self-shooting and edit producing.

Freya Short – Assistant Producer
Address: Bristol, UK
Email: freya@freyashort.com
Phone: +44 (0)7968 843 086
Website: www.freyashort.com

I am an Assistant Producer specialising in natural history, science and adventure documentary productions. I have over 10 years of production experience across blue-chip, children's, presenter-led and live productions. I have also developed a number of series for a range of broadcasters. I am confident at self-shooting, script writing, directing and edit producing as well as undertaking excellent development and pre-production research. I have an MSc in Animal Behaviour with specialist knowledge of nocturnal carnivores (specifically cat species) and human-wildlife conflict. I have extensive experience of setting up filming in both the UK and abroad (including diving and rock climbing shoots).

Claire Thompson - Freelance Assistant Producer
Address: 1 Redland Court Road, Bristol BS6 7EE, UK
Phone: +44 (0)7979 693 975
Email: claire_t009@yahoo.co.uk
Wildlife-film.com/-/ClaireThompson.htm

I am an experienced freelance Assistant Producer with an in-depth understanding of a wide range of natural history subjects. I have worked for the BBC Natural History Unit, Azara Film, ITV Studios, Aardman and Wildscreen; have a Masters of Research from Cambridge University in primate ecology and many years experience working in Africa and Asia under challenging conditions in the field. I have a proven history of providing thorough, in-depth research and comprehensive practical support for wildlife productions and am a passionate, resilient team member; enthusiastic in my work, with an established record of achievement.

195

Kristina Turner – AP specialising in natural history
MSc. Conservation & Biodiversity
Address: Bristol, UK
Phone: +44 (0)7963 122 924
Email: stineturner75@yahoo.co.uk
Linkedin.com/in/kristinalturner
Wildlife-film.com/-/KristinaTurner.htm

With a background in animation, zoology and conservation I now combine my interests specialising in natural history TV. I have a particular interest in conservation related projects and finding creative ways to help change attitudes as well as entertain and inform. Starting out in animation, I have a storytelling background. I then retrained and worked in wildlife research and conservation for over 10 years including working abroad, in the UK and in both office and remote field conditions. My diverse background has given me a varied portfolio of creative, logistical and communication skills along with a strong network of wildlife contacts around the world. My TV work to date has taken me all over the UK, Zambia, Alaska and Taiwan working on projects for channels such as the BBC1, 2 and 4, BBC Earth, Channel 4, France 5 and National Geographic. Key skills: Knowledge and experience working with wildlife and conservation issues particularly in the UK and Africa, research/development of ideas for various channels including pitching to Channel 4, edit producing/producing/directing, live OBs, setting up and providing practical support for UK and overseas shoots, second camera e.g. Canon 5D, liaising with people at various levels and nationalities, living and working in small teams in remote locations. As well as conservation projects I'm also interested in wildlife behaviour, communication, science and research, travel, adventure and children's TV. I'm an enthusiastic, reliable, easy going and friendly team member offering practical and creative support to wildlife productions and am keen to gain more writing/producing/directing and shooting experience.

Oliver Upton – Shooting AP / Researcher
Address: Rugeley, Staffordshire, UK
Phone: +44 (0)7972 696 511
Email: ollie.upton@gmail.com
Linkedin.com/in/oliver-upton-6b289b16
Thetalentmanager.co.uk/talent/31555/oliver-upton
Wildlife-film.com/-/OliverUpton.htm

An enthusiastic Shooting Assistant Producer / Researcher with excellent communication, writing, team work and presentation skills. Experienced in working on Broadcast Television and independent fiction and factual work. Confident in many types of

filmmaking and all relevant tasks, including directing, camera work and editing. Experienced traveler, interested in observational documentary, anthropology, specialist factual, history, adventure and wildlife. Interested in working on and making exciting factual documentaries. Work example · Youtu.be/mDqrucPcoLg

PRODUCTION MANAGERS/FIELD DIRECTORS

Steven Ballantyne – Producer, Field Director
EPM Asia Ltd
Address: HONG KONG
Wildlife-film.com/·/StevenBallantyne.htm
Main listing in 'Producers/Directors' on Page 178
See EPM Asia's listing in 'Location Managers' on Page 87

Fabio Borges Pereira – Photographer & Filmmaker
Fabio Borges Fotografia / Hydrosphera
Address: Fernando de Noronha – PE, BRAZIL
Main listing in 'Camera Operators' on Page 140

Sajid Darr – Fixer / Wildlife Manager / Guide
Address: PO Box 14098, Nairobi 00800, KENYA
Phone: +254(0)717 305750, +254 (0)722 516039 & +254 (0)733741167 Email:
info@viewfindersltd.com
Website: www.viewfindersltd.com
Wildlife-film.com/·/ViewFinders.htm

Coming from a back ground of camp and wildlife management, Sajid has been following in Jeans' footsteps keeping Viewfinders at the forefront of fixing wildlife film crews in Kenya. His vision is to see Jeans' legacy grow and to stay true to the ethos of making sure every film crew hosted by Viewfinders keep coming back to show the world the marvels of wildlife and Kenya. Films produced under the watchful eye of Sajid are invaluable as they inspire hoards of visitors to Kenya, supporting the country's tourism industry. They come keen to experience the natural history and wildlife of Kenya first-hand after being wowed by the stories and images seen on their televisions or on cinema screens. If you're thinking of making a film in Kenya/East Africa, make sure you get in touch with Sajid early on so as to facilitate your production being as smooth and efficient as possible!

Tamara Groves – Field Producer
Address: Bristol, UK
Wildlife-film.com/·/TamaraGroves.htm
Main listing in 'Producers/Directors' on Page 184

Samuel Guiton – Photographer/Director/Cameraman
Address: Montreuil, FRANCE
Main listing in 'Camera Operators' on Page 149

Douglas Lyon – Production Manager/Producer/Director
Excelman Productions
Address: Paris, FRANCE
Wildlife-film.com/·/Excelman-Productions.htm
Main listing in 'Production Companies' on Page 20

Feisal Malik - Line Producer/Director/Camera/Fixer/Producer
Visual Africa Films Ltd
Address: Nairobi, KENYA
Wildlife-film.com/·/Visual-Africa-Films.htm
Main listing in 'Location Managers/Fixers' on Page 91

Dee Marshall – Production Manager
Address: Uriage, FRANCE
Wildlife-film.com/·/DeeMarshall.htm
Main listing in 'Writers/Script Editors' on Page 210

Jocelyn Murgatroyd - Manager. Undertakes research, filming and producing.
Address: Cornwall, England, UK
Main listing in 'Researchers' on Page 203

Joseph Muwowo – Production Consultant
Mystic Pictures Zambia
Address: Kitwe, ZAMBIA
Main listing in 'Location Managers/Fixers' on Page 89

Vivian A. N. Nuhu – Coordinator/Producer
Address: Osu-Accra, GHANA, WEST AFRICA
Main listing in 'Fixers' on Page 89

Bernhard M. Pausett – Camera Operator / Producer / Fixer / Assistant
BMP Filmproduksjon
Address: Tasen alle 16, NO-0853 Oslo, NORWAY
Phone: +47 9009 3940
Facebook.com/bernhard.pausett
Wildlife-film.com/·/BernhardMPausett.htm

Camera operator, producer, fixer, location scout, transport, logistics, drone operator. Interested in proposals in nature film, sea/beach cleaning, plastic litter and the environment. Scandinavian Wildlife Film Festival (SWFF).

199

Anthony Roberts – Manager/Editor/Motion Graphics/CGI
ZED Creative
Address: Wales, UK
Wildlife-film.com/·/AnthonyRoberts.htm
Main listing in 'Production Services' on Page 164

Rafael del Vigo – Fixer/Production Manager
Fixer in Spain
Address: Valencia, SPAIN
Main listing in 'Locations Managers/Fixers' on Page 88

Stu Westfield
Ranger Expeditions Ltd
Address: High Peak Derbyshire, UK
Wildlife-film.com/·/StuartWestfield.htm
Main listing in 'Experts/Scientists' on Page 245

RESEARCHERS

Andrew Bell – Producer/ Cameraman / Editor
Address: London, UK
Main listing in 'Producers/Directors' on Page 179

Abigail Brown – Researcher
Down to Earth Films
Address: Bristol, UK
Phone: +44 (0)7727 673 449
Email: abigail@downtoearthfilms.com
Website: www.downtoearthfilms.com
Twitter.com/Down2EarthFilms
Facebook.com/downtoearthfilms
Instagram.com/downtoearthfilms
Vimeo.com/downtoearthfilms

I am a self-shooting researcher with a passion and focus for wildlife and natural history film-making. As well as independently directing, filming and editing projects under the name Down to Earth Films, I have worked within the industry at the BBC Natural History Unit, ITV and NHK. I have experience setting up shoots both in the UK and abroad and as well as being a proficient self-shooter, I can offer sound recording on location, script writing and idea development. Above all – I am passionate about the work we do and always strive for the very best results.

Christopher Crooks
Address: London, UK
Phone: +44 (0)7454 808 980
Email: christopherjcrooks@gmail.com
Instagram.com/cj.crooks
Wildlife-film.com/-/ChristopherCrooks.htm

Catherine Doherty – Camera Operator, Floor Manager, Researcher, Assistant/Runner
Country: London, UK
Main listing in 'Assistants' on Page 206

Tania Rose Esteban – Wildlife Filmmaker/Zoologist
TRE Productions
Address: Bristol, UK
Phone: +44 (0)7482 299 623
Email: tania.esteban@betafilmworks.org
BBC Researcher: tania.esteban@bbc.co.uk
Website: www.treproductions.co.uk & taniaroseesteban.wordpress.com
Facebook.com/tania.rose.754
Twitter.com/Eagletigger
Instagram.com/tania_esteban22
Linkedin.com/in/tania-esteban-864b6a81
Wildlife-film.com/-/TaniaEsteban.htm

Tania is a bilingual Zoologist, wildlife camerawoman and researcher with a passion for visually stunning, cinematic storytelling and emotive natural history programme-making. Her love of Africa and big cats led to her award-winning short film *A Lion's Tale* about the human-wildlife conflict in Kenya, as well as the largest historical Ivory burn featuring Virginia McKenna. A MA Wildlife filmmaking graduate, she has recently worked on BBC

Wild Cats (work experience) *Planet Earth II* (Digital researcher) and on BBC Digital *Our Blue Planet*. She continues to create, innovate, develop and make independent short wildlife/adventure films. Currently training to be a CAA certified media drone pilot with own professional equipment. Also available for translation (Spanish) work · interviewing, scripts, narration and permits.

Erik Fernström
Address: Gränna, SWEDEN
Main listing in 'Production Companies' on Page 19

Tamsyn van Gelderen – Senior wildlife Researcher/Copy Editor/Fact Checker/Archive Footage Researcher for Wildlife
Address: Johannesburg, SOUTH AFRICA
Phone: +27 731 015 388 & +27 119 424 918
Email: nysmatic@gmail.com
Twitter.com/nysmaticus
Linkedin.com/pub/tamsyn-van-gelderen/9/923/a02
Wildlife-film.com/·/TamsynvanGelderen.htm

Wildlife research behind the scenes is my specialty. I am comfortable searching for extraordinary footage, experts and facts that make a script roar and the documentary count.Have worked on documentaries for Nat Geo, Smithsonian, Terra Mater and others (local and international) and have worked on reality shows for TV as well just to see what it was all about. I am happy to take on any task no matter what. I eat deadlines for breakfast and never stop learning. I copy edit articles and scripts and am an accomplished writer with a journalism background.

Della Golding – Presenter / Writer / Producer
Address: Ormeau, Queensland, AUSTRALIA
Main listing in 'Presenters' on Page 217

Dominique Gusset - Researcher/Cinematographer/DOP
Address: Nova Scotia, CANADA
Main listing in 'Camera Operators' on Page 149

Arlo Hemphill – Writer/Filmmaker/Science & Conservation Consultant
I am Wilderness, LLC
Address: 313 Madison Street, Frederick MD 21701, USA
Phone: +1 202 746 3484
Email: arlo@iamwilderness.com
Website: www.iamwilderness.com
Twitter.com/arlohemphill

Producer, writer and researcher for science, wilderness and conservation topics. Subject matter expert on tropical marine ecosystems, climate change, deep sea mining, high seas governance, Sargassum, Amazon, Caribbean, tropical Andes and coastal Ecuador/Peru. Available for short and long-term work in production.

Sam Hopes
Address: Bristol, UK
Wildlife-film.com/·/SamHopes.htm
Main listing in 'Assistants' on Page 207

Clive Huggins - Consultant Entomologist/Photographer
Address: Surrey, UK
Wildlife-film.com/-/CliveHuggins.htm
Main listing in 'Experts' on Page 243

Faye Minister – Camera Assistant/Runner
Address: Milton Keynes, UK
Main listing in 'Assistants' on Page 207

Jocelyn Murgatroyd - Manager. Undertakes research, filming and producing.
Address: 57 Pengelly, Delabole, Cornwall PL33 9AS, England, UK
Phone: +44 (0)1840 211 419
Email: jocelynmurgatroyd@hotmail.com
Website: www.dpnwordpress.org/jocelynm
Facebook.com/jocelyn.murgatroyd
Linkedin.com/pub/jocelyn-murgatroyd/51/925/8b3

My background includes primatology and anthropology. I have worked in Africa and Papua New Guinea surveying primates and large mammals, monitoring elephants, recording oral history and working with communities. I have filmed and photographed wildlife, traditional events, customs and oral history in Britain and abroad. I'm an experienced project manager and logistician, have worked for environmental and development consultancies, led expeditions, and managed conservation projects. I undertook researcher work experience with BBC NHU, Countryfile, Survival, BBC Wildlife and Geographical magazines. I was a production researcher on OADF's *Captured by Women*. Camerawork, research, recces, assistant producer and production management work considered.

Joseph Muwowo – Production Consultant
Mystic Pictures Zambia
Address: Kitwe, ZAMBIA
Main listing in 'Location Managers/Fixers' on Page 89

Bernhard M. Pausett – Camera / Producer / Fixer / Assistant
BMP Filmproduksjon
Address: Oslo, NORWAY
Wildlife-film.com/-/BernhardMPausett.htm
Main listing in 'Production Managers' on Page 199

Jack Perks – Researcher/Photographer/DOP/Presenter
Jack Perks Wildlife Media
Address: Nottingham, UK
Wildlife-film.com/·/JackPerks.htm
Main listing in 'Production Companies' on Page 26

Libby Prins – Assistant Producer
Address: Bristol, UK
Main listing in 'Assistant Producers' on Page 194

Tom Rowland – Camera Operator/Assistant & Researcher
Address: Bristol, UK
Main listing in 'Assistants' on Page 208

Gavin Shand - Shooting Junior Researcher
Address: Glasgow, Scotland, UK
Wildlife-film.com/·/GavinShand.htm
Main listing in 'Camera Operators' on Page 166

Kimberly Stewart – Researcher / Director
Address: Chichester, UK
Phone: +44 7739 233 124
Email: fulmarfilms@gmail.com
Website: www.kimistewart.com & www.fulmarfilms.com
Twitter.com/kimistewart
Wildlife-film.com/·/KimberlyStewart.htm

Documentary researcher specialising in conservation and wildlife, moving into the field of directing. Kimberly has a background in biological sciences and a Masters in Biological Photography & Imaging. Following her studies she worked as a photographer based in Cape Town, South Africa, before making the transition into wildlife film. Kimberly's skills include writing, visual story-telling, pitching, and narrating. Looking for collaborations and sponsors.

Claire Thompson - Freelance Assistant Producer
Address: Bristol, UK
Wildlife-film.com/·/ClaireThompson.htm
Main listing in 'Assistant Producers' on Page 195

Oliver Upton – Shooting AP / Researcher
Address: Rugeley, Staffordshire, UK
Wildlife-film.com/·/OliverUpton.htm
 Main listing in 'Assistant Producers' on Page 239-240

Stu Westfield
Ranger Expeditions Ltd
Address: High Peak Derbyshire, UK
Wildlife-film.com/·/StuartWestfield.htm
Main listing in 'Experts/Scientists' on Page 245

Thomas Wiewandt
Wild Horizons® Productions
Address: Tucson, Arizona, USA
Main listing in 'Production Companies' on Page 48

Rachel Wicks – Researcher
Address: 9 Raynes Road, Ashton, Bristol BS3 2DJ, UK
Email: rachelwicks@live.com
Linkedin.com/pub/rachel-wicks/77/119/aa9
Vimeo.com/user20873224

Zoologist with MA in wildlife filmmaking. Researcher and self-shooter, specialising in marine biology. PADI Divemaster and SSI level II freediver, experienced in international set up, production and underwater filming.

ASSISTANTS/RUNNERS/NEWCOMERS

Karla Munguia Colmenero - AP/Camerawoman/Presenter
Address: Cancun, MEXICO
Wildlife-film.com/·/KarlaMunguiaColmenero.htm
Main listing in 'Presenters' on Page 215

Catherine Doherty – Camera Operator, Floor Manager, Researcher, Assistant/Runner
Country: London, UK Phone: +44 (0) 7708 762 720
Email: catherine.cheyne@hotmail.com
100% enthusiastic, committed and adaptable individual. Key skills include:
- Practical working knowledge of rigging and operating broadcast cameras in both Outside Broadcasting and studio environments.
- Self-shooting on Sony Z1, Canon XF305, Sony HXR-NX5P & DSLR, Final Cut Pro, Adobe Premiere, GoPro HD operation, managing tape and tapeless media formats, full driving license (4WD experience), basic French, Swahili and Arabic, field and craft survival.
- Extensive experience of Operating Vinten pedestal, handheld and Jimmy Jib cameras (Sony HDC 1500, Sony BVP-950)
- Trainee Keeper at ZSL London Zoo.
- Health & Safety Adviser; Fire Warden, First Aider & Risk Assessor.

Bob Glowacky – Assistant/Camera Operator/Editor
Address: Brentwood, New Hampshire, USA
Phone: +1 603 706 7409
Email: rglowacky@outlook.com
Vimeo.com/robertglowacky
Facebook.com/bringingbackbodrik
Linkedin.com/in/robert-glowacky-6aa38560
Wildlife-film.com/·/RobertGlowacky.htm

Recent graduate of the BBC Natural History Unit and UWE Bristol's MA in Wildlife Filmmaking. Currently based in the Seacoast of New Hampshire, USA. Can serve as camera assistant/operator, editor, or researcher for natural history and wildlife documentary filmmakers. He's worked with various broadcasters and production companies including PBS Nature, Icon Films, Humble Bee Films, and others in the UK and US. Recently he's produced programming for local public TV and a short film about wolves and livestock guardian dogs in the mountains of Slovakia. The film, *Bringing Back Bodrik*, is currently touring film festivals in the US and Europe.

Agneta Heuman
Address: Zollikon, SWITZERLAND
Wildlife-film.com/-/AgnetaHeuman.htm
Main listing in 'Camera Operators' on Page 152

Sam Hopes
Address: Bristol, UK
Phone: +44 (0)7595 644 582
Email: samhopes88@gmail.com
Website: www.samhopes.tv
Wildlife-film.com/-/SamHopes.htm

Natural history camera assistant with several years experience. Also has experience as researcher, DIT, edit assistant, editor, AP and producer. Holds a BSc in Conservation Biology and an MA in Wildlife Documentary Production. Is also 1st aid qualified, wilderness survival trained, has an iVisa valid until 2021 and experience driving large vehicles and off-road.

Faye Minister – Camera Assistant/Runner
Address: Milton Keynes, UK
Phone: +44 (0)7812 009 475
Email: hello@fayeminister.com
Website: www.fayeminister.com
Vimeo.com/user5616958
Linkedin.com/pub/faye-minister/51/731/7b1

Faye has been working as a camera operator and editor in corporate films for the last five years, but her passion for the natural world has remained. She has filmed with Wildlife Friends in Thailand, set up an eco film festival, worked as a tutor for UK Wildlife Film School and created content for various animal charities. Faye has a hedgehog release site in her garden and is currently training to be a bird-ringer to improve her knowledge. She also has experience working in TV productions.

Jessica Mitchell – Underwater Camera Operator/Assistant
Earth Motion Pictures
Address: Bristol, UK
Main listing in 'Camera Operators' on Page 159

Oliver Mueller
Address: Bristol & Manchester, UK
Main listing in 'Camera Operators' on Page 160

Will Nicholls – Camera Operator / Assistant / Photographer
Address: Hexham, Northumberland, UK
Wildlife-film.com/-/WillNicholls.htm
Main listing in 'Camera Operators' on Page 160

Sam Oakes – Camera Operator / Assistant
Address: Richmond, North Yorkshire, UK
Main listing in 'Camera Operators' on Page 162

Bernhard M. Pausett – Camera / Producer / Fixer / Assistant
BMP Filmproduksjon
Address: Oslo, NORWAY
Wildlife-film.com/·/BernhardMPausett.htm
Main listing in 'Production Managers' on Page 199

Alex Rhodes
Address: Bristol, UK
Phone: +44 (0)7554 575 949
Email: alex@rhodesinternet.com
Twitter.com/Alex_RhodesUK
Instagram.com/alexrhodesuk
Flickr.com/photos/141730673@N02/albums
Linkedin.com/in/alex-rhodes-516084130

Young naturalist, freelance outdoor instructor and film-maker/photographer. I am a final year Zoologist at the University of Bristol seeking work as a presenter. Competent working solo at height and in mountain/wilderness environments. Extensive knowledge of UK and European wildlife, specialising in ornithology (inc licensed Bird Ringer). Expanding knowledge of Peruvian wildlife. Award winning stills photographer and adventure sport enthusiast. Qualified PADI diver & photographer, powerboat driver and hold enhanced DBS clearance.

Tom Rowland – Camera Operator/Assistant & Researcher
Address: Bristol, UK
Phone: +44 (0)7788 245 702
Email: tomrwlnd@gmail.com
Website: www.tomrowlandcamera.co.uk
Linkedin.com/in/tom-rowland-87793146
Vimeo.com/user14631148
Instagram.com/tomrowlandcamera

I am an ex-RSPB Film Unit award winning Wildlife Camera Operator particularly used to long lens, run and gun and macro filming either alone or in small teams all over the world from the Hebrides to Cuba. Confident operating on all flavours of 4K camera kit e.g. Phantom 4K Flex, Arri Amira. I am story driven, focused on getting the coverage needed for the sequence. When filming, often in uncomfortable environments, I am calm and efficient under pressure, have a can do attitude and a much needed good sense of humour. Looking to camera assist/operate on your next shoot.

Gavin Shand - Shooting Junior Researcher
Address: Glasgow, Scotland, UK
Wildlife-film.com/·/GavinShand.htm
Main listing in 'Camera Operators' on Page 166

Stu Westfield
Ranger Expeditions Ltd
Address: High Peak Derbyshire, UK
Wildlife-film.com/·/StuartWestfield.htm
Main listing in 'Experts/Scientists' on Page 245

WRITERS/SCRIPT EDITORS

Jesse Blaskovits
Existential Productions
Address: Vancouver, CANADA
Main listing in 'Camera Operators' on Page 140

Caroline Brett – Writer/Producer/Director
Shake The Tree Productions
Address: Suffield, Norfolk, UK
Wildlife-film.com/·/ShakeTheTreeProductions.htm
Main listing in 'Producers/Directors' on Page 180

Adrian Cale – Writer
Address: London, UK
Phone: +44 (0)7789 205 211
Email: ade.cale@gmail.com
Website: www.adriancale.co.uk
www.dfmanagement.tv/television-presenters/adrian-cale
Twitter.com/AdrianPCale
Wildlife-film.com/·/AdrianCale.htm

I am an independent wildlife film-maker who has written a wide variety of natural history content for various international broadcast and production partners. Content includes press releases, program pitch documents, synopsis, treatments, scripts and script editing.

Credits include:
Snow Leopards of Leafy London · 7 x 30' series · Animal Planet
Baboon Boot Camp: Parthenon Entertainment.
International Animal Rescue: Orangutan: · IAR
Gibbons: Back in the Swing: 5 x 30' · Animal Planet / Discovery Networks.
Woolly Jumpers: Made in Peru: · Animal Planet / Discovery Networks
Winner BEST NEWCOMER AWARD at the International Wildlife Film Festival (IWFF) 2006.
Make me a Monkey: · Electric Sky Distribution

My combination of skill sets can compliment a number of crewing options and allow me to accommodate flexible and demanding budgets. I also develop my own independent film projects, which affords me a clear understanding of what it takes to carry a good program idea through from concept to completion.

Alice Clarke – Self-shooting PD/FCP Editor/Scriptwriter.
Address: Bristol, UK
Wildlife-film.com/·/AliceClarke.htm
Main listing in 'Propducers/Directors' on Page 183

Della Golding – Presenter / Writer / Producer
Address: Bristol, UK
Main listing in 'Presenters' on Page 217

Arlo Hemphill – Writer/Filmmaker/Science & Conservation Consultant
Address: Frederick, Maryland, USA
Main listing in 'Researchers' on Page 202

Mike Linley – Writer/Director/Cameraman
Hairy Frog Productions Ltd
Address: Norwich, Norfolk, UK
Wildlife-film.com/·/Hairy-Frog-Productions.htm
Main listing in 'Production Companies' on Page 24

Dee Marshall – Writer/Photographer
Address: 202 Chemin des Vachers 38410 Uriage, FRANCE
Phone: +33 611 548 112 & +44 788 066 3743
Email: dee.marshall@gmail.com
Website: www.deemarshallphotography.com
Wildlife-film.com/·/DeeMarshall.htm

An experienced writer and photographer with extensive knowledge of wildlife and proven ability in wildlife filming and editing. I am currently working as a researcher and photographer for a documentary TV series about children and wildlife. In addition to a diploma in Mammal Ecology and Conservation, I have wide experience in visual and written communication. I have spent many years editing texts and writing for scientific journals. I am fluent in French and English and competent in Italian, German and Japanese. I am available to work as a writer, photographer or script editor on a freelance basis or short contract work.

Alan Miller – Editor/Director/Writer
Shake The Tree Productions
Address: Suffield, Norfolk, UK
Wildlife-film.com/·/ShakeTheTreeProductions.htm
Main listing in 'Editors' on Page 226

Kate Raisz – Producer/Director/Writer
42°N Films
Address: Boston, MA, USA
Main listing in 'Production Companies' on Page 8

Gianna Savoie – Executive Director/Producer/Writer
Ocean Media Institute
Address: Bozeman, Montana, USA
Email: gianna@oceanmediainstitute.org
Main listing in 'Production Companies' on Page 34

Werner Schuessler – Writer/Director/Producer/DOP
¿are u happy? films
Address: Freiburg, GERMANY
Main listing in 'Production Companies' on Page 11

Colin Stevenson – Writer and Zoologist
Address: Witney, Oxfordshire OX28 6JT, UK
Phone: +44 (0)7526 976 359
Email: coleosuchus@hotmail.com
Linkedin.com/pub/colin-stevenson/a/3aa/378

Experienced author and zoologist with extensive career in wildlife. Crocodilians have been a major focus, with associates across the world. Strong and continuing involvement in wildlife and conservation in India, and links with researchers and organisations within the country.
Credits include: NDTV India Heavy Petting series; Discovery Channel/Dreamworks; National Geographic Kids; Pet Talk Radio.

Darryl Sweetland – Cameraman/Biologist/Writer
Asian Wildlife Films
Country: THAILAND
Wildlife-film.com/-/DarrylSweetland.htm
Main listing in 'Camera Operators' on Page 168

Nick Upton – Photographer/Videographer/Director/Writer
Address: Corsham, Wiltshire, UK
Wildlife-film.com/-/NickUpton.htm
Main listing in 'Stills Photographers' on Page 239-240

Norm Wilkinson – Writer/Producer/Director
Visionquest Entertainment international Pty Ltd
Address: Victoria, AUSTRALIA
Main listing in 'Production Companies' on Page 46

PRESENTERS/NARRATORS

Casey Anderson – Camera Operator/Presenter/Naturalist
VisionHawk Films
Address: Bozeman, Montana, USA
Website: www.caseyanderson.tv
Main listing in 'Camera Operators' on Page 137

David Attenborough – Veteran Presenter/Narrator/Writer
Country: UK

Sir David Attenborough is Britain's best-known natural history film-maker. His career as a naturalist and broadcaster has endured for more than five decades and there are very few places on the globe that he has not visited. He is probably most famous for writing and presenting the BBC NHU's *Life* series.

Steve Backshall – Adventurer & Natural History Presenter
Country: UK
Agent: Jo Sarsby Management
Address: 154 Cheltenham Road, Bristol BS6 5RL, UK
Phone: +44 (0)117 927 9423
Email: jo@josarsby.com
Website: www.stevebackshall.com
www.josarsby.com/steve-backshall
Facebook.com/stevebackshallofficial

Adventurer, natural history TV presenter, public speaker and author.

Nick Baker – Naturalist/Television Presenter
Country: UK
Agent: Jo Sarsby Management
Address: 154 Cheltenham Road, Bristol BS6 5RL, UK
Phone: +44 (0)117 927 9423
Email: jo@josarsby.com
Website: www.nickbaker.tv
www.josarsby.com/nick-baker
Twitter.com/bugboybaker

Wildlife and science presenter whose TV credits include the *Really Wild Show*, *Autumnwatch Unsprung*, *Weird Creatures*, *Tomorrow's World*. He was one of National Geographic's Ultimate Explorers.

Abbie Barnes - Film-maker, Presenter and Conservationist
Song Thrush Productions
Country: United Kingdom
Email: abbie@songthrushproductions.co.uk
Website: www.songthrushproductions.co.uk
Facebook.com/pages/Song-Thrush-Productions/426384884130124
Twitter.com/AbbieSongThrush
Linkedin.com/in/abbie-barnes-46318161
Wildlife-film.com/-/AbbieBarnes.htm

Abbie is a semi-professional filmmaker and presenter specialising in adventure/expedition, wildlife conservation, promotional shorts, and mental and physical

wellbeing. Her internationally recognised work has won numerous multi-national awards. She has previously worked with the UN and European Parliament, UNESCO, and local, smaller-scale charities and organisations. She runs the production company, Song Thrush Productions, and is experienced in all areas of production, as well as radio presenting and public speaking. She is currently (mid-2017) studying for a BSc degree in geography and environmental science, is a trained mountain leader, bushcraft instructor, fitness instructor, personal trainer and PADI Open Water diver. Abbie strives to connect with her viewers in a raw and honest way, inspiring them to head outdoors and reconnect with the natural world around them. She is as passionate about people as she is wildlife, and is no stranger to exposing sensitive subjects and environmental messages. Abbie is professional in manner, versatile in skill, and fearless in the face of a challenge. With her unique set of skills and extensive knowledge in a wide range of fields, Abbie is quick to learn on the job, and welcomes conversation about projects of any size or topic.

Big Gecko
Adam Britton (Crocodile Specialist), Erin Britton (Biologist)
Address: Humpty Doo, Northern Territory, AUSTRALIA
Main listing in 'Experts/Scientists' on Page 241

Liz Bonnin – Biochemist, Wild Animal Biologist & Presenter
Country: UK
Agent: Jo Sarsby Management
Address: 154 Cheltenham Road, Bristol BS6 5RL, UK
Phone: +44 (0)117 927 9423
Email: jo@josarsby.com
Website: www.lizbonnin.com
www.josarsby.com/liz-bonnin
Twitter.com/lizbonnin

Biochemist, wild animal biologist and TV presenter.

Matt Brash – TV Zoo Vet
Country: UK
Agent: David Foster Management
Address: PO Box 1805, Andover, Hampshire SP10 3ZN, UK
Phone: +44 (0)1264 771 726
Email: david@dfmanagement.tv
Website: www.mattbrash.co.uk
www.dfmanagement.tv/television-presenters/matt-brash

Television zoo vet Matt Brash's most popular and long running series for ITV were Zoo Vet and Zoo Vet at Large which ran for nine years and followed Matt as zoo vet at Flamingo Land in North Yorkshire.

Hal Brindley – Producer, Cinematographer, Photographer, Editor, Presenter
Travel For Wildlife
Main listing in 'Camera Operators' on Page 141

Giuseppe Bucciarelli – Presenter/Producer/DOP
Terra Conservation Films
Address: Fiesole, ITALY
Wildlife-film.com/-/GiuseppeBucciarelli.htm
Main listing in 'Production Companies' on Page 42-43

213

Gillian Burke
Country: UK
Agent: Jo Sarsby Management
Address: 154 Cheltenham Road, Bristol BS6 5RL, UK
Phone: +44 (0)117 927 9423
Email: jo@josarsby.com
Website: www.gillianburkevoice.com
www.josarsby.com/gillian-burke
Instagram.com/gillians_voice
Twitter.com/gillians_voice

Presenter, wildlife film-maker and voice-over Artist.

Adrian Cale – Narrator/Presenter
Address: London, UK
Wildlife-film.com/-./AdrianCale.htm
www.dfmanagement.tv/television-presenters/adrian-cale
Main section in 'Producers/Directors' on Page 181-182

Adam L Canning – Presenter & Filmmaker
Address: West Midlands, UK
Email: WildlifeFilmerAdam@live.co.uk
Website: www.cannedwildlife.wordpress.com
Facebook.com/CannedWildlife
Twitter.com/AdamLCanning
Instagram.com/AdamLCanning

Adam recently co-produced and co-presented 'The Wild Side' on Cambridge TV and advocates wildlife gardening at BBC Gardeners' Word Live at the NEC. Before that, he wrote, produced, presented, filmed and edited his own films for Reader's Digest Magazine and his YouTube channel · which he occasionally updates. Adam loves collaborations. He has wrote for New Nature magazine, BBC Birmingham and has been on BBC Midlands Today twice, due to getting unique of a squirrel's drey and waxwings feeding at garden centre in Worcestershire.

Mark Carwardine – Zoologist, Conservationist, Whale Specialist & TV Presenter
Country: UK
Manager: Rachel Ashton
Address: 5 Chesterfield Road, Bristol BS6 5DN, UK
Phone: +44 117 904 8934
Email: rachel@markcarwardine.com
Website: www.markcarwardine.com
Instagram.com/markcarwardine1
Facebook.com/markcarwardinephotography

Mark Carwardine is a zoologist, an outspoken conservationist, an award-winning writer, a TV and radio presenter, a widely published wildlife photographer, a best-selling author, a wildlife tour operator and leader, a lecturer, and a magazine columnist.

Andy Brandy Casagrande IV – Cinematographer / Producer / Presenter
ABC4EXPLORE
Address: Naples, Florida, USA
Main listing in 'Production Companies' on Page 8

Lindsey Chapman – TV/Radio Presenter/Social Media Expert
Country: UK
Agent: David Foster Management
Address: PO Box 1805, Andover, Hampshire SP10 3ZN, UK
Phone: +44 (0)1264 771 726
Email: david@dfmanagement.tv
Website: www.lindseychapman.co.uk
www.dfmanagement.tv/television-presenters/lindsey-chapman
Twitter.com/lindsey_chapman

Lindsey presents BBC Two's *Springwatch Unsprung* with Chris Packham; a live, audience-centred show celebrating the very best of UK wildlife. She is also the co-presenter (alongside Hugh Fearnley-Whittingstall) of BBC One's *Big Blue UK*, exploring marine life around the British Isles.

Karla Munguia Colmenero - Camerawoman/Presenter/AP
Address: Cancun, MEXICO
Phone: +52 1 9982271218
Email: karla.munguia@gmail.com
Facebook.com/Karmuncol
Twitter.com/Karmuncol
Wildlife-film.com/-/KarlaMunguiaColmenero.htm

I'm a wildlife Camerawoman, Journalist and Presenter from Mexico with 3 years experience in South Africa. My work behind camera includes the Animal Planet Series *'Shamwari: A Wild Life'*, aired in Africa, Europe, Asia, the Middle East and USA and a series for NatGeo called *'Wild and Woolly'*, the story of a baby elephant and his best friend, a sheep! I am an enthusiastic Presenter, who came second place at the first ever 'Wildscreen's Got Talent' competition in 2010, and I'm fluent in both Spanish and English. I'm a level 5 SSI Scuba Diver including Night Limited Visibility and Stress and Rescue Specialties. My latest projects as Production Assistant include *Crazy Monsters: Bats*, for Earth Touch and The Smithsonian and *Whale Sharks*, a film for WildAid. I am open to any adventurous project anywhere in the Planet as Presenter, Production Assistant and Off Line Editor.

Cristian Dimitrius – Presenter/DOP
Cristian Dimitrius Productions
Address: Sao Paulo, BRAZIL
Wildlife-film.com/-/CristianDimitrius.htm
Main listing in 'Camera Operators' on Page 144-145

215

Saba Douglas-Hamilton – Conservationist & Anthropologist
Country: UK/KENYA
Agent: Jo Sarsby Management
Address: 154 Cheltenham Road, Bristol BS6 5RL, UK
Phone: +44 (0)117 927 9423
Email: jo@josarsby.com
Website: www.douglas-hamilton.com
www.josarsby.com/saba-douglas-hamilton

Conservationist, award-winning TV presenter, anthropologist, author and public speaker

Ed Drewitt – Naturalist/Broadcaster/Wildlife Detective/Consultant
Address: Bristol, UK
Main listing in 'Experts/Scientists' on Page 242

Claire Evans – Presenter/AP
Address: Bristol, UK & CANADA
Main listing in 'Assistant Producers' on Page 194

Dr Jess French – Presenter/Vet/Zoologist/Naturalist
Country: UK
Agent: David Foster Management
Address: PO Box 1805, Andover, Hampshire SP10 3ZN, UK
Phone: +44 (0)1264 771 726
Email: david@dfmanagement.tv
Website: www.dfmanagement.tv/television-presenters/jess-french
Twitter.com/Zoologist_Jess

Zoologist, naturalist and TV presenter of CBeebies 'Mini Beast Adventures with Jess' Jess French is passionate about animal conservation and educating and inspiring children in the importance of caring for nature.

Dr Ben Garrod
Country: UK
Agent: Jo Sarsby Management
Address: 154 Cheltenham Road, Bristol BS6 5RL, UK
Phone: +44 (0)117 927 9423
Email: jo@josarsby.com
Website: www.josarsby.com/ben-garrod
Twitter.com/Ben_garrod

Evolutionary biologist and great ape conservationist

Aaron Gekoski
Country: UK
Agent: Jo Sarsby Management
Address: 154 Cheltenham Road, Bristol BS6 5RL, UK
Phone: +44 (0)117 927 9423
Email: jo@josarsby.com
Website: www.aarongekoski.com
www.josarsby.com/aaron-gekoski
Twitter.com/Aarongekoski

Presenter, adventurer, underwater/land photographer, journalist, travel writer and filmmaker

Della Golding – Presenter/Producer/Remote Location Specialist
Address: Bristol, UK
Phone: +44 (0)741 197 049
Email: dellagolding@hotmail.com
Facebook.com/dellagoldingwildlife
Linkedin.com/in/dellagolding

I am an experienced Documentary Presenter, Producer and Researcher with qualifications and expert knowledge in zoology and remote area location filming. A graduate of the prestigious MA in Wildlife Filmmaking, University of West England with film credits in producing, directing and presenting natural history content. An Australian based in Bristol, UK specialising in filmmaking with dangerous wild animals and indigenous people in remote locations.

Zack Heart – Outback Zack
Address: PO Box 8233, Green Valley Lake, CA, USA
Phone: +1 310 614 1574
Email: info@zackheart.com
Website: www.outbackzack.com
Facebook.com/zackheart
Twitter.com/zackheart

Australian TV Personality, Host, Actor, Wildlife Expert, Conservationist, Animal Handler, Trapper, Stuntman, Porsche Race Car Driver & Ufologist. Zack Heart, (born in Melbourne, Victoria) is an Australian television and film personality. Heart is recognized as a Host, actor, stunt man, producer, wildlife expert, conservationist and trapper.

Tom "The Blowfish" Hird – Broadcaster/Wildlife Expert/Author
Address: Bristol-based, UK
Phone: +44 (0)7967 584 360
Email: tom.theblowfish@gmail.com
Website: www.theblowfish.co.uk
Agent: www.cloud9management.co.uk/blowfish
Twitter.com/TheBlowfish
Wildlife-film.com/-/Tom-TheBlowfish-Hird.htm

It's official, The Blowfish is the worlds ONLY Heavy Metal Marine Biologist. The Blowfish, AKA Tom Hird, has been a regular face on British TV for the past 5 years, bringing his unique style of presenting to audiences of all ages. Be it live TV with dangerous wild animals, or stage shows in front of huge audiences, The Blowfish is a one of a kind creature not to be missed. In 2015 he took on his biggest challenge to date, filming a 10 x 60 minute series for BBC Worldwide and ITV1. *Fishing Impossible* sees three fishing fanatics travel the world for the most amazing fishing and marine conservation experiences. Needless to say, the Blowfish was in his element getting up close and personal with some of the ocean's most stunning creatures. The show was such a success that a second series (7 x 60) was commissioned immediately and once again, The Blowfish found himself travelling the globe to the most incredible locations to find the most unbelievable fish! The son of a respected veterinary surgeon, The Blowfish learnt the value and beauty of animals from a young age and now he devotes himself to teaching the wonder of wildlife and the importance of conservation to young people. The subject closest to his heart, of course, is the sea. As a fully trained BSAC Dive Leader and PADI Dive Master with over 18 years experience, The Blowfish knows all too well the perilous state of our oceans. Throughout his years working directly with many dangerous animals, both in controlled settings and in the wild, The Blowfish has gather incredible experience which allows him to free dive with sharks, wrangle snakes and dance with scorpions.

217

Always showing the utmost respect to the creature, but also exploring and explaining it's most amazing features, The Blowfish can access a side of nature that no one else can. A key player in British Science Communication, The Blowfish has presented live shows to thousands of children and adults alike across the UK, appearing at The Big Bang Fair, The Skills Show, Oxford Science Festival, Otley Science Festival and Swansea Science Festival, to just name a few! Just make sure you take your ear plugs along, as the shows are known to get LOUD. Tom "The Blowfish" Hird's debut book Blowfish's *Oceanopaedia* about the hidden facts of the ocean, was published by Atlantic in October 2017.

Octavia Hopwood – Television Presenter
Address: Shrewsbury, UK
Phone: +44 (0)7847 414 877
Email: octavia.tv@gmail.com & info@octaviahopwood.co.uk
Website: www.octaviahopwood.co.uk
Twitter.com/OctaviaTv
Wildlife-film.com/·/OctaviaHopwood.htm

In an attempt to get up-close and personal with nature, Octavia couples a deep-rooted passion for the natural world with a love for adventure. As a rock-climbing instructor, PADI Divemaster and bush craft leader, Octavia loves anything that allows her to explore the outdoors. Octavia is a passionate advocator of conservation and with a degree in Environmental Science and experience working as an Environmental Consultant, she has a profound knowledge of British wildlife. As an experienced presenter Octavia is at ease under pressure and has also worked as a researcher for BBC's *Wonders of Life* and *Bang-Goes-the-Theory*. I am currently looking for a role presenting nature documentaries or adventure type programs.

Martin Hughes-Games – Presenter/Naturalist/Zoologist
Country: UK
Agent: David Foster Management
Address: PO Box 1805, Andover, Hampshire SP10 3ZN, UK
Phone: +44 (0)1264 771 726
Email: david@dfmanagement.tv
Website: www.martinhughesgames.co.uk
www.dfmanagement.tv/television-presenters/martin-hughes-games
Twitter.com/MartinHGames

Wildlife TV presenter Martin Hughes-Games is one of the UK's most popular and respected naturalists and zoologists. He is best known for the last nine years as one of the presenters of the BBC's highly successful live shows *Springwatch*, *Autumnwatch* and *Winterwatch*, which he co-hosted with Chris Packham and Michaela Strachan.

Andy Jackson – Presenter/Underwater Cameraman
SubSeaTV
Address: Scarborough, UK
Wildlife-film.com/·/AndyJackson.htm
Main listing in 'Camera Operators' on Page 155

Alex Jones – Presenter/Wildlife Cinematographer
Wildlife Film Productions
Address: 734 Esther Way, Redlands, California 92373, USA
Wildlife-film.com/·/AlexJones.htm
Main listing in 'Camera Operators' on Page 156

Sandesh Kadur - Camera Operator
Felis Creations
Address: Bangalore, INDIA
Wildlife-film.com/·/SandeshKadur.htm
Main listing in 'Camera Operators' on Page 157

Shazaad Kasmani – Photographer, Presenter, Expert
Wild Kenya Safaris
Address: Mombasa, KENYA
Wildlife-film.com/·/ShazaadKasmani.htm
Main listing in 'Location Managers/Fixers' on Page 92

Simon King – Presenter/Cameraman
Simon King Wildlife
Address: Frome, Somerset, UK
Main listing in 'Production Companies' on Page 40

Miranda Krestovnikoff – Wildlife Broadcaster/Presenter
Address: Avon, UK
Phone: +44 (0)7773 307 535
Email: mizk@btinternet.com
Website: www.mirandak.co.uk
Twitter.com/MirandaKNature

Miranda has 18 years' experience of presenting wildlife programmes on radio and television, most recently being the wildlife expert on on BBC2's "*Coast*" and BBC1's "*The One Show*". She is a passionate naturalist and currently President of RSPB. An experienced diver, she is never happier than when she is underwater and has presented many programmes from beneath the waves.

Trevor LaClair – Presenter / Explorer / Photographer
Trekking with Trevor
Address: Missouri, USA
Phone: +1 660 619 3408
Email: laclairts@gmail.com
Website: www.trekkingwithtrevor.com
Twitter.com/trevor_laclair
Facebook.com/trekkingwithtrevor
Instagram.com/trevorlaclair
Linkedin.com/in/trevor-laclair-9a158a77
Wildlife-film.com/·/TrevorLaClair.htm

Trevor is an explorer who is passionate about wildlife and has a taste for adventure. He is a certified Wilderness First Responder and scuba diver. He is also skilled in several other outdoor activities. Trevor has spent several years working with animals in either zoos, sanctuaries, during research, or as a conservationist. As a freelancer, Trevor searches for opportunities as an on-camera presenter and voice-over artist. Trevor is interested in projects about wilderness adventures, wildlife interactions and education, and conservation. His mission is to build a sense of fascination and passion for wildlife while educating people about the natural world.

Dominique Lalonde – Presenter/Producer/DOP/Photographer
Dominique Lalonde Productions
Address: Québec, CANADA
Wildlife-film.com/-/DominiqueLalonde.htm
Main listing in 'Production Companies' on Page 17

Steve Leonard – Veterinary Surgeon & TV Presenter
Country: UK
Agent: Jo Sarsby Management
Address: 154 Cheltenham Road, Bristol BS6 5RL, UK
Phone: +44 (0)117 927 9423
Email: jo@josarsby.com
Website: www.steveleonard.co.uk
www.josarsby.com/steve-leonard
Twitter.com/ThatVetOffTheTV

Veterinary surgeon, wildlife TV presenter and public speaker.

Jackson Looseyia
Country: KENYA
Agent: David Foster Management
Address: PO Box 1805, Andover, Hampshire SP10 3ZN, UK
Phone: +44 (0)1264 771 726
Email: david@dfmanagement.tv
Website: www.jacksonlooseyia.co.uk
www.dfmanagement.tv/television-presenters/jackson-looseyia

Jackson is the charismatic Masai TV presenter who is passional about the Mara. The BBC's *Big Cat Live* marked his television debut where he shared his incredible knowledge of animal behaviour.

Rob Nelson – Biologist/Science Communicator/Presenter
Untamed Science
Address: Charlotte, NC, USA
Agent: www.josarsby.com/rob-nelson
Main listing in 'Production Companies' on Page 44-45

Will Nicholls – Presenter/Camera Operator/Photographer
Address: Hexham, Northumberland, UK
Wildlife-film.com/-/WillNicholls.htm
Main listing in 'Camera Operators' on Page 160

Vivian A. N. Nuhu – Presenter/Narrator
Address: Osu-Accra, GHANA, WEST AFRICA
Main listing in 'Fixers' on Page 89

Bill Oddie OBE
Country: UK
Agent: David Foster Management
Address: PO Box 1805, Andover, Hampshire SP10 3ZN, UK
Phone: +44 (0)1264 771 726
Email: david@dfmanagement.tv
Website: www.billoddie.com
www.dfmanagement.tv/television-presenters/bill-oddie
Twitter.com/billoddie

The UK's best known birder, Bill Oddie is a multi-talented celebrity – wildlife TV presenter, broadcaster, writer, song-writer, musician and conservationist. And also one third of The Goodies.

Mark O'Shea – Presenter/Venomous Snake Specialist
Country: UK
Agent: David Foster Management
Address: PO Box 1805, Andover, Hampshire SP10 3ZN, UK
Phone: +44 (0)1264 771 726
Email: david@dfmanagement.tv
Website: www.markoshea.info
www.dfmanagement.tv/television-presenters/mark-oshea
Facebook.com/herpetofauna
Twitter.com/micropechis

Internationally renowned wildlife TV presenter and one of the world's top reptile experts who specialises in venomous snakes. Star of successful '*O'Shea's Big Adventure*' (Animal Planet / C4).

Chris Packham
Country: UK
Agent: David Foster Management
Address: PO Box 1805, Andover, Hampshire SP10 3ZN, UK
Phone: +44 (0)1264 771 726
Email: david@dfmanagement.tv
Website: www.chrispackham.co.uk
www.dfmanagement.tv/television-presenters/chris-packham
Twitter.com/chrisgpackham

Naturalist and TV presenter of BBC 2's *Springwatch*, *Autumnwatch* and *Winterwatch*, critically acclaimed *Secrets of our Living Planet*, *Operation Iceberg* and many popular wildlife series since the *Really Wild Show*.

Jack Perks – Presenter/Photographer/DOP/Researcher
Jack Perks Wildlife Media
Address: Nottingham, UK
Wildlife-film.com/-/JackPerks
Main listing in 'Production Companies' on Page 26

Maya Plass – Presenter/Marine Scientist
Country: UK
Agent: David Foster Management
Address: PO Box 1805, Andover, Hampshire SP10 3ZN, UK
Phone: +44 (0)1264 771 726
Email: david@dfmanagement.tv

Website: www.mayaplass.com
www.dfmanagement.tv/television-presenters/maya-plass Twitter.com/MayaPlass

Female marine scientist and TV presenter Maya Plass has appeared on BBC Two *Springwatch*, *Autumnwatch* and *Coast*, and ITV1 *Hungry Sailors*. She is a marine ecologist, coastal expert and qualified diver.

Alex Rhodes
Address: Bristol, UK
Main listing in 'Assistants' on Page 208

Michaela Strachan – Wildlife Presenter
Country: UK/SOUTH AFRICA
Agent: Jo Sarsby Management
Address: 154 Cheltenham Road, Bristol BS6 5RL, UK
Phone: +44 (0)117 927 9423
Email: jo@josarsby.com
Website: www.michaelastrachan.co.uk
www.josarsby.com/michaela-strachan
Twitter.com/michaelastracha

Award-winning TV presenter, author and public speaker.

Anneka Svenska – Presenter/Conservationist/Canid Expert
Country: UK
Agent: David Foster Management
Address: PO Box 1805, Andover, Hampshire SP10 3ZN, UK
Phone: +44 (0)1264 771 726
Email: david@dfmanagement.tv
Website: www.annekasvenska.com
www.dfmanagement.tv/television-presenters/anneka-svenska
Twitter.com/AnnekaSvenska

Anneka Svenska is a warm, passionate, engaging naturalist and conservationist, but what makes her unique is that she is one of TV's few women specialising in wolves and apex predators.

Richard Taylor-Jones – Presenter/Cameraman/Photographer
Country: UK
Agent: David Foster Management
Address: PO Box 1805, Andover, Hampshire SP10 3ZN, UK
Phone: +44 (0)1264 771 726
Email: david@dfmanagement.tv
Website: www.richardtaylorjones.co.uk
www.dfmanagement.tv/television-presenters/richard-taylor-jones
Twitter.com/rtaylorjones

Richard Taylor-Jones is an expert wildlife TV presenter, film maker, camera man and photographer known for his live and scripted work on BBC *Springwatch*, *Autumnwatch*, *Big Blue UK*, *Coast* and *Countryfile*.

Ajay Tegala – Presenter/Naturalist
Country: UK
Agent: David Foster Management
Address: PO Box 1805, Andover, Hampshire SP10 3ZN, UK
Phone: +44 (0)1264 771 726
Email: david@dfmanagement.tv
Website: www.ajaytegala.co.uk
www.dfmanagement.tv/television-presenters/ajay-tegala Twitter.com/AjayTegala
Facebook.com/AjayTegala

Wildlife TV presenter, naturalist and countryside ranger, Ajay has worked on some of the UK's most important nature reserves and has appeared on BBC *Springwatch Unsprung*, *Winterwatch* and *Coast*.

Gavin Thurston – Cameraman/Director/Presenter
Country: UK
Main listing in 'Camera Operators' on Page 169

Iolo Williams – Presenter/Naturalist
Country: UK
Agent: David Foster Management
Address: PO Box 1805, Andover, Hampshire SP10 3ZN, UK
Phone: +44 (0)1264 771 726
Email: david@dfmanagement.tv
Website: www.iolowilliams.co.uk
www.dfmanagement.tv/television-presenters/iolo-williams

Wildlife TV presenter who speaks both Welsh and English. A presenter on *Springwatch*, *Autumnwatch*, *Countryfile* and *Nature's Top 40*. Author, keen sportsman, paraglider, PADI Divemaster.

Kim Wolhuter – Producer/Cameraman/Talent
Mavela Media
Address: White River, SOUTH AFRICA
Main listing in 'Production Companies' on Page 30

EDITORS & MOTION GRAPHICS/CGI

Trevor Almeida – Producer / DOP / Editor
Geonewmedia
Address: Glen Waverley, Melbourne, Victoria, AUSTRALIA
Main listing in 'Production Companies' on Page 23

Jiri Bálek - Cameraman/DOP/Zoologist/Editor
Lemuria TV
Address: Tisá, CZECH REPUBLIC
Main listing in 'Camera Operators' on Page 137

Andrew Bell – Producer/ Cameraman / Editor
Address: London, UK
Main listing in 'Producers/Directors' on Page 179

Hal Brindley – Producer, Cinematographer, Photographer, Editor, Presenter
Travel For Wildlife
Main listing in 'Camera Operators' on Page 141

Alice Clarke – Self-shooting PD/FCP Editor/Scriptwriter.
Address: Bristol, UK
Wildlife-film.com/·/AliceClarke.htm
Main listing in 'Propducers/Directors' on Page 183

Robin Crofoot – Editor / Camera Man
Address: Rossow, Mecklenburg-Vorpommern, GERMANY
Main listing in 'Camera Operators' on Page 143

Claire Evans – Editor/AP
Address: Bristol, UK & CANADA
Main listing in 'Assistant Producers' on Page 194

Bob Glowacky – Assistant/Camera Operator/Editor
Address: New Hampshire, USA
Wildlife-film.com/·/RobertGlowacky.htm
Main listing in 'Assistants' on Page 205-207

Ricardo Guerreiro - Filmmaker (photography, editing, fixer)
Address: Lisbon, PORTUGAL
Wildlife-film.com/·/RicardoGuerreiro.htm
Main listing in 'Camera Operators' on Page 149

Bronwyn Harvey - Video Editor
Address: Bristol, UK
Phone: +44 (0)7511 288 065
Email: sayhello@bronwynharvey.com
Website: www.bronwynharvey.com

Natural History · Credits have included Smithsonian, Terra Mater, National Geographic, Discovery plus more.

Kiril Ivanov
Videodiver.ru
Address: Moscow, RUSSIA
Wildlife-film.com/·/Kirillvanov.htm
Main listing in 'Camera Operators' on Page 154

Hilco Jansma – Editor / Camera Operator
Address: Groningen, THE NETHERLANDS
Wildlife-film.com/·/HilcoJansma.htm
Main listing in 'Camera Operators' on Page 154

Mike Johnson – Editor / Cinematographer / DP
Michael Johnson Entertainment, LLC
Address: Missouri, USA
Wildlife-film.com/·/MikeJohnson.htm
Main listing in 'Camera Operators' on Page 155

Alex Jones - Wildlife Cinematographer/Editor
Wildlife Film Productions
Address: 734 Esther Way, Redlands, California 92373, USA
Wildlife-film.com/·/AlexJones.htm
Main listing in 'Camera Operators' on Page 156

Dave Keet – Producer/DOP/Editor
Aquavision TV Productions (Pty) Ltd
Address: Johannesburg, SOUTH AFRICA
Wildlife-film.com/·/Aquavision-Productions.htm
Main listing in 'Production Companies' on Page 10

Adam Kirby – Freelance Film Editor
Address: Bristol, UK
Phone: +44 (0)7833 565 206
Email: adamkirby@akediting.com
Website: www.akediting.com
Twitter.com/Adamkirby484
Linkedin.com/pub/adam-kirby/4a/834/646

Dominique Lalonde – Producer/DOP/Editor/Photographer
Dominique Lalonde Productions
Address: Québec, CANADA
Wildlife-film.com/·/DominiqueLalonde.htm
Main listing in 'Production Companies' on Page 17

Peter Lamberti – Producer/DOP/Editor
Aquavision TV Productions (Pty) Ltd
Address: Johannesburg, SOUTH AFRICA
Wildlife-film.com/·/Aquavision-Productions.htm
Main listing in 'Production Companies' on Page 10

Arthur Machado – Editor/Producer/DOP/Photographer
Address: Christchurch, New Zealand
Vimeo.com/arthurmachado
Wildlife-film.com/·/ArthurMachado.htm
Main listing in 'Producers/Directors' on Page 186-187

Matt Meech - Editor
Address: Bristol, UK
Email: mm@mattmeech.com
Website: www.mattmeech.com
Twitter.com/mattmeech

I am an award winning, freelance, offline editor working in Bristol & London, as well as overseas. Over the past ten years I have made documentaries for BBC, PBS, Netflix, Nation Geographic, Animal Planet & Discovery. I am a creative storyteller with a natural editorial instinct. Recent and future documentary broadcasts include; *Blue Planet II*, *Planet Earth II*, *Dynasty*, *Our Planet*, *Africa*, *Wild Canada*, *Monsoon*, *River Monsters*, *Shark*, and *The Hunt*. More information can be found on my website.

Alan Miller – Editor/Director/Writer
Shake The Tree Productions
Address: Keeper's Cottage, Rectory Road, Suffield, Norfolk, NR11 7ER, UK
Phone: +44 (0)1263 731 659
Email: alanmiller@mac.com
Website: www.camuspublishing.co.uk/contact Facebook.com/alan.miller.186590
Twitter.com/AlanCamusMiller
Wildlife-film.com/·/ShakeTheTreeProductions.htm

Alan has been editing wildlife documentaries for over thirty years. BBC trained, he started editing wildlife programmes at Partridge Films and worked on many of its Wildscreen Panda award winners. He has worked for many companies, including Granada, BBC, NHK Japan and Nature Conservation Films for whom he wrote, directed and edited a wildlife feature film and edited two other wildlife feature films. He has also written and directed many documentaries but remains passionately interested in editing. He is experienced in both Avid and Final Cut Pro systems. Alan is a Wildscreen Panda award-winner and his independent feature film won best of category in 2012's London Independent Film Festival. He continues to make distinctive documentaries and writes as Camus for Cineoutsider.com, a website championing filmmaking.

Stan Nugent – Camera Operator / Producer / Editor
Waxwing Wildlife Productions Ltd
Address: Ennis, Co. Clare, IRELAND
Main listing in 'Production Companies' on Page 47

Ben Please - Composer/Sound-design/Camera-person/Editor
Harbour Studio
Address: Wigtown, Dumfries and Galloway, Scotland, UK
Main listing in 'Music Composers' on Page 233

Pete Price – Editor
Address: Bristol, UK
Phone: +44 (0)7968 698 474
Email: pete@peteprice.tv
Website: www.peteprice.tv
Twitter.com/petepricetv
Wildlife-film.com/·/PetePrice.htm

I've been editing factual television for over 12 years, cutting a diverse range of programmes for all major UK broadcasters. Whether editing a stunning natural history series or a fascinating observational documentary, I demonstrate an excellent sense of structure and creativity, while working quickly and efficiently, keeping the edit on schedule. I'm happy to work alone or accompanied using Avid, Final Cut Pro or Adobe Premiere.

Olivia Prutz – Freelance Camera Operator and Editor
Country: London, UK
Wildlife-film.com/·/OliviaPrutz.htm
Main listing in 'Camera Operators' on Page 163

Jeff Reed – Chief Operations Officer/Producer/DOP/Editor
Ocean Media Institute
Address: Bozeman, Montana, USA
Email: jeff@oceanmediainstitute.org
Main listing in 'Production Companies' on Page 34

Anthony Roberts – Editor/Motion Graphics/CGI
ZED Creative
Address: Wales, UK
Wildlife-film.com/·/AnthonyRoberts.htm
Main listing in 'Production Services' on Page 164

Darryl Saffer – Filmmaker/Composer
Studio Ray
Address: Sarasota, Florida, USA
Wildlife-film.com/·/DarrylSaffer.htm
Main listing in 'Producers/Directors' on Page 189

Alberto Saiz – DOP
NaturaHD
Address: Madrid, SPAIN
Main listing in 'Production Companies' on Page 31

Sue Scott - Editor
Country: SOUTH AFRICA
Phone: +27 82 400 5525
Email: suescott@gmail.com
Website: www.susanscott.com
Twitter.com/susan_scott
Wildlife-film.com/·/SusanScott.htm

Susan has been making documentary films for nearly twenty years now. After studying cinematography and the craft of non-linear editing in the US, she went on to mentor with an ACE editor in Washington DC, the home of documentary. So, it's no wonder Susan fell in love with the craft of editing documentaries! Not only has she worked with some of the

best wildlife and documentary filmmakers on the planet, she has gone on to win a Jackson Hole Wildlife Film Festival award for Best Editing, three SAFTAs as well as several international awards for her cutting. In 2010 she was awarded the use of the acronym from the South African Editors Guild. Shortly after receiving recognition of her body of work by the guild, she returned to her love of cinematography and after two decades in dark cutting rooms, she now spends as much time outdoors as she can! Susan is now directing the crowd-funded independent film *STROOP* on the rhino poaching crisis.

Christian Stehlin – Cameraman & Crew
Address: Balearic Islands, SPAIN
Wildlife-film.com/-/ChristianStehlin.htm
Main listing in 'Camera Operators' on Page 168

Frederik Thoelen – Camera Operator / Editor
Wild Things
Address: Hasselt, BELGIUM
Main listing in 'Camera Operators' on Page 169

Gareth Trezise – Editor/Cameraman
Address: Bristol, UK
Wildlife-film.com/-/GarethTrezise.htm
Main listing in 'Camera Operators' on Page 169

Laura Turner – Editor/Camera Operator/Filmmaker
Fuzzfox and The Wildlife Garden Project
Address: Nottingham, UK
Phone: +44 (0)7948 377 224
Email: laura@wildlifegardenproject.com
Website: www.wildlifegardenproject.com and www.fuzzfox.com
Wildlife-film.com/-/LauraTurner.htm

I am an Apple-certified FCP editor, camera operator and filmmaker specialising in conservation and charity films. I am the founder and filmmaker at The Wildlife Garden Project, an organisation who make online tutorial videos advising on ways to help garden wildlife. (Take a look at our entry in the Organisations section!) I also own Fuzzfox, who specialise in online videos for charities, non-profits and small businesses, as well as whiteboard animations. In the past I worked as an editing tutor on the Wildeye Big Cat

Film Safari in Kenya and was also the in-house editor for CTV Perth, Australia, where a conservation documentary I edited won a WA Screen Award. Please take a look at my websites or give me a bell!

Tim Visser – Editor/Producer/Wildlife Cameraman
Wild Step
Address: Den Bosch, The Netherlands
Wildlife-film.com/·/TimVisser.htm
Main listing in 'Production Companies' on Page 50

Stefanie Watkins – Offline Editor
Address: 41 Brecknock Rd, Bristol BS4 2DE, UK
Phone: +44 (0)7837 591 777
Email: stef@stefaniewatkins.com
Website: www.stefaniewatkins.com
Twitter.com/StefanieWatkins
Wildlife-film.com/·/StefanieWatkins.htm

Stefanie has been editing factual shows and films for over eleven years, specialising in natural history and science, and working on programming for the BBC, Discovery, National Geographic, Channel 4, and PBS, to name a few. Often brought-on for her modern editing style and specialised science background, Stefanie is a strong independent storyteller, who thrives on collaboration and loves combining the edgy flair of music videos with the elegant grace of wildlife shows.

MUSIC COMPOSERS/SOUND DESIGNERS

Brollyman Productions
Country: UK
Phone: +44 (0)7887 508 973
Email: brolly@brollyman.com
Website: www.brollyman.com
Main Contact: Brolly
Wildlife-film.com/·/Brollyman.htm

We write lots of music to picture for lot's of lovely wildlife programmes but are always looking for new people to work with. There's plenty of clips on our website as well as our full CV & our blog/newsletter keeps people up to date with what we do. Email me to be added to the list. Hugs brolly.

Davide Caprelli
Country: ITALY
Email: d.caprelli@usa.net
Twitter.com/DAVIDECAPRELLI
Facebook.com/davide.caprelli
Youtube.com/user/PAKIDAT
Soundcloud.com/davidecaprelli
Wildlife-film.com/·/DavideCaprelli.htm

Davide Caprelli is an eclectic and inspired Italian composer. His talent, in recent years, has been requested for composing the soundtrack of important naturalistic and historical documentaries broadcast on the main Italian networks, the soundtrack of dozens of theatrical performances and for composing the music of several television themes.

Jez riley French – field recordist, composer, artist
Address: East Yorkshire, UK
Email: tempjez@hotmail.com
Website: www.jezrileyfrench.co.uk
Twitter.com/jezrileyfrench
Wildlife-film.com/·/JezrileyFrench.htm

Using intuitive composition, field recording, improvisation and photography, Jez has been exploring his enjoyment of and interest in detail, simplicity and his emotive response to

places and situations for over 3 decades. Alongside performances, exhibitions, installations, JrF lectures and runs workshops around the world and his range of specialist microphones are widely used by recordists, sound artists, musicians, sound designers and cultural organisations. He also works as a curator of live events, a record label, of sound installations and an arts zine 'verdure engraved'. In recent years he has been working extensively on recordings of surfaces, spaces and situations and developing the concept of photographic scores and 'scores for listening', which have featured widely in publications and exhibitions. His work has been exhibited in shows and installations alongside that of Yoko Ono, David Bowie, Pauline Oliveros, Chris Watson, Alvin Lucier, Annea Lockwood, Ryuchi Sakamoto, Stars of the Lid, Jeremy Deller, Sarah Lucas, Brian Eno, Signe Liden, Sally Ann McIntyre etc, at galleries including The Whitworth Gallery (Manchester), Tate Modern and Tate Britain, MOT · Museum of Contemporary Art, Tokyo (Japan), Artisphere (USA)

Morten Gildberg – Composer
Address: Odense, DENMARK
Email: mortengildberg@gmail.com
Phone: +45 20 60 41 83
Website: www.mortengildberg.com
Facebook.com/pages/MUSIC-by-Morten-Gildberg/225983104083361
Twitter.com/MGildbergMusic
Soundcloud.com/musicbymortengildberg
Linkedin.com/in/mortengildberghansen
Wildlife-film.com/-/MortenGildberg.htm

I am a Danish music composer with a great interest in the natural world. My main interest is conservation filmmaking. I am interested in composing music for films who aim to make a difference and educate people · young and old · about the importance of protecting animal life and plant life on the planet. I have a solid classical background and I offer anything from solo piano to full orchestra. 10 years of professional working experience in Denmark & abroad.

Jonathan Kawchuk
Address: UK and CANADA
Wildlife-film.com/-/JonathanKawchuk.htm
Main listing in 'Sound Operators', see: Page 175

David Mitcham
Address: Wiltshire, UK
Phone: +44 (0)1380 720 141
Email: david@davidmitcham.co.uk
Website: www.davidmitcham.co.uk

Multi award-winning wildlife film composer.

Matt Norman - Composer
Silverscore Productions Ltd
Country: UK
Phone: +44 (0)7761 332 084
Email: matt@silverscoreproductions.com
Website: www.silverscoreproductions.com
Wildlife-film.com/-/MattNorman.htm

Original music composed and scored to picture by Matt Norman for Natural History films. Credits include "T-Rex Ultimate Survivor", "Bandits of Selous", "Humpbacks · Cracking the

231

Code", "21st Century Shark" (National Geographic) and "Wild Australia", "Animal Black Ops", "World War 2 in Colour" and "Britain's lost water lands" for Discovery, ITV, Channel 5 and the BBC. Please see the website for video and audio samples.

Gregory Ovenden – Location, Outside Broadcast and Post Production Sound
The Sound Farmer
Address: Garden Cottage, Holwood, Keston, Bromley, London, BR2 6HB, UK
Phone: +44 7732 125 827
Email: gregoryovenden@gmail.com
Website: www.thesoundfarmer.com
Facebook.com/ovendensoundfarmer
Twitter.com/thesoundfarmer
Instagram.com/thesoundfarmer
Wildlife-film.com/·/GregoryOvenden.htm

A Location Sound Recordist based in London and Kent offering location and post sound services for TV production, documentaries, short and feature films, corporate projects, radio, installations, studio sound, sound design and post-production sound worldwide.

Fraser Purdie
Country: UK
Phone: +44 (0)7870 479 939
Email: fraser@fraserpurdie.com
Website: www.fraserpurdie.com
Twitter.com/fraser_purdie
Linkedin.com/in/fraserpurdie
Audiojungle.net/user/fraserpurdie
Wildlife-film.com/·/FraserPurdie.htm

BAFTA TV Nominated Composer for film, television and media. Recent works include 'Attenborough and the Empire of the Ants' for Ammonite TV / Terra Mater factual Studios due for broadcast BBC 2 in December 2017 and "Gudrun The Viking Princess', a 10 part CBEEBIES series for Maramedia. Music has also been used in the BBC production Sinatra - Our Way, Jimmy Kimmel Live Christmas Special and the trailer for horror film "We Are Still Here" "Working with Fraser was easy right from the start. My brief for the music for 'Life that Glows' was complicated to say the least. I wanted everything and nothing, classic but modern, electronic but orchestral, otherworldly but not sci fi. Fraser instantly got it and his music fitted our intentions perfectly. He was fast yet consider and everything sounded new and different. A pleasure to work with." Joe Loncraine, Director, Attenborough's Life That Glows

Ben Please - Composer/Sound-design/Camera-person/Editor
Harbour Studio
Address: 5 Harbour Road, Wigtown, Dumfries and Galloway, Scotland, UK
Phone: +44 (0)7789 348 165
Email: benplease@hotmail.com
Website: www.harbourstudio.net

Ben has composed for a number of short films (Marylin Myller, Woodsman), commercials (Nike, Martini) and animations, with regular work through Blink Inc. and Parabella Studios In 2011 a short animation (The Eagleman Stag) which he created the sound design, foley and composed the music for, won a BAFTA for Best Short Animation and was long listed for an Oscar the following year. He also has over 18 years experience working as an environmental film editor, director, producer and camera-person for The Brock Initiative and CBCF (Community-based Biodiversity Conservation Films) in East Africa, and then freelance.

Darryl Saffer – Filmmaker/Composer
Studio Ray
Address: Sarasota, Florida, USA
Wildlife-film.com/·/DarrylSaffer.htm
Main listing in 'Producers/Directors' on Page 189

Vinzenz Stergin – Stergin Music
Address: 3 Allison Close, London SE10 8AZ, UK
Phone: +44 (0)7531 830 784
Email: info@stergin.com
Website: www.stergin.com
Facebook.com/vinzenzstergin
Twitter.com/VinzenzStergin
Youtube.com/user/StreetGin

I am a composer and songwriter and I am offering scores, signature songs but basically anything music related in a documentary production. I am looking for documentaries of any kind but specifically I am interested in nature. If you need a sound guy for a documentary shoot in the Antarctic I am in as well as I love nature and programs about it. Please check my website to see what my musical world is all about. Please check my IMDB for credits: imdb.com/name/nm4410312

Tobin Stokes – Composer
Address: Victoria, CANADA
Phone: +1 250 598 7664
Email: tobinstokes@gmail.com
Website: www.tobinstokes.com
Twitter.com/livecomposer

Canadian composer of natural history & wildlife docs for BBC, Eden, Discovery, CBC, etc. From full orchestral scores (I work with orchestras in Vancouver, Moscow, and Bratislava) to midi & experimental. Series include *Captain Cook: Obsession and Discovery* w/Vanessa Collingridge, *Darwin's Brave New World*, *Wild Canada*, & *The Wild Canadian Year*.

Jobina Tinnemans – Wildlife Sound Composer/Producer
Country: Pembrokeshire and London-based, UK
Phone: +44 (0)7428 629 821
Email: mail@jobinatinnemans.com
Website: www.jobinatinnemans.com

Looking for something different than one-size fits all library music? After all the patience and efforts of capturing that very special wildlife moment on film you need a soundtrack which reflects this passion to capture your audience. I'm an experienced studio-based or on-location music producer, field recordist, mastering sound engineer, with over ten years of experience in composing music performed by ensembles, choirs or in software. Supply me with your visual concept, mood, interests, targets and I will write you your measured-to-fit music score which will elevate all details and colours of your film into the next level. Try me. Book a meeting.

Twisted Jukebox Ltd.
Address: Suite 34, 272 Kensington High Street, London W8 6ND, UK
Phone: +44 (0)20 3397 4848
Email: contact@twistedjukebox.com
Website: www.twistedjukebox.com
Soundcloud.com/twisted-jukebox
Facebook.com/twistedjukebox
Twitter.com/TwistedJukebox
Music Director and Management: Matt Welch · matt@twistedjukebox.com

Twisted Jukebox is a music publishing and production music library. We have a range of music suitable for nature themed documentaries that cover different moods and scenarios as well as a team of talented composers that can write bespoke music to fill clients briefs.

Cody Westheimer - Composer
Address: 3127 Glendon Ave, Los Angeles, CA, USA
Phone: +1 213 709 5643
Email: codymusic@me.com
Website: www.newweststudios.com

Cody Westheimer is a noted film and television composer. A multi-instrumentalist and magna cum laude graduate of the music composition program at USC's Thornton School of Music, his gift for thematic writing and creative instrument choices has made him a sought after composer for both studio and independent projects. A passion for wildlife and the son of a veterinarian, Cody's love of nature gives him a unique perspective scoring such projects. Equally comfortable with the orchestra and the rock band, his blend of contemporary musical styles has taken over 100 films to the next level of storytelling.

Josh Wynter – Film & TV Composer
Josh Wynter Music
Addresses: Chichester, UK & Cape Town, SOUTH AFRICA
Phone: +27 (0)637 750 192
Email: contact@joshwynter.com
Website: www.joshwynter.com
Wildlife-film.com/·/JoshWynter.htm

Bespoke scores & soundtracks for film and television. Interested in being a part of new exciting projects, especially in historical & wildlife documentary film.

235

PRODUCTION STILLS PHOTOGRAPHERS

Fabio Borges Pereira – Photographer & Filmmaker
Fabio Borges Fotografia / Hydrosphera
Address: Fernando de Noronha – PE, BRAZIL
Main listing in 'Camera Operators' on Page 140

Hal Brindley – Producer, Cinematographer, Photographer, Editor, Presenter
Travel For Wildlife
Main listing in 'Camera Operators' on Page 141

John Brown – Photographer/Director/Producer/Camera
Address: Oxford, UK
Main listing in 'Camera Operators' on Page 142

Mark Challender – Photographer/Producer/Director
Address: UK / USA
Website: www.challenderphotography.com
Main listing in 'Producers/Directors' on Page 182

Cristian Dimitrius – Photographer/Director/Filmmaker
Cristian Dimitrius Productions
Address: Sao Paulo, BRAZIL
Wildlife-film.com/·/CristianDimitrius.htm
Main listing in 'Camera Operators' on Page 144-145

James Dunbar – Photographer/ Camera Operator/Assistant
Address: Bristol, UK
Wildlife-film.com/·/JamesDunbar.htm
Main listing in 'Camera Operators' on Page 146

Paul Duvall – Drone Operator / Photographer
Address: Worthing, West Sussex, UK
Main listing in 'Camera Operators' on Page 146

Ricardo Guerreiro - Filmmaker (photography, editing, fixer)
Address: Lisbon, PORTUGAL
Wildlife-film.com/·/RicardoGuerreiro.htm
Main listing in 'Camera Operators' on Page 149

Clive Huggins - Consultant Entomologist/Photographer
Address: Surrey, UK
Wildlife-film.com/·/CliveHuggins.htm
Main listing in 'Experts' on Page 243

Sandesh Kadur – Photographer/Camera Operator/Stills
Felis Creations
Address: Bangalore, INDIA
Wildlife-film.com/·/SandeshKadur.htm
Main listing in 'Camera Operators' on Page 157

Shazaad Kasmani – Photographer, Presenter, Expert
Wild Kenya Safaris
Address: Mombasa, KENYA
Wildlife-film.com/·/ShazaadKasmani.htm
Main listing in 'Location Managers/Fixers' on Page 92

Trevor LaClair – Presenter / Explorer / Photographer
Trekking with Trevor
Address: Missouri, USA
Wildlife-film.com/·/TrevorLaClair.htm
Main listing in 'Presenters/Narrators' on Page 219-220

Dominique Lalonde – Producer/DOP/Editor/Photographer
Dominique Lalonde Productions
Address: Québec, CANADA
Wildlife-film.com/·/DominiqueLalonde.htm
Main listing in 'Production Companies' on Page 17

Justin Lotak – Photographer, Videographer
Conservation Atlas
Address: Georgetown, Texas, USA
Phone: +1 312 823 9917
Email: justinlotak@gmail.com
Main listing in 'Organisations' on Page 115

Arthur Machado – Photographer/Producer/Editor
Address: Christchurch, New Zealand
Wildlife-film.com/·/ArthurMachado.htm
Main listing in 'Producers/Directors' on Page 186-187

Feisal Malik - Line Producer/Director/Camera/Fixer/Producer
Visual Africa Films Ltd
Address: Nairobi, KENYA
Wildlife-film.com/·/Visual-Africa-Films.htm
Main listing in 'Location Managers/Fixers' on Page 91

Dee Marshall – Photographer/Writer
Address: Uriage, FRANCE
Wildlife-film.com/·/DeeMarshall.htm
Main listing in 'Writers/Script Editors' on Page 210

Angels Melange – Cinematographer/Filmmaker
Address: Barcelona, SPAIN
Main listing in 'Camera Operators' on Page 159

Faye Minister – Camera Assistant/Runner
Address: Milton Keynes, UK
Main listing in 'Assistants' on Page 207

Jessica Mitchell – Macro Photographer / Underwater Camera
Earth Motion Pictures
Address: Bristol, UK
Main listing in 'Camera Operators' on Page 159

Robin Moore - Wildlife/Nature/Conservation Photographer
Robin Moore Photography
Address: 4112 4th St NW, Washington, DC 20011, USA
Phone: +1 2023605339 & +1 57123163455
Email: robindmoore@gmail.com
Website: www.robindmoore.com
Twitter.com/robindmoore Facebook.com/RobinMoorePhotographer

I am a Senior Fellow of the International League of Conservation Photographers, represented by National Geographic Creative, and hold a PhD in biodiversity conservation. I am widely published and have won awards for my images of wildlife, landscapes and cultures including Nature's Best International Photo Awards, Wildlife Photographer of the Year, National Geographic Traveler and American Photo. I run annual photo safaris in Kenya, and am communications director with Global Wildlife Conservation. I am always interested in ideas for projects centered around a conservation theme. I do consider co-productions and am open to invitations to collaborate.

Will Nicholls – Photographer / Camera Operator/Assistant
Address: Hexham, Northumberland, UK
Wildlife-film.com/·/WillNicholls.htm
Main listing in 'Camera Operators' on Page 160

Chris Perrett
naturesart
Address: Shropshire, UK
Phone: +44 (0)1938 561 981
Email: sf7@mac.com
Website: www.chrisperrett.com

Stills Photographer and Cinemagraph Artist with over 30 years Experience hung out of Helicopters and Hot Air balloons, walked in rainforests, crawled towards lions in South Africa and swam in the Okavango Delta Botswana.

Frederique Olivier
Address: Tasmania, AUSTRALIA
Wildlife-film.com/·/FrederiqueOlivier.htm
Main listing in 'Camera Operators' on Page 162

Rubén Duro Pérez – Scientific Photographer/Scientific Advisor/Camera Operator/Producer/Director
Address: Dosrius, SPAIN
Wildlife-film.com/-/RubenDuroPerez.htm
Main listing in 'Producers/Directors' on Page 188

Jack Perks – Photographer/DOP/Presenter/Researcher
Jack Perks Wildlife Media
Address: Nottingham, UK
Wildlife-film.com/-/JackPerks.htm
Main listing in 'Production Companies' on Page 26

Libby Prins
Address: Bristol, UK
Main listing in 'Assistant Producers' on Page 194

Colin Ruggiero - Independent Filmmaker/DP/Photographer
Rhythm Productions, LLC
Address: Missoula, USA
Main listing in 'Camera Operators' on Page 164-165

Alberto Saiz – Photographer / Cinematographer
NaturaHD Films
Address: Madrid, SPAIN
Main listing in 'Production Companies' on Page 31

Gavin Shand - Shooting Junior Researcher
Address: Glasgow, Scotland, UK
Wildlife-film.com/-/GavinShand.htm
Main listing in 'Camera Operators' on Page 166

Mark Slemmings – Photographer/Cameraman
Country: UK
Main listing in 'Camera Operators' on Page 167

Kimberly Stewart
Address: Chichester/London, UK
Main listing in 'Researchers' on Page 204

Nick Upton – Photographer/Videographer/Director/Writer
Address: 5 Kingsdown House, Kingsdown, Corsham, Wiltshire SN13 8AX, UK
Phone: +44 (0)1225 742 300 and +44 (0)7732 361 521
Fax: +44 (0)1225 742 300
Email: nickupton@btopenworld.com

Website with my images for sale: www.naturepl.com
Wildlife-film.com/·/NickUpton.htm

I'm an experienced wildlife stills photographer and director/writer/producer of wildlife films for the BBC, PBS, European and Asian Public service broadcasters. My stills won the British Wildlife Photography Awards Documentary Series category in 2014 and 2016. My films won Best of Festival awards in 8 countries and approaching 100 awards in total. I now primarily work as a wildlife and nature/people stills photographer and videographer, with infra red work of beavers (dam building screened on BBC *Springwatch*) and other nocturnal wildlife a speciality. My stills appear in many books and newspapers and magazines, illustrating ten features in BBC Wildlife magazine in 2014-2018 and I've been published in National Geographic. Film credits include *The Trials of Life*, 6 Natural World films including *Beetlemania and Vampires*, *Devibirds and Spirits*, *Living Europe*, *Triumph of Life*, *Baltic Secrets*, *Predators' Paradise*, *Return of the Cranes*. I am not seeking funds for my own productions but could work with production companies on projects that need input. I do not offer work experience.

Kate Westaway – Producer, Underwater Stills Photography
Address: Clifton, Bristol, UK
Phone: +44 (0)7866 748 629
Email: kate@katewestaway.com
Website: www.katewestaway.com
Wildlife-film.com/·/KateWestaway.htm

I am a Producer and Underwater Stills Photographer with my HSE Part IV Scuba qualification. I'm very experienced at setting up shoots overseas and capable of working alone. I've worked on a variety of TV programmes from sensitive, investigative human-interest documentaries to adventure/wildlife subjects. I've worked for Icon Films, Tigress Productions, Diverse TV, Granada, RDF to name a few and made programmes for the BBC, ITV, Channel 4 and Discovery Channel among others. My photography has been published in magazines all around the world including Time Magazine, I exhibit regularly and I have a book published on Humpback Whales.

Wild Horizons® Productions
Address: 5757 West Sweetwater Drive, Tucson, Arizona 85745, USA
Phone: +1 520 743 4551
Fax: +1 520 743 4552
Email: info@wildhorizons.com
Website: www.wildhorizons.com
Linkedin.com/company/wild-horizons
Owner/Producer/Photographer: Thomas Wiewandt
Underwater Still Photographer: Barry Brown

Thomas Wiewandt and Barry Brown are available for stills photography on projects based anywhere in the world. We are both natural history and travel specialists. Barry is also an expert, fully equipped underwater photographer. Tom holds a PhD in ecology from Cornell. Our work has appeared in books, calendars, and magazines worldwide, including Audubon, Arizona Highways, Smithsonian, Sport Diver, National Wildlife, GEO, and publications by the National Geographic Society. We both have an excellent rapport with field biologists, and Barry is an Ikelite Ambassador. Our professional memberships include the Authors Guild, ASMP, NANPA, ASPP, and the SSC of the IUCN.

David Wright – Photographer/Cinematographer/DP
Address: Appleton, Maine, USA
Main listing in 'Camera Operators' on Page 171

EXPERTS/SCIENTISTS

Jiri Bálek - Zoologist/Cameraman/DOP/Editor
Lemuria TV
Address: Tisá, CZECH REPUBLIC
Main listing in 'Camera Operators' on Page 137

Nick Ball - Wildlife Cameraman/Zoologist
Address: Hampshire, UK
Main listing in 'Camera Operators' on Page 137-138

Big Gecko
Adam Britton (Crocodile Specialist), Erin Britton (Biologist)
Address: PO Box 353, Humpty Doo, Northern Territory 0836, AUSTRALIA
Phone: +61 407 185 182 & +61 889 884 607
Email: gecko@crocodilian.com
Website: www.big-gecko.com and www.crocodilian.com
Facebook.com/BigGecko
Twitter.com/adambritton
Adam Britton – abritton@crocodilian.com
Erin Britton – erin@crocodilian.com

Big Gecko are well-established crocodile specialists with 20 years experience exceeding 150 TV and film credits. We provide expertise at all stages of the production, including our own research projects. Adam Britton is also highly experienced in front of the camera. Big Gecko's Australian resources include an underwater filming enclosure, several large crocodiles, specialist filming vessel, logistical & fixing support, safety training, and stock footage. All resources are insured for film-related work. We are particularly interested in novel and innovative approaches to storytelling, rather than covering familiar ground. There are plenty of interesting films that have yet to be made.

Dr. Sarah Bologna – Anthropologist / Copyeditor
Address: Kilbrittain, Co. Cork, IRELAND
Phone: +353 87 919 4940
Email: sabologna@gmail.com
Linkedin.com/pub/sarah-apap-bologna/9/878/a17
Wildlife-film.com/-/SarahBologna.htm

241

Sarah Bologna is a social anthropologist who specialises in conservation-driven rural development. Her research examines the complex and conflicting issues around the environment, resource use, and climate justice, most explicitly at the interface between humanity and nature. Her work aims to bring into clear focus the lives and priorities of those who bear the brunt of global inequalities. She is also a keen and experienced academic copyeditor who specialises in working with authors in the fields of environment, ecology and conservation.

Anita Chaumette – Underwater/Marine Environment Expert
Liquid Motion Underwater Film Academy
Address: Cozumel Island, MEXICO
Main listing in 'Education/Training' on Page 109

Ed Drewitt – Naturalist/Broadcaster/Wildlife Detective/Consultant
Address: Bristol, UK
Phone: +44 (0)777 2342 758
Email: ed@eddrewitt.co.uk
Website: www.eddrewitt.co.uk
Facebook.com/pages/Ed-Drewitt-Naturalist-and-Broadcaster/493747694019162
Twitter.com/eddrewitt

Ed's been a naturalist for over 20 years and has excellent communicating skills translating difficult messages or concepts into interesting and accessible broadcasts. While Ed is often involved in television through his work on urban peregrines, he is also an expert on identifying birds and birdsong, wildlife tracks and signs, and engaging young people with nature. Ed has a range of resources such as feathers and skulls that are often used to compliment stories. He is a frequent contributor to TV and radio, including as a consultant for the BBC's *Springwatch* programmes. Ed also delivers professional training on using plain language, working with schools and presenting/communication skills.

Tania Rose Esteban – Wildlife Filmmaker/Zoologist
TRE Productions
Address: Bristol, UK
Wildlife-film.com/-/TaniaEsteban.htm
Main listing in 'Researchers' on Page 201

Will Goldenberg
Address: California, USA
Wildlife-film.com/-/WillGoldenberg.htm
Main listing in 'Camera Operators' on Page 148

Della Golding – Presenter/Producer/Remote Location Specialist
Address: Bristol, UK
Main listing in 'Presenters' on Page 217

"possessing expert skills in dangerous wild animal handling, including snakes and crocodiles."

Steve Hamel – Biologist/Camera Operator/Sound Recordist
Address: Montreal, Quebec, CANADA
Main listing in 'Camera Operators' on Page 150

Arlo Hemphill – Writer/Filmmaker/Science & Conservation Consultant
Address: Frederick, Maryland, USA
Main listing in 'Researchers' on Page 202

Agneta Heuman – Conservation Biologist
Address: Zollikon, SWITZERLAND
Wildlife-film.com/-/AgnetaHeuman.htm
Main listing in 'Camera Operators' on Page 152

Tom "The Blowfish" Hird – Broadcaster/Wildlife Expert/Author
Address: Bristol-based, UK
Wildlife-film.com/-/Tom-TheBlowfish-Hird.htm
Main listing in 'Presenters' on Page 218-218

Octavia Hopwood – Science Communicator/ Presenter
Address: Shrewsbury, **UK**
Wildlife-film.com/-/OctaviaHopwood.htm
Main listing in 'Presenters' on Page 218

Clive Huggins - Consultant Entomologist/Photographer
Address: Surrey, UK
Phone: +44 (0)20 8942 7846
Email: clivehuggins@ymail.com
Wildlife-film.com/-/CliveHuggins.htm

Insects & Spiders Worldwide, (Terrestrial Arthropods). Research & develop ideas/stories; Script fact checking; Access to specialists & local contacts; Bug Wrangling; Field support; Macro & habitat stills photography. Advising on entomological issues including historical for film sets. Previously Entomologist at Natural History Museum London, found new insect species, made behavioural & biological discoveries with published material. Fellow Royal Entomological Society; Butterfly Conservation committee. Training in Film production includes BBC Academy. Padi Advanced Scuba Diver. Recent Credits include; · *"Galapagos 3D"* Colossus (Atlantic) Productions. · *"Winterwatch, Microworlds"* BBC NHU. · *"Camp Africa"* Plimsoll Productions. · *"Planet Earth II"* BBC NHU. · *"Amazon Adventure"* IMAX, SK Films.

Andy Jackson – Marine Life Expert/Cameraman
SubSeaTV
Address: Scarborough, UK
Wildlife-film.com/-/AndyJackson.htm
Main listing in 'Camera Operators' on Page 155

Shazaad Kasmani – Photographer, Presenter, Expert
Wild Kenya Safaris
Address: Mombasa, KENYA
Wildlife-film.com/-/ShazaadKasmani.htm
Main listing in 'Location Managers/Fixers' on Page 92

Trevor LaClair – Presenter / Explorer / Photographer
Trekking with Trevor
Address: Missouri, USA
Wildlife-film.com/-/TrevorLaClair.htm
Main listing in 'Presenters/Narrators' on Page 219-220

Jocelyn Murgatroyd – Primatologist/Anthropologist
Address: Cornwall, England, UK
Main listing in 'Researchers' on Page 203

Wolfgang Neun – Zoologist / Macro Cameraman
Address: Würzburg, GERMANY
Phone: phone: +49 (0)9367 988 1343 & +49 (0)151 2133 8179
Email: w.neun@t-online.de
Vimeo.com/wolfgangneun
Linkedin.com/in/wolfgang-neun-11737ba0
Wildlife-film.com/-/WolfgangNeun.htm

Wolfgang is a graduate zoologist specialized in production of Ultra High Definition macro content on insect and other invertebrate behaviour. He is available for documentary and commercial work both on location and in the studio and looking for commissions from production companies and broadcasters for programme inserts and sequence work.

Rob Nelson – Science Communicator/Marine Biologist/Host
Untamed Science
Address: Charlotte, NC, USA
Main listing in 'Production Companies' on Page 44-45

Pim Niesten – Zoologist & Camera Operator/Filmmaker
Address: Mechelen, BELGIUM
Wildlife-film.com/-/PimNiesten.htm
Main listing in 'Camera Operators' on Page 161

Rubén Duro Pérez – Scientific Advisor/Scientific Photographer/Camera
Operator/Producer/Director
Address: Dosrius, SPAIN
Wildlife-film.com/-/RubenDuroPerez.htm
Main listing in 'Producers/Directors' on Page 188

Libby Prins – MSc Veterinary Epidemiology
Address: Bristol, UK
Main listing in 'Assistant Producers' on Page 194

Steven Siegel – Videographer/Producer/Director/Expert
Raven On The Mountain Video
Address: Placitas, New Mexico, USA
Main listing in 'Producers/Directors' on Page 190

Specialties include hummingbirds, songbirds (singing), and waterfowl in flight.

David Spears – Director/Specialist Macro Cameraman
Western Science Events CIC
Address: Rock House, Curland, Taunton, Somerset TA3 5SB, UK
Phone: +44 (0)1823 481 894

Email: david@spearsimaging.co.uk
Website: www.cloudshillimaging.com

FRPS ASIS FRMS · Consultant microscopist doing imaging work using scanning electron microscopy, light microscopy, macro, time-lapse and other advanced imaging techniques. Not looking for proposals. Not offering work experience.
Running a Big Bang Science & Engineering Festival at Weston Super Mare 26/27 April 2019.

Colin Stevenson – Writer and Zoologist
Address: Oxfordshire, UK
Main listing in 'Writers/Script Editors' – Page 211

Darryl Sweetland – Cameraman/Biologist/Writer
Asian Wildlife Films
Country: THAILAND
Wildlife-film.com/·/DarrylSweetland.htm
Main listing in 'Camera Operators' on Page 168

Stu Westfield
Ranger Expeditions Ltd
Address: High Peak Derbyshire, UK
Phone: +44 (0)7890 620 274
Email: rangerexped@hotmail.co.uk
Website: www.rangerexped.co.uk
Facebook.com/rangerexpeditions
Linkedin.com/in/stuartwestfield
Wildlife-film.com/·/StuartWestfield.htm

Pre-expedition skills training from qualified and experienced professional Mountain Leader.
Courses available year round, Peak District.
Expedition leader · Countries: Tanzania, Uganda, Kenya, Namibia, Rwanda, South Africa, Swaziland, Iceland. Environments: Altitude, mountain, savanna, volcanic desert, jungle.

Wild Horizons® Productions
Address: 5757 West Sweetwater Drive, Tucson, Arizona 85745, USA
Phone: +1 520 743 4551
Fax: +1 520 743 4552
Email: info@wildhorizons.com
Website: www.wildhorizons.com
Linkedin.com/company/wild-horizons
Owner/Producer/Ecologist: Thomas Wiewandt
Underwater Still Photographer: Barry Brown

Thomas Wiewandt and Barry Brown are available as consultants on projects based anywhere in the world. We are both natural history and travel specialists. Barry is an expert, fully equipped underwater photographer and an Ikelite Ambassador. Tom holds a PhD in ecology from Cornell. Our work has appeared in books, calendars, and magazines worldwide, and we both have an excellent rapport with field biologists. Our professional memberships include the Authors Guild, ASMP, NANPA, ASPP, and the SSC of the IUCN.

FURTHER READING

Conservation Film-making: how to make films that make a difference by Madelaine Westwood and Piers Warren with a Foreword by Jane Goodall – published by Wildeye 2015

A complete 'how to' guide, aimed at both film-makers and conservationists who want to use film as a tool for conservation. Covers all pre-production activities including how to raise funds, how to choose and use the filming equipment you need, plus a guide to post-production. Explores reaching audiences, organising screenings, using social media, monitoring effectiveness and ethical considerations. Features case studies from leading conservation film-makers including Mike Pandey, Rob Stewart (*Sharkwater* and *Revolution*), Will Anderson (*Hugh's Fish Fight*) and Shekar Dattatri. Describes how organisations use film effectively in conservation; including Greenpeace, Royal Society for the Protection of Birds (RSPB), Environmental Investigation Agency (EIA) and Great Apes Film Initiative (GAFI).
(see www.wildeye.co.uk/publishing)

Careers in Wildlife Film-making by Piers Warren – published by Wildeye 2002, 2006

The essential book by Piers Warren, packed with guidance and advice for aspiring makers of natural history films. Described as 'long-overdue' and 'much-needed', this is not just an essential book for newcomers and wannabes – the fascinating case studies of well-known individuals, and unique discussion of the future of the industry from top professionals, make this an important read for those already working in the fields of wildlife, underwater and conservation film.
(see www.wildeye.co.uk/publishing)

Wildlife Film-making: Looking to the Future edited by Piers Warren, foreword by Neil Nightingale – published by Wildeye 2011

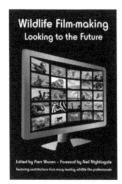

What does the future of wildlife film-making hold for us all? Whether you are a budding film-maker, an experienced amateur or a seasoned professional, this new book – an accompaniment to the hugely successful *Careers in Wildlife Film-making* – attempts to answer this question. As technology advances rapidly and viewers' options increase, this book presents a unique collection of views and advice that make it an invaluable resource for everyone who wishes to succeed as a wildlife film-maker in years to come. With articles from many leading figures in the industry and case studies of numerous skilled practitioners. (see www.wildeye.co.uk/publishing)

Confessions of a Wildlife Filmmaker: The Challenges of Staying Honest in an Industry Where Ratings Are King by Chris Palmer – published by Bluefield Publishing 2015

Chris Palmer's new book is part memoir, part confession, and part indictment of the cable and television networks for failing to put conservation, education, and animal welfare ahead of ratings and profits. It's also about the mistakes he's made while struggling to excel in a profession he loves. He argues that the state of the wildlife filmmaking industry worsens every year and says that it's time for wildlife filmmaking to move in a more ethical direction. He makes a compelling case that we must make broadcasters like Animal Planet, Discovery, National Geographic, and the History Channel do better, and that it's time for viewers and film-makers to fight back.

Shooting in the Wild: An Insider's Account of Making Movies in the Animal Kingdom by Chris Palmer – published by Sierra Club Books 2010

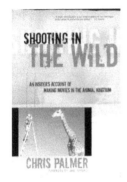

Longtime producer Chris Palmer provides an in-depth look at wild animals on film, covering the history of wildlife documentaries, safety issues, and the never-ending pressure to obtain the "money shot." Marlin Perkins, Jacques Cousteau, Steve Irwin, Timothy Treadwell, and many other familiar names are discussed along with their work, accidents, and in some cases, untimely deaths. Chris Palmer is highly critical of Irwin, and offers fascinating revelations about game farms used by exploitative filmmakers and photographers looking for easy shots and willing to use caged animals to obtain them. He also considers the subliminal messages of many wildlife films, considering everything from *Shark Week* to *Happy Feet* and how they manipulate audiences toward preset conclusions about animal behavior. In all this is an engaging and exceedingly timely look at a form of entertainment the public has long taken for granted and which, as Chris Palmer points out, really needs a fresh and careful reconsideration.

Go Wild with your Camcorder - How to Make Wildlife Films
by Piers Warren – published by Wildeye 2006

Whether you want to film wildlife as a fascinating hobby, or are hoping for a career as a professional wildlife film-maker, this book and a basic camcorder are all you need to get started! Packed with information and advice acquired over years of teaching wildlife film-making Piers Warren guides you through all aspects of making a wildlife film from choosing a camcorder to editing the final product.
(see www.wildeye.co.uk/publishing)

Wildlife Films by Derek Bousé – published by University of Pennsylvania Press 2000

This book is a scholarly analysis of the development of wildlife films up to the 21st century. Derek Bousé's exploration of wildlife film-making over the last few hundred years is fascinating, and the book is littered with behind-the-scenes anecdotes. Although the book focuses on the industry in the USA and UK, the discussions (to what extent are wildlife films documentaries for example) are applicable to wildlife film-makers the world over. There are so many well-known names – both companies and individuals – in the business today, and it's hard to keep track as units change name, merge or disappear. This book certainly helps piece the jigsaw together as the genre's development is analysed.

100 Years of Wildlife by Michael Bright – published by BBC Books 2007

Ever since 1907, when a flickering film about birds enthralled a cinema audience, we've been fascinated by watching the natural world on film. For 100 years wildlife films have taken us to places and shown us things we would never be able to see – the excitement, the strangeness, the danger of the wild. Today, our interest in the wonders of the natural world is stronger than ever. Discover the history of the wildlife moving image: the first heady days when an ant juggling a matchbox was big box office; the charismatic and sometimes controversial celebrity presenters; the astonishing behaviour of animals and plants; the boggling oddities of nature; the animals now extinct that poignantly only exist on film. Explore 100 years of revelation – from the black-and-white silent footage that started it all to the almost magical photography techniques seen today in programmes like *Planet Earth*. From famous faces of wildlife TV to extraordinary animal (and plant) behaviour, natural history filming has changed the way we look at and think about our world. It's all here – so weird, you couldn't make it up; so wonderful, you wouldn't want to miss it.

Reel Nature by Gregg Mitman – published by Harvard University Press 1999

In this book Gregg Mitman explores the history of nature films focusing on the conflict between the desire for scientific authenticity and the demand for audience-pleasing dramatisation. He discusses the driving forces behind the evolution of nature films over the decades, highlights good and bad nature film-makers, explores the relationship between scientific establishments and Hollywood, and analyses Disney's contributions to this genre and the huge success of natural history on TV. He finishes by concluding that while nature films help us to understand the natural world, the truth about our place in the web of life has been left on the cutting-room floor.

Celebrity and the Environment by Dan Brockington – published by Zed Books 2009

The battle to save the world is being joined by a powerful new group of warriors. Celebrities are lending their name to conservation causes, and conservation itself is growing its own stars to fight and speak for nature. In this timely and essential book, Dan Brockington argues that this alliance grows from the mutually supportive publicity celebrity and conservation causes provide for each other, and more fundamentally, that the flourishing of celebrity and charismatic conservation is part of an ever-closer intertwining of conservation and corporate capitalism. Celebrity promotions, the investments of rich executives, and the wealthy social networks of charismatic conservationists are producing more commodified and commercial conservation strategies; conservation becomes an ever more important means of generating profit. 'Celebrity and the Environment' provides vital critical analysis of this new phenomena.

Media, Ecology and Conservation: Using the media to protect the world's wildlife and ecosystems by John Blewitt – published by Green Books 2010

Media, Ecology and Conservation focuses on global connectivity and the role of new digital and traditional media in bringing people together to protect the world's endangered wildlife and conserve fragile and threatened habitats. By exploring the role of film, television, video, photography and the internet in animal conservation in the USA, India, Africa, Australia and the United Kingdom John Blewitt investigates the politics of media representation surrounding important controversies such as the trade in bushmeat, whaling and habitat destruction. The work and achievements of media/conservation activists are located within a cultural framework that simultaneously loves nature, reveres animals but too often ignores the uncomfortable realities of species extinction and animal cruelty.

Missouri in Flight by Mundy Hackett – published by University of Missouri Press 2007

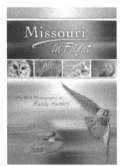

With its rugged Ozarks, rolling plains, big rivers, and wetlands, Missouri offers a diversity of habitats for native birds, and its location along a major migration route attracts many avian visitors. Wildlife biologist and photographer Mundy Hackett offers more than one hundred spectacular color images, along with his thoughts on the beauty of birds, the subtleties of their behavior, and all of the elements that make them the ultimate photographic subject. Along with interesting facts about the various birds of Missouri, he shares tips on how amateur shutterbugs can improve the overall quality of their photos. Mingled with his amazing photos of coots, crows, kestrels, and more are Hackett's thoughts about choosing cameras, taking photos from cars, visualization, composing an appealing scene, using contrasting colors—a host of practical tips that can help birders and photographers better capture those elusive images. He even passes along suggestions on the most challenging of photos, those of birds in flight. Through its examples and subtle instruction, the book can help readers record their own timeless moments and rediscover the beauty in the skies.

251

Wildlife Stalker: Days in the Life of Filmmaker Bob Landis
by Kevin G. Rhoades – published: Five Valleys Press 2011

Recording wildlife behavior on movie film and video is the hallmark of Bob Landis' films. He has filmed wildlife in Yellowstone for over 40 years – a place dear to his soul. This book is comprised of two stories wound into one: a depiction of days afield with a wildlife cinematographer who has filmed and co-produced stories about Yellowstone's iconic species – the bear, the wolf, the bison – films that have aired on *PBS*, *Nature* and on *National Geographic Television*. This book also is a collection of flashbacks to Landis' past – growing up as a small-town Wisconsin boy where he followed his destiny to become a football player, teacher, diehard Green Bay Packers fan, and wildlife filmmaker. Bob Landis is one of America's premier wildlife filmmakers.

Time-lapse Photography: A Complete Introduction to Shooting, Processing and Rendering Time-lapse Movies with a DSLR Camera by Ryan A Chylinski – published by Cedar Wings Creative 2012

An excellent guide to the techniques of creating time-lapse sequences with 350+ easy to understand examples, workflows, walkthroughs and diagrams covering basic and advanced topics. The book covers time-lapse gear from basic to advanced: tripods, intervalometers and remote timers, DSLR cameras and lenses; balancing time-lapse image settings; shooting time-lapse: composition and exposure; preventing time-lapse flicker; creating the time-lapse movie: codecs and frame rates, software workflows and walkthroughs; time-lapse challenges: astrophotography time-lapse, flicker-free day to night transitions, HDR time-lapses and time-lapse motion control devices. Throughout the book there are many links to online examples of time-lapse sequences. Author Ryan Chylinski is an American photographer and founder of LearnTimelapse.com, a community powered time-lapse education and experimentation hub.

Born in a Drop by Rubén Duro – published by 3.14 Servicios Editoriales. Website: www.borninadrop.com

Born in a drop is a photomicrography book. Large format microscope photographs show a world of water microorganisms whose small size belies the fundamental role they play in the functioning of all ecosystems. Microscope images in this book condense a great number of passionate hours of observation through the microscope, of collecting samples in rivers, ponds and lakes, and of the author's tireless effort to maintain these living beings in conditions suitable for developing their activity in front of the camera lens. Rubén Duro shows us the best photographs with microscope he has taken ever.

Ivory, Apes & Peacocks: Animals, adventure and discovery in the wild places of Africa by Alan Root – published by Vintage 2013

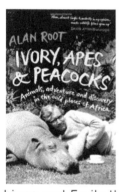

In *Ivory, Apes & Peacocks*, Alan tells the story of his life's work, from his arrival in Kenya as a young boy (furious at having to leave behind Britain's birds) to the making of his game-changing films. Instead of sticking to the Big Five animals, these looked up close at whole ecosystems · baobab trees, termite mounds, natural springs · and involved firsts such as tracking the wildebeest migration from a balloon, then flying it over Kilimanjaro, filming inside a hornbill's nest and diving with hippos and crocodiles. Along the way we meet Sally the pet hippo and Emily the house-proud chimp, watch as Dian Fossey catches sight of her first mountain gorilla and have sundowners with George and Joy Adamson. And here, too, is Joan Root, Alan's wife and collaborator for over thirty years, who was brutally murdered in retaliation for her environmental campaigning. In this extraordinary memoir we look at Africa's wonders through the eyes of a visionary, live through hair-raising adventure and personal sorrow, and also bear witness to a natural world now largely lost from view.

Looking for Adventure by Steve Backshall – published by Phoenix 2012

A childhood dream leading to a journey of a lifetime. It all began after a rainy-day visit with his family to an exhibition of artefacts from Papua New Guinea. From that moment on the seven-year-old boy was captivated: he knew this was somewhere he needed to go, this was a place he needed to explore. But how could a boy from the suburbs go about becoming an explorer? Full of the most incredible wildlife, mind-blowing wildernesses, hairy adventures in the jungle, cannibals, nasty bacteria, hilarious camaraderie with other crew members and natives alike, triumph, danger and non-stop excitement, *Looking for Adventure* is the irresistible and inspiring story of how a little boy from a normal British family went on to become a modern day explorer, with his heart winning out and the adrenalin all-consuming and unrelenting.

The Great Animal Orchestra: Finding the Origins of Music in the World's Wild Places by Bernie Krause – published by Profile Books 2012

A fascinating and unique exploration of nature's music, from plants and animals to wind and rain. Bernie Krause is the world's leading expert in natural sound. He has spent the last forty years recording ecological soundscapes and has archived the sounds of over 15,000 species, but half of the wild soundscapes he has on tape no longer exist because of human actions. Krause divides natural sound into three categories: biophony is the sound made by animals and plants, like the shrimp that makes noises underwater equivalent to 165 decibels; geophony is natural sound, like wind, water and rain, which led different tribes to have different musical scales; and anthrophony is human-generated sound, which affects animals as it changes, for example causing disoriented whales to become beached. In *The Great Animal Orchestra* he invites us to listen through his ears to all three as he showcases singing trees, contrasting coasts and the roar of the modern world. Just as streetlights engulf the stars, Krause argues that human noise is drowning out the sounds of nature.

HIMALAYA – Mountains of Life by Sandesh Kadur – published by Ashoka Trust for Research in Ecology and the Environment 2013

From the great canyon of Yarlung Tsangpo and the Siang Gorge in the east to the Kali Gandaki Gorge in the west, the Eastern Himalaya encompasses within its vast realm, ancient mountain kingdoms, forested valleys and snow-covered peaks – all in a relatively young landscape, still growing, higher and more enigmatic each day. Within its rugged folds lay many mysteries, new species, primeval cultures and the promise of magical cures to heal all humanity. No doubt, the greatest mountain range on earth the Himalaya hides many treasures. This book attempts to unravel these treasures and showcase what lays hidden to the cursory eye with the hope that some value is added to our biocultural treasures which otherwise, will certainly disappear. Himalaya, takes us on a journey through these Mountains of Life and tells us why preserving this heritage is important, not just for us, but for the future of all life on earth.

In The Field: The Art of Field Recording by Cathy Lane and Angus Carlyle – published by Uniformbooks 2013

This is a collection of interviews with contemporary sound artists who use field recording in their work. From its early origins in wildlife sound and in ethnographic research, field recording has expanded over the last few decades into a diverse range of practices which explore and investigate aspects of the lived environment, from the microscopic to the panoramic, through the medium of recorded sound. These conversations explore the fundamental issues that underlie the development of field recording as the core of their activity. Recurring themes include early motivations, aesthetic preferences, the audible presence of the recordist and the nature of the field. Conversations with Andrea Polli, Annea Lockwood, Antye Greie, Budhaditya Chattopadhyay, Christina Kubisch, Davide Tidoni, Felicity Ford, Francisco López, Hildegard Westerkamp, Hiroki Sasajima, Ian Rawes, Jana Winderen, Jez Riley French, Lasse-Marc Riek, Manuela Barile, Peter Cusack, Steven Feld and Viv Corringham.

Save the Humans by Rob Stewart – published by Random House Canada 2013

Beginning with a childhood spent catching poisonous snakes and chasing after alligators, Rob Stewart, the award-winning documentary film-maker behind *Sharkwater* and *Revolution*, charts his development into one of the world's leading environmental activists. Risking arrest and mafia reprisal in Costa Rica, nearly losing a leg in Panama and getting lost at sea in the remote Galapagos Islands, Stewart is living proof that the best way to create change in the world is to dive in over your head. With his efforts to save sharks leading to tangible policy change in countries around the world, Stewart sets his sights on a slightly bigger goal: saving humanity. Criss-crossing the globe to meet with the visionaries, entrepreneurs, scientists and children working to solve our environmental crises, Stewart's message is clear: the revolution to save humanity has started, the only thing missing is you! Tragically, Rob Stewart died while diving in 2017 aged 37.

The Shark and the Albatross: Adventures of a wildlife film-maker by John Aitchison – published by Profile Books 2015

For twenty years John Aitchison has been travelling the world to film wildlife for the BBC and other broadcasters, taking him to far-away places on every continent. *The Shark and the Albatross* is the story of these journeys of discovery, of his encounters with animals and occasional enterprising individuals in remote and sometimes dangerous places. His destinations include the far north and the far south, expeditions to film for *Frozen Planet* and other natural history series, in Svalbard, Alaska, the remote Atlantic island of South Georgia, and the Antarctic. They also encompass wild places in India, China and the United States. In all he finds and describes key moments in the lives of animals, among them polar bears and penguins, seals and whales, sharks and birds, and wolves and lynxes. He reveals what happens behind the scenes and beyond the camera. He explains the practicalities and challenges of the filming process, and the problems of survival in perilous places.

Wild Kingdom: Bringing Back Britain's Wildlife by Stephen Moss – published by Square Peg 2016

Can Britain make room for wildlife? Stephen Moss believes it can. The newspaper headlines tell us that Britain's wildlife is in trouble. Wild creatures that have lived here for thousands of years are disappearing, because of pollution and persecution, competition with alien species, changing farming and forestry practices, and climate change. It's not just rare creatures such as the Scottish wildcat or the red squirrel that are vanishing. Hares and hedgehogs, skylarks and water voles, even the humble house sparrow, are in freefall. But there is also good news. In Newcastle, otters have returned to the river Tyne and red kites are flying over the Metro centre; in Devon, there are beavers on the River Otter; and peregrines – the fastest living creature on the planet – have taken up residence in the heart of London.Elsewhere in the British countryside things are changing too. What were once nature-free zones are being 'rewilded'; giving our wild creatures the space they need – not just to survive, but also to thrive.

ReWild: The Art of Returning to Nature by Nick Baker – published by Aurum Press 2017

As our busy, technology-driven lives become more sedentary we have become less connected to our natural surroundings. In these challenging times, it is by rediscovering our links to the world around us that we can rekindle the natural, human connection we have to the wild. Nick Baker introduces rewilding as a concept that needs to be established at a personal level. Taking the reader back to their natural sensitivities, we rediscover the instinctive potential of our senses. From learning to observe the creatures and beasts within hands' reach and seeing and hearing the birds and trees of our forests, Baker's expert advice offers the practical tools to experience the wilderness on your own doorstep, as well as in the wider, wilder world. ReWild mixes memoir with practical advice, to delight, inform and inspire us all to discover the art of returning to nature.

Farmageddon: The True Cost of Cheap Meat by Philip Lymbery – published by Bloomsbury Paperbacks 2015

Farm animals have been disappearing from our fields as the production of food has become a global industry. We no longer know for certain what is entering the food chain and what we are eating · as the UK horsemeat scandal demonstrated. We are reaching a tipping point as the farming revolution threatens our countryside, health and the quality of our food wherever we live in the world. *Farmageddon* is a fascinating and terrifying investigative journey behind the closed doors of a runaway industry across the world · from the UK, Europe and the USA, to China, Argentina, Peru and Mexico. It is both a wake-up call to change our current food production and eating practices and an attempt to find a way to a better farming future.

Dead Zone: Where the Wild Things Were by Philip Lymbery – published by Bloomsbury Publishing 2018

Climate change and poaching are not the only culprits behind so many animals facing extinction. The impact of consumer demand for cheap meat is equally devastating and it is vital that we confront this problem if we are to stand a chance of reducing its effect on the world around us. · We are falsely led to believe that squeezing animals into factory farms and cultivating crops in vast, chemical-soaked prairies is a necessary evil, an efficient means of providing for an ever-expanding global population while leaving land free for wildlife

· Our planet's resources are reaching breaking point: awareness is slowly building that the wellbeing of society depends on a thriving natural world

From the author of the internationally acclaimed *Farmageddon*, *Dead Zone* takes us on an eye-opening journey across the globe, focussing on a dozen iconic species and looking at the role that industrial farming is playing in their plight.

The Vegan Cook & Gardener: Growing, Storing and Cooking Delicious Healthy Food all Year Round by Piers Warren and Ella Bee Glendining – published by Permanent Publications 2018

The Vegan Cook & Gardener

Grow your own fruit and vegetables, herbs, salads and sprouts, and then turn your produce into delicious, no-fuss vegan meals that are healthy for you and the planet. Father and daughter team, Piers Warren and Ella Bee Glendining, share successful growing techniques and seasonal recipes, plus years of experience of animal-free, healthy living. Piers Warren, founder of Wildeye and wildlife-film.com, devised this book as a practical way to encourage people to reduce their carbon footprint. It's increasingly clear that the livestock industry worldwide is a huge contributor to climate change, land acidification and eutrophication, as well as using vast amounts of land and water. All this has been a major factor in the loss of the wildlife we want to film and conserve. Grow and eat for a more ethical, healthy and sustainable world!

In the book they show you how to:

* Grow your own food
* Garden without animal products
* Grow more challenging but delicious crops
* Produce food all year with practical growing techniques
* Store any excess to keep you going through the leaner months
* Cook your produce with a selection of satisfying and delicious recipes.

Elephants Wear Ivory by Feisal Malik and Tanvir Ali – published by Visual Africa Films Ltd 2018

This coffee table book with embedded videos includes fifty images of elephants, fifty stories, and a full length documentary about elephant poaching produced by Visual Africa Films: *The Last In Line*. The video technology used in the book is called augmented reality (AR) and enables the reader to scan images with a smartphone and watch the resulting video on the device. Some of the AR used features behind the scenes photography for the book in Amboseli National Park. Part of the proceeds from the sale of the book are going to Elephant Conservation in Kenya. This is the first book of its kind in Kenya, and amongst the first in the world.

INDEX